MW00610215

Wilmette Public Library
1242 Wilmette Ave.
Wilmette, IL 60091
847-256-5025

ALSO BY TOM SHONE

The Irishman: *The Making of the Movie*

Tarantino: A Retrospective

Woody Allen: A Retrospective

Martin Scorsese: A Retrospective

In the Rooms

Blockbuster: How Hollywood Learned to Stop Worrying and Love the Summer

THE NOLAN VARIATIONS

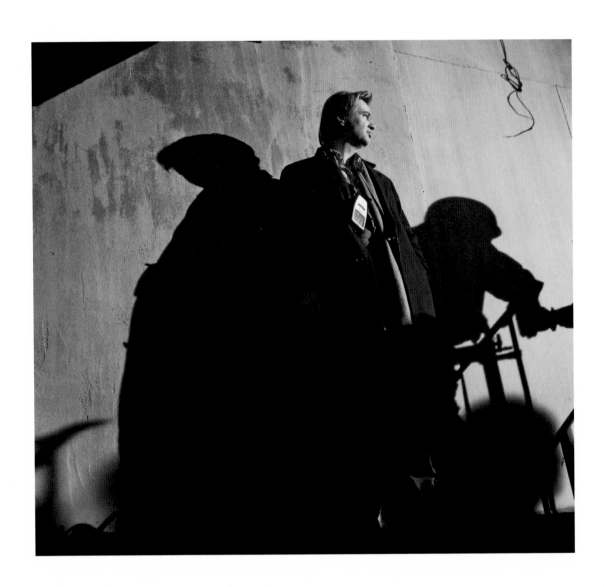

Nolan in Cardington,
England, while shooting
The Dark Knight (2008).

THE NOLAN VARIATIONS

THE MOVIES, MYSTERIES, AND MARVELS OF

CHRISTOPHER NOLAN

TOM SHONE

WILMETTE PUBLIC LIBRARY
1242 WILMETTE AVENUE
WILMETTE, IL 60091
847-256-5025

 ALFRED A. KNOPF | NEW YORK | 2020

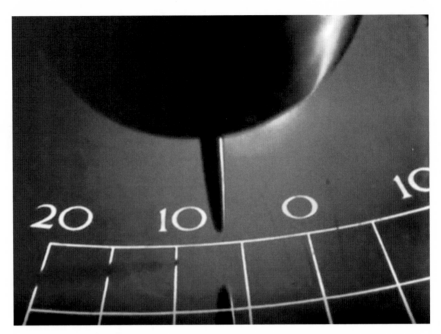

Don Levy's *Time Is* (1964).

THIS IS A BORZOI BOOK PUBLISHED BY ALFRED A. KNOPF

Copyright © 2020 by Tom Shone

All rights reserved. Published in the United States by Alfred A. Knopf,
a division of Penguin Random House LLC, New York, and distributed in Canada
by Penguin Random House Canada Limited, Toronto.

www.aaknopf.com

Knopf, Borzoi Books, and the colophon are registered trademarks of Penguin Random House LLC.

Library of Congress Cataloging-in-Publication Data
Names: Shone, Tom, 1967– author. | Title: The Nolan variations : the movies, mysteries, and marvels of
Christopher Nolan / Tom Shone. | Description: First edition. | New York : Alfred A. Knopf, 2020. | Includes
bibliographical references and index. | Identifiers: LCCN 2020005526 (print) | LCCN 2020005527 (ebook) |
ISBN 9780525655329 (hardcover) | ISBN 9780525655336 (ebook) | Subjects: LCSH: Nolan, Christopher, 1970—
Criticism and interpretation. | Classification: LCC PN1998.3.N65 S56 2020 (print) | LCC PN1998.3.N65 (ebook) |
DDC 791.4302/33092 [B]—dc23 LC record available at https://lccn.loc.gov/2020005526
LC ebook record available at https://lccn.loc.gov/2020005527

Jacket image (top) Keith Horman/Alamy
Jacket design by John Gall

Manufactured in Germany

First Edition

791,
43
SH

For Juliet

Nicolas Grospierre,
The Library (The Never-Ending Corridor of Books) (2006).

A child of six was telling himself stories as he lay in bed. It was a new power, and he kept it a secret . . . ships ran high up the dry land and opened into cardboard boxes . . . gilt-and-green iron railings that surrounded beautiful gardens turned all soft . . . so long as he remembered it was only a dream. He could never hold that knowledge more than a few seconds ere things became real, and he sat miserably upon gigantic door-steps trying to sing the multiplication-table up to four times six.

—RUDYARD KIPLING, "The Brushwood Boy"

Time is a river which sweeps me along, but I am the river; it is a tiger which destroys me, but I am the tiger; it is a fire which consumes me, but I am the fire.

—JORGE LUIS BORGES, "A New Refutation of Time"

CONTENTS

INTRODUCTION 3

ONE STRUCTURE 21

TWO ORIENTATION 51

THREE TIME 77

FOUR PERCEPTION 108

FIVE SPACE 125

SIX ILLUSION 148

SEVEN CHAOS 174

EIGHT DREAMS 202

NINE REVOLUTION 235

TEN EMOTION 257

ELEVEN SURVIVAL 283

TWELVE KNOWLEDGE 310

THIRTEEN ENDINGS 334

Acknowledgments 351

Filmography 353

Bibliography 357

Index 367

Floor Mosaic, Basilica di
San Giovanni in Rome.

THE NOLAN VARIATIONS

INTRODUCTION

AMAN WAKES UP in a room so dark that he cannot see his hand in front of his face. How long he has been sleeping, where he is, or how he got there he does not know. All he knows is that the hand he is holding in front of his face is his right hand.

Swinging his feet out of the bed, he places them on the ground, which is cold and hard. Maybe he is in the hospital. Has he been hurt? Or maybe a barracks. Is he a soldier? With his fingers, he feels the edge of the bed—metal, with rough wool sheeting. A memory comes back to him—of cold baths, a bell ringing, and a dreadful feeling of being late—but just as quickly the memory is gone, leaving him with a piece of knowledge: a light switch. On the wall somewhere. If he can just locate this switch, then he will be able to see where he is and everything will come back to him.

Gingerly, he pushes one foot across the floor, his sock snagging on something: splintery wood. Floorboards. These are floorboards. He takes a few steps forward, feeling his way with outstretched arms. His fingertips brush a cold, hard surface of some kind: the metal frame of another bed. He is not alone.

Feeling his way around the end of the second bed, he triangulates its position with respect to his own and determines where he imagines the central aisle of the room to be. Then he proceeds to inch down it, hunched

over to better feel the way. It takes him several minutes—the room is a lot longer than he thought—but eventually he comes up against a wall, the plaster cool to the touch. Flattening himself against it, he spreads his arms wide, catching a few flakes of plaster with his fingertips, and, with his left hand, finds the light switch. Bingo. With one flick of the switch, the room is bathed in light and he knows instantly where and who he is.

He does not exist. He is a hypothetical figure in a thought experiment by the German philosopher Immanuel Kant. In a 1786 essay entitled "What Does It Mean to Orient Oneself in Thinking?" Kant attempted to determine whether our perception of space is an accurate reflection of something "out there" in the universe, or an a priori mental apprehension, something intuited "in here." A former geography teacher, he was well placed to address the matter. Just a few years earlier, the invention of the telescope by his countryman William Herschel had led to the conception of "deep sky" and the discovery of Uranus, while the invention of the hot-air balloon had spurred mapmakers to new advances in meteorology and the understanding of cloud formation. It was to their example that Kant looked first. "If I see the sun in the sky and know it is now midday, then I know how to find south, west, north, and east," he wrote, "even the astronomer—if he pays attention only to what he sees and not at the same time to what he feels—would inevitably become disoriented." Kant thus posited the example of a man who was awakened in a strange room, unsure which way he was facing. "In the dark I orient myself in a room that is familiar to me if I can take hold of even one single object whose position I remember," he said, "and if someone as a joke had moved all the objects around so that what was previously on the right was now on the left, I would be quite unable to find anything in a room whose walls were otherwise wholly identical." Left and right are not something we are taught or observe. It is a priori knowledge that we simply wake up with. It derives from us, not the universe, and yet from it flows our entire apprehension of space, the universe, and our place within it. Unless some joker has been tampering with the light switch, in which case all bets are off.

The career of the film director Christopher Nolan has spanned no less convulsive a period of technological change than Immanuel Kant's. In August 1991, Nolan's second year at University College London, the World Wide Web was launched by Tim Berners-Lee on a NeXT computer at the European Organization for Nuclear Research. "We are now living on Internet time," said Andrew Grove, chief executive of Intel, in 1996. In

1998, the year Nolan released his first film, *Following,* U.S. vice president Al Gore announced a plan to make the GPS satellites transmit two additional signals for civilian applications, and Google was launched with the Faustian mission "to organize the world's information." A year later came wireless networking, Napster, and broadband, just in time for Nolan's second feature, *Memento.* By the time of his third movie, *Insomnia,* in 2002, the world's first online encyclopedia, Wikipedia, had arrived. In 2003, the anonymous bulletin board 4Chan was launched, quickly followed in 2004 by the first source-agnostic social media platform, Facebook, and then by YouTube and Reddit in 2005. "It's hard to overstate the flabbergasting speed and magnitude of the change," Kurt Anderson has written. In the early 1990s, less than 2 percent of Americans used the Internet; by 2002, less than a decade later, most Americans were online, overseeing the biggest shrinking of our conception of distance since the invention of the steam engine. With Euclidean space fragmented by the simultaneity of the Internet, time has become the new metric of who is available, but rather than unite us, it has made us aware as never before of the subjective bubble of time in which we each sit. "People 'stream' music to us and video, the tennis match we're watching may or may not be 'live,' the people in the stadium watching the instant replay on the stadium screen, which we see repeated on our screen, may have done that yesterday, in a different time zone," writes James Gleick in *Time Travel: A History.* "We reach across layers of time for the memories of our memories."

A simpler way of putting this is that our lives have become a Christopher Nolan movie. Like the maze that adorns the logo of his production company, Syncopy, Nolan's movies have entrances that are clearly marked. You probably have seen them advertised on TV. They are likely playing in your neighborhood multiplex. They occupy traditional genres like the spy thriller or heist movie. Many of them begin with a simple shot of a man waking up from a dream, like Kant's hypothetical subject. The world around them is heavily textured, solid to the touch, lent granular texture by immersive IMAX photography and enveloping sound design. The evidence of our eyes and ears compels our investment in this world, this hero, as the familiar tropes of genre filmmaking—heists, car chases, shootouts—surface around him in alien, unfamiliar configurations. The streets of Paris fold back on themselves like origami. An eighteen-wheel truck flips like a beetle. Planes are upended mid-flight, leaving the passengers clinging to the now perpendicular chassis. Some joker seems to be playing

with the light switch. Looped narrative schemes and shattering second-act twists further rock the ground beneath our feet, lending the otherwise solid narrative architecture a gauzy metafictional shimmer, as all we had thought solid melts into air, resulting in a delighted astonishment in the audience, which is a million miles away from the bluster and bombast of a typical Hollywood blockbuster. Enlivened by the unshakable sense of a great game being afoot, of having engaged in delicious conspiracy with the film's maker against the Punch and Judy shows that pass for entertainment on screens elsewhere, we wander dazed out onto the street, still debating

the ambiguity of the film's ending or the Escher-like vertigo induced by its plot. Easy to enter, Nolan's films are fiendishly difficult to exit, ramifying endlessly in your head afterward like plumes of ink in water. The film we have just seen cannot be unwatched. It isn't even really over. In many ways, it has only just begun.

• • •

I first met Nolan in February 2001 at Canter's Deli on North Fairfax Avenue, not far from the Sunset Strip in L.A. The director's second film, *Memento*, had just earned great reviews at Sundance, after a long, anxious year spent trying to secure distribution. A devilishly structured neo-noir with the eerie, sunlit clarity of a dream, *Memento* concerns an amnesiac trying to solve the case of his wife's death. Everything up to that point he can remember; everything after he loses every ten minutes or so—a discombobulation mirrored by the film's structure, which unspools backward before our eyes, plunging the audience into a permanent state of in medias res. It seemed almost blasphemously smart in a way that made you wonder how it might fare, exactly, in a film landscape typified that year by the likes of *Dude, Where's My Car?* The film's knack for winning fans but not distribution had become something of an open secret in Hollywood after a screening the weekend of the 2000 Independent Spirit Awards, at which Nolan had been turned down by every distributor in town with some variation of "This is great," "We love it," "We really want to work with you," and "But this is not for us." Director Steven Soderbergh was moved to comment on the website Film

Nolan when I first met him in 2000, on the eve of *Memento*'s release.

Threat that the film "signaled the death of the independent movement. Because I knew before I saw the film that everyone in town had seen it and declined to distribute it . . . And I watched it and came out of there thinking, 'That's it. When a movie this good can't get released, then it's over.'"

After a year in movie limbo, the film's original production company, Newmarket Films, took the risky decision to distribute it. So the Nolan I met that day, sitting in a red banquette at Canter's Deli, was a relieved man, although outwardly he projected an air of confidence, his blond forelock of hair falling into his eyes as he talked about the influences on his film—the short stories of Argentinian writer Jorge Luis Borges, the novels of Raymond Chandler, and the films of David Lynch. He seemed a very familiar type of Englishman to me, the kind of upper-middle-class son of the home counties one could imagine with a career in the City who plays rugby with his fellow brokers on the weekend; and yet here he was in Hollywood, with his backward-running film about a man fleeing unfathomable emotions, betrayed by his treacherous head. The dissonance was striking, as if a young Howard Hughes were fronting a start-up representing the interests of Edgar Allan Poe. As he picked up his menu, I couldn't help but notice that he leafed through it backward. He was left-handed, he said, and always leafed through magazines and such from back to front. I wondered if this had anything to do with the structure of his film, which plays its scenes in reverse order. He told me I may have hit on something, explaining that he had long been fascinated by notions of symmetry, mirroring, and inversion. As Nolan talked, his powder blue eyes betrayed the distant glint of someone doing math problems in his head three weeks in advance, and it became clear to me that the film, for all its sunlit geometries, was as personal to him as any Sundance-farmed coming-of-age movie or down-in-the-hood first feature. *Memento* was borne into the world on the back of obsession, powered by a voice whose failure to find expression would have been almost inconceivable to its owner. Nolan made it because he had to.

"Always in the back of my head, I was like, Can you really do this? *You're going to make a film backward,*" he told me. "It was like, at some point someone is going to break in and go, 'I think that's crazy.' What happens when you make a film is you burrow into it or dig in, so you kind of can't see it anymore, you're so immersed in it, and the film stops being real. So you have to kind of go, Well, okay, I wrote the script six months ago and it seemed like a good idea at the time. . . . I had an odd empathy for the

central character, who has to trust these notes that he's written to himself. The only thing you can do is trust your initial instincts. You just have to say, This is what I'm making. This is what I'm doing. This is why I wrote this script. It is going to work. Just trust it."

Finally released into eleven theaters a few weeks later, on March 16, the film took in $352,243 in its first week, expanded in its second week to fifteen theaters, where it took in $353,523. Among the distributors who had initially turned the film down was Miramax, which circled back and frantically tried to buy the film from Newmarket, but as word of the picture spread, and it expanded in its third week to seventy-six theaters, taking in $965,519, Miramax could only watch as the film took off, spending four weeks in the top ten, sixteen in the top twenty, eventually playing in 531 theaters, a larger number of venues than even *Jaws* played in during the summer of 1975. *Memento* would gross over $25 million in North America and $14 million overseas, making the film's total worldwide tally nearly $40 million—the sleeper hit of the summer. It earned two Oscar nominations, one for Best Original Screenplay and the other for Best Film Editing, and won Best Director and Best Screenplay for Nolan at the 2002 Independent Spirit Awards, two years to the day after that disastrous screening for distributors.

Nolan's ascent since has been near vertical. Of all the directors to break through in the late nineties to win either popular or critical success, or both—Paul Thomas Anderson, the Wachowski brothers, David Fincher, Darren Aronofsky—"no other filmmaker of his generation has had as meteoric a career," film historian David Bordwell has written. In the space of two decades, the British-born director has gone from eking out micro-budgeted three-minute shorts to making such billion-dollar blockbusters as the *Dark Knight* (2008), *Inception* (2010), *Interstellar* (2014), and *Dunkirk* (2017). Collectively, Nolan's films have earned over $4.7 billion worldwide, making him the most successful filmmaker to come out of

The poster design for *Memento* (2000). "To understand recursion, you must first understand recursion," as the joke has it.

the British Isles since Alfred Hitchcock. To the studios, he is as close to a sure thing as a director gets, one of a few filmmakers who can walk into a studio with an original script idea—one that is not part of a pre-existing franchise, intellectual property, or a sequel—and exit with the $200 million necessary to make it. Like Spielberg and Lucas before him, he has become a franchise unto himself. Even the *Dark Knight* films, the closest Nolan has come to accommodating the reigning economic logic of Hollywood, comprised a deeply personal vision of a society teetering on the very edge of chaos, channeling the darker currents of the Bush years just as the noirs of Fritz Lang and Jacques Tourneur did the America of the thirties and forties. Unusual for a director working at his level, he has either written or had a hand in writing all eleven of his movies to date, granting him entry to a very exclusive club of directors with a genuine claim on the title blockbuster auteur, the only other two being Peter Jackson and James Cameron, and unlike them, he is still focused on making original movies, rather than acting as caretaker to his most successful franchises.

"He works within the system here in a very commanding way," said Michael Mann, whose 1995 movie, *Heat,* influenced Nolan's *Dark Knight* trilogy. "He has large ideas. He invented the post-heroic superhero. He came up with an idea for a science-fiction heist inside the moving contours of a dreaming mind and he had the boldness and audacity to have that singular vision and make it happen. I think that the reason he has such a great response and great resonance with people is because he operates very much in the present, in the now. He's tuned into the reality of our lives, our imagination, our culture, how we think, how we try to live. We're living in a post-modern, post-industrial world with decaying infrastructure. Many feel disenfranchised. Seclusion is difficult. Privacy is impossible. Our lives are porous. We swim in a sea of interconnectedness and data. He directly deals with these intangible but very real anxieties. The quest to understand that and to tell stories from there, that is a central motivator for him, I think." The late British director Nicolas Roeg, whose films *Performance* (1970), *Don't Look Now* (1973), and *The Man Who Fell to Earth* (1976), inspired some of Nolan's more audacious manipulations of time and cinematic space, spoke to me not long before he died, in 2018. "People talk about 'commercial art' and the term is usually self-negating. Nolan works in the commercial arena and yet there's something very poetic about his work. They're marvelously disguised. *Memento* has this backward-running time scheme, and yet you automatically find yourself applying the situa-

tion to oneself, to one's daily life, which is very strange. The slipperiness of time, especially when it involves memory, that feeling of subjectivity, of 'It's all true . . . but it wasn't like that,' he's got that on film, somehow. It's a very rare thing, what he has done."

Among his collaborators, he is known for his punctuality, discipline, and secrecy. Of the more than six hundred people who helped bring Nolan's World War II drama *Dunkirk* to life, only twenty or so crew members were allowed to read the script, copies of which were kept on-set or watermarked with the actors' names, so that any missing copies could be traced back to their negligent owners. The first time Nolan met Michael Caine, who has been in all his films since *Batman Begins* and whom the director has come to regard as something of a lucky charm, Nolan came around to the actor's house in Surrey with a copy of the script for *Batman Begins*. Caine thought the blond, blue-eyed young man on his doorstep was a messenger.

"My name's Chris Nolan," he said. "I've got a script for you."

Caine asked what role Nolan had in mind for him. "I want you to play the butler," Nolan replied.

"What do I say, 'Dinner is served'?"

"No. The butler is Bruce Wayne's stepfather."

"Well, I'll read it and get back to you."

"No, no, can you read it now?"

Nolan insisted on staying with him, drinking tea in the actor's living room, until he had finished the script, then took it away with him. "He stayed there drinking tea while I read it," said Caine. "And then I gave it back to him. He's very secretive. He's made all these millions and millions of dollars, but none of that has rubbed off on him. He lives exactly the same way. No Rolls-Royce, no gold watch, no diamond cuff links, none of that; he still has the same watch he always had, still wears the same clothes. You wouldn't know he's the director. Very quiet, very confident, very calm. No bombast at all. Just standing there in his long coat whatever the weather, with a flask of tea in the pocket. I asked him once, 'Is that vodka in there?' 'No, it's tea.' He'll drink it all day. It's how he solves problems."

Visually, he is a classicist, eschewing monitors while filming, preferring to be on an eye line with his actors, seeing what the camera sees, and he likes to watch dailies with the cast and crew the old-fashioned way. He refuses to use a second unit, preferring to shoot every frame him-

self. "Minds don't wander on a Chris Nolan set," said Matthew McConaughey. Nolan is known by his crews for shooting fast, starting at 7:00 a.m. and finishing at 7:00 p.m., with a single break for lunch. He likes to shoot in IMAX, the granularly detailed format originally used for documentaries about space, which fills the viewer's field of vision and eschews computer-generated imagery as much as possible, preferring effects recorded in-camera—using models, mattes, physical sets, projections—to those added in postproduction with a computer. His postproduction coordinator says he has worked on romantic comedies with more effects than *The Dark Knight Rises,* which featured only 430 effects shots out of a total 3,000. And yet this devotion to cinema's analogue powers of illusion have only further recommended his films to a generation reared on wraparound digital imagery, attracting the kind of passionate following one associates with a cult director—a Paul Thomas Anderson, a Tarantino—not a commercial one.

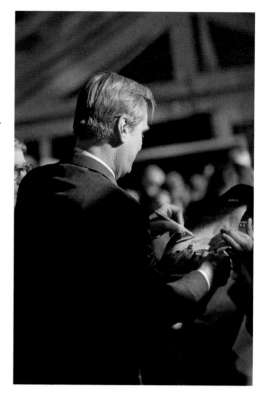

Critics have received death threats when they give his films a bad review. "The IMDB F.A.Q. about the meaning of the end of 'Inception' makes 'Infinite Jest' look like a pamphlet on proper toaster installation," noted *The New York Times* in 2014. Online, debate about his work approaches the density of a black hole, the reporter added, "with intersecting wormholes tunneled by warring pro-Nolan factions . . . watching his movies twice, or three times, bleary-eyed and shivering in their dusky light, hallucinating wheels within wheels and stopping only to blog about the finer points. . . . If the fact that the white van is in free-fall off the bridge in the first dream means that, in the second dream, there's zero gravity in the hotel, then *why is there still normal gravity in the third dream's Alpine fortress?????*"

Of Nolan himself, little is known, the filmmaker having long perfected the art of talking about his films while giving away nothing about himself, leaving profile writers circulating the same half a dozen facts. He holds dual nationality, and was raised in London and Chicago. His English father worked in advertising; his American mother was a flight attendant and later a teacher. He spent most of his teens at a boarding school in

Nolan signing autographs at the New York premiere of *Interstellar* (2014). A franchise unto himself, Nolan's fame sometimes eclipses that of the stars of his films.

Hertfordshire and attended University College London, where he met his future wife and producing partner, Emma Thomas. They have four children. Beyond that, he has the matte mystique of the magician played by Hugh Jackman in Nolan's 2006 film, *The Prestige,* who takes his applause *below* the stage, having just disappeared through it. "People will say to me, 'There are people online who are obsessed with *Inception* or obsessed with *Memento,*'" Nolan told me during the first of the interviews that form the basis of this book. "They're asking me to comment on that, as if I thought it were weird or something, and I'm like, 'Well, *I* was obsessed with it for years. Genuinely obsessed with it. So it doesn't strike me as weird.' We put a lot into the films. I had lunch with a producer a few years ago, a very successful producer, not somebody I've worked with, and he was curious about my process. At some point, I said, 'Every film I do, I have to believe that I'm making the best film that's ever been made.' He was absolutely shocked by this. It just never occurred to him that someone would think like that. And that, to me, was truly shocking, because films are really hard to make. I'm not going to say it's the hardest job in the world—I've never tried coal mining—but they are all-consuming. Your family life, everything goes into it for a couple of years. So it had never occurred to me there were people doing it who weren't trying to make the best film that ever was. Why would you otherwise? Even if it's not *going* to be the best film that's ever been made, you have to believe that it *could* be. You just pour yourself into it and when it affects someone that way, that is a huge thrill for me—*huge* thrill. I feel like I have managed to wrap them up in it the way I try to wrap myself up."

· · ·

The first time I suggested the idea of collaborating on a book with Nolan, he didn't think he'd made enough films for a career-length retrospective. At that point, having just completed *Interstellar,* he had made just nine pictures. Three years went by. Meeting again on the eve of the release of his film *Dunkirk,* in the offices of his production company, Syncopy, a two-story tan bungalow nestled on the Warner Bros. lot, just a stone's throw from Clint Eastwood's Malpaso Productions, I pointed out that his argument against a book had just grown one film weaker. We talked some more via his assistant—Nolan does not have an email account or a cell phone—and finally he agreed to meet in Manhattan, where he was going

to be for a meeting of the Directors Guild of America to vote on whether to strip Harvey Weinstein of his membership: *The New Yorker* had just blown open the story of the mogul's abuses. *Dunkirk,* meanwhile, had taken in almost $527 million at the box office and was on its way to eight Oscar nominations, including Best Director for Nolan, breaking the shut-out he had received in that category for *The Dark Knight* and *Inception.*

"I've definitely retired from the business of just doing another film for the sake of doing it," he told me. "I can't do that anymore. I find filming very difficult. I find it totally engaging, but it's an arduous process; there's a lot of strain on family, on personal relationships; it takes a lot of physical strength. So it's got to be great. It's got to be something I love. I think the problem is I am a writer and I don't want to give that up. The first time I was nominated for a DGA award, I got to meet Ridley Scott, and he was asked about choosing his next project. He said that looking back at his career twenty years in, he had done ten films, which while not inordinately slow, made him think, 'why not just get on with it?' But he doesn't write. I think that's a big difference. I'm not really looking for a script to come fully formed and land on my desk. No project that I have ever been involved with has ever been like that. I would never want to give that up. Steven [Soderbergh] has found a way: He stopped writing, so he could work faster. He found a way of being able to do a more whimsical production, something small. It just takes me too long to make a film. And if they were smaller, they wouldn't be any quicker. They'd be quicker to shoot, but the writing, the conceiving of the thing, takes time."

He had an idea for a story, he said, but there was no guarantee it would turn into anything. "It's happened to me a couple of times, and it's a huge sidetrack," he said. "I've lost years." And so, while he researched the idea that might or might not turn out to be his next screenplay, he agreed to a series of sit-down interviews over a period of a year, while the Oscar sea-son played itself out. I got the impression he was happy for the diversion. "In the introduction to the published screenplay of *Dunkirk,* I unwisely revealed the fact that I had gone to Emma [Thomas] and said, 'I think I can make this film without a screenplay.' She immediately shot me down, saying, 'You are being an idiot.' Which she was right about. Of course, I've been asked about that ever since. 'You were going to try and do it without a script?' It was a mad idea, but it was expressive of something, which is that the relationship between a written screenplay and a finished film is very inadequate. A script is not a great model of what a finished film is

going to be. It is too difficult for a filmmaker to put your visual ideas into words, without getting bogged down in style. I enjoy writing screenplays because they are very stripped-down, simple documents. And the more stripped down they are, the better they are. The less literary they are, the more they approximate the direct experience of what's going to happen on-screen. I'm always looking for ways around that, or ways to help myself understand the narrative beyond that. Once you start pushing that cursor forward on the screen, once you go into the world of words and start pushing forward in a linear fashion, you're very, very trapped by that process until you finish. Until you get there, you're trapped in the maze."

Clearly, the only way to properly understand Christopher Nolan or his films was to follow him into the labyrinth.

• • •

This book is not a biography, although it starts with an account of Nolan's early life and is followed by a chronological march through his films. Nolan was happy to talk for the first time about his transatlantic upbringing, his experience of boarding school, all his influences, inputs, and inspirations prior to picking up a movie camera, but he remains almost physically allergic to biographical readings of his work. "I don't want to be comparing myself to Hitchcock, but I think I risk suffering the same sort of misunderstanding because there are a lot of very clear connections between the films I've made, and I don't really fight that, but it's more from a craftsman's point of view than from an inner obsession, and I see Hitchcock the same way. He's a terrific craftsman, but there's no Freudian subtext. Yeah, you can go to the next level with the analysis of his films, but you do so at the risk of ignoring what the more obvious engine of the work is. I feel that what I do is based more in artifice and abstraction and theatricality. I feel more of a craftsman than an artist, genuinely. I'm not saying that with false modesty. I think there are filmmakers who are artists. I think Terrence Malick is an artist. Maybe it's the difference between saying are you using it to express something purely personal, that comes from inside that you're

The maze logo of Nolan's production company, Syncopy.

just trying to get out there, or are you trying to speak to, are you trying to communicate with, people, and tap into their expectations and their experience. My films are much more about filmmaking than people think."

What is perhaps most striking about this assessment is how much it lines up with the opinion of Nolan's fiercer critics, who regard him as nothing more than a neatnik showman making the cinematic equivalent of Magic Eye puzzles—expert but empty technical tricks un-warmed by the imperatives of creative expression and drawing no breath beyond their own immaculately beveled edges. Nolan differs from his critics only in the *value* placed on that glasslike quality. Where his critics sense impersonality, Nolan takes a magician's pride in his skills of self-vanishment. I wrote this book because I believe both to be wrong. Nolan's films may not be autobiographical in the way that, say, *Mean Streets* is autobiographical, or even *E.T. the Extra-Terrestrial*, but they *are* personal. Shot under code names frequently borrowed from his children—*The Dark Knight* was "Rory's First Kiss," *Inception* was "Oliver's Arrow," *The Dark Knight Rises* was "Magnus Rex," and *Interstellar* was "Flora's Letter"—Nolan's films map out a landscape and mythology every bit as personal to their maker as Scorsese's dive bars or Spielberg's suburban subdivisions. They are set in cities and countries Nolan has lived in, echo the architecture of buildings that housed and educated him, draw on the books and films that have shaped him, and shuffle the themes of his own path to adulthood: exile, memory, time, identity, fatherhood. His films are deeply personal fantasies lent urgency and conviction by their maker's need to view fantasy not as some second-rate version of reality but its coequal, as vital as oxygen. He dreams with his eyes open and asks that we do the same.

Nor is this a book of interviews, although it is the result of dozens of hours of interviews conducted at Nolan's home in Hollywood, over what turned out to be a three-year period, during which Nolan wrote, prepped, shot, and edited his most recent film, *Tenet*. Does he have any rules? What separates a great plot twist from a merely good one? How personal are his films? What moves him? What frightens him? What is the ideal plot duration measured in weeks, days, and hours? What are his politics? One of the first things you quickly learn about interviewing Nolan is that if you ask him point-blank about the origin of some of his most distinctive themes and obsessions, you get nowhere. Ask him about how he first became interested in labyrinths, for example, and you very soon end up in one yourself. "I don't remember, actually. I'm not being coy. I think I got more

interested specifically in labyrinths and all the rest as I got into storytelling, as I got into making films." Press harder on the obsession and it reveals yet more obsessions, in a long, recursive chain. "I think my fascination with identity probably really stems from my fascination with subjectivity in storytelling," he will say, or "I think the fascination with time actually comes from the fascination with movies." A rhetorical habit born of his desire to observe an absolute distinction between his life and his films, his obsessions—or "fascinations," as I came to call them—float in midair like an Alexander Calder mobile, connecting up with one another, and all lead back, eventually, to the original fascination: cinema itself. All roads lead to Rome.

The second thing you learn is that he uses the word *fascinating* a lot. Here is a partial list of the things he found fascinating over the course of our interviews:

The imagery of blurred heads in the paintings of Francis Bacon
The absence of heroics in David Lean's *Lawrence of Arabia*
The orphaning of Howard Hughes
Kubrick's use of miniatures in *2001: A Space Odyssey*
The moment in *Heat* where De Niro's gang slashes the vacuum-
 sealed bag of money
The work of Jorge Luis Borges
Brando's recital of T. S. Eliot's "The Hollow Men" at the end of
 Apocalypse Now
Pink Floyd: The Wall
The work of Industrial Light & Magic
His father's work in advertising for Ridley Scott
The illusion of scale in movies
Gothic architecture
Einstein's thought experiments involving separated twins
The "great game" in Southeast Asia between the British Empire and
 Russia
Wilkie Collins's novel *The Moonstone*
The way morality is expressed through architecture in Murnau's
 Sunrise
The fact that nobody understands how iPads work
The work of David Lynch
The way GPS satellites factor in the effects of relativity

Wikipedia
A nature documentary he watched unspool backward at age sixteen
The hydrofoil

His use of the word *fascinating* has a slightly archaic feel, reminding you of its etymological origin—from the Latin *fascinatus,* past participle of *fascinare,* "to bewitch, enchant, fascinate," from *fascinus,* "spell, witch-craft." I had a hard time placing the literary sources at first, but finally I realized whom the word reminded me of. Determined not to delay until "the fascination of the wanton undead have hypnotised him," Van Helsing finds himself "lapsing into sleep, the open-eyed sleep of one who yields to a sweet fascination" in Bram Stoker's *Dracula.* The bloody muzzles of the hounds of the Baskervilles are "a malignant and yet fascinating sight," remarks Watson in Conan Doyle's *The Hound of the Baskervilles,* "so awful and yet so fascinating." As often with the Victorians, you get the sense of rationality bulging beneath the weight of fixations not strictly speaking rational, and so, too, with Nolan's films, which ripple and bulge at the edges of the explainable: They are films of traumatized rationality. Scratch a Christopher Nolan film and you frequently find a Victorian source. Goethe's *Faust* looms large over *The Prestige* and the *Dark Knight* trilogy. *The Dark Knight Rises* reworks Dickens's *A Tale of Two Cities* (1859). There is a surprising amount of Thomas Robert Malthus in *Interstellar,* alongside a 382-stop pipe organ and the *Collected Works* of Conan Doyle. The boat in *Dunkirk* is named after Wilkie Collins's 1868 novel, *The Moonstone,* while its score, by Hans Zimmer, echoes Edward Elgar's *Enigma Variations.* "I saw huge buildings rise up faint and fair, and pass like dreams," says H. G. Wells's time traveler after fashioning a time machine of nickel, ivory, brass, and quartz—a more sophisticated version of the forty-pound bicycle that Wells loved to ride up and down the Thames Valley—that transports him thirty million years into the future. If Wells's traveler had sent his machine instead to the year 2000, dropping him off at Canter's Deli in order to embark on a twenty-year filmmaking career in Hollywood, the career he ended up with might not look so very different from that of Christopher Nolan. His eventual critical reputation has yet to come to rest, but Nolan can with some legitimacy lay claim to being the greatest living filmmaker of the Victorian era.

Of all the influences that feed into his work—from Raymond Chandler, Frank Lloyd Wright, and Jorge Luis Borges to T. S. Eliot, Francis Bacon,

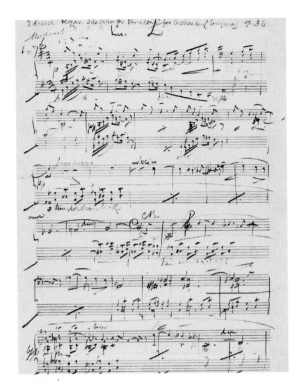

and Ian Fleming—the artistic antecedents that proved the most helpful to me in an understanding of his work and in the writing of this book were musical. The name of his production company, Syncopy, is a play on *syncopation,* and was suggested to him by his father, Brendan, a classical music fan who, before he died in 2009, loved to visit the recording sessions for the scores of his son's movies. As Nolan's films have grown larger and more epic in scope, their sound tracks have become an ever more crucial means of structuring them, and Nolan's input ever more integral, to the point where composer Hans Zimmer called Nolan "cocomposer" of the score for *Dunkirk.* "The music of *Dunkirk* is Chris's work as much as it is mine," said Zimmer of their work on the film, which is essentially fugal in form, playing a series of variations on a theme, sometimes inverted or reversed but always harmonizing and leaving the viewer with an impression of ceaseless movement.

"Music has been such an increasing and fundamental part of the films I've made," Nolan says. "I read a quote from Angelo Badalamenti many years ago in which he said David Lynch used to say to him things like 'Play big chunks of plastic.' The funny thing is, when I first read the quote, I remember thinking, Wow, what a crazy thing, but now I make complete sense of it. Good film music does something you can't articulate in other ways. If you would, you could, but you can't. What I've done with the bigger film scores over the years is figure out a way to build the machine, and then use the mechanism of the music to get the heart of it, to get the emotion into that form. With *Interstellar,* it was essential that that happened. I didn't want to leave that to chance at the end. I wanted to try and totally reverse the process and start with the emotion, start with the basic heart of the story, then build the mechanics out from that. I really took Hans up on that more and more with each film, *Dunkirk* being the most extreme example because it was conceived in musical form. There's a part of me that doesn't really understand why I've gone that way, and to that

Edward Elgar's drafts for the *Enigma Variations,* which composer Hans Zimmer reworked in his score for *Dunkirk* (2017).

degree, but I have and it works for me. It helps me express a bit of myself, and it's the only way I *can* express it."

This book follows suit. Each chapter takes a film of Nolan's as its starting point, detailing how it was made and what he thinks of it now, paying particular attention to the writing, designing, editing, and scoring of the film—all the points in the process in which a film draws closest to the intentions of its creator—as opposed to the court intrigues of production that preoccupy many film books. Nolan's virtues are chiefly conceptual, which is not to say that his films do not contain vivid, often startling performances—as anyone who has seen Guy Pearce in *Memento,* Rebecca Hall in *The Prestige,* Heath Ledger in *The Dark Knight,* or Mark Rylance in *Dunkirk* can attest—but Nolan's films, more than most, stand or fall by the strength of their ideas. "What is the most resilient parasite?" asks Leonardo DiCaprio's Cobb in *Inception.* "Bacteria? A virus? An intestinal worm? An idea. Resilient . . . highly contagious. Once an idea has taken hold of the brain it's almost impossible to eradicate." Nolan's is the patron saint of the idée fixe and midnight thought. As each chapter progresses, it develops a theme—time, perception, space, illusion—cutting loose from the forward march of chronology to tunnel down into Nolan's fascinations, be they a book or film that influenced him or a piece of music that took up residence in his head and refused to budge. "The Enigma I will not explain," wrote Elgar of the hidden theme said to be woven into the fabric of the *Enigma Variations,* each of which was dedicated to one of the composer's friends. "Its 'dark saying' must be left unguessed." Some, like Elgar's biographer Jerrold Northrop Moore, have argued that it is not a melodic theme at all but an idea—the idea of self-development through the personality of others. "The real subject of the *Variations* would be the creation of self in music." So, too, with Nolan's films, which are variations on a series of themes, repeated in different voices and keys, inverted, slowed down or sped up, creating an impression of ceaseless movement. As with the *Enigma Variations,* there is a final figure interwoven among all the others, hidden in plain sight but present in every frame. That figure is Christopher Nolan.

ONE

STRUCTURE

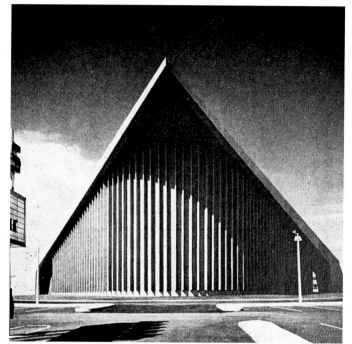

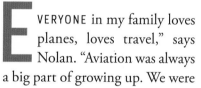EVERYONE in my family loves planes, loves travel," says Nolan. "Aviation was always a big part of growing up. We were always flying back and forth. My mother worked as a flight attendant for United Airlines for many years, so I got free plane tickets, just flying standby—I would get on a plane and go anywhere I wanted—and my dad traveled a lot for his work. My dad worked for some of the big advertising agencies when he was younger; he was a creative director of commercials, and spent time in Los Angeles in the sixties. They would fly him out there and they would do five commercials in one go. Then he ran his own marketing consultancy for twenty years. It wasn't about TV advertising so much; it was more about launching brands and figuring out packaging. So Cadbury's Starbar, for example, was one of my dad's. I remember him bringing home chocolate samples for us to try."

One of Nolan's earliest moviegoing memories was going to see Alan Parker's musical *Bugsy Malone* (1976), starring Jodie Foster. He can remember looking at the advertisement in the paper and his parents saying, "Oh, that was directed by a friend of your dad's"—a slight exaggeration, but his father, Brendan, had shot a commercial with Alan Parker. Not long after, Nolan was taken by his parents to visit Pinewood Studios on the studio's fortieth anniversary, in 1976, and remembers seeing the pedal cars from

Parker's film. "That to me was very significant because there was this group of five British directors who all came from advertising in that period. I remember my dad explaining to me that he'd worked with some of these men—there was Ridley Scott and Tony Scott and Adrian Lyne and Hugh Hudson and Alan Parker. My dad always thought Hugh Hudson was the most interesting of them. He was always waiting to see what he would do—this was in the days before he made *Chariots of Fire*. Fascinatingly for me, I later learned that my dad had worked with Ridley Scott, very briefly, not to say hello to on the street, but he'd done a couple of jobs through Scott's company years before."

His father spent long stretches of time in Africa and Southeast Asia for his work, always returning with presents and stories of where he'd been. The three boys—Matthew, the eldest, Chris, and Jonathan (known in the family as "Jonah")—used to play a game of figuring out where in the world he was. Brendan met their mother, Christina, while working in Chicago. A flight attendant for United Airlines, she was forced to quit her job upon her marriage to Brendan because airlines in the sixties insisted their female flight attendants be single, although a class-action lawsuit would eventually win her job back, by which time she had forged a second, successful career teaching English. They spent much of Nolan's childhood trying to figure out where they wanted to live, London or Chicago, with occasional visits to see his maternal grandmother in Ohio, where Nolan remembers seeing George Lucas's *Star Wars* upon its release in 1977, when he was seven.

"I saw it in a small suburban theater in Ohio," he says. "We were visiting my grandmother. Those were the days when England used the same film prints as America, so nothing would open in the UK until months after it had opened there first, so the summer movies would always open at Christmas. I remember going back to school in Highgate and trying to tell my friends what we'd done that summer, trying to tell them about this film, how there's a guy with this black mask, and there're these storm trooper guys who are in white, but they're not the good guys—and I remember nobody really getting what the hell I was talking about. Then when it came out over Christmas, everybody was obsessed with it. Everybody had their *Stars Wars* claim—I remember a friend whose dad had played in the orchestra that recorded the music—and mine was I saw it months before anybody else. Then I was the kid who'd seen it the most times. I had a real fascination with those films and with the technology behind them—the

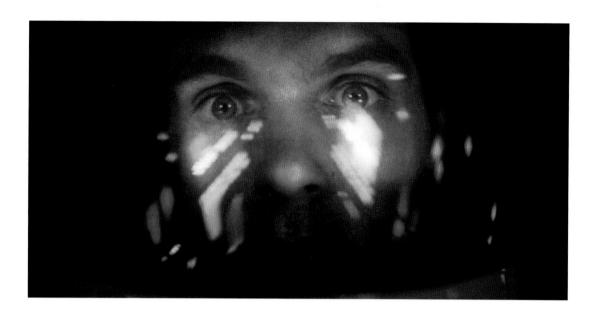

tricks of it. I remember I had a magazine about Industrial Light and Magic that I read obsessively. Anything about the behind the scenes and how they made these films was fascinating to me."

Not long after seeing *Star Wars* in Ohio, he was taken by his father to see a rerelease of Stanley Kubrick's *2001: A Space Odyssey* (1968) at the old Leicester Square Theatre in London. "That was a big event; he was taking us out to see it on a huge screen. I think I had been warned that it wasn't going to be like *Star Wars,* but when you look at the *Discovery* passing, each one of those miniature shots was *deeply* fascinating to me. It's just such a primal atmosphere—the bit in the beginning with the cheetah, his eyes glowing, the image of the star child appearing on the screen at the end, and being baffled by it, but not in a frustrated way. I remember seeing the film again in Chicago with a bunch of friends and talking to them about what it meant, because if you read Arthur C. Clarke's novel, which I did at some point after I'd seen the film, it's a bit more specific about the meaning of things. In some ways, I think I understood it better then than I do now, because it's an experience and I think kids can be more open to that. There's a level of pure cinema, of pure experience that's working there. *2001: A Space Odyssey* is the movie that first showed me that movies can be anything. It's the punk rock of movies."

In the summer of 1978, Nolan and his family moved to Chicago to be closer to Christina's side of the family. Initially, it was just going to be for

Keir Dullea in Stanley Kubrick's *2001: A Space Odyssey* (1968).

a year, but one year turned into three, the family settling in the affluent, leafy suburb of Evanston, on Chicago's North Shore, land of ivy-covered mock-Tudor brick mansions with station wagons in the driveways and backyards with woodlands beyond, soon to be immortalized as Teenland USA by director John Hughes. "My experience was entirely suburban," Nolan recalls. "You know, *Ferris Bueller's Day Off, Uncle Buck*—it's that exactly. Those John Hughes films were all filmed on the North Shore, in Chicago suburbs like Evanston. We lived out in the suburbs, across from the school, and there was a small park, a forest reserve, with paths running through it, which we could bum around in. I found it liberating. My friends and I rode bikes everywhere. The weather was better, at least in the summer, and then in the winter you had these incredible snowy winters. I remember very vividly visiting London as a kid, after we had moved to Evanston, coming back to our house in London that we had rented out. We had been gone probably a year and I remember everything seemed tiny—obviously, because things tend to be bigger in America. The houses were bigger. The streets were laid out a bit wider. But also, I'd grown a few inches. I was developing so quickly. I remember that very clearly. I remember simply looking at the staircase in the front hall, thinking, I don't remember this place being this tiny."

Even the local movie theaters were vast, the biggest being the old Edens Theater in Northbrook, a stunning sixties-era futuristic structure next to the Edens Expressway. The building was acclaimed as "the world's largest hyperbolic paraboloid" when it opened in 1963. You couldn't miss it as you drove along the Edens Expressway on Skokie Boulevard—it looked like something out of *The Jetsons* or Gene Roddenberry's Starfleet, with

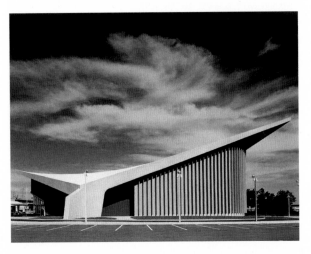

walls of corrugated concrete broken up by long, undulating swaths of glass and a roof that shot off into the sky. The main lobby featured ultramodern furniture in a color scheme of gold and off-white. There was a huge screen, complete with red curtains, carpeted partitions in the front of the first row, and a small stage area. "It was incredible-looking," he says. "I remember going to see *Raiders of the Lost Ark* there with my mum. It was packed. It was a huge screen. We had to sit toward the front; I don't know if it was literally

the front row, but I remember being slightly off to one side. I can still remember the scale of the image and the distortion; I could see the grain of the film because we were that close to the screen. I very much remember that. It's very much that sort of larger-than-life feeling of being sucked into the screen."

When he turned eight, his father gave him his Super 8 camera to play with. It was pretty basic, using little cartridges that ran for two and a half minutes and recorded no sound, but it opened up a whole world for him. Together with his new school friends in third grade, Adrian and Roko Belic, the sons of Czech and Yugoslav immigrants, who would go on to successful documentary careers of their own, Nolan shot a series of home-made space epics in his parents' basement, using primitive stop-motion techniques to animate his Action Man and *Star Wars* figures. He remembers fashioning sets from egg boxes and toilet-paper rolls, throwing flour across the Ping-Pong table to re-create explosions, or heading outside into the Chicago winter to re-create snowscapes inspired by the ice planet Hoth in *The Empire Strikes Back* (1980). "One was called *Space Wars*," he recalls. "It's safe to say *Star Wars* was more than a heavy influence. Carl Sagan's TV series *Cosmos* had just aired and I was obsessed with anything to do with space and spaceships. One of my big disappointments in life was to go back and look at the films again and realize how crude they are. Everything I did in filmmaking was a slow evolution. As a kid, it was just about putting interesting images together and getting a narrative to it, because Super 8 was silent, of course. So, unlike kids today, who have sound at their disposal, it was purely an image-making process. I was reading Eisenstein's book *Film Form* the other day, and the argument he makes—it's funny that it would ever have been controversial—but you take shot A and shot B and put them together and that gives you thought C. And that, I realize now, is what I was working out for myself."

The son of a master mason in Riga and trained as an architect and civil

OPPOSITE AND LEFT The old Edens Theater in Northbrook, Illinois, where Nolan saw everything from Steven Spielberg's *Raiders of the Lost Ark* (1981) to Adrian Lyne's *Jacob's Ladder* (1990).

engineer at the Institute of Civil Engineering in Saint Petersburg before turning his attention to set design and filmmaking, Eisenstein was cinema's first great structuralist thinker. Famously, he compared the art of cinematic montage to Japanese hieroglyphs, where the combination of two hieroglyphs of the simplest series is more than just the sum of its two parts—it creates a third meaning. So if you cut from the shot of a woman with pince-nez to a shot of the same woman with shattered pince-nez and a bleeding eye, as Eisenstein did in *Battleship Potemkin* (1925), you create a third thing entirely: the impression of a bullet having hit the eye. One day, Nolan's uncle Tony brought him some footage of the *Apollo* missions on Super 8. "What I wound up doing was filming some of the *Apollo* stuff off the TV screen and then splicing that into my humble little movie to fool people into thinking that maybe I had done the shot. One of the friends I used to make these films with, Roko Belic, saw the trailer for *Interstellar*, called me, and said, 'Those are kind of the same shots, because these are classic camera-mount shots.' We tried to make it look as absolutely real, but it was kind of the same thing."

When Jonah, who cowrote *Interstellar* with Nolan, came to visit his brother on Stage 30 at Culver City, he found the actors strapped into a life-size space Ranger mounted on hydraulic rams while the effects team projected, via computers situated in London, a moving starfield onto a massive three-hundred-by-eighty-foot screen to simulate the effects of interstellar travel. "He said to me, 'Of *course* we're doing something like this—this was our whole childhood,'" says Nolan. "We were always going to do this kind of thing. It is kind of weird we hadn't before. It felt like coming home in a way."

• • •

Home would always be the movies, as the family moved back and forth across the Atlantic. In 1981, when Nolan was eleven, they moved back to England, where Brendan wanted his sons to have the same Catholic prep-school education he had had. Brendan's father, a pilot on a Lancaster bomber, had been killed in the war; the discipline of boarding school had been a godsend. "There was a lot of Catholic indoctrination," says Nolan, who was enrolled at Barrow Hills, a Catholic prep school in Weybridge, Surrey, run by Josephite priests, a Roman Catholic brotherhood who ran a series of seminaries and boarding schools as far afield as the Democratic Republic of the Congo. Housed in an Edwardian manor house with

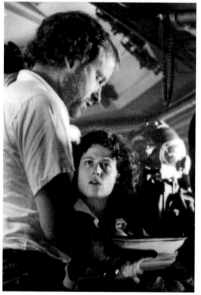

baronial-style gabled roofs, Barrow Hills was then a grim, unkind institution, with teachers who reminisced about their service in World War II and delivered two lashes of the cane for even such minor infractions as talking after lights-out. The food was largely inedible, so they frequently went hungry, their lives revolving around the tuck shop. "At the time, it's like you're a bunch of kids and they're the enemy," says Nolan. "It's like they're trying to make you take it seriously and praying, and you're sort of naturally reacting against that, not in any intellectual way or anything, but I come from that era, the seventies, when there wasn't any doubt in anybody's mind that science was supplanting religion. Of course, now I'm not sure that's the case. That seems to have shifted somewhat."

There was no film club, although every week war movies like *Where Eagles Dare* or *The Bridge on the River Kwai* were shown, and Nolan does remember being allowed to watch a pirated VHS of Ridley Scott's *Blade*

TOP RIGHT Rutger Hauer as replicant Roy Batty; TOP LEFT Ridley Scott directing Harrison Ford on the set of *Blade Runner* (1982); and BOTTOM directing Sigourney Weaver on the set of *Alien* (1979). Together, the two films opened Nolan's eyes to the job of director.

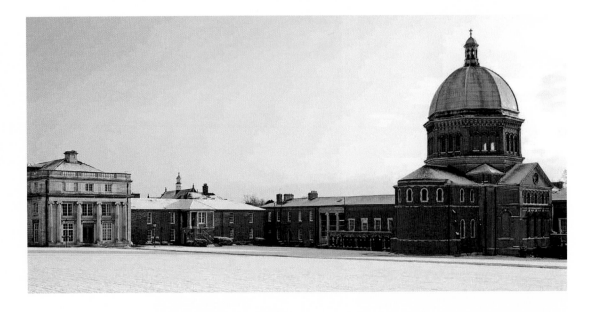

Runner (1982) on a TV in his housemaster's lodge. "We were allowed to pop down to the master's house and watch half-an-hour chunks of it," he says. It was only later that he caught Ridley Scott's *Alien* (1979) and put it together with the film about replicants he had seen in half-hour chunks in his housemaster's study. "I can remember this very palpably, identifying some tone to those films that was common and not really understanding it and wanting to understand it—something that almost felt like a sound, a low throbbing, a particular lighting, or an atmosphere to those films that was clearly the same. Then what I found out was, same director. So, totally different story, different writers, different actors, different everything, all the things that as a kid you identify as making films what they are—you think the actors basically make the film up—all those things are different, but there's a connection, and that connection is the director. I can remember thinking, *That's the job I want*."

Every filmmaker has a eureka moment where the lightbulb goes on—Ingmar Bergman's first encounter with a magic lantern, Scorsese seeing Gary Cooper in a long shot in *High Noon* and realizing that films were *directed* by someone. Nolan's eureka moment was staggered, involving patience, cunning, and a certain amount of detective work, qualities his own films would require and reward in their audiences.

Haileybury and Imperial Service College in Hertfordshire, England, where Nolan boarded from 1984 to 1989.

After three years at Barrow Hills, Nolan went to Haileybury and Imperial Service College, a boarding school just north of the M25 London circular. Originally founded in 1862 to train the sons of empire for the Indian

civil service, Haileybury in the early eighties had the feel of a school for a country that no longer existed, its vast grounds whipped in winter by winds from the Urals and dotted with war memorials commemorating the brave old boys who had died in the Boer War or won the Victoria Cross, imparting the Victorian virtues of manly self-sacrifice to children from the middle-class suburbs of north London. Things had improved since RAF group captain Peter Townsend claimed, "Survive your first two years at Haileybury and you could survive anything," but it was a spartan, old-fashioned institution, with not many carpets or curtains, barracks-style dorms with radiators conveying modest heat. When John McCarthy, the journalist taken hostage by Hezbollah in the late eighties, said upon his release that the one thing that prepared him for the rigors of imprisonment had been his time as a boarder at Haileybury, he was only half joking. "It was remarks like this that made me wonder from time to time what kind of world I was presiding over," wrote his old housemaster, Richard Rhodes-James. "It reminded me that the exercise in care, that I regarded as the running of a house, operated within quite harsh parameters." It was to McCarthy's old house, Melvill, that Nolan went in the autumn of 1984.

"I think there was an element of sly humor to McCarthy's comment," says Nolan. "I remember Stephen Fry being asked about jail in an interview and him saying, 'Oh, I went to boarding school, it's not so bad.' That was not my experience. I enjoyed it, but I also recognized that a lot of people didn't, so I guess there's some ambivalence there. There's definitely a weird tension between the massive sense of independence you get and the environment itself, which can be hard and quite restrictive. You're away from home, it's isolated and a little isolating, but you're living on your own terms. It's a different kind of freedom. I've always referred to boarding school as a Darwinian environment. It's sink or swim. It's very militaristic at Haileybury. The school and students are self-policing. Sixth formers become prefects and they are in charge of the boys. It's a very old-fashioned hierarchical system, or was when I was there. You either roll with it or you absolutely hate it. I was large for my age and I was good at rugby, and if you're good at rugby, you're kind of okay."

The first thing that strikes any visitor to the school is its size; it is located on five hundred acres in the middle of the Hertfordshire countryside. The school's front terrace is first visible through the trees lining the road from London, with Corinthian columns of Portland stone and porticoes taking their cues from the Erechtheion in Athens. At 120 yards square, the main quad rivals the great court at Trinity College, Cambridge. Designed to

inspire "hopes immortal / Far beyond time, with thoughts of long ago," in the words of the school's first headmaster in 1862, it was built by the nineteenth-century architect William Wilkins, who also designed the National Gallery in London, and, coincidentally, University College London, which Nolan would attend after completing his A-Levels at Haileybury. "Not to disparage Mr. Wilkins, but they're pretty much the same building," he says. "In my mind, when I think of my school, I think of a beautiful terrace with the rugby pitch out front, the front of Wilkins's terrace, this huge quadrangle. They're both very beautiful places. They feel bigger than they are. That's the purpose of that kind of architecture, to make you feel small, but in making you feel smaller, it makes you feel part of something bigger."

Life at the school was lived under the clock in every sense, every minute of every day rigorously time-tabled, the main quad overlooked by the large Clock House, which struck the hour and half hour, starting at 7:30 a.m. with a loud electric bell awaking the students in their dorms. Fifty or so boys would make a mad dash for the bathroom to wash, pulling on their school jackets and trousers in time to prepare their beds for inspection, followed by a short chapel service, the entire school squeezing in sardinelike beneath stained-glass windows, pretending to pray and mouthing the words to the hymns, then making their way to the refectory, a large, domed, walnut-paneled dining room smelling of butter and boiled cabbage, where all seven hundred or so

ABOVE The chapel at Haileybury, so large the Luftwaffe used it as a sign they had flown too far during the Blitz; RIGHT One of the lampposts that lit the quads at night.

pupils would sit twenty-four to a table, oil portraits of old boys such as former prime minister Clement Attlee, wolfing down porridge or cereal. The acoustics were such that you could hear the conversations on the other side of the room. More bells summoned the boys to four hours of lessons, from 9:00 a.m. to 1:00 p.m., with only five minutes in between each class, which meant you frequently saw them flying around the vast main quad, books under their arms, arriving for their lessons out of breath or with a stitch.

After lunch, the afternoon was devoted to compulsory games—rugby in winter, cricket in summer—everyone sluicing the dirt from their pores afterward in the bathhouse, a companionable cavern with a long line of showers, deep tubs, and tall-tapped basins. Wednesdays were given over to the Combined Cadet Force, the in-house military force, compulsory after two terms, originally designed to feed students into the National Service. "Mostly, it was just marching around in uncomfortable uniforms and learning how to read maps," recalls Nolan, who joined the RAF section of the Cadet Force. "It was actually map folding, as I recall. I still can't do it properly—there's a very particular way you're meant to fold a map so you could then flip it over, unfold it, refold it. Once a year we got to go up in a plane and perform aerobatics in a trainer called a 'Chipmunk,' which was tremendous. You'd sit behind the pilot; you'd see quite a wrinkled neck below the helmet. If it was your first time going up, you'd have a quite boring flight, but if you told them you'd been up before, then they would do aerobatics—loop-the-loop, stall turns, and barrel rolls, really amazing. That was the advice of the older boys, who had done it before: Tell them that you'd been up before and then they would do aerobatics. They're not looking at you in the eye and saying, 'How much experience do you have?' It's a sort of shouting conversation over the radio."

Afternoon lessons were followed by supper in the big hall, with a big urn of ready-mixed tea at the head of each table, all the clatter and chatter silenced briefly by a quick Latin grace announced with a gong fashioned from an old World War II shell casing. Then it was study or "prep" time before everyone retired to their dorms—long, cold, barracks-style dormitories sleeping forty-seven boys ranging in age from thirteen to eighteen in identical iron-frame beds. The younger boys went to bed at 9:00 p.m., the older boys at 10:00 p.m., the prefects anytime they liked. By the end of the day, everyone was too tired to do much but fall into their beds, exhausted. Nolan remembers lying in his bed after lights-out, listening to the sound

tracks for *Star Wars, 2001,* or Vangelis's score for *Chariots of Fire* on his Walkman, using batteries he had warmed on the radiators to squeeze the last drop of juice from them. "It depended on who was the prefect on duty," he recalls. "You probably had to ask permission. There was a whole trade in batteries. You could never have enough double-A batteries. They were always running out; they didn't really last that long. You never had the right batteries. It wasn't like a CD or DVD player, where the picture would just go; it would just slow down. So you would try to save batteries by rewinding the tape with a pencil and then warm them on the radiator."

Nolan's films have sometimes attracted criticism for the volume of Hans Zimmer's scores, but the all-enveloping union of music and image Nolan is after approximates the level of entombed transport he felt listening to sound tracks in the dark, while Vangelis's groundbreaking mixture of synthesizer and orchestra in his score for *Chariots of Fire* provided the model for all the scores that Zimmer would compose for Nolan in the years to come. "What I see with my kids, just creatively, is that if they have a fascination for something they're interested in, they can follow the train of media, the train of thought, very deep, very quickly. That wasn't the case for me. We had to very much work for it. The way in which our escapes worked was you would listen to music and your imagination would have to fill in the blanks. Film scores leave a bit of space for the pictures and for your imagination. It gave me a bit more space to think, more like ambient music, I suppose. I certainly prized the imaginative space of listening to music in the dark, thinking about things, imagining things, films, stories. That was very important to me."

• • •

Such imaginative sallies represented more than just a quick, easily repeated hit of escapism; they constituted a small, vital victory for self-sovereignty in an environment in which the boys lived and slept in a room that never had fewer than fifty people in it and was under constant threat of being shopped to the master. "A closed community within a closed world," in the words of Rhodes-James, the school was a world unto itself, a microcosm of the society whose officer class it was once tasked with replenishing. It was perfectly possible to spend the entire three-month term without once leaving the school grounds, which were kept locked at night: 6:00 p.m. in winter, 7:00 p.m. in summer. Discipline was maintained by the prefects, the elder boys selected by the master as his eyes and ears, with the power to

dish out on-the-spot punishments like litter collecting, physical exercises, or "Dates," which involved the writing out of famous dates from British history—the Battle of Hastings, the Magna Carta, and so forth—in multiples of three, five, and ten for minor infractions like walking on the grass. Those who balked at the school's Byzantine rules and quasi-military discipline quickly went under. "It was just a horrible place; everyone was bullying everyone," said Dom Joly, a contemporary of Nolan's who used to spend the Sunday letter-writing sessions begging his parents to come and rescue him ("Dear Mum and Dad, I fucking hate it here, get me out of here"), only to have his letters intercepted with the words "I don't think Mum and Dad want to read that, do they?" He later read the letters that did get through, and they were all things like "Dear Mum and Dad, the film this Sunday was *Where Eagles Dare*, the first 15 won, I'm very happy . . ." If you were unhappy at the school, the mixture of misery and abandonment was potent.

"It's the establishment and your orientation to the establishment," says Nolan of his schooling. "That atmosphere and that sort of feeling, it's there in me. We were singing 'Jerusalem,' you know? It's *Chariots of Fire*. I saw *Chariots of Fire* when I was twelve years old and knew I was going to Haileybury, absorbing the mythology of the British establishment, the greatness of empire, and all that—you know, blah, blah, blah. Funnily enough, I did go back and look at *Chariots of Fire* a couple of years ago

Ian Charleson in Hugh Hudson's *Chariots of Fire,* the film Nolan says best sums up his school days.

and showed it to my kids, and it's a massively subversive movie. It wasn't written by some old Etonian. It was directed by an old Etonian, but it wasn't written by one. It's very antiestablishment, very radical. *The Dark Knight*'s like that. I think that my upbringing, my really establishment, old-fashioned schooling, has been very relevant to the way in which I've charted a course through the politics of Hollywood, because that is what you learn at boarding school: how to relate to an establishment you're inherently rebelling against but can't push too far. A lot of filmmakers try to fight it, or they don't fight it enough. It's anytime you have a structure to test the limits of. Playing the game, but not playing the game. That, for me, is the takeaway of my experience of boarding school."

This is a bit like Fred Astaire saying that the only thing he got from Broadway was his sense of movement. Structure is the abiding obsession of Nolan's films, the one truly intemperate taste he has: architectural structure, narrative structure, chronological structure, musical structure. Even psychology is a function of structure in Nolan's films, his characters doubling and quadrupling like tessellations in an Escher print. The choice at boarding school is not, as Nolan suggests, between conformity and rebellion. Open rebellion is quickly crushed, like the schoolboys in Lindsay Anderson's Palme d'Or winner *If. . . .* (1969), who are gunned down with weapons from the school's armory. The choice is not between rebellion and conformity. The canny boarder learns to do both, publicly conforming while rebelling in the privacy of his head. "Our world must be inside our heads," the eight-year-old Magnus Pym is told in *A Perfect Spy* (1986), John le Carré's semiautobiographical novel about a master spy's formative years at boarding school, based on le Carré's experience at St. Andrews and Sherborne, where the unthinking pro-British propaganda led him to sympathize secretly with the Germans, "since everyone hated them so much." That mixture of outward conformity and secret rebellion—learning the enemy's language, wearing his clothes, aping his opinions, and pretending to share his prejudices—left him, le Carré said, "for the rest of my life with an urge to fight off whatever threatened to enclose me" and was his first taste of what it was to be a spy.

Bruce Wayne exercises a similar double-jointedness in *Batman Begins,* when, after seven years of physical and mental brutalization at the hands of the League of Shadows, he realizes the noxiousness of the League's ideology and, turning their Ninja tricks against them, razes their compound to the ground, in a fashion surely recognizable to that old Etonian James

Bond at the end of *You Only Live Twice:* "The top-storey crumbled first, then the next, and the next, and then, after a moment, a huge jet of orange fire shot up from hell towards the moon and a buffet of hot wind, followed by an echoing crack of thunder . . ." School's out. Looked at one way, Nolan's films are all allegories of men who first find their salvation in structure only to find themselves betrayed or engulfed by it, like Leonardo DiCaprio enfolded by the streets of Paris in *Inception.* "There's a point far out there, when the structures fail you," says Jim Gordon (Gary Oldman) in *The Dark Knight Rises.* "When the rules aren't weapons anymore, they're shackles, letting the bad guy get ahead." Like Batman trapped in his armor or the soldiers of *Dunkirk* entombed in the very ships and planes that once carried them to safety, they must divest or perish. The *Dark Knight* films in particular would draw strength from their geographical confinement to Gotham, another "closed community within a closed world" like Haileybury, also self-policing with its own system of rough justice and constant surveillance, forever teetering on the edge of chaos but for the actions of a few individuals. "A hard system run by good people" was one Dutch student's verdict on the school: Gotham in microcosm.

Nolan's prowess on the rugby field would eventually win him a place on the coveted first XV, one of the teams entrusted with bringing glory to the school against rival schools—"If you were part of the fifteen, you were a god," said one old boy—but despite Nolan's attending Haileybury on an arts scholarship partly secured by his short films, his filmmaking ground to a halt while he was there. Reunited with Jonah for the holidays, Nolan would visit the Scala cinema, the palatial 350-seater with marble staircases and bolt upright seats in King's Cross, where he saw David Lynch's *Blue Velvet* (1986), Michael Mann's *Manhunter* (1986), Alan Parker's *Angel Heart* (1987), Kubrick's *Full Metal Jacket* (1987), Katsuhiro Otomo's cyberpunk anime *Akira* (1988), and Ridley Scott's *Black Rain* (1989). One time during the holidays, when he was about sixteen, he made a trip to Paris to improve his French, staying with a friend of his parents, a writer and translator who happened to be working on a TV documentary—a nature film of some sort. One day, Nolan tagged along with him to the editing suite where he was working and watched him record the voice-over. "As these things do, it took forever, just running film back and forth, but I was just fascinated by it because he kept running the film backward while the sound was running forward. We had VHS machines at the time, but the quality wasn't extremely good backward. You didn't often see high-quality projection of

things running backward. It was quite a significant visual effect, for me. I sat there for two or three hours, however long it took, watching it run back and forth, just fascinated. There's no other way to conceive of this. The camera sees time in a way that we can't. That's the essence of it. That, for me, was the magical thing. It's about that fascination."

<p style="text-align:center">• • •</p>

The work of boarders is often marked by an unusually personal relationship with time. Anthony Powell's *Dance to the Music of Time* oversees the cycle of decades like a vast waltz. The imagery of clockwork fills Philip Pullman's *His Dark Materials* trilogy. While attending a sequence of English boarding schools in the 1920s, author C. S. Lewis noticed the curious dilation to which term-time was subject:

> To-morrow's geometry blots out the distant end of term as to-morrow's operation may blot out the hope of Paradise. And yet, term after term, the unbelievable happened. Fantastical and astronomical figures like "This time six weeks" shrank into practicable figures like "This time next week," and then "This time to-morrow," and the almost supernatural bliss of the Last Day punctually appeared.

This dilation had "a terrible and equally relevant reverse side," noted Lewis.

> In the first week of the holidays we might acknowledge that term would come again—as a young man in peace-time, in full health, acknowledges that he will one day die. But like him we could not even by the grimmest *memento mori* be brought to realise it. And there too, each time, the unbelievable happened. The grinning skull finally peered through all disguises; the last hour, held at bay by every device our will and imaginations knew, came in the end, and once more it was the bowler-hat, the Eton collar, the knickerbockers, and (clop-clop-clop-clop) the evening drive to the quay.

As the Christian imagery suggests, the temporal distortions of boarding school fed directly into the Narnia books, where time in the magical realm of Narnia stretches at a luxuriously elongated rate, so that the Pevensie children can fit in their reigns as kings and queens of Narnia just in time

for tea back in England. "Our world is going to have an end some day," Jill
tells the unicorn at the end of *The Last Battle.* "Perhaps this one won't. Oh
Jewel—wouldn't it be lovely if Narnia just went on and on—like what you
said it has been?" This feeling—a kind of exultant melancholy in which
every happiness is limned with the knowledge that it will end—is, if you
remove the Christian theology, very close to the multiple-braided climaxes
of *Inception* and *Interstellar,* where time slows and dilates, interrupting
friendships and separating parents from children. "I came back for you,"
says Cobb (Leonardo DiCaprio) to the now ninety-year-old Saito (Ken
Watanabe) at the end of *Inception.* "Come back and we'll be young men
together again." Time steals people away in Nolan's films, and he takes
careful note of the theft.

 "Time is an emotional issue when you're younger," says Nolan. "The
young are very nostalgic because they're changing so quickly. Your friends,
the people you knew when you were eleven or twelve, you have a totally
different relationship with. Everyone's going all kinds of ways. Things
change so fast, so quickly. I think that when you're in your twenties or
thirties, time evens out and you're able to look at it a bit more objectively,
a bit more logically. Then in middle age it's come back to that obsession
with the emotional aspects of time passing, how trapped we are by that.
Time is something that we can't really understand, but we can feel it. We
have a very strong sense of time, it affects us greatly, but we don't know
what it is. We have clocks and watches, but time is inherently subjective.
I don't know if you know L. P. Hartley's *The Go-Between.* 'The past is a
foreign country: they do things differently there.' Harold Pinter adapted
the novel for the Losey movie. He put that line right at the beginning. It's

A map of C. S. Lewis's
imaginary world of
Narnia.

at the beginning of the book. And it's also stuck with me because I grew up in the seventies, which, Christ, when you look back at it objectively, were not great."

Hartley's novel is a haunting exploration of the effects of time on memory and the tyrannical hold of the past on the present. "[My] imagination was then, though it is no longer, passionately hierarchical," says Hartley's schoolboy narrator whose cyclical sense of time "in an ascending scale, circle on circle, tier on tier" was based on his experience of Harrow, where he lived in a state of a "continual dread of being late," he said. "It left a dent on my consciousness, inflicted a Freudian bruise from which I would never recover." With Nolan it went the other way. It was at Haileybury that he acquired the punctuality, discipline, and indifference to cold weather for which he would be famous among his film crews—the relentless ticking clock that drives his plots. The boys marked their passage through the three-month terms in small white calendars, big enough to fit in a breast pocket, marked with all the big fixtures of the school year—matches, visiting preachers, outings to museums, annual CCF inspections, the dreaded school steeplechase—but no matter how many days they ticked off, the remainder of the term seemed to stretch out like an eternity. In Nolan's

Harold Pinter with Julie Christie on the set of Joseph Losey's *The Go-Between* (1971).

last two years at the school, the dilations of time were augmented by those of space when his family moved back to Chicago, leaving him to finish his A-Levels in England—3,945 miles away, a different time zone, six hours away.

"I loved being in England, I loved playing rugby, I loved how different it was from America, I thrived on the back-and-forth, the change of gears, but I'd come home and the adjustment could be a little tricky. You feel glad to be home, you get to resume some friendships, but your school friends are all in different parts of the world; everyone has moved on." With his family, too, he faces the usual problems faced by boarders as they catch up with households that have moved on without them, exacerbated in his case by the distances involved. As his younger brother, Jonah, passed through the American high school system, he became more Americanized, while Nolan, moving back and forth between the two countries, found himself unsure for a period which country he called home, exactly. "When they meet us people are often surprised that Jonah has a completely American accent and I don't. It's something you have to figure out when you're a kid. You have to make a decision: How am I going to speak for the rest of my life? Being of two countries and two cultures, I think you wind up being naturally self-conscious about that. There was a certain amount of discombobulation. I sometimes felt a little like an outsider on both continents."

It was during this period of maximum displacement that a number of key influences converged for Nolan, each of them pivoting from psychological fracture to structural fracture and exploring the ways the one could be made to stand in for the other. In his art class, he discovered the work of M. C. Escher, the Dutch printmaker whose infinite landscapes seem to summon a world both limitless and claustrophobic at the same time. "Escher's prints were a big influence on me," he says. "I remember doing drawings of Escher's negative reflections and drawings of spherical reflections." In his English A-Level class, he read *Four Quartets*, T. S. Eliot's poem about time and memory. "I come back to that one a lot: 'Footfalls echo in the memory / Down the passage which we did not take / Towards the door we never opened / Into the rose-garden.' It's very cinematic. All of Eliot is. I think I first encountered Eliot through *Apocalypse Now*, where Brando reads parts of 'The Hollow Men.' When I first watched that film, I was so fascinated by that sense of madness and enigma. Then later I read *The Waste Land*, which absolutely confounded me. I love that poem."

He also read Graham Swift's 1983 novel, *Waterland*, narrated by a history

teacher who has taken to telling his pupils tall tales about his childhood in the Fens of Norfolk instead of getting on with the French Revolution. "Time has taken us prisoner," he notes. "How it repeats itself, how it goes back on itself, no matter how we try to straighten it out. How it twists and turns. How it goes in circles and brings us back to the same place." The narrator's digressions turn out to be pathological in nature: guilty attempts

to filibuster an examination of his part in the abortion that led to his wife's abduction of a child and commitment to a mental institution. It was Nolan's first encounter with the idea of an unreliable narrator. "I found it to be such an amazing story structurally," he says. "It gets to the point where you're not even finishing sentences because you know where you're going with the different time lines running parallel and jumping to an extremely complicated structure that absolutely paid off. Just fabulous."

While spending a couple of weeks with his aunt and uncle in Santa Barbara one

summer, Nolan came across a laser disc of Roeg's 1976 film, *The Man Who Fell to Earth,* starring David Bowie—pale, elegant, vulnerable, then at the apex of his rock-star dissipation—as an alien visitor who splashes to Earth in a remote western lake and proceeds to build a business empire that will allow him to ship water back to his parched planet. Returning to England, Nolan sought out the director's *Eureka* (1983) and *Performance* (1970), Roeg's debut film, starring James Fox as an ultraviolent cockney enforcer on the run who finds refuge in a run-down Notting Hill boarding-house occupied by a fading pop star (Mick Jagger). "I thought it was really extraordinary," he says. "*Performance* was just so shocking and fascinating. It had such an edgy structure and rhythm. I saw it as a kid at school and we were all massively energized by the beginning, with the gangster, and as it gets weirder and weirder, it feels a little more of its time—claustrophobic in a way that's hard to get around. All films are of their time; there were a lot of things happening in the early seventies in films that were really out there, but also really exciting, and startling and new to an audience. I feel that I stand on the shoulders of those experimental filmmakers because they bring new things into the language—they show you the possibilities."

He also caught up with *Pink Floyd: The Wall* (1982), Alan Parker's grand, chaotic prog-rock opera, best remembered for Gerald Scarfe's animated sequence in which an auditorium of speechless putty-faced schoolchildren

OPPOSITE, BOTTOM Nolan saw Nicolas Roeg's *The Man Who Fell to Earth* (1976), starring David Bowie, one summer and later saw Roeg's *Performance* (1970), starring James Fox, ABOVE at his school; Roeg on the set of *Don't Look Now* (1973). "A magical and mysterious combination of reality, art, science, and the supernatural," Roeg OPPOSITE, TOP called the movies in 2011, "and perhaps even the first clue in solving the puzzle of what we're doing here on this world."

Alan Parker's *Pink Floyd: The Wall* (1982), whose entwining of personal history, memory, and imagination informed *Inception*.

march in lockstep to the sound of the anarchistic hymn "Another Brick in the Wall" ("We don't need no education / We don't need no thought control") before being fed into a giant meat grinder: As the scene reaches its crescendo, it is revealed as a daydream of a young schoolboy, rubbing the hand that his teacher has just struck with a ruler. Nolan would screen the film again for the cast and crew of *Inception,* to show the way it entwines memory with imagination, and dreams with reality. "The thing I wanted to show everybody was the way in which they combined memory with imagination, the present tense, and a fantasy past. I suppose the album gave it structure, but you wind up with these incredible parallel realities, jumping between them and relating them. I remember seeing *The Wall* around the same time as I read *Waterland,* and I found the two things very related—structurally the film was very similar to what I was reading on the

page. I was in a period where I was thinking a lot about movies and what I could do with them, and what interested me about storytelling and structure. I remember quite consciously drawing connections between them. I had a very good English teacher—he was very frank—who said to me one day, 'You have to be about books the way you are about movies.' Great advice, but I knew in my heart, I never would be. As soon as he said that, I thought, That's never going to happen, so I've got to fake it."

• • •

"Faking it" would mean enrolling at University College London to read English literature, after a year off in which he traveled, made more short movies, and did odd jobs. "I wound up in English and humanities because I was interested in people and storytelling, but I was quite good at math when I was younger," he says. "I just got fed up with the dryness of it. I didn't have the discipline for it; I was more interested in things involving people. But I'm still very much interested in patterns and geometry and numbers. I used to get asked—I don't know why; for some reason it's something you get asked a lot when you're starting—'What would you do if you couldn't be a filmmaker?' I think architecture is probably the answer that I gave most. My mother thought it was a cool job. I think that all architecture, and the best architecture in particular, has a narrative component to it. It's very specific. A few years ago, we went on holiday to Cambodia, to Angkor Wat. With rich tourists, what they do for you is they take you at dawn in the back entrance so that you have a completely private experience. I realized quite quickly this was a total mistake, because Angkor Wat was built to be viewed in a narrative sequence like the Taj Mahal in India. You're meant to approach it from the front, instead of sneaking in the back to get a premium experience of being there on your own. Fundamentally, it's like watching a film in the wrong order. We really cheated ourselves of the experience—what an architect does in terms of creating space that has a narrative component to it. Your mise-en-scène, the way you put shots together, and the way you create a geography for the story has a very strong relationship with architecture. It's about the world of the film. The geometry of stories is very important to me, and it's something I'm conscious of as I'm planning a film."

Not for nothing does DiCaprio first come across Michael Caine's professor of architecture in *Inception* sitting in front of a blackboard on

The self-supporting dome of Florence Cathedral built by watchmaker Filippo Brunelleschi using a method scholars still don't fully understand.

which is sketched the self-supporting octagonal dome of the cathedral in Florence. Built atop the existing walls with four million herringbone-patterned bricks, using a method scholars still don't fully understand, Filippo Brunelleschi's dome is an impossible structure, an architectural mystery. "Sometimes I'm filled with gratitude for what he accomplished," the Italian Massimo Ricci told *National Geographic* recently. "Other times he frustrates me so much, I tell him to go to hell." The cathedral could be a symbol of all Nolan's films, equally impossible structures designed to entrap and ennoble their protagonists as well as beguile and bedevil their audiences. His work might best be understood, in fact, as an attempt to plot a course or bridge the gap between two very different buildings 3,945 miles apart—two very different architectures, implying two very different social structures, with very different human implications. Reconcile them and you have an important key to his work.

The first is his dormitory at Haileybury: a long, antiseptic, barracks-style single-story building with wooden floors, a low ceiling supported by wooden arches, and two parallel rows of identical metal-frame beds, each covered with the striped school woolen blanket and separated from the others by a low wooden wall over which a white school towel was draped—an arrangement "for the better supervision of the pupils," in the words of the school's first master, the Reverend A. G. Butler. The dorm's regimented, repetitive design was a visible distillation of rank, with the youngest boys at one end, the eldest at the other, so you worked your way up the room as you worked your way through the school, leaving no one in any doubt as to where they were in the given pecking order. An early short of Nolan's, *Doodlebug* (1997), reminded at least one Haileyburian of the Hobbesian power dynamics that prevailed. In the film, just three minutes long, a man (Jeremy Theobald) chases a small bug as it darts frantically across the floor. In his hand, the man wields a shoe, but upon cornering his imp, we see that it is really just a miniature version of the man chasing it. He corners and clobbers his tiny doppelgänger with the shoe, only to look over his shoulder and spy an even larger version of himself about to do the same to him. Our doodlebug crusher is someone else's doodlebug. And so infinitely on, in an endless recursive chain. "Whether this represents life in the Melvill Dormitory in the late 1980s I leave to you to decide," wrote Father Luke Miller, a school chaplain, in a blog post when the film was posted on YouTube, tongue only halfway in cheek.

"The dormitory in *Full Metal Jacket* made an incredible impression on

ABOVE One of the
school's dormitories,
where Nolan first
conceived of the
germ of *Inception;*
OPPOSITE Vincent
D'Onofrio as Private
Leonard "Gomer Pyle"
Lawrence in Kubrick's
Full Metal Jacket (1987).

me, but at the time I was living in one, so there was also a pretty strong literal connection there," says Nolan, who would unconsciously re-create something of the arrangement in the dormitory of sleeping dreamers in *Inception,* stacked side by side in identical metal-frame beds, and also the tesseract in *Interstellar,* where McConaughey is caught in an Escher-like maze made of endless variations of his daughter's bedroom, the beds repeating to infinity. Indeed, it was during one of his storytelling sessions after lights-out in the sixth form that the idea for *Inception* first took shape. "I didn't quite have the sense of it," Nolan says. "It wasn't specifically that story that it became, but the essentials were in place. The idea of sharing a dream, that was the jumping-off point and the use of music or playing music outside someone dreaming, and the idea that if you played music to somebody who was asleep that it would translate in some interesting way. It had a more gothic sensibility in the first part of it; then the horror story sort of died on me and it became something else over the years. It's funny for me to realize—I was talking to my kids about it recently—I really did come up with a couple of ideas that went into *Inception* when I was about sixteen. That film was a very long time in coming. I said it was ten years; it was probably more like twenty. It was just something I was thinking about

for a *very* long time, trying to make it work. It had many, many different iterations. I was thinking about that film for a long time. It's humbling. I'm now forty-seven. That one took me nearly twenty years to figure out."

The second building—an ocean away, five time zones, eight hours' flying time—is the Sears Tower in Chicago. Located in the heart of the area of downtown Chicago known as the Loop, the tower's internal structure, finished in 1974, consists of nine squared tubes, each rigid within itself without internal supports, bundled together as a closed square above the first fifty stories, and terminating at varying heights, creating a multitiered form reaching 110 floors and a height of 1,450 feet—two hundred feet taller than the Empire State Building. Atop this lofty eyrie, you can see, on a clear day, somewhere up to fifty miles, across four states. It is, in other words, the exact architectural and philosophical opposite of Nolan's dorm, an impersonal barracks in which you are subject to the prefect's field of visibility, a body in a berth, stacked, ranked, and repeated. Atop the Sears Tower, you are effectively invisible, enjoying unbounded visibility in all directions for miles on end. It is the architecture of exultant omniscience. Nolan first visited the tower as a teenager during one of his holidays from school, and he would return almost twenty years later to film Christian

Lower Wacker Drive, where Nolan shot scenes in *Batman Begins* and *The Dark Knight*.

Bale atop the very same building in *The Dark Knight* for a scene demonstrating Bruce Wayne's ascendency.

"If you're going to look at architecture in my life, there's no comparison," he says. "I would come home on holidays, when I was sixteen, seventeen, and go to downtown Chicago, going on the train, and go to the 110th floor of the Sears Tower and take photographs. It's staggering, the architecture and the atmosphere of the city. I was very, very interested in that aspect of the American urban experience and how architecturally extraordinary that is. America is not a symbolic presence for me. I grew up with it. It's always been part of my life." Returning to a city he had once called home, it nevertheless took on a very different aspect from the John Hughesian suburbia he had experienced a few years earlier. This time, he found himself captivated by the impassive glass and steel structures of the Loop—the Sears Tower, One Illinois Center, the Mies van der Rohe–designed IBM Building, the mazy stretch of underground freeway around Lower Wacker Drive. Returning to Chicago in his year off between school and university, Nolan would shoot a short Super 8 film, *Tarantella* (1989), with his childhood friend Roko Belic. It was shown on Chicago public television as part of a show called *Image Union*.

"It was just a surreal short, a string of images," Nolan says. "They put it on their Halloween edition, because it was vaguely sinister. The interesting part is that I took Roko down to Lower Wacker Drive, the same set of

streets where we ended up shooting the big chase scenes for *Batman Begins* and *The Dark Knight.* It's literally some of the same places. The city for me has always functioned as a maze. If you look at *Following,* it's all about loneliness in the middle of the crowd. The threat of the city in the *Dark Knight* trilogy is very much about the absence of people, lonely streets, lonely architecture at nighttime, that kind of thing. One of the things I was fascinated by when I was younger was this phenomenon of—when you first go into an architectural space, when you move into a building, you have one sort of feeling. Then you walk or you live there and that impression just shifts; it completely changes. They are two entirely different geographical spaces, two different architectural spaces. For some reason, I am able to remember that initial impression, that incomplete understanding of the space and how it made me feel. When I was younger, I could do it much more strongly. The interesting thing about my memory is I can still remember that impression, that feeling of how fragmented the city was. When you think about what your memories do, what your brain is doing, it's holding two contradictory ideas in the same physical space, sort of in opposition, with no problem."

The effect Nolan is describing—a kind of spatial defamiliarization born of the itinerancy of his upbringing, which allowed him to look on the world with the eyes of a permanent stranger—he would reproduce in film after film. If you can practice a similar bifocalism and hold both those buildings in your mind at the same time—Nolan's dormitory at Haileybury and the Sears Tower, the panopticon and the skyscraper, confinement and liberation, alienation and homecoming—superimposing the one over the other, with all the contradictions that involves, you are very close to the impossible perspectives of Nolan's world. He essentially spent his formative years commuting between a nineteenth-century English landscape and a twentieth-century American one, and his films do the same, mapping the endless labyrinths of the information age using the shadowy tropes of early industrialization: doubles and doppelgängers, prisons and puzzles, the secret self and guilty heart. His heroes are like those late-Victorian voyagers of innerspace you find in the mysteries of Conan Doyle and Poe, frantically mapping their insides as if they were buildings but strangers to their own hearts, summoned by the siren song of home but nagged by the fear that they may never be able to return, or unable to recognize themselves once they do.

"I'm the product of two cultures and I've grown up in two places, and I

think that makes you think about the concept of home a little differently, because it's not as simple as geography necessarily," says Nolan. "At the end of *Inception,* he goes through immigration and gets his passport stamped; that's always been a resonant moment for me because I don't take it for granted that you'll hand over your passport and they'll say, 'Come in.' I was told when I was a child that I would have to decide when I turned eighteen whether to have British citizenship or American citizenship. Fortunately, the law changed by the time I turned eighteen, so I could be both, but when I was a kid, my parents let me know that I was going to have to figure out which to be. And fortunately, I didn't have to make that choice; it would have been impossible. So, I've never taken those kinds of things for granted. I mean for me, home now has been Los Angeles for some years because the kids are in school here, but I get to work in England quite a bit. I have this conversation with Emma a lot because she misses England, and I don't miss it because I know that I can go back, and don't miss America when I go to England, for the same reason. I mean, it would be a different thing if somebody said, 'Okay. Never again. You have to choose one place or the other'; that would be very hard. But I really enjoy going to different places; I enjoy that process of refreshing. It's that change of gears I had growing up. I thrived on that back-and-forth. For me, it's about switch flipping. You go from one culture, you go to the other, and I've always really enjoyed that change. I always found it invigorating."

TWO

ORIENTATION

THE OFFICES of the University College London Film & TV Society are located in the basement of the Bloomsbury Theatre & Studio in London's West End, a brick neo-Brutalist building on Gordon Square with a first-floor glass façade dating back to 1968. If you've seen *Following,* the writer played by Jeremy Theobald walks past it at the very start of the film. Inside is the box office, a long strip café, and a gift shop selling college scarves and newspapers. To find the basement, you have to thread a tricky course, passing the café and going out through the foyer to the back of the building, where an alley with crates and garbage bins winds past the UCL refectory, then down several flights of stairs into the gloom of the basement, where a single red door was kept locked, until Nolan, the president of the Film & TV Society from 1992 to 1994, arrived with the keys. Somehow it makes perfect sense that a filmmaker whose signature movement is down—through cracked ice, trapdoors, layers of dream, the tunnels of the Batcave—should have spent much of his early twenties holed up in a windowless, soundproofed basement room not unlike the basement where Hugh Jackman takes his bow in *The Prestige.*

Back then, it was crammed with filmmaking bric-a-brac—long strips of negative film hanging from the ceiling, a large old-fashioned analogue Steinbeck editing suite in the corner with *Doctor Who*–era monitors and

metallic blue finish, some metal tracks for tracking shots. "The venue was an Aladdin's cave for budding filmmakers," said Matthew Tempest, secretary of the society when Nolan first came to it, who used to take minutes for the meetings wedged into an old wheelchair pilfered from the University College Hospital. "For Chris, it was his office."

Half American, half British, dapper, opinionated but not overly so, Nolan struck a noticeably more mature figure than many of his contemporaries at UCL, London's "global university," a bustling metropolitan campus nestled in the heart of Bloomsbury and popular with overseas students. Nolan was long adjusted to the wrench of being away from home. A year older than some of the students, he had taken a year off, during which he returned to Chicago, shot several short films, and traveled. Arriving in the autumn of 1990, he stood out from a student body then in the throes of Britpop and grunge, with his penchant for blazers and shirts, and his air of quiet confidence; inside, however, he was taking furious notes, keen to shed his patina of privilege and complete the process of reeducation that some public-school boys find themselves conducting upon leaving the school gates.

"I remember feeling like that was a lot easier for me at UCL than it was for some of the people I was around just because I'd been abroad; I'd been away from home a long time, so it really wasn't that big of a deal," he says. "People who go to public school, when they leave, they either join the establishment and carry on talking the way they talk, or they kind of throw it all away. It's like having been Catholic, and you either stick with it and you go to church or you toss it away. One of the great things about UCL and one of the ways in which I grew up very, very quickly there, and shed a lot of that public-school entitlement nonsense that I left school with, is that you were just around regular people, people from all backgrounds, just there because they wanted to study their particular subject. Immediately there was this mix, just getting on with it. It was like joining the modern world. I used to put great stock in whether or not a person seems self-aware. Do they have a sense of themselves? I was very passionate about that when I was younger, when I was in my late teens and twenties. I think what happens as you get older is you just start to realize that people are who they are. You dress the way you want to dress. You have the haircut you have. Whereas, when you're a teenager, that sort of signaling is everything. There's a time in which you feel it incumbent to self-create, to make something of yourself, invent yourself, to the point of where, as a

kid, you practice your signature, stuff like that. Of course, later you realize you were always going to become somebody."

The undergraduate English course at UCL was a fast-paced, rigorous system of lectures, seminars, and one-on-one tutorials modeled on the Oxford system, where once a fortnight students had to defend their essays in a tiny room, in their first year covering everything from Homer and the *Odyssey* and Virgil and the Bible to *The Waste Land* and Toni Morrison.

University College London, which Nolan attended from 1990 until 1993 and to which he returned to shoot scenes in *Batman Begins* and *Inception*; the Gustave Tuck Lecture Theatre where he attended talks on Dante, Darwin, and Freud.

"There was actually no hiding place if you hadn't read it or were bullshitting," says Nolan, who quickly gained a reputation as the kind of student who, if he missed one essay deadline, would have the essay on the instructor's desk the week after; one time, Nolan surprised one of his tutors by supplementing a discussion of the work of V. S. Naipaul with an account of his travels in West Africa during his year off. He wasn't a bad student, necessarily—he would eventually get a 2:1, an upper second-class degree—but he did spend most of his time at the college down in the basement of the Film & TV Society, learning firsthand how to operate cameras, how to edit using the Steinbeck, to cut film by hand, and sync sound.

Meeting every Wednesday at lunchtime, he and the society's members would choose the slate of films they were going to show in the theater above—*Wayne's World, 1492: Conquest of Paradise, The Horseman on the Roof,* or the 1992 director's cut of *Blade Runner*—each film preceded by a very scratched recording of the old Pearl & Dean advertising jingle, which always got a big laugh. The money collected from the screening would then be used to finance short films by the society's members, among them composer David Julyan, actors Jeremy Theobald, Alex Haw, Lucy Russell, and Nolan's future wife and producing partner, Emma Thomas, whom he met after following the noise of a party in Ramsey Hall, the redbrick residence building just off Tottenham Court Road, where both roomed. "We were in the same hall of residence," he says. "I remember seeing her on the first evening of my first day. Emma has had such a profound impact on my life, my work, and how I go about things. We've collaborated on everything I've done. She's always involved in casting decisions and she's always the first point of contact in terms of story. After we met at UCL, we ran the film society together, which is where we developed our shared love of celluloid, cutting on film, projecting 35mm. That's something we really came to love doing together. We spent three years in college, making short films, running the film society, raising money to make more films. We ended up making a lot of great friends there. It was a terrific environment because it was student-led. There was somebody who knew about sound, there was somebody who knew the camera, somebody who knew about acting. It was full of interesting people who knew how to do this or that but didn't necessarily want to make films themselves, looking for people with ideas. I learned a huge amount about the craft of putting films together because not everyone would be available, so I had to do a bit of everything. I was able to learn by doing. It was a great education."

One of the student films gathering dust in the basement of the Bloomsbury Theatre was an adaptation by UCL alumnus Chester Dent of a short story by the Argentinian writer Jorge Luis Borges. Made without permission of the Borges estate, never shown publicly but acquiring cult status within the society as an example of what could be done with minimal resources, the film was based on the short story entitled "Funes the Memorious" ("Funes el memorioso"), about a man cursed with perfect recall. A nineteen-year-old Uruguayan cowboy who "had lived like a person in a dream: he looked without seeing, heard without hearing, forgot everything," on falling from his horse, is inundated with intolerably "rich and bright" memories new and old.

> With one quick look, you and I perceive three wineglasses on a table; Funes perceived every grape that had been pressed into the wine and all the stalks and tendrils of its vineyard. He knew the forms of the clouds in the southern sky on the morning of April 30, 1882, and he could compare them in his memory with the veins in the marbled binding of a book he had seen only once. . . . Funes remembered not only every leaf of every tree in every patch of forest, but every time he had perceived or imagined that leaf.

As is clear from that passage, Borges's subject is not really memory. If looking at a wineglass on a table, Funes sees every grape that had been pressed into the wine and the stalks and tendrils of its vineyard, then he has access to memories that are not even his: His problem is not perfect recall, but omniscience, excessive consciousness. The child of middle-class parents in turn-of-the-century Buenos Aires, Borges had an upbringing that echoes something of Nolan's own mixture of the cosmopolitan and the cloistered. "I can't tell you how long I was in one place or another," Borges once told an interviewer about the decade of wandering that followed a disastrously ill-timed trip to Europe made by his family when he was fifteen. "The whole thing is a jumble of division, of images." Within months

Jorge Luis Borges, the Argentinian author whose short stories were influential on *Memento, Inception,* and *Interstellar* and which Nolan first read while at UCL. "If you forgot everything, you would no longer exist," Borges once told an interviewer. "Memory and oblivion, and we call that imagination."

of their move, in the summer 1914, World War I broke out, marooning the family in Geneva, then the south of Switzerland, then Spain, in a series of hotels and rented apartments; his friendships were constantly interrupted and his first romance, with a Swiss girl named Emilie, abruptly ended. Finally returning to Buenos Aires in 1921, when Borges was twenty-two, he found a city that appeared to him as an endless labyrinth, both weirdly familiar and utterly foreign to him, the run-down barrios on the south side of the city seeming to symbolize their own half-remembered status. "I have repeated ancient paths / As though I were recovering a forgotten verse," he wrote in "La vuelta" ("The Return"), one of the poems in his first book of poems, *Fervor de Buenos Aires* (1923), in which Buenos Aires appears as a giant labyrinth whose corridors always seem to hold out the possibility of horrified self-confrontation. You might run into someone you know there—or worse, yourself. When someone accosted him on the streets of Buenos Aires to ask whether he was *the* Jorge Luis Borges, he was fond of replying, "At times."

Nolan had first come across Borges's name while watching Nicolas Roeg's *Performance.* In the film, one of the gangsters is seen reading the writer's Penguin *Personal Anthology;* Mick Jagger later reads from Borges's short story "The South," and an image of the author is flashed up, briefly, when James Fox is shot at the film's end. After showing the film of Borges's "Funes the Memorious" as part of a season of experimental shorts at the Bloomsbury Theatre, Nolan immediately went out and bought every Penguin edition of Borges fiction and nonfiction he could find. Nolan has bought so many copies of this author's work over the years, to give as gifts and help inspire collaborators, he's lost count. "I'll give them to people, or I'll have them so I don't have to carry them," he says. "I'll stick them in different places. I've got one here, and I've got one in the office, because they're a little bit thick. I feel like I've always been reading them. I don't know what it is about Borges or about his work, but I can never really remember, when I dive back into his books again, whether I've read a particular story or not. There're a few that I'm very familiar with and focused on, but there will be others where I'm like, Have I actually read this before? And then I get to the end and the concept comes full circle, and you go, 'Oh, yeah. Okay, I remember that one.' So they are a source of endless fascination to me."

Toward the end of his first year at UCL, his father bought him a copy of Jon Boorstin's *The Hollywood Eye* (1990), a book exploring the vari-

ous connections—visceral, vicarious, voyeuristic—between movies and their audiences. The associate producer of *All the President's Men,* who had gone on to direct a number of Oscar-nominated science and nature documentaries, Boorstin had much to say about several things close to Nolan's heart, including the slit-scan photography developed by Stanley Kubrick for *2001: A Space Odyssey* ("as close as anyone has come to the distilled sensation of pure speed"), the format of IMAX ("the closest we've come to pure movie"), and the editing of the shower sequence in Hitchcock's *Psycho* (1960), and more particularly the cleanup Norman Bates (Anthony Perkins) performs afterward. Bates's horror mirrors our own, Boorstin wrote.

> Ever the dutiful son he now mops up the mayhem to protect his "mother" (though the poor fellow is in such a state of shock he never takes off his suit jacket for the messy work). Perkins not only earns our sympathy by sharing our horror, he earns our respect for his stoic bravery and resourcefulness. It is hard to remember the first release of the film when we didn't know Perkins himself was the killer, but such is the strength of the sequence that even after we know the truth our heart goes out to poor Norman Bates. Finally, Perkins pushes Leigh's car into the swamp with her body in the trunk. For a few agonizing seconds the car won't sink. We see the panic and desperation in Perkins' face; in an astonishing switch we find ourselves actually rooting for the car to disappear. Hitchcock has turned us so far around that five minutes after we've seen his star brutally murdered he has us cheering for a man to hide her body . . . this vicious sleight of hand, more than the shower sequence, is the true *tour de force* of *Psycho.*

The observation struck deeply with Nolan.

"It's the most incredible thing, what Hitchcock's done; he's taken our point of view and flipped it," he says. "How has he done that? Simply by showing you and making you complicit in the difficulty of the task of cleaning up. I think for me, *Psycho*'s probably the Hitchcock film that's the most beautiful, photographically. If you took any frames from *Psycho,* they would be immediately striking. I mean, *Vertigo* has cinematic beauty, obviously, but it's not pretty, but in *Psycho,* you had that beautiful close-up of Norman Bates's eye; that was the thing I remember from that, just looking through the peephole. It's kind of exquisite. Everything you do as a filmmaker is about point of view. Where you put the camera. It's the

process I am going through as a filmmaker. When I am deciding how to shoot something on the day, whose point of view is it? Where do I want the cameras? It's always that. The conventions have changed over time, but filmmakers have all wrestled with the same essential trick of geometry. That is why first-person movies so rarely work. You'd think maybe it would remove the camera, but if you watch *The Lady in the Lake,* with Robert Montgomery as Marlowe, it's all shot from his point of view. You only see him in mirrors—they punch the camera in the face; he kisses the girl. It's a fascinating experiment."

Hollywood's most infamous example of sustained subjective camerawork, Montgomery's *The Lady in the Lake* (1947) is shot entirely from the point of view of its protagonist, the private detective Philip Marlowe (played by Montgomery). "YOU accept an invitation to a blonde's apartment!" claimed the ads. "YOU get socked in the jaw by a murder suspect!" When Marlowe lights a cigarette, smoke curls up in front of the camera; when his eye follows a secretary, the camera pans that way, dollies in for a kiss, starts to sway when he gets slapped around, and goes black when he loses consciousness. But the film doesn't quite work. Montgom-

ery's costars have a distinct deer-in-the-headlights look of panic as the camera swings their way, while Montgomery himself, who might ordinarily orient the audience through his reactions to events, is entirely off-camera except when he looks at himself in the mirror. Denied reaction shots, we are denied emotional attachment: We are in his shoes but not his head. "'Let's make the camera a character,'" noted Raymond Chandler. "It's been said at every lunch table in Hollywood one time or another. I know one fellow who wanted to make the camera the murderer; which wouldn't work without an awful lot of fraud. The camera is too honest."

Nolan first came across Chandler's name on the credits of Hitchcock's *Strangers on a Train,* studied him in his second year as part of a course segment entitled Moderns II, and would read his work on almost constant rotation throughout his time at university and beyond, seeding all three of his first features, *Following, Memento,* and *Insomnia.* Chandler's upbringing contains, like Borges's, uncanny echoes of Nolan's own. Born in Chicago in 1888 to an Anglo-Irish mother and an American father, he split his childhood between Chicago and London, where he was educated at Dulwich College, a public school five miles from Piccadilly Circus, where he enrolled as a day boy to study the classics—Ovid, Aeschylus, and Thucydides. Making himself over in the image of an English public-school boy in an Eton collar and black coat, Chandler found upon re-exposure to his fellow Americans, "I wasn't one of them. I didn't even speak their language. I was in effect a man without a country." Returning to Los Angeles, he started writing stories for the pulps, exploring the city's glittering, sordid world of pimps and players, paranoid millionaires and bastard cops through the weary perspective of that "shop-soiled Galahad" Marlowe, so named after his old house at Dulwich, a man forever out of time and place, driven by a version of the schoolboy code: Keep your mouth shut; protect good people from bad; cooperate with the cops but break the law if you need to, because the system is rigged; and, above all, keep your distance, because no one can be trusted.

"I think most people, if you ask them, feel themselves to be outsiders in some way," Nolan says. "When you have dual nationality, you're quite clearly in that position, so I can relate to that Chandler feeling of being stateless—he was pretty negative about it, and I think I was when I was younger, as well. I've since come to reconcile the two parts of myself, but

OPPOSITE TOP Audrey Totter in Robert Montgomery's *The Lady in the Lake* (1947), shot entirely from the point of view of private detective Philip Marlowe, a man "as honest as you can expect a man to be in a world where it's going out of style," wrote Raymond Chandler in *The Big Sleep* (1939); BOTTOM Chandler in Los Angeles in 1945.

when I was younger, I used to look at everything from the outside, which is a very noirish point of view. It was just a great advance, really, reading Chandler. The great gift of Chandler is the intimacy. So you're very, very close to these characters, their personal habits, their tastes in food and clothing. There's this very tactile quality that you also get later in the work of Ian Fleming. I think there's a flavor of it in the *Dark Knight* films and in *Inception*, but I think you feel Chandler's influence more in *Memento*; it's that very intimate point of view that leads very directly to *Following* and *Memento* and *Insomnia*, those three films in particular. I remember reading Agatha Christie as a kid—my mum loved her and got me into her books— but I can remember her saying, The books can't be that great if the person you least expect is always the bad guy. Because they're novels and they seem to be playing by a novel's rules. Whereas in Chandler, he's very up front about those kinds of switchbacks and doublecrosses. The whole point is you're being lied to. It was like a lightbulb going off for me. Chandler was thinking about the actual linear experience that is driving everything. It's not the plot. It's the point of view of the story."

Chandler himself was famously offhand about the mysteries driving his plots—the "few drops of Tabasco on the oyster," as he put it—which are generally circular, the guilty party often turning out to be a member of the family that first employs Marlowe. Either the client did it or the missing person is guilty, or not missing at all. At the end of the story, Marlowe may nominally clear up the mystery he has been assigned to solve, but that mystery is, in turn, part of a larger corruption that can never be fully seen or understood. He can never truly win. "The Los Angeles that began to emerge from these early stories was one where all institutions were to be instinctively distrusted, all witness account doubted, and everything straightforward ignored," writes Chandler's biographer Tom Hiney. The only thing that can be trusted in this world is the evidence of the senses, and sometimes not even that. In *The Big Sleep,* Marlowe says, "My mind drifted through waves of false memory, in which I seemed to do the same thing over and over again, go to the same places, meet the same people, say the same words to them, over and over again . . ." That could as easily be Leonard Shelby, the amnesiac insurance agent whose life is stuck in permanent repeat in *Memento.*

So if the plots are not what the books are about, what *are* they about? Here's Chandler: "A long time ago when I was writing for the pulps I put into a story a line like 'He got out of the car and walked across the sun-drenched sidewalk until the shadow of the awning over the entrance fell

across his face like the touch of cool water.' They took it out when they published the story. Their readers didn't appreciate this sort of thing—just held up the action. I set out to prove them wrong." When in doubt, follow the verbs. Marlowe does a surprising amount of walking in the seven novels and half a dozen short stories in which he appears. In his debut, *The Big Sleep,* he follows a customer on foot from Geiger's bookstore, west on Hollywood Boulevard to Highland, then another block, turns right and then left into a "narrow tree-lined street" with "three bungalow courts." Later, he walks to Geiger's house in Laurel Canyon, then to and from the Sternwood mansion in West Hollywood, covering ten blocks of "curved rain-swept streets" until he comes out at a service station, then adds, "I made it back to Geiger's house in something over half an hour of nimble walking." The world's most famous gumshoe earns the title. What would happen if you took out the crime plot altogether but kept the foot-leather pursuit? Lost the blackmail but kept the sidewalks and peeled-eye perception? You might have something very close to Nolan's first full-length feature, *Following.*

· · ·

A man (Jeremy Theobald) follows another man (Alex Haw) into a café in the center of London. He carefully selects a seat at a table a safe distance away and picks up a menu, as if to hide behind it. His hair is shoulder-length, lank, and looks unwashed; on his chin is the kind of beard you get after several days of not shaving, and he is wearing a leather coat over a rumpled collarless shirt. He looks unemployed. He soon attracts the attention of the waitress.

"A coffee, please," says the young man, barely making eye contact with her.

"Come on, it's lunch," she says, though the café seems relatively empty.

He orders a toasted cheese sandwich to keep her happy, not taking his eye off his quarry, who sits there sipping a coffee, staring out the window. A well-dressed professional in a dark suit—tie, pressed shirt, with an expensive-looking haircut—he seems to be on his lunch break from a bank or brokerage.

Except now he is moving again, picking up his briefcase and making his way toward the exit. His stalker shrinks down as he passes, lowering his head, but to his horror, the pinstriped man slips into the chair opposite him.

"Mind if I join you?" he asks.

His voice is posh, polite. He orders two black coffees from the waitress, and the moment she is out of earshot, his voice takes on an even more interrogative tone. "Well, you're obviously not a policeman. So who are you and why are you following me? Don't mess me about—*who the fuck are you?*"

So begins *Following* (1998), Nolan's black-and-white thriller about identity theft—a charcoal-sketch noir of lies, feints, theft, doubt, betrayal—such that even after seventy minutes we are no closer to answering that question: "*Who the fuck are you?*" The writer gives his name as "Bill," but it's worth taking that with a pinch of salt, like just about everything else we are told in the course of the film. Made six years after Nolan left UCL, but drawing on a lot of the resources, influences, and equipment he had enjoyed while attending the university, *Following* shines a torchlight into the tangle of questions about identity that Nolan had wrestled with in his early teens, shuttling back and forth between England and America, unsure whether he was an English public-school boy in Chicago or an

American in Hertfordshire. Like many of Nolan's films about doppelgängers, the film seems designed to resolve two conflicting elements of his own creative persona. The writer, with his grungy clothes and student digs, complete with tape deck and rubber plant, could easily represent the kind of redbrick bohemian Nolan had observed at UCL, or his own fledgling artistic instincts, then beginning to emerge as he took his first steps in the outside world. He's a writer taken to trailing random people around London, ostensibly to gather material, but really because he is lonely and bored; glomming on to strangers seems a way of filling up his own empty life. "It wasn't some sex thing," he tells an unseen interrogator in a voice-over. "Your eyes pass

over a crowd of people and then slowly stop and fix on one person, and all
of a sudden that person isn't part of the crowd anymore. They become an
individual, just like that."

The dark-suited stranger Cobb (Alex Haw), on the other hand, with
his plummy accent, cosmopolitan manner, and casual knowledge of wines
("don't be fooled by the supermarket label"), could be the embodiment
of the kind of smooth, ruthless upper-middle-class entitlement Nolan
had observed at Haileybury, both in himself and others. Nolan seems to
be inspecting his own leadership charisma for shadows: Beware of well-
dressed, well-spoken, quietly commanding strangers telling you what to
do. Cobb is a cat burglar of a very particular sort. He likes to break into
people's homes, not to steal their belongings but to mess with their heads—
planting women's underwear in a man's jacket pocket, for instance, or mis-
placing a single earring. "That's what it's all about, interrupting someone's
life, making them think about all the things they take for granted," he
explains. "You take it away and show them what they had." Taking on
the writer as an apprentice, Cobb schools him, grooms him, gives him the
money to get a haircut, buys him a nice suit, and treats him to nice meals
in French restaurants on stolen credit cards—"Just because you break into
people's homes doesn't mean you have to look like a burglar," he says—
before finally betraying him. Cobb's makeover is a frame-up for murder.
Be careful who you turn into, says Nolan. It might just stick. Stoking

OPPOSITE Jeremy
Theobald's writer tailing
a target in Nolan's
first feature, *Following*
(1998); ABOVE on the
rooftop where his
punishment awaits.
"How can I explain?" he
says. "Your eyes pass
over the crowd, and if
you let them settle on a
person, then that person
becomes an individual.
Just like that."

queasy fears about the consequences of chameleonism, the film is *Pygmalion* for shape-shifters.

"It's all these protagonists who, the more they feel they're exerting control, ultimately the deeper they're getting into a situation where they're completely out of control," he says. "The further you can take all that, the better the realization is. To me what's interesting about the writer is, he's a guilty innocent. He's doing something that's very naughty, but it's nothing compared to what is *actually* going on. And I think that's true of innocent people, in a way. They can carry a lot of guilt. They worry about what they're doing and think, 'Oh gosh, if people knew what I was up to . . .' And that to me is the humor of the thing. Guilt allows you to create a sense of mystery around a character. There's a motivation the audience don't fully understand, and then when you reveal it, as we did in *Inception,* for example, the story with his wife, you get a sense of peeling the onion—you see the layers. Guilt is just a really powerful engine of drama."

After graduating from UCL, Nolan had applied to and was turned down by the National Film and Television School in England and the Royal College of Art, but he immediately found work as a camera operator for Electric Airwaves, a small video shop in the West End turning out corporate videos and media training for large corporations all over the world. Frequently walking through London's West End, he found himself fascinated by the unconscious, unspoken laws governing the city's pedestrians. "There were a couple of things that I started noticing. The main one being that you never keep pace with a stranger. You just don't. Faster or slower, but you never keep pace with a stranger. There are all these unconscious barriers we use to try and retain a sense of privacy in the middle of a very crowded city. You know when you get on the tube at rush hour, back then reading your newspaper. All pressed up against each other, pretending that no one else exists, I'm really good at it. When you read the novels of Austen or Hardy, and the people of some small town can't talk to this new arrival because they haven't been formally introduced, we think it's insanity that anybody ever lived that way. But we live that way right now. If you just interact with a stranger on the street, or in a shopping mall, you're changing the rules. People will get very, very uncomfortable instantly. I'm not recommending you stalk people, but if you ever pick somebody out of a crowd and just concentrate on them or watch where they go, immediately you have changed everything. You're violating their privacy just by acknowledging them."

One night, returning to his and Emma's basement flat in Camden, they found a far grosser intrusion: His front door had been kicked in, and some CDs, books, and personal mementos were missing. Was he also missing a bag? asked the police when they arrived. Yes, he was. The thieves had likely used it to stash the stolen goods, he was told, a common MO among petty thieves. "So I put that in the film," says Nolan. "I think the raw and immediate response is, it's just repulsive. It's about intimacy and inappropriate intimacy. In the moment, when you see your stuff dumped out of drawers and sitting on the floor, you are suddenly in a very intimate relationship with someone you will never see or know. But then, when I put myself into their position, as a writer, I started connecting to things. The first thing was they kicked the door in. When I really looked at it, I realized that a front door is entirely symbolic. I mean, this thing was made of plywood. It wasn't keeping anybody out; it was so utterly flimsy. But, of

Following grew from Nolan's experience of being burgled. "You can tell a lot about people from their stuff," says Cobb (Alex Haw). "You take it away, to show them what they had."

course, I'd never even thought about that, because when you shut a front door and it locks, that's a sacred thing. That was a revelation for me. It was a symbolic barrier, just like those flimsy conventions that we adhere to, just to be able to live together. And that got me thinking: What happens if someone starts violating those conventions?"

The incident gave him the theme for a short film, *Larceny* (1995), shot on black-and-white 16mm film over the course of a single weekend. "It was a case of 'Okay, let's get a bunch of people together one day on a weekend, shoot twenty minutes' worth of film, and cut a six- or seven-minute film from that with a very tight narrative,'" he says. "It's about somebody breaking into somebody's flat. It was very much the model of *Following*. In fact, one of the reasons I never showed it to people afterward is that *Following* took over. *Following* was very much the result of experimenting with 16mm films and trying to figure out how best to maximize that. The script was written with a view of 'What can I do with really no resources, just with a camera and scraping together money for film stock?' So the technical compromises were built into the script. There's a tone to no-budget films that you can't necessarily get around—it's always an eerie quality that they have. There's a kind of blankness or emptiness in the production that becomes a little bit eerie, even when it's a comedy, so for me *Following* was a synthesis of a lot of different attempts of how do you not fight the qualities that are going to insert themselves anyway? So, follow the aesthetic."

He wrote the script for *Following* on the typewriter his father had given him for his twenty-first birthday, teaching himself how to touch-type as he went. (The typewriter appears as a prop in the film.) Emma Thomas had by this point secured a job as a production coordinator at Working Title, and she helped apply to various sources for funds, but upon being repeatedly turned down, they decided simply to use the bonus from his cameraman job and shoot the film only on weekends for almost a year, rehearsing each scene carefully, almost like a play, so they could shoot it in one or two takes. Working out that they could afford to shoot and process between ten and fifteen minutes of footage a week, using black-and-white film bought one roll at a time, he told his actors not to leave town or get a haircut. Every weekend, everyone would squeeze into the back of a taxi and head to whatever location they'd been able to scrounge—Nolan's parents' house, or a friend's restaurant—where they shot without permits, Nolan operating the camera himself, an old handheld Arriflex BL. Some weekends, they would rest. He would get the film processed by Tuesday, editing in his head as he went, and repeat the whole process until they

were done. He'd written the script in chronological order, then rearranged the order of the scenes, but it was while editing the film on three-quarter-inch videotape that this structural ingenuity began to pay off. One of the scripts Thomas brought back with her from work one day was Tarantino's *Pulp Fiction.*

"I was heavily influenced by *Reservoir Dogs,*" says Nolan, "so I was very interested to see what he had done for his follow-up. If you look at *Pulp Fiction* and *Citizen Kane,* they've a lot of similarities in terms of their structure. In no other media is there this insistence that information be introduced chronologically. There's none—in novels, plays, Greek mythology, Homer—and I think it all has to do with television. The birth of home video is a seminal moment in film narrative and the narrative structures that films can adopt. *Star Wars* is very direct-cut action and everything, but it's intensely linear, as is *Raiders of the Lost Ark.* Because in that era, they had to sell the films to television. That was the big sale. So from the 1950s through to about the mid-1980s, I suppose I'd say, every movie made had to play on television. There's this era of chronological conservatism that *Pulp Fiction* pretty much brought to a close."

Around the time *Following* came out and Nolan first started talking to journalists, he became aware that we rarely follow chronological order in our everyday lives. "When you read a newspaper, you read the headline, and then you read the story, and then you read the story the next day, and add to your knowledge, and then the next week. It's a process of expansion, a filling in of detail, and making connections—not based on chronology, but on the particulars of the story. We don't tend to have chronological conversations, either; they go all over the place. That was very interesting to me. The more I thought about it, the more conscious of it I became. What I tried to do with *Following* was tell a story in something like three dimensions. Instead of just expanding in one direction, it expands in every direction as you're passing through it. But I wanted my use of nonlinearity to be obvious to the audience in terms of plot payoff. I tried to make it more obvious why these things come together in a particular way. It was a difficult and awkward process. You had to roll through the tape to find the thing you wanted, lay it down on another tape, so you were going down a generation, just to make your first cut—it was a nightmare. I didn't know what I was doing, I just knew that I had a structure that made a lot of sense to me, and it really took me the making of the film to figure it out. People were like, 'Why didn't you just do it on digital?' Digital video was brand new at the time, but analog video was already there and there was already

this movement to shoot on tape. When I speak about how important film is to me, people often ask, 'What was the film where people first asked me why I was shooting on film?' And the answer is: my very first film, *Following*. The industry has had a profound shift, but that distinction and that choice has been there throughout my career."

• • •

Following plays hopscotch with three different time lines. In the first, the writer is interrogated by a police sergeant about his association with Cobb. In the second, the writer has become involved with one of the women they burgle, a cool, no-illusions blonde (Lucy Russell) who claims she is being blackmailed by her nightclub-owner boyfriend with some pornographic pictures—the MacGuffin of *The Big Sleep*, as it happens, although, as is often the case when Nolan lifts directly from a noir, we're meant to spot the theft: The blonde's story is a little *too* juicy, a little *too* familiar. Be on guard. In the third time line, the writer picks himself up from a brutal rooftop beating that has left him with his lip and nose busted, one eye closed. The cross-cutting casts a deterministic, moralistic eye over the characters, like Dostoevsky on fast-forward: crime meets instantaneous punishment. Like many a noir hero, Jeremy Theobald's writer is a naif, a bohemian manqué playing at being a criminal, and he gets his nose split by the real thing.

The nested, Russian-doll narrative structure provides perfect cover for a couple of twists in the movie's final twenty minutes, both going off like grenades triggering each other, the first distracting the audience for long enough to allow the second one even greater impact. In the first, the blonde reveals to the writer that he's been set up. Cobb needed someone to copy his MO so that person could take the rap for the murder of an old lady. "It's not personal," she says. "He followed you and realized you were just some weirdo, waiting to be drawn into it, used." So far, typical film noir: We've seen a thousand and one femmes fatales. It is the second twist that bears Nolan's distinctive shimmer. Thus forewarned, the writer takes everything he knows to the nearest police station to exonerate himself. "Your lies won't stand up to the truth," he tells the blonde, and he tells the police everything—that's the voice-over we've been listening to throughout the movie: his confession—but the police sergeant knows of no murdered old lady, nor does he have any suspect named Cobb. Just the man who is now sitting in front of him. And a trail of burglaries bearing

his fingerprints. The film traces a perfect circle of self-incrimination. He's just handed himself in.

"That type of narrative, I always think of it like a trap closing," says Nolan. "And that's very satisfying for the audience, the click of the lock. In another genre or with a different set of expectations, it would be bleak and depressing. When people say about films, 'It doesn't really fit any genre,' I never quite buy that, because genre is not some box you put it into; it is about audience expectation. It is what you tell people about a film. It clues you in; it orients you. That is not to say you have to be rigid in your adherence to it—I certainly haven't

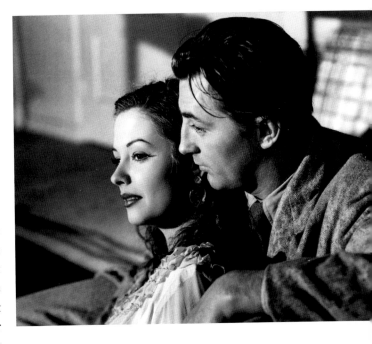

been—but the walls of that box are very useful for bouncing things off. The audience's expectations give you something to play with. That's how you fool them. That's how you create those expectations. You are going down a particular road, they think—and then you change direction. The whole thing about film noir is that it has to speak to you and your neuroses. I think *Following* speaks to a very basic fear. It's like Stephen King's *Carrie*, where there's something the cool kids are interested in, and you want to get in on it, and you find out it's because they want to play some awful joke. It's that extrapolated. That's what film noir is all about. It's all about extrapolating from recognizable neuroses. The femme fatale being, Can I trust the relationship that I'm in? I could be horribly betrayed. Do I really know my partner? That's the stuff in the end. These are the most relatable fears that we have. I was going through a huge Jacques Tourneur phase when I was writing that script—huge. All his films with Val Lewton, *Cat People, I Walked with a Zombie, The Leopard Man,* and then the ones that weren't, like *Out of the Past,* which is just an extraordinary, brilliant film and very influential on *Following.*"

In Jacques Tourneur's 1947 masterpiece, *Out of the Past,* Robert Mitchum plays a private investigator hired to track down the missing girlfriend (Jane Greer) of a gangster (Kirk Douglas). Mitchum, starting over

Jane Greer and Robert Mitchum in *Out of the Past* (1947), which looks askance at the American Dream.

in a new town as the owner of a gas station by a lake in the Sierras, finds that his past hunts him down again and sucks him under as terribly as a riptide. Told largely in flashbacks, the film essentially throws the American Dream into horrifying reverse: It's about our inability to ever fully escape the past, a theme Nolan would fully explore himself in *Memento*. At the film's end, Virginia Huston, playing Mitchum's innocently wholesome girlfriend, asks a mute kid who worked at his gas station whether Mitchum was ever really going to run off with Greer, and the kid lies to her, says yes, so she can forget him and move on. Then, in the film's closing shot, he salutes Mitchum's name on the gas station's sign. A lie trumps the truth. At the end of *Following,* with the writer now under lock and key for crimes he didn't commit, Cobb disappears back into the lunchtime crowds from whence he first emerged, like a wraith. Is anything he told us true? Is he even a cat burglar? He could be the director himself, disappearing into the weave of his own creation. The whole film could be an allegory about how easily writers are seduced and betrayed by directors, or the internal fight that goes on in the heart of anyone who aspires to be both: *Faust* for aspirant auteurs. Written, produced, shot, and edited by Nolan alongside coeditor Gareth Heal, *Following* binds all the disparate, competing strands of his identity together under the one rubric capable of reconciling them all: *film director.*

. . .

"You can spend a lot of time trying to figure out why, when you look in a mirror, your left and right are reversed, but up and down are not," Nolan told me one morning not long into our interview schedule.

We were sitting in his small L-shaped office, situated midway between his home in Los Angeles and the production facility that sits in a nearly identical residence at the end of his garden. The two residences sit back-to-back on opposite sides of the same block, like mirror images of each other, linked by two quads: Nolan's commute between home and work, on the days when he is writing, can be completed in under a minute. His office is filled to bursting with books, framed pictures, awards, and assorted film memorabilia. The clown masks of the Joker's gang in *The Dark Knight* sit atop one set of shelves, along with a small stuffed bat, a framed photograph of Nolan and director Michael Mann celebrating the twentieth anniversary of Mann's *Heat,* awards from the American Society of Cinematographers and the Art Directors Guild, his Writers Guild of America award

for *Inception*. His desk is as messy as an academic's, with papers and books spilling onto the floor in teetering piles, rather resembling an overgrown garden, or the subconscious processes of a forgetful person: James Ellroy's 2014 novel, *Perfidia*, books on military history by Max Hastings, and the *Collected Poems* of Borges.

"I've been thinking about that mirror puzzle for years," he said. "It's the kind of thought I can get totally lost in. I've got a few of those. I'll give you my favorite. In words only, over the telephone, explain the concept of left and right." He holds up his hand. "I'm going to stop you right there. You can't do it. You can only do it by feeling the concept of your left hand and right hand, which is purely subjective. It's completely impossible to describe objectively."

It reminds me of the first conversation we had, in Canter's Deli in 2000, where I noticed him leafing through his menu backward and wondered if it had anything to do with the structure of *Memento*, which

How explain "left" and "right" to an alien intelligence? The Project Ozma telescope at Green Bank, West Virginia, built in 1960 and named after a character in L. Frank Baum's *Oz* books.

mimics the discombobulation of its hero by reversing the sequence of its scenes, so the audience is caught in a constant state of in medias res. In *Insomnia,* similar effects re-create Al Pacino's sleeplessness, where he must find his footing over slippery rocks, trapdoors, and rolling logs. Hidden trapdoors wait beneath the feet of the magicians in *The Prestige,* and one of their assistants dies performing a trick called "the Upside Down," in which he must escape while hanging upside down, hands tied, in a water tank. "Downwards is the only way forwards," says Cobb in *Inception,* in which the streets of Paris fold back on themselves and the laws of gravity are suspended inside a hotel. Not even trucks and planes are immune: In *The Dark Knight,* an eighteen-wheel truck is flipped on its back, while in the sequel, *The Dark Knight Rises*, a jet plane is hung like a mackerel in midair until its wings shear off, leaving its passengers clinging to its perpendicular frame. Nolan is the DeMille of disorientation.

In the days after Nolan issued the following challenge, I could not get it out of my head. The problem Nolan set me is, I found out, a variant of what mathematician Martin Gardner called, in his 1964 book, *The Ambidextrous Universe,* the "Ozma Problem," referring to the telescope in West Virginia, pointed toward distant galaxies to pick up possible radio messages from other worlds. Positing contact with alien life-forms on another planet through Project Ozma—named after Frank Baum's princess in *The Wonderful Wizard of Oz*—Gardner asked how it might be possible to communicate the meaning of left and right to them when they have not one object in common. One might, for instance, ask them to draw a Nazi swastika, then tell them right is the direction to which the top arm of the swastika points, but one would have no means of telling them what a Nazi swastika is. The problem was first posed by William James in *The Principles of Psychology* (1890):

> If we take a cube and label one side *top,* another *bottom,* a third *front,* and a fourth *back,* there remains no form of words by which we can describe to another person which of the remaining sides is *right* and which *left*. We can only point and say *here* is right and *there* is left, just as we should say *this* is red and *that* blue.

Kant's 1786 essay entitled "What Does It Mean to Orient Oneself in Thinking?" is of little help. The difference between left and right is the a priori basis for all attempts at orientation, says Kant, rationality's unsplittable atom. You just *know*.

A few mornings later, I woke up early, still on New York time, in the appropriately *Memento*-like apartment building that I had rented through Airbnb—courtyard mezzanine, stucco walls, numbered doors, eerily empty—and went to a nearby diner, where I prepared a list of questions over a bagel and coffee. By the time I'd finished breakfast, the sun had come up far enough to peep over the top of the buildings across the street, and as I began the walk to Nolan's house, my elongated shadow entwining with the shadows of the palm trees stretching across the sidewalk in front of me, an idea occurred to me. By the time I arrived at Nolan's production facility, I was certain of it. Buzzed in through the black iron security gate and shown into the conference room, I sat in front of the fireplace, drumming my fingers until Nolan entered the room on the dot of 9:00 a.m.

"Okay, so here's what I would do," I told him. "I would ask the person I'm speaking to to step outside their house and to remain in place for a few hours, long enough to track the movement of the sun across the sky. And I would say, 'The sun just moved from your left to your right.'"

For a few seconds, he was silent.

"Say that again," he said.

"I would ask the person I'm talking to to step outside their house and stay there for a few hours—I guess I'd be running up a big phone bill, or maybe I would call back—but long enough for them to see the motion of the sun in the sky. And I would say, 'The sun just moved from your left to your right.'" This time, I held up my hands to demonstrate. "*That's* your right hand. *That's* your left."

"That's good," he said, nodding. "That's very good—"

I could hear the chirp of birds outside.

"I'm just wondering," he continued, "if it invalidates it because, in the Southern Hemisphere, it would be wrong. It doesn't work in all situations. It depends on your knowing someone's in the Northern Hemisphere."

"Ah. But. I would know which hemisphere you're in because I dialed the area code, wouldn't I? I know you're in L.A. Or London, or wherever. In the universe presupposed by the puzzle, phones exist, right? And if phones exist, then so do area codes." He still looked doubtful. "Or I would say, 'Go stand outside for a few hours, and if you are in the Northern Hemisphere, the sun just moved from left to right, and if you are in the Southern Hemisphere, it moved from right to left.'"

The length of my answer seemed somehow troublesome. Finally, he said, "It's like, 'Oh, this is good,' but you have basically given a really fancy version of 'If I know you're in this room, and I say, "Okay, stand with your

back to the fireplace, point the hand that's nearest to the door you came in, and that's your left hand."' You see what I'm saying? So, you slightly degrade the terms of the experiment. It's not a universal solution, but it's good. I didn't want you to be disappointed about it."

I thought about it. "No. I almost felt disappointed that I had solved it so quickly."

"Well, if it's any consolation, I don't think you did."

Subsequent reading revealed my answer to be a version of the answer Martin Gardner proposed using Foucault's pendulum, a heavy weight suspended on a fine wire, shown by French physicist Jean-Bernard-Léon Foucault to rotate clockwise in the Northern Hemisphere and counterclockwise in the Southern Hemisphere. "Unless we could make clear to Planet X which hemisphere was which, the Foucault pendulum would be of no help," Gardner pointed out.

In other words, Nolan was right.

<p align="center">• • •</p>

As Nolan was finishing the edit on *Following* in the spring of 1997, Emma Thomas was offered a job in the L.A. offices of Working Title. Nolan already had U.S. citizenship, so it seemed an obvious idea to follow her out to L.A. and try to get the film on the North American film festival circuit. In his memoir, *Love, Africa,* Jeffrey Gettleman provides a sketch of the twenty-seven-year-old filmmaker playing paintball with Roko Belic at the Field of Fire Paintball Adventures Park, on the outskirts of L.A., alongside skinheads and kids from Watts. "Rather than being discouraged by his rejection from film school, he was hot on a new idea for a movie, the story of a guy who loses his short-term memory and tries to solve the murder of his wife by tattooing clues on his body, like little mementos. It sounded complicated. Chris also wanted to tell the story backward—that was very important, he said. I couldn't quite see it, but when you're around someone who does, you start to believe it. 'You know,' he said, brushing back his blond hair, 'the greatest special effect in all of filmmaking is the cut.' I believed that, too."

While Nolan was in England editing *Following*, Jonah had been attending psychology class, in his final year of college in Washington, D.C., learning about "anterograde amnesia"—not the kind of amnesia suffered by characters in soap operas, where everything is lost, but the kind where

you have difficulty forming new memories after a traumatic incident. Jonah was fascinated, particularly in light of an incident he had experienced while on holiday in Madrid with his girlfriend later that year. Arriving late at night, the couple got lost looking for their hostel and were picked up by three thugs, who, upon following them to their hostel, held them up at knifepoint. The thieves didn't get much, just a camera and petty change, but Jonah spent the next three months obsessing over what he should or could have done to fend them off. The seed of revenge was further planted by a recent reading of *Moby-Dick*. He returned to his parents' house in London and was lying in bed one day, killing time, when an image popped into his mind of a guy in a motel room. Just that. The guy has no idea where he is, and no idea what he's doing. He looks in the mirror and sees that he's covered in tattoos giving him clues. Jonah started writing a short story.

A little while later, the two brothers marked Chris's move back to the United States with a road trip from Chicago to Los Angeles in their father's 1987 Honda Civic. The trip had a practical purpose—getting the car from Chicago to L.A. so Chris could use it—but it was also a rite of passage to underline Chris's impending move. Toward the end of their second day of driving, as they were passing through Wisconsin—Jonah remembered it as Minnesota—he turned to Chris, who was at the wheel, the windows down, and asked him, "Ever heard of this condition where you lose your short-term memory? It's not like those amnesia movies where the guy doesn't know anything, so anything can be true. He knows who he was but not who he has become."

He finished and fell silent. His brother was an eagle-eyed critic, able to spot the flaw in the premise of a plot idea within seconds, but this time Chris was quiet. That's when Jonah knew he had him.

"That's a terrific idea for a movie," said Chris, jealous. They stopped for gas, and when they got back in the car, he asked Jonah outright: Could he write a script from his story? Jonah agreed, and they fell to throwing ideas around excitedly as the roadside streamed by—the plot had to be cyclical; motel rooms were key—with Jonah's Chris Isaak tape stuck on a loop in the car's tape deck. "I just remember the idea was perfect for a Lynchian film noir," says Nolan. "That's how it struck me, film noir, but with a subversive modern or postmodern spin. The thing that I said to him right away, with both the short story and the screenplay, was if we could find a way to tell it in the first person, and put the audience in that character's

point of view, *that* would be amazing. That would crack something open. The question was how to do it."

Nolan wrote the script through the end of 1997 and into the following year, all the while hustling to get *Following* accepted into film festivals. It was finally accepted for the 1998 San Francisco International Film Festival. Nolan had to scrounge up another two thousand pounds for editor Gareth Heal to cut the negative in London and make their first print. "We could only afford one print for our first public screening in front of an audience of four hundred people in San Francisco. I think about doing that now, I mean screening the print sight unseen, it was insane. The irony is, the print was perfect, which I later learned was almost unheard of." After premiering in San Francisco—"a far-seeing creative imagination," wrote Mick LaSalle in the *San Francisco Chronicle*. "Nolan is a compelling new talent"—the film went on to screen in Toronto and at Slamdance, where it won the Black and White Award as well as being nominated for the Grand Jury Prize, and was picked up for U.S. distribution by Zeitgeist Films. Despite great reviews—*The New Yorker* found it "leaner and meaner" than Hitchcock—it would eventually bring in only fifty thousand dollars from its theatrical run, but wherever it went, it won admirers and sparked the inevitable question: "What are you going to do next?"

At which point, Nolan would simply hand them his script for *Memento*.

"I had *Following*," he says. "I had this movie that also had structural complexity that they could understand. You could show that to somebody and they would get the experience of the film. It was a powerful sales tool as we were doing the festivals, but always in the back of my head, I was like, Can you really do this? Can you really make a film backward?"

THREE

TIME

WHILE STILL A STUDENT AT UCL, Nolan was returning to his flat in Camden one night after the pubs had closed, when he saw a couple having a loud argument on Camden Road. Things got physical and the man pushed the woman to the ground. Nolan slowed to a stop on the opposite side of the street, wondering what he should do. "They were clearly a couple; it wasn't like a random attack, but I couldn't just walk on," he says. "It was one of those moments that you really remember emotionally because you ask yourself, Okay, what do I do? You know the right thing to do, but you also know you are afraid of it. The thing I *do* know is, I didn't walk on. So I know I didn't do the wrong thing. Would I have done the right thing? I don't know, because this other guy came running down the street and grabbed the first guy and pulled him off the woman. So I ran over and helped calm the guy down. Now here's the interesting thing: I was talking about this story years later with my brother and he is 100 percent convinced that he was there with me. And I don't think that he was. I genuinely don't. I believe that I told him about it. He was staying with me and I went home—he's quite a bit younger, six years, so at the time he would have been fourteen or fifteen—and I told him about what had happened in great detail, and I think he . . . well, the truth is, I don't know whether he was there or not. We will literally never know the answer. Some issues you can verify one way or another, sort of

figure it out, but a lot of them you can't. And that's why people talk about recovered memory syndrome, because the truth is, our memories don't work the way we think they work. And *that's* what *Memento* is all about."

A dizzyingly structured neo-noir with the eerie, sunlit clarity of a dream, *Memento* stars Guy Pearce as Leonard Shelby, a former insurance investigator whose short-term memory has been wrecked by a blow to the head sustained, he believes, during an attack in his house that left his wife dead. Everything up until the attack, he can remember; everything after it is wiped out every ten minutes or so, like on an Etch A Sketch board. Cruising a sun-bleached landscape of anonymous motels, bars, and derelict warehouses in a dusty Jaguar, he hunts for the clues that will lead him to his wife's killer, staying on top of the case by tattooing his body with important clues—"John G. Raped and Murdered Your Wife"; "Consider the Source"; "Memory Is Treachery"—and taking Polaroids of the people he meets and inscribing what he takes to be their motives on the back with a Sharpie. "Don't believe his lies," he wrote of a gum-chewing wiseacre named Teddy (Joe Pantoliano), who dogs Leonard like a shadow. "She has also lost someone," he has written on the back of his Polaroid of a lugubrious bartender named Natalie (Carrie-Anne Moss). "She will help you out of pity." How can he tell friend from foe? A lover from a casual acquaintance? Nolan re-creates his hero's discombobulation by means of a stunning technical feat: The film's scenes run in reverse order, each one ending where the last one began, before jumping again, and again, like Danny Lloyd stepping backward through his own footprints at the end of *The Shining*. It's harder to describe than it is to watch. One of the more curious aspects of watching *Memento,* in fact, is not how hard it is but how quickly we learn to get with the narrative game that is afoot. If we see a bruise on a character's face, we will shortly find out what put it there. If we see that the window of Leonard's Jaguar is smashed, we can expect to find out what smashed it. The effect is both wildly disorienting and ticklishly entertaining, plunging us into a permanent state of in medias res right alongside Leonard, but also turning each scene into a mini cliff-hanger as he races to get up to speed. "I'm chasing this guy," Leonard says in voice-over, after coming to in the middle of a foot chase, only to find the man he is chasing drawing a gun and firing at *him*. "No, he's chasing me." The film is a revenge thriller in X-ray, its insides glowing luminously.

After returning to Los Angeles in the summer of 1997, Nolan waited patiently for his brother to finish his short story, pestering him every few

weeks to see how he was doing. Toward the end of the summer, he received a rough draft. Opening with a quote from Melville ("What like a bullet can undeceive!"), the story finds its hero, Earl, in a hospital room, to which he has been admitted after the attack. An alarm clock is ringing. THIS IS A ROOM IN A HOSPITAL. THIS IS WHERE YOU LIVE NOW reads a sign taped above his bed. The desk is covered with Post-it notes. Lighting a cigarette, he sees that another sign is taped above the box. CHECK FOR LIT ONES FIRST, STUPID. Looking in the bathroom mirror, he finds a scar running from his ear to his jawline, an MRI taped to the door, and a photograph of a mourner at a funeral. An alarm clock is ringing. He wakes up and starts again. Bristling with tough-guy cynicism ("Not too many professions out there that value forgetfulness. Prostitution, maybe. Politics, of course"), the story reads a little like *Groundhog Day* as rewritten by Mickey Spillane. Certain elements of the finished film are already in place—the prominence of a shower curtain during the killing, the use of tattoos and Post-it notes as reminders, a desperate search for a pen before a crucial clue is forgotten—but it seems almost deliberately incomplete, a character sketch, as if Jonah felt his brother hovering at his shoulder. Set almost entirely in the hospital room in which he wakes up, it ends with his hero unbuttoning his shirt to reveal a police sketch of the assailant tattooed on his chest. Case closed. Watching his brother flesh out his idea was, said Jonah, "like feeding a virus into a petri dish and watching it multiply."

Nolan's biggest change to his brother's story is to realize how vulnerable Leonard's condition would make him—how ripe for exploitation by

Guy Pearce as Leonard Shelby in Nolan's first American film, *Memento* (2000).

others. Aside from one sign in Earl's room that reads GET UP, GET OUT RIGHT NOW. THESE PEOPLE ARE TRYING TO KILL YOU, the external threats in Jonah's story are notional. He is a brain in a vat, his tough talk going untested. Flushing him out of the safety of that hospital room, Nolan forces Leonard to take his chances on the dusty outer limits of Los Angeles, where he is prey to the city's grifters and pickup artists, like Teddy, the story's Quilty, who keeps popping up like the pest you hoped wouldn't show at the party, or the friend you regret making in your first week of school—ingratiating, overfamiliar, his first act is to lead Leonard to the wrong car outside his motel as a joke. "Shouldn't make fun of someone's handicap," Leonard tells him. "Just trying to have a little fun," responds Teddy. Horribly alone, Leonard barely gets a moment to himself. Unable to trust anyone, he must or be horribly alone. "I know I can't have her back," Leonard tells Natalie. "But I don't want to wake up in the morning, thinking she's still here. I lie here not knowing how long I've been alone. How can I heal—how am I supposed to heal if I can't feel time?" It's a remarkable speech and there is nothing quite like it in Jonah's treatment.

Unlike *Following,* which he wrote in straightforward fashion on his father's typewriter and then chopped up afterward, *Memento* was written straight through, so Nolan could experience it as Leonard does. He wrote on a computer this time. "I wrote the script totally from Leonard's point of view," he says. "I would put myself in his position, and start examining and questioning my own process of memory, purely subjectively, and the choices you make about what to remember and what not to remember. Once you start doing that, it gets a little tricky. It's a bit like with eyesight perception. Our eyes don't see what you think they see. Only a small percentage of our eyesight is accurate, and memories are like that. The systems that Leonard employs were a very sincere and categorical response to 'How do I live my life?' I realized I always keep my house keys in the same pocket, and I never leave the house without them, and I check my pockets without even thinking about it. Leonard systematizes it. That's very much the way the script was written, extrapolating from my own memory processes."

As he wrote, he listened to *OK Computer,* Radiohead's 1997 album of digital-age dislocation, one of the peculiarities of which, for him, was that he could never remember which song came next. "Normally, when you listen to an album, your body almost anticipates the next song. With *OK Computer,* that's not really the case. It's very difficult for me. Likewise,

Memento is a film I get completely lost in. I can't identify which scene comes before which because of the way the structure works in the film. It's back to this thing about fighting time. You're trying to break the tyranny of the projector, which is the ultimate linearity. With *Following,* I had the structure mapped out, but I thought the obvious way to write it was to write it chronologically, so that everything worked, and then cut it up and apply the structure. There was a substantial amount of rewriting involved with that, because nothing flowed. With *Memento,* I thought, I have to write the way the audience will watch it. It's actually the most linear script that I've written—truthfully. You can't remove one scene. You can't because it goes A, B, C, D, E, F, G. The connections are so ironclad, there's so little room for maneuver in terms of changing it editorially. If you tell that story the right way around, it's unwatchable. It's pure cruelty. You have to be under the illusion that this guy is under for it to be bearable. You have to have his optimism and his ignorance for it to be okay. Otherwise, it is literally just a couple of characters torturing somebody."

Told forward, in fact, *Memento* is remarkably simple: A corrupt cop and a bartender convince an amnesiac to pull off a contract killing. Or, as critic J. Hoberman remarked, "Two veterans of *The Matrix* confound one of the framed heroes of *L.A. Confidential.*" Nolan uses the noir framework just as he had in *Following,* both to orient the viewer and to pull the rug from beneath our feet. Like Fred MacMurray in *Double Indemnity* (1944), Leonard is now an insurance investigator who must investigate his own case. "I had to see through other people's bullshit," he says. "It was a useful experience because now it's my life." Leonard has become an expert reader of body language, and avoids the phone, preferring face-to-face contact with people so he can tell how sincere they are being. Even the motel clerk is scamming him, charging him for two rooms instead of just one. Teddy is the weasel, like Peter Lorre in *The Maltese Falcon,* and Natalie is the femme fatale. Initially a sympathetic ear for his memories of his wife, Natalie sleeps with Leonard and, in a memorably nasty reveal, shows her true nature. "I'm gonna use you, you twisted fuck," she hisses, circling him like a serpent. "You won't remember any of what I've said, and we'll be best friends, or even lovers . . ." Leonard strikes her with the back of his hand, drawing blood. Natalie nurses the bruise, looking victorious, gets to her feet, and leaves, while Leonard searches her apartment, looking for a pen to write down all he has just witnessed before it slips down the memory hole—too late. Here is Natalie again, nursing a bloody lip, blam-

QUALITY FOODS

RIGHT Barbara Stanwyck and Fred MacMurray in Billy Wilder's *Double Indemnity* (1944); OPPOSITE Bill Pullman in David Lynch's *Lost Highway* (1997), both of which influenced *Memento*.

ing someone else, and Leonard, the poor fool, hares off to wreak his revenge for something *he* did: a big clue to where this story is ultimately headed.

Natalie, you'll note, has gone through all the normal developmental stages of a classic femme fatale, from seduction to trust to betrayal. The scenes are in reverse order, but everything else, the rhythms of character and plot development, proceed forward as normal. The universe of *Memento* may be one of pure, tumbling chaos, but the storytelling is a model of clarity, with Nolan using all the means at his disposal—Leonard's tattoos, his notes, his voice-over, the sounds that start each scene, the cleanness or unkemptness of Lenny's clothes, the age of the wounds on his face—to nudge our memory and reassure us that we are on track.

"The overarching narrative of *Memento* is incredibly conventional," says Nolan. "On purpose. The emotion and experience needed to be extremely familiar. One of the films I saw as I was writing it was David Lynch's *Lost Highway*. I'm a Lynch fan, but I was left like, What the hell *was* that? It felt too strange, too long; I almost didn't finish watching it. And then, about a week later, I remembered the film as if I were remembering one of my own dreams. I realized that Lynch had created the shape

of a film that would project a shadow in my memory, assuming the shape of a dream. It's like a hypercube—the shadow of a four-dimensional object in our three-dimensional world. It's back to Eisenstein's shot A plus shot B gives you thought C. That's the ultimate aspiration of what you want to try and do with the form of a movie. You want to try and create something that isn't just film running through the projector. I think there are other films like this, Tarkovsky's *Mirror,* for example, and Malick's *Tree of Life.* And that's what *Memento* tried to do in its own way and succeeded in doing, judging by people's response. The thing I was proudest of is that your experience of the film was not just the film running through the projector. It bled off in all these different ways. It created a three-dimensional narrative."

As Nolan had intuited when he made *Following,* we are much more accustomed to jumbled chronology than we think we are. It isn't just *Double Indemnity* that moves backward in time. Almost all detective stories do so, moving from crime to culprit, effect to cause, and requiring the audience to reverse-engineer the sequence of events. It is the essence of the deductive method. "In solving a problem of this sort, the grand thing is to be able to reason backward," Sherlock Holmes tells Watson in *A Study in Scarlet.* "That is a very useful accomplishment and a very easy one, but people do not practice it much." The whodunit was a breach delivery. The idea of telling *Memento* backward occurred to Nolan two months into his first draft. His dad's Honda Civic had broken down. Sitting at home, waiting for Emma Thomas to return to take him to the mechanic to discuss the plight of the vehicle, Nolan began to get the idea of how to structure the film. "I remember very clearly just being in my apartment on Orange Street in Los Angeles and drinking too much coffee one morning and thinking, How do you do it? And then just getting that eureka moment: Oh, if you have it run backward, you withhold the information from the audience the same way it is withheld from the character. It was one of those moments where you had it. It took me a very long time then to write the script, but in that moment it was done."

•　•　•

After that, it just poured out of him. It took him just a month to finish a first draft of 170 pages, much of it written in motels up and down the California coast. "Part of my writing process has always been to plan and plan, to the point I have to kind of get out of town, as it were. I used to just get in the car and drive, go to a motel, whatever. I wrote *Memento* staying in motels in Southern California. The problem with Los Angeles for writing is you have very little contact with strangers on a daily basis because you drive around in the car. When I first moved to L.A., I greatly missed the interaction with strangers. The friction of everyday life, of getting on the tube, wandering around town. If you look at *Following,* the whole film is based on that. In New York, you take that for granted. It's very much part of your life. In L.A., just in terms of stimulating the imagination and seeing things you don't see every day and seeing faces you don't see every day, you actually have to seek it out. The city's not built that way."

Half the movie, in fact, is set entirely within the confines of a single motel room. Intercut with the main plot is a subplot, shot in black and white for easy identification. Leonard, holed up in his motel room, talks on the phone about an old case of his involving a man called Sammy Jankis (Stephen Tobolowsky), who suffered a similar case of anterograde amnesia. As we see Sammy undergoing a battery of tests alongside his wife (Harriet Sansom Harris), we are struck by the tenderness of this marriage as the couple undergo this medical trial, uncommon in its detail but not in the concern they show for each other. Originally, the entire Sammy Jankis story was told in one scene. In subsequent drafts, Nolan scattered its various parts throughout the movie, whose every square inch is otherwise so ruthlessly purposed, thus creating a gathering sense of dread: Where is this going? Why is this important? "Why don't you investigate yourself?" says Teddy at around the one-hour mark, thus beginning the slow pivot of our suspicions toward the one person in whom we've most invested our trust. Two drafts later and Nolan had a 150-page script he was ready to show to people—Jonah, Emma Thomas, executive producer Aaron Ryder—but the script would remain a work in progress right up until filming, as Nolan, explaining the film to his cast and crew, hit little knots of confusion and worked to smooth them out, simplifying and clarifying the action further.

"I always remember Emma reading the script of *Memento* for the first time. Every now and again she would stop reading, turn back a few pages to check something with a frustrated sigh, and then start reading again.

She did that many, many times before she got to the end. She had a very clear-eyed view of how it worked, what worked about it, what didn't. She's very, very clear on what the audience are capable of taking in and when you're just spinning your wheels. She's always been extremely helpful to me in terms of pointing out areas where I'm sacrificing clarity." In the first draft, Leonard stayed in two motels, to indicate more explicitly the cyclical nature of the story; in subsequent drafts, two motels became two rooms at the same motel. The character of Burt, the motel clerk, originally two men, became one. By the time Nolan finished the script, in the spring of 1998, Jonah had arrived in Los Angeles in time to supply the story with its coup de grâce. "We spent a long time trying to figure out the ultimate conclusion of the film. I wrote the screenplay on my own, and then Jonah moved out to L.A. and worked on the film, just when I was trying to finish the end, trying to bring a bit more clarity to it, and he had this eureka moment, where he was like, Well, *he's already done* it—and *of course* that's the key to the end."

· · ·

The film was shot in a variety of locations in the Los Angeles area—a diner in Burbank, a derelict refinery in Long Beach, a courtyard motel in Tujunga with pleasingly prisonlike bars on its entrances—over twenty-five days at the end of a long, hot summer that almost sent them farther north in search of gloomier weather. Nolan wanted an overcast, diffuse light. Production designer Patti Podesta built the film's main motel room interior on a soundstage in Glendale, making it slightly smaller than was comfortable and blocking the light through the windows to further give the film a sense of constriction, together with a closed courtyard and glassed-in lobby: a motel as designed by M. C. Escher. Working for the first time with cinematographer Wally Pfister, whom Nolan had met at Sundance the year before while on the *Following* tour, they shot with a Panavision Gold II camera, using anamorphic lenses, a format more usual for epic landscapes than claustrophobic thrillers, giving shallow depth of field, so that when the camera was on Guy Pearce's face, nothing else was in focus: perfect for a story in which he can be sure of nothing outside his immediate sensorium. The word that kept coming up was *tactile*. Nolan wanted to register the sights and sounds of Leonard's world with pinpoint sharpness.

"One of the things I took away from 'Funes the Memorious' is the clar-

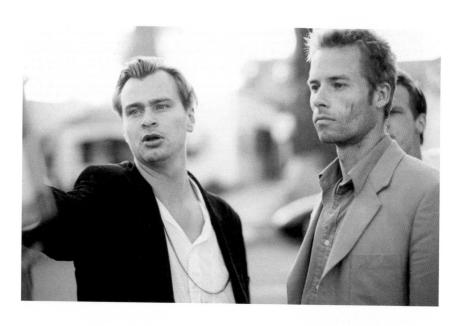

ity," says Nolan. "Borges talks about how crystal clear everything is. That sense of tactility, of physicality from that short story is very important to *Memento*. I used to compare it to making sculpture because it is so tactile. Interviewers were kind of like, 'What the hell are you talking about?' It's about a connection with the audience. The more physical that connection, the more you can do with it as a storyteller. And that is very difficult, to

Nolan directs Guy Pearce on location in Los Angeles; Joe Pantoliano during a break in filming.

make a connection. It's a way of putting you in the character's shoes. Leonard's sense memory becomes the major way of cluing himself in. The important speech that Guy has—it's a very emotional moment and an extraordinary piece of acting; it was a real lesson for me—was about knowing the feel of the world. 'I know how this wood will sound when I knock; I know how this glass will feel when I pick it up.' That knowledge of the world, that memory of the world, is so precious to him because that still functions, that still works. There're all these things he talks about taking for granted, things that we don't even think of as memory, that are, in fact, powerful uses of it. He is aware of the fact that his memory isn't working anymore, so he then treasures the way in which it *does* work. When I talked to the actors, it was all about *feeling* the world. You don't know what's outside your immediate sensory

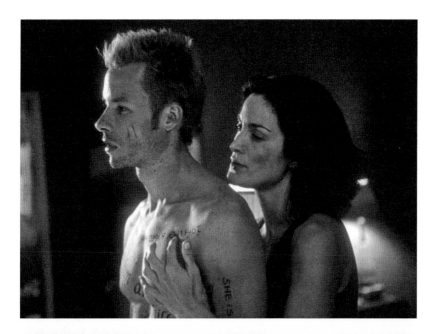

sphere, so that stuff becomes really important, not just for clues but also just to hang on to. The feeling of that."

Leonard's sense memory is his only proof that he exists, the one slim tether holding his identity in place.

There are things you know for sure. Such as? I know what that's gonna sound like when I knock on it. I know what that's gonna feel like when I pick it up. See? Certainties. It's the kind of memory you

Guy Pearce and Carrie-Anne Moss; Natalie discovers Leonard Shelby's tattoos. The tactility of *Memento* was inspired by Borges's treatment of memory in "Funes el memorioso" (1942), depicting "a multiform, momentous, and almost unbearably precise world."

take for granted. You know, I can remember so much. The feel of the world . . . And her.

The speech evolved partly in response to all the questions Nolan was getting from cast and crew about the film; it's how he explained the movie to them. Viewing the dailies of the "feel of the world" speech, Nolan thanked his lucky stars that he'd chosen Pearce. "As soon as I saw that scene on-screen, I thought, Thank goodness I had Guy," he says. "He found what I didn't even know I needed if it was to work. He had understood it from the inside and he brought this extraordinary emotion to it."

On the advice of her acting coach, Carrie-Anne Moss unstapled her script to get a better idea of what her role felt like in forward sequence, but Pearce kept his as he was given it, so that he might better feel Leonard's discombobulation. Editing as they shot, editor Dody Dorn kept track of the film's different time lines with a wall of three-by-five cards with titles like "Leonard heats the needle" and "Sammy accidentally kills his wife," color-coded so they could see when material was repeated and whether it was the first or second time they were seeing it. It looked very similar to the collage of his case that Leonard has pinned on his wall—a mad assembly of maps, Polaroids, Post-it notes, linked with pieces of string. Nolan had Dorn watch Terrence Malick's South Pacific war film, *The Thin Red Line* (1998), for inspiration, drawing her attention to the scenes in which Ben Chaplin's Private Bell thinks about his wife back home—shot almost like a home movie, in a haze of summer colors, but cut in and out with no fanfare, no dissolves. "I think *The Thin Red Line* is one of the best films ever made. When I came to shoot memories in *Memento,* which is a very important part of the film, I knew from *The Thin Red Line* that when you try to remember somebody from the past, it's always small details. That to me became, Yes, that's how a memory works; it doesn't come in black and white. There's no wavy dissolve. You just cut."

Each scene begins the same way, with a distinct sound that allows us to identify it—Leonard putting the clip into the gun, Teddy knocking on the door to the motel, his cry of "Lenny!" at the start. For the flashbacks, sound designer Gary Gerlich drained all the ambient street noise the way Frank Warner had done for the fights in *Raging Bull.* Not a fan of using temp music tracks patched in from other movies, Nolan commissioned temp music from composer David Julyan as soon as the script was finished, the music evolving alongside the film itself. "Nine Inch Nails

meets John Barry," Nolan told Julyan, sending finished scenes by FedEx to London, and receiving cassette tapes of musical cues in return. Rather than come up with a wholly new way of making movies just because he was in Hollywood, Nolan was adapting his preexisting shooting methodology, adding to it as he went. "Chris always seems to have a sound in his head," said Julyan. "There'll be a couple of sounds that he'll be obsessed in getting, rather than melodies or tunes. With *Following*, there was a ticking noise that runs through the music, which he wanted. In *Memento,* there are a lot of ominous rumblings." The Polaroids and the choice of the Sharpie Leonard uses to write with came directly from the set itself.

"I remember borrowing a Polaroid camera from a friend to see, okay, could you write on that, and trying out various pens to see which one worked best," says Nolan. "Then I saw the wardrobe department would take Polaroids and write on them with Sharpies. It became a much more known visual trope after the film came out. You'd see ad campaigns. That and the Polaroid are both gone now. I had never been exposed to that real filmmaking world until I made *Memento*. People always think it was the Batman film that was the big leap for me, but it wasn't; it was *Memento.* To go from *Following,* which was a group of friends wearing their own clothes and my mum making sandwiches to spending three and a half to four million dollars of somebody else's money and having a proper crew there with trucks and trailers—a very small film by Hollywood standards, but it was the biggest leap I'd made. Then we started showing it to people, and things got very, very scary. It was a very rough ride. It was the lowest of lows and the highest of highs. The ride of *Memento* was an extreme roller coaster."

After the film wrapped on October 8, with the scene at the warehouse where Leonard attacks a drug dealer, Pearce recorded his voice-overs for the black-and-white sequences, Nolan encouraging him to improvise to give the sequences the feel of a documentary—Leonard's joke that he reads the Gideon Bible "religiously" being an example. After postproduction work was finished, in March 2000, the film's producers, Jennifer and Suzanne Todd, together with executive producer Aaron Ryder, organized a screening for all the major distributors so as to catch them all while they were in town for the Spirit Awards. "We got turned down by everyone," recalls Nolan. "Every time we would screen it, there'd always be somebody who 'got' it. I would get a meeting with Fox and they'd be like, 'Oh, this is a brilliant script,' but they always wanted to talk about other projects. So I was gaining in contacts and reputation; I was able to keep trying to

push my career forward, while the film sort of sat there in limbo. For a whole bloody year, nobody would put the film out, and obviously that was horribly stressful for the producers, who had convinced everybody to put four million dollars into it. I was beginning to get very despondent about whether it would ever get out into the world. The Newmarket guys, to my eternal gratitude, never lost faith in the film. They never asked us to change a frame of film. They actually wound up forming their own distribution company and distributed the film themselves. We went back to the Spirit Awards a year later and we swept—Best Feature, Best Director, Best Cinematography, Best Screenplay, and Carrie-Anne for supporting. It was literally that storybook turnaround."

Deciding to launch the film on the festival circuit, as Nolan had done with *Following*, the producers secured a berth for *Memento* at the 2000 Venice Film Festival as part of the "Cinema del presente" sidebar, where it was shown on the festival's biggest screen on the Lido, in a venue that could seat fifteen hundred. It was the first time they had seen the film with an audience of more than twenty people. "It was fucking massive," recalls Nolan, who took his seat with Emma and, as he did so, remembered something that they had been told the day before about audiences in Venice booing or slow-clapping the films they didn't like. "As a filmmaker, you sit in the royal box—it is called a 'box,' but there's no railing; you're literally head-to-toe exposed, with the entire audience in front of you, so you can't sneak out for anything. You're just hung out there."

The movie started, Nolan listening to every rustle and cough as the audience strained to catch the subtitles. "None of the humor played whatsoever. It was a dead-silent audience. It was mostly Italians watching the subtitles, and a lot of the humor is about the language. The film finishes in a very abrupt manner, and there was this moment of shock. My films always end the same way, with some sort of sudden flourish—it's building to that moment, and then the film ends very abruptly. And for a few seconds, everyone was completely silent. Not a cough. I thought, *Oh no, they hate it.* There were a couple seconds where literally I had no idea what was about to happen. Like, *no* idea. I kind of liked that. I was very frightened, but I always remember feeling very, very proud of that. And then there was an enormous standing ovation and everything. It was extraordinary. It was the turning point of my life."

• • •

A very Nolanesque emphasis on a very Nolanesque moment—not the standing ovation itself, but the few ticking seconds of silence *before* the applause, when his fate still hung in the balance, like the bullets fired by a firing squad in Jorge Luis Borges's "The Secret Miracle," about a Czech playwright who in the moment of his execution is given a year to finish his last play. Arrested by the Gestapo on trumped-up charges, he is sentenced to death. At the appointed time, he is taken outside and the firing squad is lined up before him. The sergeant calls out the order to fire, and time stops. "The drop of water still clung to his cheek; the shadow of the bee still did not shift in the courtyard; the smoke from the cigarette he had thrown down did not blow away. Another 'day' passed before Hladík understood." God has heard and granted his request for enough time to finish his unfinished tragedy, *The Enemies*. Working entirely from memory, "he omitted, condensed, amplified, occasionally, he chose the original version. He grows to love the courtyard, the barracks; one of the faces endlessly confronting him made him modify his conception of Romer-Stadt's character." He brings his drama to a satisfying conclusion, lacking only in one detail, which he finds in the drop of water sliding down his cheek. "He began a wild cry, moved his face aside. A quadruple blast brought him down." Hladík is executed by firing squad on March 29, at 9:02 in the morning. The story would prove influential when Nolan came to make *Inception,* whose final act plays out in the time it takes a van, filmed in extreme slow motion, to fall from a bridge.

(Left to right): Emma Thomas, Christopher Nolan, Guy Pearce, and Pearce's wife, Kate Mestitz, attend the world premiere of *Memento* at the Venice Film Festival on September 5, 2000—the turning point in Nolan's life and career.

Many directors have played fast and loose with chronology in their films—Orson Welles, Alain Resnais, Nicolas Roeg, Andrei Tarkovsky, Steven Soderbergh, Quentin Tarantino, to name a few—but no director of the modern era has laid such systematic siege to what he calls "the tyranny of the projector" as Nolan. *Following* chops up three different time lines and cuts back and forth between them. *Memento* cuts back and forth between two time lines, one running forward, the other backward. *The Prestige* cuts between four time lines. *Inception* cuts between five, of varying speeds, where five minutes spent dreaming is equal to an hour in the real world. Whole lifetimes can play out—men and women can grow old together—in the time it takes a van to fall from a bridge. In *Interstellar,* a father is separated from his daughter by relativity's distorting effects on time and is forced to watch helplessly as her childhood slips away right in front of him. Representing more than just the tinkerings of a watchmaker, his films have an unerring grasp of the way time *feels*—its surges and slippages, constrictions and convergences. Time is Nolan's great antagonist, his lifelong nemesis. He seems almost to take it personally.

"I *do* take it personally," he says. "It's terrible to say so, but your relationship with time changes over time—I mean the flow of time. My view of it is very different now than it was when I started out. It's certainly more of an emotional issue now because time is accelerating for me. My kids are growing up and I'm getting older. It is extraordinary, the first time we met, neither of us had gray hair. Now I have gray hairs; it's hidden by my blond hair, mostly. We were different people. I'm fascinated by the notion that we all feel the passage of time to be unfair to us, and yet, we are all aging at exactly the same rate. This is the most level playing field there is. Every twenty-five-year-old you look at who looks slimmer than you will be aging at exactly the same rate. There is no favoritism here, but it feels intensely unfair to each of us. I think because nobody else can die for us. At the end of the day, nobody else is going to saddle that one up. That is coming down to us. It's the great leveler. When they talk about mortality rates, I always in my head go, Well it's 100 percent. You know what I mean?"

As he once wrote in an article for *Wired* magazine, "If you've ever been in the booth when the film spills off the reel and onto the floor while the movie is running, you have a very tactile idea of the relentless and frightening passage of time by which we all live." Losing three or four years to creative projects that disappear in a couple of hours, film directors experience the flow of time at a different rate from their audiences. "It's not an

equal match between a filmmaker and the audience. That is to say, I have years and years to plan, to figure out, what it is I'm going to put in front of them, and they have real time, two hours, two and a half hours, to catch it as it flows by. I do see it as my job to put all of the things in there that I can. To fine-tune it for that real-time experience. Every now and again you see a film where it fucks things around slightly. *The Naked Gun* has this wonderful bit where Leslie Nielsen gets together with Priscilla Presley and then they go into this very MTV montage where they're at the beach, they're riding horses, and at the end he goes up to the door and it's like, 'I had a wonderful day, Frank, I can't believe we just met yesterday. . . .' And you're like, Oh that was all in one day? It's very nicely done. An interesting experiment for you to try with people—think of a movie, some romantic comedy or something. Just some random film and after you have seen it, 'Okay, how much time passed?' And you'll never get a simple answer. People will go, 'Oh, I guess it was three days. Was it a week? Was it a month?' It's really tough to figure out time because time is so elastic. The way that time is dealt with in regular films is incredibly sophisticated. I take the mechanism and make it visible, like making the watch transparent in the back or something. So suddenly people are going, 'Oh, there's all this going on with time.' I actually make it simpler."

• • •

To test whether this is true, I organized a screening of Sydney Pollack's *Tootsie* in one of the classrooms at NYU's Tisch School of the Arts, inviting twelve guests, ranging in age from twenty to sixty-five, and in profession from acting to beauty PR. I told them nothing about what they were about to see, or what I was about to ask them. For those who need a reminder, *Tootsie* tells the story of Michael Dorsey (Dustin Hoffman), a respected but difficult actor who, after many months without a job, hears of an opening on a daytime soap from his on-again, off-again girlfriend, Sandy Lester (Teri Garr), playing the hospital administrator, Miss Kimberly. Impersonating a woman named "Dorothy Michaels," he lands the job but finds Kimberly's doormat status too much to take and starts playing her as a feisty feminist, turning the character into a national sensation. But the act proves hard to keep up, particularly after he falls in love with one of his costars, Julie Nichols (Jessica Lange), a single mother in a toxic relationship with the show's sexist director. Holidaying with her, Dorothy

attracts the amorous attention of her father, Les (Charles Durning), who proposes marriage. As the subplots converge, Michael finds a way to extricate himself: When the cast is forced by a technical problem to perform an episode live, he improvises a grand speech, which climaxes with him pulling off his wig, on-camera, and revealing that he is actually a man. Julie punches him. Sometime later, he gives Les back his ring. Later still, Michael waits for Julie outside the studio, she forgives him, and they walk down the street together.

Nat, who is an actor, pointed out there's a montage at the beginning, showing Michael's ups and downs over an unspecified period, then complaining to his agent, played by Sydney Pollack, who says "two years ago" he wouldn't cross the stage when dying in a play, playing a tomato. Which we've just seen. Then six months from audition to outing himself. "I actually think it's a little less than two and a half years."

Glenn's hand had gone up. "I processed the story as the story," he said. "Because to me the pith of the story was the time period from the time of his birthday party to the time of the final scene of him walking with Jessica Lange. The romance."

"And what did that feel like?" I asked.

"That felt like, you know, somewhere from six weeks to two months. It's explicitly referenced in the dialogue. Lange says to him, 'These weeks with you have been the best in my life,' although the story arc that hap-

How many days, weeks, months, and years does the action of *Tootsie* (1982) take? Accepting the *Tootsie* challenge are (clockwise from top left): Niki Mahmoodi, Glenn Kenny, Jessica Kepler, Tom Shone, and Roni Polsgrove.

pens is kind of improbable—to be on all those magazine covers after only a few weeks—but she still says, 'These weeks with you have been the best in my life.'"

"But that's exactly it: Can you get that famous in just a few weeks?" asked Kate. "The main thing we see happen to him in the course of the movie is he gets really famous as Dorothy. Superstar famous. He's on the cover of *New York* magazine and *TV Guide* and *Cosmo* and posing with Andy Warhol. . . . I thought it was about six months minimum. Six to nine months."

"You can, theoretically, become really famous and photographed for a magazine cover within a couple of weeks," said Janet, who worked in magazines, "and have that magazine come out, giving one- to two-month lead time, so it would come out in three months, four months."

"Is that why the reference to Warhol?" asked Niki. "He became so famous so fast, that, you know, it was an Andy Warhol kind of thing?"

"Warhol said you'd be famous for fifteen minutes. Not *in* fifteen minutes," said Kate. "And this was before the Internet, so the fan letters start to increase; we see the autograph hunters and so on. And then there's the scene with the agent where he says, 'They want to renew your contract for another year.' Another *year.*"

"That was the only time frame that I noticed, the year," said Emma. "It felt like everything had changed that fast for an actor in a year; it can go from a brief six-week run on the show and then issuing a year contract to renew . . . except we never saw it. Or coats. They made such a big thing about the birthday, too, I thought we'd have to see another birthday to mark that time. To actually get to a complete year. And the kid, she doesn't age."

"How old's the kid?" I asked.

"Fourteen months," she said.

"Babies grow fast," said Kate.

"You do wonder how long a person can maintain that kind of a lie before you become emotionally exhausted, as he did," said Janet. "I don't think you could do it for a year, actually; I think it has to be a matter of months. It can't be a matter of weeks. I think you'd probably enjoy it for those first two months, and then about three months in, things start to go."

"Yeah, could he really string Teri Garr along all that time?" said Lee. "He says he's slept with her once and he's keeping up this pretense that he's her boyfriend the whole film.

"... And what's his name—the guy who plays the doctor and squirts Listerine into his mouth and gets the hots for Dorothy all of a sudden," said Lee. "That felt like a few weeks' trajectory, not months."

"It's playing with time," concluded Glenn. "I mean, it's probably not consciously doing that; there was probably no mastermind saying, 'We're going to have different parallel times operating at once.' It's in the narrative's best interest for you not to think about the amount of time that's passed. Because in the meat of it, when you're negotiating with the two different narrative threads—the thread of Michael's own deception to all the people he knows, and the thread of his growing emotional attachment to Julie—it's best for the film to not make you think about the passage of time as you asked us to describe it, because the plausibility suffers the more you attach that to it."

In the end, we uncovered what seemed to be three separate and distinct time frames all running simultaneously, but at different rates: The Jessica Lange plot is on rom-com time (from three to four months); the Teri Garr subplot is playing at the speed of farce (from four to six weeks); while the "fame" story leapfrogs over both of them with two montages that could take anything from two to three years. Collectively, their answers ranged from one month to six years. By the time I put the results to Nolan, he has been to India for a three-day event in Mumbai called "Reframing the Future of Film," hosted by Indian filmmaker Shivendra Singh Dungarpur to support the preservation of film as a medium—all the while, I will subsequently learn, scouting for *Tenet* locations. He has grown a beard.

"This is great," he says, reading my results. "I mean, you chose a good film, because it's exactly right—it's a great movie, but also not one where time is a factor."

"Romantic comedies tend to be about three months. Because they have to allow the person to fall in love, break up, get back together. That takes about three months."

"Action movies can much more be the *Naked Gun* thing."

"I almost went with *The Empire Strikes Back*."

"That's an interesting one because that would be a difficult one to figure out."

"It seemed to be about a month."

"Where'd you get that from? I'm just curious; it's not one I've thought about."

"There is a fair amount of debate about it online. There is a lot of squished time in *Star Wars.* The *Millennium Falcon* spends a couple days dodging Imperial Cruisers, hiding in asteroids, then flies to Bespin without a hyperdrive. During which time, Luke is training to be a Jedi on Dagobah, which is where it gets tricky. Some people say weeks; some people say months, six months. We see distress on the garments, but it's not clear."

"Well, that, for me, is the point. That's the interesting thing. That's the fun thing about the way movies work. It's very indefinable. That's why *Tootsie* was such a good choice. It reminded me of the link that I took to dreams in *Inception,* and how I think that conventional films can tap into a dreamlike sense of time. The different elements of the narrative run at different rates, but you accept it completely. There's kind of a dream logic. In that sense, film can be very dreamlike. It has a relationship to our own dreams that is difficult to articulate, but you're hoping to make connections and find things that are hidden from you all the while you are living your life or being in the world. I think dreams do that for us, and I think films do that for us. The flip side of that is that speech of Hugh Jackman's at the end of *The Prestige,* essentially saying we create a more complicated, mysterious idea of the world because we're disappointed by our reality. I think that is also a very valid idea, but it's a very bleak idea of what fiction is—a series of complications designed to obscure the mundanity of our reality. I prefer the other version, especially when I'm writing. I prefer Werner Herzog's idea of ecstatic truth."

"I'm pleased that we've made the case for *Inception* using *Tootsie.*"

"Basically, any film that I say I'm a fan of that isn't a dead-straight thriller, or action movie, whatever, people are surprised by. Like, *La La Land,* to me, is an extraordinary film. I saw it three or four times; it's just an amazing piece of directing, and I don't usually like musicals. What you like as a filmmaker, or as a consumer—they're not going to be the same thing. I've got a soft spot for the *Fast & Furious* movies. I work in action movies, and so I love seeing when the action's done well, and there's a charm to some of the stories, particularly when it comes to the first one, from the first one onward, there's a charm to the relationship between all the characters. And the way that franchise has developed is fascinating, almost like a season of a TV show; it becomes a sort of ensemble family. But yeah, people, for whatever reason, whatever it says about me, but they're all surprised when I talk about comedies that I like. Can you believe

that? Like, 'Oh, you like comedies?' Everybody likes comedies. If you look at Woody Harrelson's performance in *Kingpin,* it's one of the great performances. I went back to see it two or three times in the cinema. I was so struck by his performance. Other than the fact that I found it funny and it was silly. The bit where he's like, 'I haven't been back to my hometown, gosh, since . . ." and then he turns to her, and his hair is all over, and he's like, 'How do I look?' It really is a remarkable performance. It's about that commitment and that sincerity."

· · ·

Looked at this way, *Memento* is the ultimate glass watch, driven less by an urge to subvert or deconstruct than by an urge toward radical transparency: a film noir as written by Luigi Pirandello, its hero a script-brainstorming session made quite literal flesh, his backstory and motivation written on his body, the ten-minute wipes that expunge Leonard's memory identical to the ten-minute action beats demanded of American action cinema, his amnesia our amnesia as we scramble to make sense of whatever movie we've wandered into this week. Much of the audience's work in *Memento* consists of exactly the kind of semiconscious puzzle solving we do with any movie, only this time we've got company. Sardonic, sly, frantic, quick-witted, disheveled, melancholy, vulnerable, Leonard Shelby is more than just our hero and narrator. He is our constant companion, the camera always a little closer to him than it is to other people, so that he almost seems to be sitting next to us in the movie theater, keeping up a chatterbox commentary on the events as they unfold on-screen. "I've told you about my condition," he will say upon meeting someone new, with a slight question in his tone, anxious not to repeat himself or bore them, and when he fails to recognize someone, he reassures them not to "take it personally." That's the first thing we notice about him: his politeness. Alienation was never so courteous. Jackknifed with grief, he is denied the luxury of self-pity by the speed with which the world comes at him.

Memento sets an infernal trap for its protagonist and audience, bringing into conflict two opposing fears, the solution to one of which only aggravates the symptoms of the other. The first is the fear of the solipsist, reliant on his own leaky head for information. "I have to believe in a world outside my mind," he tells Natalie. "I have to believe that my actions still have meaning, even if I can't remember them. I have to believe that when

my eyes are closed, the world's still there." Fearing above all that he is alone in the universe, and craving certainty, he throws open his door to let others in, but in so doing lays himself wide open to the opposing fear, that of the paranoiac. The paranoiac, fearing above all of being exploited and manipulated by others, wishes the opposite of the solipsist, wishing to shut himself away so that he can be safe. Leonard is both. He can have safety or he can have certainty, but he cannot have both. Which is it to be? Who is to have the upper hand, the paranoiac or the solipsist? Whose problems do we address first? Hopelessly riven, Leonard shuttles endlessly from one front of his two-front war to the other, desperate to unravel the misinformation being fed him by others, but unable to rely on his own leaky head to do so. He cannot trust people and he must. Or, as he puts it, "I was the one who disagreed with the cops. And *I* had brain damage."

It *seems* like an exotic condition—something out of a book by Oliver Sacks—but it has surprising resonance. Leonard's two-front war is instantly recognizable to anyone who as a child was ever lied to by an adult—that is to say, someone who is certain he is being lied to but lacks the internal resources and confidence to be certain or challenge the person

Guy Pearce during a break in filming in 1999. Nolan's keenest insight was into the vulnerability of Leonard's condition.

on it. What Leonard most forcefully resembles, in fact, is a brave, resourceful child who has been thrown to the wolves. One wonders how much of a clue to the emotions churning away beneath the film's sunlit surfaces is provided by the license plate that Natalie gives Leonard, which she claims is that of his wife's killer—SG13 7IU. The MacGuffin of the film, the piece of information that leads Leonard to his single act of revenge, driving the whole plot, is the zip code of Nolan's old school, Haileybury, slightly misremembered (the U should be an N). Time is an emotive issue for boarders because it is not really about time: It is about distance. "A child depends on the memories carried by, and shared with, attachment figures to reflect a sense of continuity of being and of belonging to a community," writes Joy Schaverien in *Boarding School Syndrome*, a book whose themes—"Time," "Repetition," "Amnesia," "The Body Remembers"—read like a checklist of the themes of *Memento*. "Shared memories and the stories attached to them are indicators of intimate family connection. Without these shared memories the child is separated from the continuity of his or her young existence. It is therefore hardly surprising that when as an adult he or she comes to tell the tale, it may lack a narrative flow. This may be why it is sometimes difficult for the ex-boarder to remember the sequence of events." Isn't this exactly what *Memento* dramatizes? Exiled from the family "photo album," trapped in his own subjective bubble of memories, unable to narrate his own experience, Leonard is forced to fend for himself in the piranha pool, not knowing whom he can trust.

"I actually think that's a bit of a stretch, if I'm honest," says Nolan a little uneasily when I put this interpretation to him. "But I don't know. It's not for me to say, ultimately, but I'm pretty resistant to the biographical interpretations because I find them a bit easy, honestly. By the way, I think I'm being totally straight with my answer. It's not an attempt to be evasive; I really do feel it's a part of myself that I haven't actually allowed myself to address in my films. I mean, *Dunkirk,* interestingly, was probably the first film that I made where that was on the table, if you like, because it's very much about establishment ideas of history. And in the end I think I just sidestepped it, not for any reason other than I thought it was more interesting to tell a story in a much more experiential, boots-on-the-ground kind of way, so I don't really get into the relationship between Kenneth Branagh's rank and the guys'. I mean, it's there loosely and everything, but I think I managed to sort of avoid that."

"It's not about class so much as psychology," I said. "Leonard is like a

child who's been forced into this hostile environment where he can't trust anyone. Suspended in limbo. You come back to that state again and again."

He pauses. "I think you're barking up the wrong tree. I think it's based too much on semantics. Semantic relationships between concepts, rather than the feeling—"

"That's what I'm talking about. The emotions of the film—"

"I always credited Guy Pearce with that. He draws people into the dilemma. The dilemma is massively emotional. The character has massive pathos, but as when I made *Dunkirk*, which has a massively emotional situation, I feel in both cases I wanted the filmmaking to be deliberately unsentimental. I heard this thing from Hans Zimmer, who attributed it to Ridley Scott, although I think James Joyce said it originally, which is 'Sentimentality is unearned emotion.' That seems to me a very precise and accurate comment. A lot of movies use sentimentality to keep the audience engaged. I've never really liked that. It's not a useful tool for me, so when some people come to the films, it defies their expectations a little bit in terms of where a mainstream film sits with sentimentality. I think in terms of earned emotion, genuine emotion. The situation is so freighted in *Memento* that it doesn't need much. Guy makes that real; he opens up the film to you, and that does the work that music or dialogue can sometimes do in terms of pathos. He's a brilliant actor."

It's my first lesson: Happy to admit elements of his biography at the level of theme, Nolan is loath to allow any links between himself and his characters of a psychological nature. We chase the subject around the table a couple more times before I let it drop. We have gone from talking about *Memento* to enacting it, I realize, with me in the role of Teddy, trying unsuccessfully to convince Nolan of my version of events, and him in the role of Leonard, holding fast to his, both as convinced of the other's sincerity as we are that the other is also quite mad.

• • •

Determined to set down all his recollections in writing, Borges's Funes manages to reconstruct the contents of an entire day before he realizes that his memory is recursive—consulting a memory turns it into a memory of a memory—and that he will likely die before even classifying all the memories of his childhood. He is eventually driven mad and he dies of pulmonary congestion in 1889. "Funes goes mad because his memory is

endless," Borges told one interviewer. Cursed with perfect recall, Funes suffers from the opposite problem to Leonard's, but even Borges saw the potential for the story to be flipped. "Of course, if you forgot everything, you would no longer exist," he said.

Memento takes only a sip from this madness, but it is enough. We've known from the very first frame how this story ends: with Leonard's revenge killing of Teddy. We know the place he is going to do it: the abandoned warehouse. And we know how: with a bullet to the back of his head. By the time we actually get there, the black-and-white footage bleeding into color as the film's two time lines finally sync, Nolan has invested all of these elements with the dreadful familiarity of traumatic memory, endlessly relived, the ever more urgent synthesized pulses from David Julyan's score sounding like a computer having bad dreams. *"You don't even want the truth,"* claims Teddy. *"You're living a dream, kid. A dead wife to pine for, a sense of purpose to your life, a romantic quest that you wouldn't end even if I wasn't in the picture."* The intruders didn't kill Leonard's wife, he says. *Leonard* did, accidentally administering a lethal injection of insulin, a story he has been misattributing to Sammy Jankis ever since. If you accept Teddy's version of events, the film is a whodunit about guilt and denial, about a man stumbling toward his own long-suppressed complicity. But Leonard cannot accept this version of events. Reeling, he exits the building, protesting his innocence to Teddy in voice-over: *"Can I just let myself forget what you've told me? Can I just let myself forget what you made me do? You think I just want another puzzle to solve? Do I lie to myself to be happy? In your case, Teddy, yes, I will."* At which point, he

Leonard (Guy Pearce) has his revenge on Teddy (Joe Pantoliano)—or does he? Even after the film was released, the filmmakers didn't agree.

writes himself a note identifying Teddy's license-plate number—SG13 7IU—as the killer's, and drives to the nearest tattoo parlor to get it tattooed on his thigh, thus setting in motion the very first scene of the film: *Now where was I?* Structurally, the film outlines a hairpin or Möbius strip. Teddy and Leonard are doomed to tangle, over and over again, tumbling in an hourglass, every time the film is watched, until time immemorial.

"I find the idea of not being able to trust your own mind very creepy," says Nolan. "*The Shining*'s very much about that. I think *Memento* speaks to the moral relativism of film, which is very good at getting an audience to accept different moral codes than they would in everyday life—so, in the Western, for example, we're very happy when the hero guns down the bad guy in whatever way he needs to. As long as it's according to the rules that film sets out. I enjoy playing with them. In *Memento,* you have a revenge fantasy in which the character cannot remember his own revenge. You have the internal set of ethics that are largely, in cinema, defined by the point of view. Then you have the experience—usually after you've seen the film—of reassembling your mind and going, Hang on, what are the

Joe Pantoliano and Guy Pearce consult over the script.

ethics of that if you step outside of this guy's point of view? *Memento* is a film that tries to do that at various times *within* the film, tries to make that tension part of the text."

Another way of putting that is that the film was born to be argued over. After their triumphant screening at the Venice Film Festival in the spring of 2000, the *Memento* posse, including Nolan and Pearce, went to dinner and proceeded to have a two-hour argument about who should be believed at the end of the film. It amazed Nolan that two years after they finished making it, they were still debating this. At a press conference the next day, he made the mistake of spelling out who *he* thought the audience should believe. "Somebody asked about the ending and I said, 'Well, ultimately the point of the film is that it is up to the audience, but I needed to have an underlying truth and this is what it was . . . ' " he recalls. "And I told them. Jonah took me aside after that press conference and said, 'Nobody listened to the first part of your answer about it's being up to the audience. They just zeroed in on what you thought. You can never tell people your actual interpretation, because then it'll drown out the ambiguity.' And he was right. They're always going to value my answer over their own or the ambiguity of the film. Fortunately, this was in the—I wouldn't say pre-Internet days, but it wasn't so ubiquitous, so I don't believe that answer actually exists anywhere. I think you can find it in an Italian newspaper archive somewhere. You have to have a version of events, it just doesn't need to be public. I don't believe you can create an effective, productive ambiguity without knowing what you think yourself, what your own belief is. Otherwise, I think it's a contrivance. People feel the difference."

As William Empson wrote in *Seven Types of Ambiguity* (1930), "An ambiguity . . . is not satisfying in itself, nor is it, considered as a device on its own, a thing to be attempted; it must in each case arise from, and be justified by, the peculiar requirements of the situation." Empson was writing before the Internet, of course. The late 1990s and early 2000s saw a wave of films like *Pulp Fiction* (1994), *Twelve Monkeys* (1995), *The Usual Suspects* (1995), *L.A. Confidential* (1997), *The Truman Show* (1998), *The Matrix* (1999), *Being John Malkovich* (1999), *eXistenZ* (1999), Nolan's own *Memento* (2000), *Waking Life* (2001), *Vanilla Sky* (2001), *Donnie Darko* (2001), *Minority Report* (2002), and *Eternal Sunshine of the Spotless Mind* (2004), all featuring multiple plot lines, mind-bending twists, temporal schemes inverting cause and effect, deliberately blurred lines of fact and fiction, and the exploration of the idea of life as a kind of waking

dream—a "new microgenre," in the words of Steven Johnson: the *mind-bender*. Whether knowingly or not, the Nolans had hit upon one of the key elements of success in the information age: that in the age of spam and bot farms and self-validating falsehoods, more occult power will accrue not to things you do know but to things you do not. And the only thing more valuable than both? Something you cannot know. In some ways *Memento* was the world's first spoiler-proof movie: Nobody could understand it well enough to spoil it.

"There were a lot of films right around when I was making *Following* and *Memento* which were fundamentally based on pulling the rug under your sense of reality. *The Matrix, Fight Club, The Sixth Sense.* There's a cluster of these movies. Everything at the time was, 'Your reality is completely upside down. You don't know what it is you're seeing.' There is a strong sense in which we're all making the same film in a way. . . . I find ambiguity tough to deal with, in films or in life. I can honestly say that I've never put anything in my films that was intentionally ambiguous. You have to have an answer. That was Jonah's point about *Memento*. 'Yeah, of course, I have an answer, but that's because it was sincere ambiguity.' One of the first people I ever spoke to once it was finished, the first journalist, read the film basically the way I had intended or the way I interpreted it myself. They saw it exactly the way I saw it. Okay, so they were probably about the last person who did, but it made me feel like, Yes, okay, I'm not crazy. I did put it in there."

Over the years, he has found something interesting in the way the debate breaks down. Those who believed their visual memory tended to believe Leonard, because of his Polaroid inscribed with the words "Don't believe his lies," which they had seen flashed up several times in the course of the film. Those who believed their verbal memory believed Teddy, because his version of events is delivered in the form of straight exposition. There's another way to settle it, though: Which is the better twist? If Teddy is telling the truth, and Leonard killed his wife, then the character flagged as the biggest liar ("Don't believe his lies") has, in a satisfying irony, turned out to be the biggest truth teller, while the one character we least suspect (Leonard) has, by a similarly pleasing circumvention of the Last of the Least Likely Suspects, turned out to be guilty as sin. The whole film, like many of Nolan's, is a study in atrocious guilt, false consciousness, denial. Even the way Leonard frames this to himself ("*Can I just let myself forget what you've told me? Can I just let myself forget what you made me do?*") supports this

reading. If, on the other hand, we refuse to accept Leonard's guilt, then all of this is undone: The character flagged as the liar is indeed a liar, and the one character we believe to be innocent is indeed so. Surely it's no contest. The film with all the irony and guilt and layered characterization pleases.

Nolan listens as I tell him this, nodding.

"It makes sense, but I'm not sure that I would go along with your idea of Leonard having been billed as truthful. The reason is . . ."

"No, innocent."

"Or indeed innocent, because there were very explicit references throughout the film to him being an unreliable narrator. The idea that he lies to himself to be happy. We all do."

"Right! That's exactly my point. 'Do I lie to myself to be happy? In your case, Teddy, yes, I will.' The alternative—that he's as innocent as he says he is, and that Teddy is just as much of a liar as we're told he is—is far too on the nose. There's no twist."

Nolan refuses to say anything, just smiles like the Cheshire cat.

"And now you're not going to say anything because you know I'm right and you don't want to ruin it for everybody else," I say.

"I am just going to say that you sound a lot like Hugh Jackman's character at the end of *The Prestige*," he says.

"How come?"

"I mean, if you watch toward the end, it's what Michael Caine says to that. It's very apt."

"What is it?"

"Watch the film again."

That evening, I return to the apartment I have rented through Airbnb for the duration of our interviews, and I rewatch *The Prestige* for the umpteenth time. The movie concerns two magicians locked in a fatal rivalry, ostensibly over a trick called "the Transported Man," in which the magician walks behind a door on one side of the stage and reappears magically from a door on the other side. Determined to prize the secret of the trick loose from his rival, Hugh Jackman resorts to theft, even murder, and when he finally learns the secret, he can barely believe his ears. "It's too simple," he cries, which leads to this piece of voice-over narration from Michael Caine's Cutter, a recapitulation of a similar speech at the very beginning of the film.

Now you're looking for the secret. But you won't find it. Because you don't really want to know. You *want* to be fooled.

In other words, as much as I want Nolan to confirm whether I have "solved" the puzzle of *Memento,* I don't want him to tell me, because then the fun would go out of it. On some level, I *want* to be fooled. From which we can infer the slightly cruel dynamic that informs Nolan's films. Call it William Empson's "eighth type of ambiguity," Nolan's favorite: when it's the other guy's problem.

PERCEPTION

STEVEN SODERBERGH basically got *Insomnia* made," says Nolan of his third film, a remake of Erik Skjoldbjærg's 1997 icy Norwegian thriller about a cop who feels guiltier than the killer he is chasing. Set in a remote Norwegian town where the sun never sets, the film follows a disgraced forensics expert (Stellan Skarsgård), on the trail of a killer of a young teenage girl, while his deductive processes are befuddled by sleeplessness, splintered editing, sudden whiteouts. Nolan was deep into his redrafts of *Memento* when he saw the film, and what he saw up on the screen—"a reversed film noir with light, not darkness, as its dramatic force," in Skjoldbjærg's words—seemed very similar to what he was trying to do. "I watched it twice in one sitting, because I really loved the texture of it," he says. "It's about sleeplessness; it's about the distortion of thought processes, like *Memento,* with this unreliable narrator and this very subjective experience. I really wanted to try and get into people's heads the way I had in *Memento,* so it was quite a specific relationship, like, 'I'd love to do this in a slightly different way. If you take that situation, you can make it into a Hollywood movie with big movie stars. You could make it like *Heat.*'"

Hearing that Warner Bros. was planning a remake, he attempted to land the job of directing it, but his agent, Dan Aloni, couldn't even get him a meeting with the executives at the studio, and he had to watch as they gave

the screenwriting assignment to another newcomer, Hillary Seitz. Once Nolan had finished *Memento,* things changed. Aloni got a copy of *Memento* to Steven Soderbergh, then coming off the career resurgence sparked by *Out of Sight* in 1998. Soderbergh, upon hearing of Nolan's difficulties getting a meeting with the executives at Warner Bros., marched across the lot to the head of production and told him, "You're insane if you don't meet with this guy," offering to executive-produce *Insomnia* himself, with George Clooney by way of a guarantor on the then thirty-one-year-old director.

"Everybody needs that somebody who just takes a risk," says Nolan. "Steven didn't have to do that but he did. He and George became the executive producers of *Insomnia.* So I managed to get my foot in the door that way. I'm very proud of the film. I think, of all my films, it's probably the most underrated. People will say stuff like, 'Oh, this isn't as interesting, or personalized, as *Memento,*' but there's a reason for that. It's from a script somebody else wrote. It's a remake of another film. The reality is it's one of my most personal films in terms of what it was to make

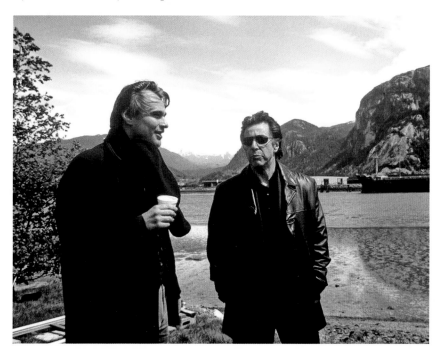

Hilary Swank reads her script for *Insomnia* (2002), Nolan's first studio film; Nolan and Al Pacino on location in British Columbia.

it. It was a very vivid time in my life. It was my first studio film; I was on location; it was the first time I'd worked with huge movie stars. So it was a very powerful experience to be making it, and that all comes back whenever I watch it. Of all the films I've made, it sits the most squarely or comfortably within the genre that I was trying to make it in. It doesn't really challenge the genre, and that's what people have come to expect from the other films I've made. But I think the film holds up very well. That's not really for me to say, but every now and again I meet a filmmaker and *that's* actually the film that they're interested in or want to talk about. Yeah, very proud of the film."

Insomnia marked Nolan's first collaboration with big movie stars, three Oscar winners, no less—Al Pacino, Robin Williams, and Hilary Swank. Dark circles under his eyes, his jaw slack with fatigue, his beat-up leather coat like a sagging second skin, Al Pacino plays detective Will Dormer as if he is not just a cop but *the* cop—Frank Serpico or *Heat's* Lieutenant Hanna gone to seed. Arriving in a remote Alaskan town with his partner, Hap Eckhart (Martin Donovan), to solve the murder of a local girl, they are greeted by local cop Ellie Burr (Hilary Swank), who gushingly reveals that Dormer's brilliant work on one of his cases in L.A. formed the subject of her college thesis. Eagerly tagging around town with him, she takes notes from the great detective as he sets about solving the case. Dormer quickly finds his suspect, a mild-mannered mystery writer named Walter Finch (Robin Williams), but insomnia together with the relentless midnight sun of the region have taken their toll. Chasing his subject across a foggy, rock-strewn beach, Dormer shoots and kills his partner by mistake. The tables have been turned. Now it's *his* turn to feel the noose of a tightening investigation, as his dogged Watson, Swank, edges ever closer to unmasking her idol. The biggest change from the original film was the introduction of a backstory for Pacino's character involving an internal affairs investigation, a case in which Hap is due to testify against him. Dormer thus has a reason for killing his partner, even if it is an accident.

"I was very keen the guy have this mass of guilt before you even get to Alaska," says Nolan, who rewrote the script extensively through 2000, as negotiations to land the sixty-year-old Pacino dragged on. He and Seitz met at the Hamburger Hamlet in Hollywood to give and take notes. "I don't have a writing credit on the film and I didn't ask for one, because when I came on as director, Hillary Seitz really rewrote the script in the ways that I wanted her to, but I did do a set of rewrites for Pacino that

were reasonably substantial. We were on a very hard deadline because of the strikes. What he really liked and encouraged in me was the messiness of things, the sort of awkward in-between of a few things—when we were rewriting the scene where he calls the wife of his partner, he wanted her to be awkward. It's the sort of in-between bits that you don't usually see in these films, and he liked that a lot."

On both *Following* and *Memento,* he'd had the luxury of lots of rehearsal time, but on *Insomnia,* they had virtually none. Shooting on location in Alaska and British Columbia, Nolan would run through a scene the night before with his actors, then shoot it the next day, sometimes surprising Pacino with how close he wanted his camera, at other times amazed by the actor's intuitive knowledge of where the camera was, what the angle would be, and how little he needed to do to communicate what he was thinking. "I learned a lot about acting from Pacino, and also about the value and purpose of stardom from him—what that charisma buys you," he says. "The original film is very brilliant in its process of slow alienation from the protagonist. My film's the opposite: You go with him on the journey and, in a way, you get closer to him at the end than you are at the beginning. I love the idea of going, 'Okay, take this exact plot, but you just change a few things; you change your relationship with them.' That's the point of stars. They have a relationship with the audience. You tend to trust them. You trust their competence; you trust they know what they're doing. They can make something acceptable; they can make something comfortable that's very uncomfortable. They can guide you through it. You only get through *Serpico* because there's a charismatic presence at the heart of it that you'll go down the road with, you know? So playing with that, and having them fuck up, is very interesting and puts the audience on the back foot, just turning everything on its head. The idea of getting two really recognizable actors and putting them together in this crazy situation, I loved that."

. . .

With its themes of guilt, doubles, and perception, *Insomnia* is the most clearly Hitchcockian of Nolan's films. (There was even an episode of *Alfred Hitchcock Presents* entitled "Insomnia," about a man whose insomnia turns out to be symptomatic of his guilt about his wife's death in a fire.) "Can't sleep, Will?" asks Robin Williams's preternaturally calm killer Walter Finch, who takes to calling the detective late at night, always just as

he is on the verge of sleep, like Poe's raven, or Bruno Anthony (Robert Walker) in Hitchcock's *Strangers on a Train,* who dogs Farley Granger's tennis pro like a guilty thought. "A wonderful idea I had once," he says before first proposing a trade of murders. "I used to put myself to sleep at night figuring it out." It is the awful fascination of an *idea,* the prospect of being corrupted by your own thoughts, that similarly obsesses Nolan. Like many Nolan heroes, Dormer is guilty not so much of an action as a thought. He *wanted* his partner dead. And that is almost as bad as killing him. Certainly, it is enough for Finch to blackmail him. Finch has a disturbing will-o'-the-wisp quality, kept forever on the periphery of our vision during the chase scenes, always disappearing out of frame. After the final shoot-out, he slips through another trapdoor and slowly disappears into the watery depths below—*the* Nolan exit move, like Cobb slipping into the crowd at the end of *Following.* It is as if he never existed. He could almost be a creature of Dormer's dreams, his guilty conscience come to life.

"*Strangers on a Train* is a great favorite of mine," says Nolan. "In my conversations with Robin, I did actually say to him, 'This is something we'll only talk about, but the guy could be unreal,' as in, he might not exist. He's very much Dormer's conscience, like a Jiminy Cricket—that was Robin's take on it. I always relate it to *Macbeth,* where it's all about the central character's guilt and his self-destructiveness, essentially. Finch just whispers in his ear to point out things he already knows, or should already know." Perhaps Nolan's biggest debt to Hitchcock lies in the expressionist use of landscape. Working for the first time with British production designer Nathan Crowley, Nolan wrings as many possibilities from the craggy, inhospitable landscape of British Columbia and northern Alaska as he can, deconstructing the layout of the building where Dormer first encounters Finch: a single-story wood cabin held on pilotis aloft treach-

Bruno (Robert Walker) strangles Miriam (Kasey Rogers) in Hitchcock's *Strangers on a Train* (1951), a favorite of Nolan's and his introduction to the work of Raymond Chandler.

erous rocks, with a trapdoor through which Finch drops at a key point, forcing Dormer to give chase through a mazy set of underground tunnels before emerging into thick fog, clambering over slippery rocks toward the figure of the escaping Finch. He keeps our attention on Dormer's feet as they scramble for purchase on the rocks, and again during a later chase across a waterborne jam of logs—half bridge, half rolling road—through which Dormer falls into icy water, fighting for air as he attempts to thread his fingers through the clashing logs above. The setup is pure Nolan, playing to a phobia of both enclosure *and* exposure at one and the same time.

"I've always been a little bit allergic to wilderness stories," he says. "There's something very 'TV' about the concept of the Alaskan town with a lot of fir trees, whether it's because I'm thinking about *Twin Peaks*, or whatever—and so with my production designer Nathan Crowley—it was the first time I worked with him—we spent a lot of time trying to figure out 'How do we create a geography to the story that feels more expressive or expressionistic?' The fogbound beach being the key. *Insomnia* is about the unfamiliarity of the place and the journey through it, the fogbound beach, going through the cabin and then down to the tunnel. The tunnel becomes this sort of gateway, and I didn't approach it in a thematic way that way; these things are instinctive. It's like, 'We've got to get from less fog to more fog to this tunnel, run in the tunnel, and then he can be completely blinded by the fog.' In *Insomnia,* we got the ever-present daylight from the original film, and it was just like, 'Okay, that's definitely the thing to do.' When people say, 'Oh, let's do a film noir,' what they basically mean is shadow and lighting. You know? They really don't embrace the essence of it. When I went to the San Francisco Film Festival with *Following,* one of

Dormer (Al Pacino) searches the fogbound beach for the killer. Nolan planned the scene as a descent into an underworld.

Robin Williams as the homicidal Walter Finch, as we first see him in the pivotal ferry scene. "You and I share a secret," he tells Dormer. "We know how easy it is to kill someone."

the programmers talking to me afterward said that one of the things that was so exciting about *Following* is it's a film noir, but it takes place in daylight. Everyone forgets *Double Indemnity* has a scene in a supermarket, and another in a bowling alley."

The unforgiving glare of the midnight sun provides Nolan with a metaphor for Dormer's plight—he cannot escape his own guilty thought processes—while the blue glacial ice evokes his cool, creeping quarry, Walter Finch. "You know this glacier moves a quarter of an inch every day?" says Finch, as if spotting a soul mate. After eluding Dormer twice, he invites the exhausted detective to meet on a ferry at just past the film's halfway mark. It is a pivotal scene, one of the fulcrum points Nolan is so keen on in his films, in which the entire weight of the drama abruptly shifts beneath the audience's feet. We see Williams first from the side, staring out the ferry's aft window. "What a view," says Pacino, joining him, as Nolan cuts to a side view of Williams's profile, as still and cryptic as a Sphinx. The water behind him is eerily becalmed. "I'm not who you think I am," he tells Dormer. "When I heard they had brought someone in from L.A., I panicked." Cool and logical and preternaturally calm, all his empathy and intelligence doing their usual soft dance with his features, Williams could as easily be playing one of his therapists or doctors. "Killing changes you, you know that," he says. "How did you feel when you found out it was Hap? Guilt? Relief? Did you ever think about it before that moment? Didn't you ever think, What would it be like if he wasn't there anymore? Doesn't mean you did it on purpose, you know." His intimacy is obscene, bizarre. After eluding Dormer twice, here he is, confessing to the crime. Why?

Pacino, his arm around the back of Williams, as if on a date, leans in. Nolan frames them together in the same shot for the first time. "You don't get it, Finch; you're my job," he growls. "You're about as mysterious to me as a blocked toilet is to a fucking plumber." Seitz's original script is both

less vivid ("I get up every morning just to bring someone like you down") and hotter-tempered, both men having disembarked by this point so that Dormer can rise to Finch's provocation and assault him ("SUDDENLY Will lunges at him . . . Walter flounders"). By keeping them in public all this time and having them observe the demands of propriety, Nolan forces Dormer onto the back foot, and strengthens Finch's hand. At one point, they are joined by another couple and have to move away for some privacy, like two lovebirds looking for privacy. When next we see the two men, they are again framed in the same shot, their heads just inches apart, separated by a green metal pole. "Think of all the other Kay Connells," says Finch, springing the final elements of his trap. "Do the math." Pacino leans his head against the pole, as if pinioned by a dilemma: If he arrests Finch, he brings to light his cover-up of Hap's death and potentially frees all the murderers his testimony has put away over the years. Finch has him in checkmate.

• • •

"I really was just sort of swimming against cliché," recalls Nolan. "I remember the words really clearly because I'd written it and then my brother helpfully figured out the best bit, which I hated him for, but when Dormer says, 'You're as interesting to me as a blocked U-bend is to a plumber,' Jonah was like, 'It's got to be a toilet.' I interviewed a homicide detective for that film when I was starting to rewrite it, and I was describing the

Brian Cox as Hannibal Lecter in Michael Mann's *Manhunter* (1986). "Do you know how you caught me? The reason you caught me, Will, is we're just alike."

situation the film presents, trying to get him to talk about the complexity of evil—all those sort of things that are in all these movies about your shadow, your Jungian reflection or whatever, and the detective was like, 'Well, no, if he killed her, then he's a murderer.' Very absolute. Simplistic. Like throwing a bucket of cold water on one of those literary ideas. And I thought, Well, all right, I came here for research; this is what he told me. And it made it very hard for me after that to buy into any kind of villain-speak. That's why we did the opposite when it came to the Joker. And, of course, people doing the job that Pacino's character does, they can't think like that. That *Manhunter* thing had taken over the culture."

A fan of Thomas Harris's novels in his youth, Nolan remembers seeing the trailers for Michael Mann's *Red Dragon* adaptation, *Manhunter,* in his second year at Haileybury. "I remember the trailer for that film long before I saw the film—the clip of Brian Cox in that cell, saying, 'You know how you're going to catch him, Will?' That idea of a mind that can't be contained by the bars of a jail cell, it's very powerful. I remember very clearly seeing that white cell when I was a kid." Hillary Seitz's script for *Insomnia* featured many of Harris's tropes. There is an autopsy scene, a tour of the victim's humdrum bedroom, the discovery of a dress revealing a secret admirer, and a series of late-night telephone calls in which the killer asserts intimacy with his cop. Arguably, Nolan never did get enough of Dormer's sleeplessness into the film. Did he really want to? Unlike amnesia, which is not an unpleasant sensation—arguably, it's what most people go to the movies *for*—the effects of exhaustion are reproduced in an audience at a filmmaker's peril, which may be why, for all its virtuosity, Dody Dorn's editing skitters along the surface of the film, conveying a more generalized sense of disorientation—percussive rhythms, blurred frames, sudden whiteouts—that could as easily have been used to illustrate the fact that the hero had swallowed a bottle of Dexedrine. There is not that solid linkup of idea, conceit, and technique that allowed *Memento* to land such a punch. The audience's investment in Dormer's dilemma is instead very dependent on viewers following every link in the logic of Finch's speech on the ferry: *If* Dormer brings him in, and *if* someone can prove to a jury his shooting of Hap was not accidental, and *if* a guilty verdict is enough to overturn the verdicts in his previous cases, then, yes, he is caught tight in a trap. But everyone knows how difficult it is to convict cops of anything, and if the audience does not buy the logic, then Dormer's paralysis becomes the film's, and his torpor infectious.

The advances marked by *Insomnia* in terms of Nolan's filmmaking were largely logistical: his first medium-size budget, huge to him, his first big location shoot, his first time working with such big stars, his first film for a Hollywood studio. *Insomnia* finds the director scaling up, martialing larger elements of landscape, production design, and setting, while negotiating new pressures from above and below. "Probably the trickiest thing with *Insomnia* was we had to shoot two endings," he says. "I changed the ending actually at Steven's suggestion. He said to me, 'He should die at the end and then it is like a John Ford film.' And I thought, Yeah, that makes a lot of sense. The whole thing becomes much more about the man's interior and ethical journey. The studio was not happy about this. And so they made me promise to shoot it both ways. And I did shoot it both ways. Pacino was not happy about it. But basically I said to him, 'Look, I gave them my word I would do it.' And he respected that. So we did it and what I realized in retrospect is the fact that we had that in the can meant that they never asked to see it. Because the ending you haven't shot is always the one that everybody thinks, Oh, we should go back and do that. If you've shot it and it's sitting there, they're not as concerned to see it. I never cut the other ending. Whatever arguments we had about the cut of the film, that was never one of them. They felt the logic of it. That was my first experience of the ending of the film being the tail that wagged the dog. It's going to color the whole experience of the film, the choice you make at the end. And so, what's the conclusion? I think in *Insomnia,* we dodged that bullet because we were so committed to him dying in the end."

By the end of production, he had learned an important lesson about working for the studios. "The efficiency of filmmaking is for me a way of keeping control. The pressure of time, the pressure of money. Even though they feel like restrictions at the time, and you chafe against them, they're helping you make decisions. They really are. Can I close off? When am I finished? If I know that deadline is there, then my creative process ramps up exponentially. Okay, live by the decisions you make. Creative power in filmmaking is very important to me. I'm very protective of it, but I get my power from spending less and moving faster. Not giving anybody a reason to come and visit me and interfere or complain. I made that decision very early in my career: If I can work a little bit faster than people expect, if I can work a little bit cheaper than people expect—they'll have other problems to deal with—they'll let me do my thing."

Growing up in the city of Potsdam, to the southwest of Berlin, in the 1820s, German physician and physicist Hermann von Helmholtz had plenty of occasion to look up. A garrison city housing Prussia's military headquarters, Potsdam had been extensively rebuilt by Frederick William III after Napoléon's forces ravaged the city—the Nikolaikirche rebuilt, an optical telegraph installed on the top of a hill as part of the Prussian semaphore system between Berlin and Koblenz. Looking up at one of Potsdam's many new towers one day, Helmholtz noticed the people standing on the top balcony. They looked tiny. He asked his mother "to reach out for the pretty little puppets—since I was thoroughly convinced that, if she would just stretch out her arm, she would be able to reach up to the tower's balcony. Later, I quite often looked up to the balcony when people were there, but they did not, to the more practiced eye, any longer want to become sweet little puppets." From this childhood observation derived the theory, advanced in the third and final volume of Helmholtz's *Handbuch der physiologischen Optik* (1856–1867), translated as *Treatise on Physiological Optics* in 1920–1925, that information derived from the retina and other sensory organs was not sufficient to reconstruct the world. Every evening, apparently before our eyes, the sun goes down behind the stationary horizon, although we are well aware that the sun is fixed and the horizon moves. In saying, "I saw the sun set," we are leaping to a set of conclusions, however reasonable. Essentially, argued Helmholtz, perceptions are the result of what he called "unconscious inferences," a kind of smart bet made by the brain based on our past experiences.

"A lot of illusions are based on this," says Nolan, "the way we think we see versus the way we really see, in matte paintings and in film and special effects and so on. I've always been interested in optical illusions and those kind of tricks, and as they sort of plot a narrative, they do become this fascinating puzzle box. A good example would be the Penrose steps which we built for *Inception*." First presented in a 1959 article in the *British Journal of Psychology*, Roger Penrose's famous steps make four ninety-degree turns as they ascend or descend, yet form a continuous loop, so that a person could climb them forever and never get any higher. "So we are forced, by the hierarchical nature of our perceptive processes, to see either a crazy world or just a bunch of pointless lines," points out Douglas R. Hofstadter in *Gödel, Escher, Bach*, a book that Nolan began once but never

quite finished. "By the time the observer sees the paradox on a high level, it is too late—he can't go back to change his mind about how to interpret the images." But why do we persist in seeing a staircase at all? Why, once the illusion has been pointed out to us, don't we just see lines on a page? Because, according to Helmholtz, the human eye is incapable of doubt. It *must* arrive at a conclusion, however erroneous. Even with our mistake pointed out to us—the stairwell is in 2-D, not 3-D—still we vacillate, able to toggle back and forth between our two alternative inferences. Our eyes are impetuous detectives, preferring an unsmart bet to no bet at all.

Nolan first became aware of the vagaries of the perceptual process when he was a young boy, attempting unsuccessfully to identify a holly bush on their road in Highgate. His struggle eventually led him to a realization: He was partially color-blind. With no green receptors in his eyes, his idea of green is very close to gray. Years later, while working as a video cameraman for Electric Airwaves in London, his boss frequently had to double-check that the batteries on the cameras were charged, because the light that told them so was red/green. "It's a bit like one of those old three-lens projectors," Nolan says. "You cover up one of the lenses and you still get color or two-strip Technicolor. My dad had the same thing. My brothers do, too; it's a genetic thing. It's quite often carried down the female line, but women don't exhibit it. As far as I'm concerned, I see a full spectrum of color. I mean, I see the world the way the world looks. I believe that very powerfully, and then someone can objectively give me a test and tells me that, well, there are actually certain distinctions I'm not making, and other distinctions that I'm making more strongly, because I don't see the range of greens that people see."

The Penrose steps designed by mathematician Roger Penrose in 1959, which served as inspiration for a sequence in *Inception*. Penrose credited M. C. Escher with the idea. Escher said Penrose inspired *him*. The steps are akin to such simultaneous inventions as the telephone, television, or movie camera.

It came up while he was filming *Memento*, in conversation with Guy Pearce, by way of illustrating why everyone seems to take advantage of poor Leonard Shelby's condition. "If you tell someone you're color-blind, the first thing they do is they show you something and say, 'What color is that?' If you were in a wheelchair, people wouldn't go, 'Oh, you're in a wheelchair. Can you stand up?' It's a bizarre response, but they're fascinated because they can't understand that you would see things differently. So they immediately start asking you what do things look like, and then laughing at you as you get it wrong. You see it with Mark Boone Junior's character, the motel clerk, where he's just fascinated by it. As soon as he tells people he can't remember things, then they start to test his memory. It seems cruel. People are fascinated by other people's perception of the world and the way in which it differs. I've always been interested in the tension between the subjective point of view and our faith in an objective reality. In *Memento,* we dealt with that enormously, particularly at the end, but I think that is in all my films. Whenever I am making a film, I'm constantly being reminded of the paradox of reconciling our subjective views of the world with our deep-seated belief or feeling that there is an objective reality outside that is fundamentally unknowable. We can't step outside our own heads—we just can't."

The beginnings of his early films, in particular, often start with an image or sequence—the writer's "confession" at the start of *Following*, or Leonard's act of "revenge" against Teddy at the start of *Memento*—that prompts the audience to make a set of unconscious inferences about what they are seeing (the writer is guilty; Teddy is the man who murdered Leonard's wife), inferences that, by the movie's end, have turned out to be partly or wholly false. They are the narrative equivalent of Hermann von Helmholtz's "puppet" humans in the tower, leading the audience astray. "Well, it's not always misinformation," Nolan says. "I mean, in certain films it is something that you know people are going to misinterpret. Like *The Prestige* or something. But if you look at the opening of *Memento* or *Dunkirk*, I very much draw on what I get from Stanley Kubrick, which is that the openings try to express a lot about what the film is going to be and how you are going to watch the film. How you want the audience to watch. You look at *Full Metal Jacket,* you just get the film in the opening shots. That dehumanizing effect of shaving the heads. It's simple and it's done. So, with *Memento,* what can I do? How can I help the audience watch this movie? And so, the reverse, that undeveloping of the Polaroid

picture, it came to me and I'm like, No, that's exactly right and it's going to help. *Dunkirk* was a very similar process: How can I express everything I need to express about what the film's going to be, so it's the propaganda leaflets saying 'We have you surrounded'? The anonymity of that and of feeling the situation right away, being in the middle of it. Every film has its different demand. Openings are very precious because you have the attention of the audience in a way that is very, very difficult to get."

In the credit sequence of *Insomnia,* we see dissolves between aerial shots of a glacier, its crevasses almost geometrically patterned, with extreme close-ups of a white cloth soaking with blood, the weave of the cloth resembling a giant grid. Not for the first time in a Nolan film, the sequence turns out to be a dream. Flying in a two-engine prop plane low over jagged ice ridges, detective Will Dormer has been trying to catch some sleep, but turbulence—or a guilty conscience—keeps jolting him awake. The first time we see that image of blood seeping through threads, we assume the blood belongs to the teenage murder victim. At the film's end, we enlarge the context to see hands depositing the blood on the cloth and realize that we are seeing Dormer in the act of planting evidence on another suspect back in Los Angeles—not the crime he is being sent to solve, but the one he is running from.

"*Insomnia* was only the second film I got to mix on a big dub stage, having sound editors and designers around—they did an excellent job; it's a beautifully mixed film—and I remember talking to them about pervasive background noises and how far you could take that before it became

The bloody credits for *Insomnia*—but whose blood? Nolan's endings often loop back to his beginnings.

noticeable, or intolerable, to an audience. I was thinking very specifically about a translation of sounds from the waking world into a dream. That idea is actually there in the beginning of *Insomnia*, so you hear thunder and it turns out to be turbulence on a plane, because I already knew that I wanted to do *Inception,* so it was a little experiment along those lines. I was talking to them about how much you can use a sound effect to define an environment, or lay under a thing before it sort of drives people crazy, and a lot of that is about allowing the subconscious, not conscious . . . It was a steady progression. *Memento* had been a great success; it was held up for being very radical, very different and all the rest, but what was great about *Insomnia* was that it allowed me to go in a more mainstream studio direction. It was done on a bigger scale, with movie stars; it ran forward and not backward. I think what you see with a lot of filmmakers, after their first success in any particular direction, is a huge temptation to keep pushing that direction, and it rarely, rarely works. There're a lot of filmmakers now who don't get to do that; they go straight from the tiny Sundance films to the giant blockbuster, and very often I've read myself quoted as somebody who did that, but it's not what I did. I don't think I *could* have done that. It was a steady progression, and *Insomnia* was a very important part of that."

Once he had completed the film, he did what he often does, paid for a ticket and sneaked into the back of a theater to see how it was playing with audiences. "The way films are made, everybody you show your film to while you're making it is scared of what the film is, and so there's a tension at every screening that is a little bit unnatural, and it's nice to remind yourself that when we pay ten or fifteen dollars to go to a movie, we want to like it, you know? So the audience is actually so on your side, whereas during the testing process, you feel that you're in an adversarial relationship, which is a very unpleasant feeling and unnatural. I like to just sneak in, watch a film, and experience it with people, because then I'm back in the audience. The audience is with you. I especially felt that on *Insomnia*, actually, because that was my first studio film. First Alcon, then Warner Bros. made us test it. I haven't done it since, but that is where they literally write you a book of how to fix your film, and it's a brutal process. We had to do it three or four times over many months, and it was a very, very stressful process of being almost pitted against the audience in a way, which is not what filmmaking is. So I remember going and seeing that in a cinema of paying customers and it was like, Yeah, actually people come to enjoy themselves. There is great relief in that."

• • •

Insomnia was a hit with audiences, taking in $113 million, and confirmed Nolan's status within Warner Bros. as the young directing talent on the rise. At the premiere of the film, in May 2002, he found himself sitting behind the executives at Warner's, Lorenzo di Bonaventura, and head of production Jeff Robinov; when the action sequences came up, the two men looked at each other, smiling. "Lorenzo had a great nose for directors who could be pushed in more of an action direction," says Nolan. "At the time, he was very much looking for people he was going to be able to grow with the studio and do bigger films. They were all very happy with the movie, which has a little bit of action, and a little bit of that suspense. The reviews were some of the best of my career, actually, which helped a lot."

Asked what film he wanted to make next, Nolan first pitched them *Inception,* the gothic story about dream theft, which had germinated in his dorm while in the sixth form at Haileybury. He'd gone back to the idea several times over the years and by now it had grown into a heist movie, against a backdrop of corporate espionage, with warring Japanese chemical companies straight out of *You Only Live Twice.* Lorenzo di Bonaventura and Jeff Robinov were both excited about what they heard, having just enjoyed a huge success with Soderbergh's *Ocean's Eleven* for the studio, but sitting down to write it in 2002, Nolan ground to a halt at page eighty. "I got into the beginning of the third act and then got stuck, and I stayed stuck for years and years," he says. "One of the reasons I couldn't finish the script is that it did not have that emotional element in it. It was just missing. The thing about dreams is they're so personal—they're part of our soul, really—it had to have emotional stakes. I was trying to approach it from more of a genre perspective, more in the noir tradition, but at the end of the day, it just didn't lead anywhere that paid off. It becomes like watching somebody else play a video game. It's somebody just getting lost in their own stuff, so then you don't care."

Instead, Warner Bros. let it slip that they were looking for a new director for Batman. The franchise had sat riderless, since Joel Schumacher's Day-Glo installment of the series, *Batman & Robin,* had been torpedoed by Internet fan sites five years before. Warner Bros. had subsequently commissioned Darren Aronofsky, fresh from his breakthrough feature, *Pi* (1998), to work with Frank Miller on an adaptation of Miller's *Batman: Year One.* Told from the point of view of a young James Gordon—a

chain-smoking, adulterous Serpico figure struggling against the corruption endemic to the Gotham City police force many years before he became commissioner—Aronofsky's pitch was a million miles from the colorful camp of Schumacher's film. The film got as far as storyboards, but for all its violence—in one sequence, the script notes that "Bruce tears into the skinheads with all the joy of a child on Christmas"—the script didn't entirely solve what Aronofsky called the "eternal question" of the Batman mythos—namely, "What does it take for a real man to put on tights and fight crime?" It was the rock on which nearly every previous Batman adaptation had foundered.

"I got one of those calls, like 'You wouldn't be interested in this, but, you know, nobody can figure out what to do with Batman,'" he recalls. "I saw it immediately. I was like, No, no, you have never done with Batman what you guys did with Superman in the seventies. The whole dig-down approach, where you submit it to this big production ethic, with all these name actors and faces, and throw it into reality—not in a gritty sense, but in an action-movie sense. What if this was as real as any other action movie? I just saw this gap in movie history." Before he pitched it to Jeff Robinov, he and Thomas spoke with executive Greg Silverman to get a better idea of the studio's baseline expectations for the project. "'Can it be R-rated?' 'No, it's PG-13 because it's Batman, and you want kids to be able to go and see it.' That was their thing. I thought about it. I had one kid, so as a new parent I could immediately relate to that. I remember Greg sat there very quietly. I said, 'What else do we need?' He said, 'It would be great if he had a very cool car.' I remember thinking, I don't know . . . *really*? Can we make that work? I said, 'That's a huge challenge.' It wound up being the thing that we focused on, even as we were writing the script. It was like, where would it come from, what would it look like, how would we explain this in our telling? It actually wound up being the key to a lot of things. We were all about 'How do you sell the idea of a guy in a costume? What's the mythology? How do you justify it?'"

FIVE

SPACE

WHEN HOWARD HUGHES was nineteen, he went to court to be declared an adult in the eyes of the law. Both his parents had died unexpectedly, his mother when he was sixteen, on the operating table after minor surgery to check her uterus for abnormalities; his father of a heart attack a few years later, at age fifty-four. The young Hughes's every move up until this point had been controlled by his parents, and he responded to his orphanhood like someone liberated. Less than a month after his father's death, he dropped out of college and moved back to L.A. to live with his legal guardian, his uncle Rupert, but soon after arriving in California, he quarreled with his uncle, saying that he didn't need a legal guardian, instructing officers of the Hughes Tool Company to open negotiations with his grandparents and uncle to acquire their 25 percent of the company's shares. Under the terms of his father's will, Howard was the main beneficiary of the Hughes estate, but only when he reached the age of twenty-one and had finished college. Hughes, it seemed, had other plans. Studying the inheritance laws of Texas, he grew fixated on a statute that allowed a nineteen-year-old resident of the state to be declared an adult, and as soon as he turned nineteen, he began petitioning to have the restrictions regarding his age removed. The judge hearing the case needed only two days to consider the appeal—

"he couldn't ask him any question that Howard didn't know the answer," said his aunt Annette—and on December 26, 1924, he declared nineteen-year-old Howard Robard Hughes, Jr., free "of the disabilities of minority and of full age." Hughes assumed full control of his father's business empire.

That stunning assertion of legal self-sovereignty provided Nolan with the beginning of his screenplay about Hughes, commissioned by Castle Rock's Martin Shafer and Liz Glotzer after they bought the rights to Richard Hack's book *Hughes: The Private Diaries, Letters and Memos*. Drawing on Hughes's private memos, the book inked in great detail the familiar portrait of the reclusive tycoon who ended his days secluded in hotel rooms, not cutting his hair or trimming his nails, wearing tissue boxes on his feet, burning his clothing if someone near him became ill, watching old movies all night. That Hughes, the agoraphobe and opiate addict, provided Nolan's screenplay with much of its focus not just its end point, as it did Scorsese's *The Aviator*, which was nearing the runway as Nolan wrote. He wanted to present Hughes from the inside, a will-to-power fantasist using his money to bend the world to his bidding. Missing from his script were some of the more usual elements you'd expect of a Hughes biopic—his mother's hypochondria, his father's excessive vigilance and overprotectiveness, Hughes's lifetime of neurotic overcompensation and perfectionism.

"In my Hughes film, I don't deal with his childhood, what his parents had done to him as a kid, which is everybody's jumping-off point, because I found it very reductive. Because I mean, yes, we're formed by our pasts, but we're also ourselves, and we're able to transcend those things. And it was a point of contention with the producers, because they wanted the Freudian backstory. The thing about Howard Hughes that had fascinated me is, at a very young age he lost both of his parents. He managed to get himself emancipated; eventually he wrested control of his fortune away from the trustees at the age of nineteen and could do pretty much anything he wanted. My Howard Hughes script tells his entire life story from that moment onward. For me, what worked about the script was, I wanted to try to take the audience on his journey, to be in that hotel room with him, to understand him. I actually think you can. In my research, I came to understand his journey, to a degree. Only from the outside does it seem irrational. Clearly, there were things psychologically wrong with the man, but I found that uninteresting. It was more interesting to try and tap into that psychology, or not view it as psychology, but just view it as a response

to the world around him—to get inside his head and go down that path. So that was really the essence of it. So this is why I hang on to the project, the fact that no one's actually done that, even though that's the thing about the story. I'm very proud of the script. I have to keep it under wraps, because ten years from now, it might be the perfect thing. To be honest, if we had made a film, we would have been in terrible trouble because Marty [Scorsese] delivered his film on time, which he wasn't accustomed to doing. So I was pitching it and going, 'Look, they're making theirs, but we'll be finished a long time before.' At the end of the day, if we had gone ahead and made it, we would have been in terrible trouble, because we would've been second."

Instead, Nolan ended up repurposing the material about Hughes's inheritance and the breakup of his father's empire in his script for *Inception*, while much of Hughes himself would find its way into the story of that other orphaned millionaire, Bruce Wayne, who drops out of Princeton, resumes his golf game, and seizes control of Wayne Enterprises, just like Hughes, who, not long after he was legally emancipated, jotted down his ambitions on the back of a receipt from Foley's men's store:

Howard Hughes in the mid-1930's; Sean Connery as James Bond in *Thunderball* (1965), both influential on *Batman Begins* (2004).

Things I want to be,

1. The best golfer in the world.
2. The best flyer pilot.
3. The most famous producer of moving pictures.

Within a few years, he was flying every day, had lowered his golf handicap, signed a distribution deal with United Artists, and owned a baronial mansion in Hancock Park, not "directly adjacent to street traffic, with an entrance suitable for multiple automobiles." Not quite the Batcave, with its waterfall-disguised entrance for the Batmobile, but close.

"A lot of my Hughes script went into *Batman Begins,*" says Nolan. "And the Bond films—*huge*. We really wanted to give it a more Bond-like global footprint. Those movies were our guiding light in terms of how the geography of a film can enhance the feeling of scale. There was also such a clear influence of Fleming from the gadgets Bob Kane had given Batman that we felt we could repay the favor by having a Q-like figure in the character of Lucius Fox. Those influences, along with a lot of the other seventies and eighties blockbusters I'd grown up with, opened up our approach to *Batman.* I didn't want to treat it as a comic book movie. Everything we did was about being in massive denial that there was such a thing. *Batman Begins* and *The Dark Knight* go massive lengths to do that. By the time we got to *The Dark Knight Rises,* there indeed was a superhero genre—*The Avengers* came out the same summer and then it grew and grew after that. The superhero genre as it exists now, that's just a given. At the time, we were simply making action films that aspired to stand alongside any kind of action film. We were trying to make epics."

· · ·

When Nolan first signed up to do the film for Warner Bros., his knowledge of the comic books was so slim that he sought out, as a screenwriting partner, David S. Goyer, writer of the *Blade* series, which had kick-started the comic book–adaptation spree of the late 1990s. Working under the code name "The Intimidation Game" to throw people off the scent, Nolan and Goyer brainstormed in his garage for several weeks, alongside production designer Nathan Crowley, working on the Batmobile, with Nolan going back and forth between them, dodging the cleaning lady ferrying laundry

from the washing machine to the dryer. Nolan wanted to present Warner Bros. with both script and designs at the same time, fait accompli, so as to better retain creative control and communicate what the film was to be.

"There was a way of doing those films that I was very afraid of because I knew it wouldn't give me something of my own," he says. "We were being told all kinds of things by the studio about how long it would take to prep and what it would involve. You are encouraged in a big movie to very rapidly hire an enormous number of people—artists, concept guys, all this stuff. Then you have to feed that beast. And so, you're in a situation where you go, 'I need a robot for this science-fiction film. Figure me out a robot.' And then you go away while they do whatever they feel like and come back with a robot. Which didn't suit my way of working at all. They will spend literally millions of dollars on films that don't happen, just a lot of design work, and you end up looking at a lot of pretty pictures. I wanted to not do that, so I had to find a way around it." They checked everything with the DC guide, but legally they never had to worry, because DC was owned by Warner Bros.; and once they were finished, Nolan invited the

Nolan and production designer Nathan Crowley in Nolan's garage during preproduction on *Batman Begins*.

executives to his home to view their work. "They were not happy about it, but Warner's had had a lot of trouble with scripts leaking—it was at the beginning of this online frenzy from a passionate fan base about what should or shouldn't be done in the movies. That had happened to a script of a Superman film, I think; the fans had somehow gotten ahold of the script and it literally would make a project untenable."

The story they ended up with departed considerably from the original comic books. Billed in his debut in *Detective Comics* number 27 as the "world's greatest detective," Batman was a creature of the Great Depression, an era of American history that gazed on privilege with a more uncomplicatedly aspirational eye than our own. "Superman began as a socialist, but Batman was the ultimate capitalist hero," writes Grant Morrison in *Supergods*. "He was the defender of privilege and hierarchy." Nolan felt very much that the key to Batman was not Batman, but Bruce Wayne. In the original 1939 *Detective Comics*, Bob Kane told the Batman's origin in just twelve panels—a mugger shoots his mom and dad, young Bruce Wayne vows in his candlelit bedroom to avenge their deaths "by spending the rest of my life warring on all criminals," works out at the gym, catches sight of a bat and—presto!—he's Batman. In Nolan's version, the death of his parents leads to seven years of self-imposed exile in Africa and Southeast Asia, far from his life of wealth and privilege, where he roughens his hands with the criminal fraternity he would one day oppose.

Unpicking the knot of class, wealth, and entitlement that had hobbled previous adaptations, Nolan fills his Bruce Wayne with self-loathing: He accepts the roughness of his handling almost as a kind of punishment for what he sees as his part in his parents' death, but also for the very fact of his pampered existence. He's slumming.

"I think British people are a little more sensitized to class than Americans. America is more of a middle-class country. It feels like there's more social mobility even if there isn't, whereas in Britain, there is a very obvious stratification of classes—you're very aware of those differences, but even for an American audience, I think, with a multibillionaire as a hero you have to be sure that you're going to generate the appropriate sympathy and the appropriate identification with that character. Killing his parents in front of him is not a bad idea—there's a certain inbuilt sympathy for this child at the beginning, and that hangs over the whole thing—but in our version there's also this period in the wilderness that he has to go through. It was like a wandering period. He has to earn his stripes, in a way. It's a little like the Count of Monte Cristo going to prison, and everyone thinking the person's dead. It's a very potent literary fantasy of the person who's disappeared coming back reinvented." Not long after arriving in L.A., Nolan saw John Huston's 1975 adaptation of Rudyard Kipling's *The Man Who Would Be King,* starring a gleefully rascalish Michael Caine and Sean Connery as two former British soldiers who march into the mountains of Afghanistan and set themselves up as rulers, worshipped as deities, until they slip and fall, as shambolic and shoddily as the empire itself. "It absolutely floored me," he says. "It is one of my favorite films and a massively important film to me. There's a romanticism to that film, a great sense of romantic invention and adventure, very much like *The Treasure of the Sierra Madre* many years before. Huston shot the film in Morocco, which obviously is a very, very long way from the country in the film, but he used a real-world texture to lend credibility. Every version of Gotham that I had seen before, Tim Burton's for example, felt very village-y, very claustrophobic, because you weren't aware of a world

OPPOSITE Christian Bale as Bruce Wayne during his seven years of exile; ABOVE Sean Connery in John Huston's *The Man Who Would Be King* (1975).

outside of the city. So you feel the edges of that world. What we were determined to do with *Batman Begins* was to frame Gotham in the context of a world city, the way we think of New York. We felt that to believe in Gotham would be to frame it in terms of its global scale."

That's how Nolan saw Bruce Wayne: a young man who finds himself overseas, much as he had. Bruce Wayne barely leaves Gotham in the comic strips, even to go to college. Nolan's Bruce would be as well traveled as he was. Toward the end of his year off, Nolan had acted as official cameraman for an African road trip organized by a young, charismatic photojournalist from Nairobi named Dan Eldon to raise money for Mozambican refugees. Besides the trip's philanthropic purpose—arriving in Malawi, they donated the bulk of the $17,000 they had raised to the Norwegian Refugee Council to build wells for drinking water—the trip had aspects of a rite of passage, of privileged kids testing themselves. "When we walked through the towns, things would suddenly stop; people around us would turn and stare, shoe-shiners would be suspended in mid-stroke, and I'd hear them whisper to each other," wrote Jeffrey Gettleman, one of the team's fourteen members, who camped on the grounds of the parks, or stayed in seedy motels with busted mattresses, subsisting on mangoes and canned beans. Something of that vagabond spirit would rub off on the young Bruce Wayne, whom we see stealing mangoes from a street market in West Africa. A few years later, while accompanying *Following* to the Hong Kong film festival, Nolan found himself fascinated by the shipping containers he saw in the harbor. "The way they stack these things, it's science fiction. They had these cranes that were moving them around in the shipyard and they had these giant tires; it looked like something in a James Cameron film. You could whip them over there, lift them like that, drop them, down-drive away, drive sideways, pick a thing up. Truly remarkable. For some reason, you just never see that stuff in films." A warehouse of those same shipping containers would provide Batman with his big entrance in the film, as he swoops down to pick off Falcone's men one by one, like Ridley Scott's alien in the air shafts of the *Nostromo*.

"I've always traveled a lot, because I had free tickets from my mother being a flight attendant. Now I can afford to go around the world. When I was writing *Batman Begins* I spent time in San Francisco and London just to travel; a lot of *The Dark Knight* I wrote in Hong Kong, while I was location scouting. Interestingly, when *Batman Begins* came out, it was considered to be a bit gritty and real compared to the other films. The reality

is, it's a very romanticized film, a very classical film. If you're looking for an emotional connection to landscape, I think, of all my films, *Batman Begins* is the most successful in that regard. I think there's a very, very strong set of connections. There's a romance and a relationship between the way the environments feel and what they represent. *Batman Begins* has everything to do with his transition into a superhero, and that's a big chunk of the film in the beginning. I felt very strongly that if we wanted to make a film that could be considered outside that specific genre—if Batman weren't just Batman but this figure that Bruce Wayne *becomes*—you would have to put all that work in just to make the audience believe it. So we wanted to do all that work. That was maybe the difference between what we were doing and what had come before us. It's the duality that is interesting."

In Nolan's version, the Waynes do not go to the cinema to see *The Mask of Zorro*, but to the opera to see Arrigo Boito's 1868 opera, *Mefistofele,* a version of the Faust legend. One scene in particular startles the eight-year-old Bruce—Walpurgis Night, with Satan himself dominating the stage before bats, demons, and otherworldly creatures swirl about him in frenzied rapture, triggering memories of a childhood encounter with bats in a cave. Bruce panics and pleads with his parents to leave and they make their way out into the alleyway to the side of the theater, their elegant eveningwear sticking out like a sore thumb in a street strewn with garbage, fire hydrants, and steam. A figure approaches, draws a gun, demands their valuables. "Take it easy," says Bruce's father, Thomas (Linus Roache), handing the man his wallet—"Here you go"—but when the mugger points his gun at Thomas's wife (Sara Stewart), Thomas moves to protect her, and the mugger panics and shoots, killing both of them. So now we know what might make a man dress up as a bat. Bruce Wayne saw the devil.

"We referenced Faust in the opera in *Batman Begins* because we didn't want to have him going to the cinema, which is what it was in the comic books," says Nolan. "Going to the movies in a movie has a different resonance than it does in a comic or novel. I wanted this massive sense of guilt and fear that he could carry with him; that was a big driving point. Over the course of the three films, there's a sense of what being Batman is costing Bruce Wayne. It's there in its elements in the first one, but it takes all three films for it to pan out. I think the Faustian narrative is a very attractive one. It's there in *Following* and in *Insomnia* as well, in twisted form, with the Robin Williams character drawing Pacino's character into this compromised relationship that really is the trick of the devil."

• • •

In the earliest version of the Faust legend, Christopher Marlowe's 1592 play, *Doctor Faustus*, the doctor is a tragic figure smitten with "proud knowledge." He wants to be a deity, able to fly, to render himself invisible, to be an emperor of the world, and for his hubris he is punished. In Johann Wolfgang von Goethe's retelling, *Faust I* (1808) and *Faust II* (1833), the story has elements of post-Enlightenment scientific allegory. As Goethe wrote in his autobiography, *Dichtung und Wahrheit,* Faust "believed he had discovered in Nature . . . something which . . . contracted time and expanded space. It seemed to be at home in the impossible and to reject, with scorn, the possible." Goethe's Faust is a heroic figure, a Promethean overreacher who seeks knowledge beyond all bounds, like the Enlightenment scholars and scientists then circling the globe and mapping the stars. We first come upon him in his study, remonstrating with himself, impatient to break out of musty scholarship into a life of action. So he makes his wager with Mephistopheles, a spirit who has followed him, dressed as a "traveling scholar," and then offers him thirty years in which to explore the world and seek unlimited knowledge, on the following condition.

> If ever I should tell the moment;
> Oh stay! You are so beautiful!
> Then you should cast me into chains,
> Then shall I smile upon perdition

Like many Nolan heroes, what Faust wants is time—thirty years in Goethe's version, twenty-four years in Marlowe's—and is granted it on the condition that he will never ask to stop the clock and prolong any particular moment (*"Augenblick"*) out of "the rush of time" (*"das Rauschen der Zeit"*). It is a wager he loses when he falls in love with Marguerite and feels "an ecstasy which must be everlasting! Everlasting!" And so he perishes, with Mephistopheles sarcastically crowing:

> The final moment, worthless, stale, and void
> The luckless creature, he would hold it fast.
> Here he who fought me off so well—
> Time triumphs—stranded lies, a whitened shell.

It would take all three films for this narrative to play out, but it is there right at the start of *Batman Begins,* which opens, like many Nolan films, with a man waking up from a dream. The dreamer (Christian Bale), dirty and bearded, is lying in a dank brick jail in a far-off, unidentified part of the world. We do not even know what country we are in, nor will we ever. There is a muddy courtyard, ringed with barbed wire, where wardens stand watch with guns; dogs can be heard barking in the distance. While Wayne is collecting slops for breakfast, his tin plate is knocked from his hand by a squat Asian brute. "You are in hell, little man," he snarls, "and I am the devil." A brutal, muddy brawl ensues, which leaves Wayne bloody and soaking, but victorious. It is the eve of his release from prison. "You have been exploring the criminal fraternity, but whatever your original intentions, you have become truly lost," he is told by a suited Ducard (Liam Neeson) and so, too, are those in the audience, who have been stranded about as far from the cinematic comforts of home as can be imagined. If you had wandered into the theater without knowing this to be a Batman film, it might have taken some time to realize it for what it was. An update of *Midnight Express*? A remake of *House of Flying Daggers,* but with a Westerner as hero? An adaptation of Kipling's *Kim*?

Working for the first time with editor Lee Smith, who worked on Peter Weir's *The Year of Living Dangerously* and whose commission by Nolan signaled a more epic instinct at play, the two men open up the landscape, giving the film a greater spaciousness than we've seen in a Nolan film before. As Bale trudges to the League of Shadows' monastery in the mountains, through flurries of snow, his cheeks are ruddy with the cold. As Bale duels with Ducard on an icy lake against the cruel blue crevasses of glacial ice, Nolan and Smith construct a sinuous weave of prowling medium shots and assaultive close-ups for the thrusts and parries. "To conquer fear, you must become fear," Ducard tells him, "and men fear most what they cannot see." No other superhero saga begins this way. Superman doesn't become Superman by playing apprentice to Lex Luthor. Spiderman doesn't become Spiderman by auditing the Green Goblin. The idea that Bruce Wayne, in order to become Batman, must first be apprenticed by his enemies is new not just to the Batman franchise but to the superhero genre as a whole, baking moral ambivalence into the saga from the get-go and making that ambivalence concrete by giving Bruce a place, or series of places, that represents his riven self. All that is best about *Batman Begins* is contained in this first hour, with its rough textures of burlap, hemp,

and ice. Looking for locations that could stand in for the Himalayas—with mountains above the tree line but also accessible to his crew—Nolan alighted on Svínafellsjökull, at Vatnajökull National Park in Iceland, a cruel, eerily beautiful landscape of white glacial ice broken by blue crevasses, where Bruce Wayne duels with Ducard. The glacier creaked and moved about four feet each week. Nolan would return to the same glacier to shoot *Interstellar*. Glaciers also feature in *Insomnia* and *Inception*, where they inform the design of "Limbo," the deepest dream state. "Couldn't anyone have dreamed of a goddamn beach?" asks Cillian Murphy's heir. Not in a Nolan film, apparently, where the prevailing conditions are icy, with high likelihood of snow flurries.

"Oh yeah, big glacier guy," says Nolan. "I remember studying them in geography class, but until you actually get to see one, or fly over one—I flew over one in Alaska for *Insomnia*—it's a remarkable thing. For me, glaciers are just incredibly beautiful and stark. It's very cinematic, and that is what we want to do. We do look for a landscape that somehow echoes, or reflects, or challenges in some way the situation of character. Those things are more instinctive to me; I don't really remember the third or fourth time shooting a film with a glacier and thinking, Yeah, you can

Svínafellsjökull glacier, Iceland, where Nolan shot portions of *Batman Begins* and *Interstellar*.

Giovanni Battista Piranesi's *Carceri d'invenzione* (1750). "Some planes, opening up to infinity behind each other, carry the eye into unknown depths, and the staircases, ledge by ledge, extend to the heavens," noted Russian filmmaker Sergei Eisenstein in *Piranesi,* or *The Fluidity of Forms* (1947). "Forward or into the depths? Here, is it not the same?"

make a joke of it. But carry on. If it's the right thing, it's the right thing. They are also great ways of getting the appearance of altitude and winter all year-round reliably, to shape an environment and get something extreme and different. I'm very much a pessimist; I always plan for the worst when it comes to weather. The one thing you don't want to be doing is sitting around waiting for snow. I've done it on one film and it's nerve-racking, because it either happens or it doesn't. With a glacier, it's there and you know it's there. So you're going to have ice; you're going to have winter. That's guaranteed. So it's a great place to reassure yourself you're actually going to get the landscape you want."

The landscape he wants is frequently as treacherous as his femmes fatales. As Darwin first noted, glaciers are blue as a result of refracted light: they are *lenses,* both an object and the means by which objects are seen, and it is this chimerical quality that fascinates Nolan. They are nature's optical illusion, a special effect for free, exercising much the same mesmeric function that mirages

did for David Lean in *Lawrence of Arabia.* "The mirage on the flats is very strong and it is impossible to tell the nature of distant objects," wrote Lean in his diary while scouting for locations in Aqaba. "Jeeps look like elongated ten-ton trucks even when they are quite near. Men look as if they are on stilts and walking in water. You certainly can't tell a camel from a goat or a horse. If a walking man sits down on his haunches, he disappears into the 'lake' and you can't see him at all." For the interior of the League of Shadows' monastery, Nolan and Crowley looked at the work of Venetian engraver Giovanni Battista Piranesi (1720–1778), the "Rembrandt of etchers," whose series of etchings called *Carceri d'invenzione,* or *Imaginary Prisons,* first published in 1750, reportedly created in a fit of fever in 1745, when Piranesi was twenty-five, depict a gargantuan dungeon whose stairs, chains, vaults, bridges, chasms, arches, corridors, wheels, pulleys, ropes, and levers seem to stretch in all directions. "In every age the nightmare of incarceration chiefly consisted of confinement," noted Belgian novelist Marguerite Yourcenar, but Piranesi's series celebrate "the idea of a builder drunk on pure volumes, pure space."

As with the work of Escher, there is fundamental ambiguity in Piranesi's work as to whether it depicts external or internal states. "If his triumphs brought him elation, he was in turn afflicted with a despair that was almost infernal," writes his biographer. "The very shattered columns he drew, bound and twisted around with creepers, writhe almost in human agony." Initially used for inspiration in the Himalayan monastery of the League of Shadows, Piranesi's influence spread to the Batcave, and then to the workshops in *The Prestige* and Crowley's designs for Newgate Prison, whose architect, George Dance the Younger, was himself inspired by Piranesi's designs. "Nathan introduced me to Piranesi," says Nolan. "We started looking at that type of architecture for the monastery in *Batman Begins,* and it plays a big part in *The Prestige,* not just for the prison but also for the workshops and stuff. There is a lot of reference to his work. I'm a big fan. The reality of prison, I mean, I'm as terrified of going to prison as everybody else. Nathan and I wound up on a scout once in the city. We were looking at the outside of a jail, and then the people showing us were like, 'Well, do you want to have a look inside?' And the cells were modern cells. They were glass walls basically, these kind of holding cells. We would just stand there like a couple of total arseholes, with our Starbucks cups. Spontaneous scouting inside a prison, not a great idea really. We dabble in the artificial version of these situations, because it's dramatically useful

to us. I've always been very concerned about three-dimensional geometry, so one of the things I have to explain to people I work with early on is, I won't fly the walls of sets. For me, it's very clear that if the camera backs up beyond the point where the audience knows the wall is, they just know you've cheated. Bear in mind that with most rooms—we're talking about boxes, so you're very aware of the perspective—you feel that you're outside the room. That can be an interesting effect, but the way I tend to tell stories, you want the constriction. You *want* to feel you're in the space. That's your ultimate prize as a storyteller: a locked-room mystery. An impossible situation. How do you get out of it? Come up with a good answer to that, it's gold."

• • •

Nolan is frequently drawn to environments of confinement—the motel in *Memento,* the cabin in *Insomnia,* the Manchurian prison in which Bruce Wayne awakes at the start of *Batman Begins*, Newgate Prison in *The Prestige*, the fishing trawler in *Dunkirk*—but confinement, in his films, is rarely confining, or solely so. His villains in particular often enjoy Faustian dominion over the bounds of space and time. "Outside, he was a giant," says the Scarecrow of Falcone, locked away in Arkham Asylum in *Batman Begins.* "In here, only the mind can grant you power." It is while imprisoned in a police holding cell that the Joker in *The Dark Knight* launches his master plan, using his one phone call to prime the bomb that will free him; sticking his head out the window of his police escort, he is as happy as a dog lapping up the wind, free already. "Was being caught part of your plan?" Bane is asked at the beginning of *The Dark Knight Rises.* "Of course," replies Bane. It is something all of Nolan's heroes must contend with or come to some sort of compromise with. They must learn to accept and even find liberation in their confinement. Exploring the well he fell down as a boy, Bruce Wayne finds the set of underground caverns, once used by slaves to escape to the North, to build the Batcave: Confinement brings salvation, a sense of identity, a base where, with the help of Wayne Enterprises' all but forgotten CEO, Lucius Fox (Morgan Freeman), he can build a high-tech Batcave beneath Wayne Manor, where he fashions a Kevlar bioweave bodysuit—a vision of stealth, wealth, and gleaming self-sovereignty. Growling his lines in a Vaderish rasp, face twisted behind his cowl, Bale's Batman seems just a few seconds away from assaulting every

person he meets, a simmering cauldron of sublimated grief and rage so intense that all else pales beside it.

Returning to Gotham, he finds a city rife with corruption. Gangsters run the economy, and most cops are on the take. "In a town this bent, who's there to rat to, anyway?" says Jim Gordon (Gary Oldman), the one good cop trying to stem the tide of rot. This middle section of the film drew heavily on Frank Miller's *Batman: Year One*, and also on Sidney Lumet's *Serpico*. A Jewish Philadelphian one generation out of Warsaw, who read Karl Marx by age eight and saw almost five years of service in the U.S. Army Signal Corps, Lumet is perhaps the most surprising of Nolan's filmmaking influences: No formalist like Roeg or Kubrick, he was the rough diamond, the rabble-rouser, whose fiery political commitment expressed itself in films like *12 Angry Men, Serpico, Dog Day Afternoon, Network, Prince of the City,* and *The Verdict,* which compel "the spectator to examine one facet or another of his own conscience," as he once put it. It is Lumet's sense of systemic rot, of a justice system out of balance, a universe permanently askew, that fascinates Nolan, whose first exposure to him was *Murder on the Orient Express* (1974) when it played on British television, followed by *The Offence* (1973), starring Sean Connery as a ferocious Manchester police detective driven to criminal acts in his interrogation of a child molester (Ian Bannen). Connery and Bannen's final confrontation, with Connery pounding impotently on a maniacally laughing Bannen, would seed the similar scene between Batman and the Joker in *The Dark Knight.*

"He had this amazing British period," says Nolan. "Watching *The Offence* on TV when I was a teenager, it was just like, 'What the fuck *is* this?' It shares something with Roeg in its editing, but it's much more recognizable as a piece of mainstream filmmaking. It does this extraordinary deconstructionist tactic with regard to playing with time. It's incredibly disturbing; Sean Connery's amazing in it as a cop under pressure, bearing the weight of his own guilt. It's remarkable. That and *The Hill,* which I think is the greatest movie that Stanley Kubrick never made. It's amazing to me that Lumet could do such varied things but could also do something that truly feels like a Kubrick film about brutality and society's lack of humanity. Both of those films are massively British, made by this New Yorker, and massively disturbing. *Serpico* is a horror movie set in the real world, well and truly. It's absolutely terrifying. We lifted it completely for *Batman Begins.* The corruption of Gotham had to be on that depressing

OPPOSITE, CLOCKWISE FROM TOP LEFT Al Pacino shooting Sidney Lumet's *Serpico* (1973); Sean Connery in Lumet's *The Hill* (1965); Jim Gordon (Gary Oldman) and Batman (Christian Bale) face the same problem as Lumet's heroes: how to be clean in a world that's dirty.

1970s level; it had to be on the *Serpico* level for Batman to make any sense. How is it that Gordon would accept a vigilante? It has to be that Frank Serpico thing where he can't otherwise do anything. The wheels of justice have ground to a halt. The thing I start to feel over time, seeing the films that I've grown up with, and where they sit in film history now, there's something about the fundamentals, something about simplicity that tends to carry the day. That is what you get from those movies, how hard it is just to be clean in a world that's dirty. That's what *Serpico* gives you."

• • •

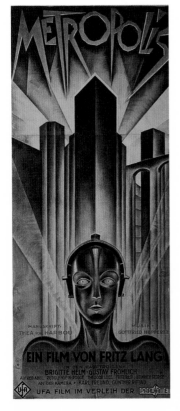

Forgoing his producer role in order to concentrate on directing, Nolan and production designer Nathan Crowley filled the largest soundstage at Shepperton Studios, in Surrey, with a sixty-foot Batcave of simulated rock, with its own running stream and waterfall. From there, production moved to a disused airship hangar in a former RAF facility at Cardington, just outside London, measuring over 800 feet long, 400 feet wide, and 160 feet from floor to ceiling, with sixteen stories of fly space, where they built an entire section of Gotham City—the tallest being eleven stories high—which gave the construction crews existing structures on which to mount facades and other set pieces with functional streets, streetlights, stop lights, neon signs, cars driv-

A poster for Fritz Lang's *Metropolis* (1927), one of the influences on *Batman Begins*; Nolan directing Katie Holmes on the set at Cardington. In conversation, Nolan references Lang more than any other filmmaker.

ing around. All this could be lit from within, like a real city, with rainfall manufactured by the special effects crew.

"When you deal with the studio system, they want more scale, and more scale and more scale," says Nolan. "Instinctively, they're always after more, more, more. From what they read on a page they think, Well, hang on. Is there enough action? That is their biggest fear. With *Batman Begins,* we very specifically wrote it in the biggest way possible. We said, 'We'll travel the world; there's going to be this huge Himalayan monastery and it's going to blow up.' We very specifically made it as big as it could possibly be. It was a huge learning curve for myself and for Nathan. Nathan had never designed a film on that scale, but he had worked as an art director on a lot of big films and had to build big sets. I looked at the Superman model and said, 'Okay, we'll go shoot in the UK.' Rather than going somewhere else to chase tax breaks, like Australia or Canada. Dick Donner shot that film [*Superman*] in the UK studios at Pinewood with about, I don't know, three weeks of location work in New York. In fact, I had wanted to do a month or six weeks on location, but gradually it got smaller and smaller for budget reasons, as things often do. I think we only did about three weeks on location in Chicago. And then everything else was studio-bound. We built these enormous sets. But, of course, what we started to learn together is, building sets is not a great way to get scale on-screen. It really isn't. *Batman Begins* is as big a film as has ever been made—I mean physically. At the end of it, the studio was very happy with the film, but they constantly kept saying, 'Well, is it really big enough?' I knew we had hit the absolute limits of geography in a movie. We couldn't stuff any more in."

He employed two composers for the film, James Newton Howard and Hans Zimmer, whose sound tracks he had listened to during his last year at school. Thirteen years Nolan's senior, Zimmer had already worked on Stanley Meyer's scores for Nick Roeg's *Insignificance* and Stephen Frears's *My Beautiful Laundrette* at that point. "When Hans started out, he was kind of the synthesizer genius. He was the young kid who could figure out the synthesizer aspects of playing the scores and so he contributed to Meyer's scores. I think it was actually Tony Scott who had first started working with him in commercials and things like that; then he did Ridley Scott's *Black Rain* (1989). I was nineteen, and I just fell in love with his music. It was really, really beautiful stuff. The thing that synthesized music does, you can create voices and sounds that don't have cultural associations, which makes them interesting for film scoring. I try to use something a bit more

open; that's why Hans and I have worked successfully together, because I like to say he's a minimalist composer with maximalist production values. So it's a very big sound, but the ideas behind it are incredibly minimalist. Very, very simple. And that gives me space to work as a filmmaker, between the notes. What I've done with the bigger film scores over the years is try and totally reverse the process and start with the emotion, start with the basic heart of the story, then build the mechanics after that, but it took a certain amount of confidence. That said, when Hans first played me the two notes he had in mind for the main theme, it scared the shit out of me. I kept saying, 'Are you sure you don't need more of a hero's fanfare?' In the end, James wrote one that was great, but we never used it for *Batman Begins*. It came back in *The Dark Knight* as Harvey Dent's theme. But for Hans, without ever saying that that's what he was going to do, he just drove in that direction, just very, very, very minimal. It's almost like an echo of a heroic theme, just those two notes."

• • •

Nolan's description of Zimmer—a minimalist with maximalist production values—does double duty as a description of Nolan himself, and hints at why the two men would forge such a close creative partnership in the years to come, although those two impulses, minimalist and maximalist, do quite enjoy the fluency of conversation in *Batman Begins* that they would enjoy in the director's subsequent films. There is a surplus of villains, three, each dropped into the pockets of the next. First up is Tom Wilkinson's mob boss Carmine Falcone, all bark and no bite once the Scarecrow (Cillian Murphy) turns up, spraying fear toxin into people's faces like Mace. The Scarecrow, in turn, is just a cutout for the return of Ra's Al Gul (Ken Watanabe), who gate-crashes Bruce Wayne's birthday celebration, like the subplot that refuses to die. But he selected Ra's Al Gul precisely because he did *not* steal the show from his hero, so his return scarcely provides the required frisson. One can appreciate Nolan's dilemma, for once we have visited the Himalayas, summoned the supernatural, and invoked the fall of empires, what does the spectacle of one mob boss lining the pockets of a cop hold? The film's global reach dissipates the sense of containment necessary for the corruption of Gotham to truly get under our skin. The Gotham of *Batman Begins* doesn't yet cohere, architecturally or morally, to the hard, clean lines of the Chicago Loop here combined with the Victorian-Gothic architecture of Wayne Manor, some unnecessary futur-

istic touches like the monorail and the fictional narrows, an homage to the rain-soaked *Blade Runner*, while the trash-your-set finale—bringing together high-flying aerobic skirmishes, WMD on the loose, psychiatric experiments, and that monorail train hurtling to disaster—feels like the work of a director honoring his studio duties rather than following his own creative north. He would resolve the issue with the IMAX photography of *The Dark Knight*, all the architectural clutter of *Batman Begins* clarified into a stark contrast between the Joker's chaos and the hard, clean lines of the Chicago Loop.

But if the flaws of *Batman Begins* feel generic, its virtues are more singular, in particular that first hour, with its use of landscape and the lasting impression that Bruce has been permanently marked by his time with the League of Shadows. "My mask is just a symbol," he tells Rachel at the film's end. "No, *this* is your mask," says Rachel, touching his face; "your real face is the one the criminals now fear. The man I loved, the man who vanished, he never came back at all." Goyer's original version of this exchange is much weaker, with Rachel complaining, "Between Batman and Bruce Wayne, there's no room for me," and Bruce offering to give up his life of crime fighting. "You didn't choose the life, Bruce," she says. "It was thrust upon you, the way greatness often is." Nolan's version is freighted with genuine sacrifice and the unmistakable sadness of the exile who knows he can never fully return.

"You have to become a terrible thought, a wraith," Ducard tells Bruce Wayne. The Dark Knight (Christian Bale) patrols Gotham City at dusk.

"Of the three films, *Batman Begins* is the one that does a lot of things right and has a nice thematic balance, and it was well received," Nolan says. "People liked the film a lot, but it actually wasn't as successful as we expected it to be. You never expect success. I'm a very negative, superstitious, pessimistic person. When they were showing people the film, everybody loved it and there was a lot of excitement around it, but there was also a lot of ill feeling toward that character and that franchise because of the last couple of movies. The first time the term *reboot* was ever applied was *Batman Begins,* I believe. Certainly, I hadn't been aware of it, and it's part of the Hollywood grammar now. The big problem we had is that we were rebooting eight years after the last film, which felt too short—way too short. And it was too short. Now they'll do it two years later. So the windows have gotten shorter and shorter now. For us, it was a real problem, because when we said to people, 'Come and see the new *Batman* film,' they were like, 'I didn't like the last one.' There's been a huge shift since we made the films in terms of audience expectations or audience confusion about 'Is this the same film that I saw before? Is this not?'"

Batman Begins ends with Jim Gordon turning up a Joker card at a crime scene—the film's eventual gross of $400 million made a sequel all but an inevitability. Nolan was about to embark on one of the most sustained runs on the resources of big-budget, Hollywood filmmaking since David Lean's great run of films in the late fifties and sixties—*The Bridge on the River Kwai* (1957), *Lawrence of Arabia* (1962), *Doctor Zhivago* (1965)—a run broken by the critical savaging received by *Ryan's Daughter* (1970). "You won't be content until you've reduced me to making a film in black and white on 16mm," complained Lean at the end of a long evening at the Algonquin Hotel hosted by the National Society of Film Critics, during which the assembled critics roasted him for making "yet another beautiful eyeful," as he summarized the consensus on his later films. Faust got trapped inside his own epic scenery. The seeming verticality of Nolan's ascent arouses similar suspicions in critics, his very success somehow parsimonious when set beside that of more flamboyant spendthrifts like Welles or Coppola, for whom a masterpiece is not really a masterpiece unless it has induced coronaries in a dozen executives or been branded a disaster by the waiting press corps. Where was his *1941*? His *Abyss*? His big, ill-fated passion project that allows him to fall flat on his face and take in the humanizing lessons of failure? How can you learn if your career is one long victory wave?

"I know," he says. "It's a serious thing. Because, yes, from an objective

point of view, you look at other filmmakers' careers and some of them you see learning from it: After *1941,* Spielberg made *Raiders of the Lost Ark* and *E.T.* But sometimes you see them learning the wrong lessons, as well. I've been through various informative experiences that, I think, were very lucky for me. One of the key ones was *The Prestige.* We were supposed to open number four or five that weekend, and our tracking, as they say, was in the toilet. But the studio liked the film a lot. They liked their campaign. They were baffled by the tracking. The first reviews came out at the beginning of the week and they were bad. It was the very beginning of the Rotten Tomatoes website. So, we had the premiere on a Tuesday, I think. I remember going to that premiere with a flop. I already had the call from my agent saying, 'It's such a shame, because it's a great movie.' You know? I was like, We're tanking. The writing's on the wall, because they have a lot of information before a film comes out. So, we drove to the pre-

miere of that movie with a shitty Rotten Tomato score. And tracking in the toilet and the audience, you can feel it. It's a Hollywood premiere at El Capitan. It turned out to be the best premiere we've ever had. Because people's expectations were very low. The buzz on the movie was like, 'They fucked up, the film is a disaster.' I actually feel very lucky to have had the experience of what it's like to drive to your premiere, knowing that you fucked up, and that everyone is going to hate your film. Because you *do* learn from that. What I learned was, it really was important to me that I knew the film was good. Because although it was unpleasant—it was an awful sensation—I knew that *I* liked what I had done. I felt very good about that. And you realize, when the chips are down and everyone turns around and tells you that it's crap, that is all you have. So, if you don't believe in it in the first place, you are taking a risk—a terrible risk."

Upon its release on October 20, 2006, *The Prestige* got the number one spot that weekend. The reviews were good and the film easily recouped its $40 million production budget, eventually earning $110 million, and was nominated at the Academy Awards for Best Art Direction and Best Cinematography. Even the matter of whether your movie is a hit or a flop is, it seems, a trick of the light.

One of the posters for *The Prestige* (2006).

SIX

ILLUSION

ARE YOU WATCHING CLOSELY?" asks a voice, which sounds like Michael Caine's, over a tracking shot of some top hats scattered in the forest. The period is the late-Victorian 1890s. Thomas Edison has invented the lightbulb, and the scientific curiosity of electricity is on its way to becoming an ordinary fact of domestic life, driving magicians to ever more dangerous feats of prestidigitation in their efforts to hang on to their dwindling audiences. In the first scene of *The Prestige*, we see Robert Angier (Hugh Jackman) plummet through a trapdoor into a waiting tank of water, where he is unable to escape and drowns. Watching him drown is another magician, Alfred Borden (Christian Bale), who is subsequently tried for his murder, convicted, and now awaits the gallows. We have seen all this with our own eyes. But of all Nolan's beginnings, the *Prestige*'s is perhaps the most slippery. At the end of the movie, Nolan will replay the exact same scene, only this time we will come to the exact opposite conclusions. Not only is Borden innocent; Angier isn't even dead. The ultimate trapdoor that is cheated is the gallows. The two men's rivalry will, over the course of the film's two hours and ten minutes, cost them their limbs, livelihoods, and finally their lives, the final twist being that they will lose their lives many more times than they have lives to lose.

Christopher Priest's 1995 novel about two dueling magicians had been first brought to Nolan's attention by producer Valerie Dean in late 1999, right after he had finished shooting *Memento,* but as he got pulled into preproduction on *Insomnia,* he found he didn't have the time to write the screenplay himself, and so in the fall of 2000, while in England to publicize *Memento,* he took a long walk with his brother Jonah in Highgate Cemetery—later to be a location in the script—and asked him if he wanted to adapt it. "I told him the story and I said, 'I know what this needs to be. I've got this idea, but do you want to try and write it?'" says Nolan. "I knew he had the right type of imagination, the right type of ideas for a story like that. There wasn't anybody else who was going to be able to move that ball forward. He really loved the idea, loved the book. When I think about screenplays to kick off with, to do as his first one, I definitely gave him a tall order, but we were young and foolish, and I'd just had this big success with *Memento,* where it was just a crazy idea that he let me take and write a crazy screenplay from, and the whole thing's backward. So anything seemed possible. The thing you have to fight against as you make more and more films is knowing what won't work, knowing what people won't let you get away with, not limiting your thinking."

As the success of *Insomnia* propelled Nolan toward *Batman Begins,* Jonah continued to labor over the screenplay of *The Prestige,* sending his brother drafts and receiving back notes. "He wrote it for years. It was about a five-year process, because it's a very, very tricky adaptation. He would send it to me and I would give input. It was like, 'This doesn't work. That doesn't work.' It's a puzzle box of a film and it took many years for us to crack through it." They both agreed they wanted immersion in a world densely layered, peeling back layer after layer. Beginning his research, Nolan was struck by the sheer visual bombardment of Victorian-era London; despite the lack of radio, film, and television, the city was lined with all manner of visual advertising.

"The Victorian era is pretty fascinating. There were a couple of good books that came out right after I left college, reassessing the Victorian era. Because the Victorian era has become fixed in the popular imagination as this period of repressive conservatism, and the reality is quite far from that. So if you look at the intellectual adventurousness of Victorians and the things that were happening, it's a fascinating era from that point of view. You have this superficial idea of repression, of dress and manner and all the rest, and then these incredibly churning, world-changing ideas. In

our own era, we look down on it with condescension, but then you think about Darwin and the theory of evolution, all the geographical exploration and people exploring the world all over, the founding of the Royal Geographical Society, Mary Shelley writing *Frankenstein* when she's just eighteen, just a few decades earlier. A time of great intellectual adventurousness. Architecturally, as well. There's a lot of bad Victorian architecture, and in the modern era there's a lot of scorn poured on the Victorians and neo-Gothic architecture, but you can see the appeal of it, this reappropriation of complex, primal fascinations. There's a strong relationship between that and the formalism of cinema in the last one hundred years."

As *The Prestige*'s mention of Thomas Edison reminds us, cinema is a Victorian invention, along with many of Nolan's favorite things: the idea of four-dimensional space, or the tesseract, science fiction, doppelgängers, typewriters, agnosticism, photography, concrete, Greenwich mean time. The more you find out about him, the less *The Prestige* seems like the outlier in Nolan's filmography and more like the locus classicus of all his themes and concerns. "All my films to some extent are about storytelling," he says. "*Memento* is, *Insomnia* is, *Inception* is, but *The Prestige* is as much storytelling as any of them. It was very much about trying to understand the language of magic, trying to get a movie that is itself a magic trick, using the grammar of the film to do so. It's not unlike finding a relation-

Hugh Jackman as Robert Angier in Nolan's fifth film feature *The Prestige* (2006).

ship between you as a director and as an architect, what an architect does in terms of creating space that has a narrative component to it—your mise-en-scène, the way you put shots together, the way you create a geography for the story. The parallels didn't come at first, because stage magic won't work on film. People are too aware of camera trickery, editing, and all of that. I think I discovered that relationship through making the film."

• • •

In 1896, the French magician and filmmaker Georges Méliès made his assistant Jehanne d'Alcy disappear onstage at the Théâtre Robert-Houdin. "My cinematic career is so closely linked to the Théâtre Robert-Houdin that one can hardly separate them," wrote Méliès in a letter to a fellow magician near the end of his life, "for it is my use of tricks and my personal taste for the fantastic that have determined my vocation as 'magician of the screen,' as I am called." Wearing a full dinner suit and goatee, Méliès ostentatiously placed a piece of newspaper on the floor to demonstrate there was no trapdoor, placed a chair upon the newspaper, and invited d'Alcy to sit down on it. As she proceeded to fan herself, he draped a large patterned blanket over her, making sure it covered every inch of her dress, a full-body bodice that went up to the neck. Then, with little ado, he whisked the blanket away to reveal an empty chair, picking the chair up and turning it around to show the audience. His first attempt to bring her back was unsuccessful: A sweep of his hands summoned only a skeleton. Placing the blanket over the skeleton, he then whisked it away to reveal his assistant, alive and well. They took their bows and left the stage, then came back to take another bow, although that was perhaps the biggest illusion of all. For there was no audience. Méliès's trick was performed for the movie camera—or, more accurately, *in* the movie camera, the disappearance effected by using a simple replacement splice.

Were audiences fooled? Yes and no. The great Jean-Eugène Robert-Houdin, the father of modern magic, in whose theater Méliès performed and who gave us magicians in evening wear, once said, "The ordinary man sees in conjuring tricks a challenge offered to his intelligence, and hence representations of sleight of hand become a combat in which he determines on conquering. The clever man [*homme d'esprit*], on the contrary, when he visits a conjuring performance, only goes to enjoy the illusions, and, far from offering the performer the slightest obstacle, he is the first

to aid him. The more he is deceived, the more he is pleased, for that is what he paid for."

This paradox is the crux, too, on which *The Prestige* turns. "If people actually believed the things I did onstage were real, they wouldn't clap—they'd scream," says Robert Angier (Hugh Jackman), a slick American showman, as much actor as magician, with a charisma that compensates for the lack of genuine sacrifice involved in his tricks. Spotlit on stage by a pure blue light, Jackman brings to the role all his stage presence, panache, and slightly unctuous pleasure in his own company. "We'll have to dress it up a bit," says the theater owner of Angier's latest trick, "the Transported Man." "Disguise it, give them a reason to doubt it." The line pokes a mischievous hole in our presumed demand for realism in movies: We want films realistic enough to be fooled, but not so realistic that we actually forget we are being fooled and mistake a gun battle, say, for the real thing. "We know that the magicians did not really crush the woman inside the box suddenly flattened before us," noted French film theorist

Magician and filmmaker Georges Méliès aimed "to make visible the supernatural, the imaginary, even the impossible," as seen in his short film *The Conjuring of a Woman at the House of Robert-Houdin* (1896).

Etienne Souriau in 1952. "But, caught up in the game, refusing to be fooled (and yet enjoying it) we refuse to believe our eyes. With cinema, we just give ourselves over to it. We delight in being credulous." So, too, with the magic of Robert Angier and the cinema of Christopher Nolan.

In the opposing corner, we have Alfred Borden (Christian Bale), Angier's opposite in every way: a gruff, rough-hewn cockney, a purist who disdains Angier's crowd-pleasing tricks and burns with a self-righteous belief in genuine magic, the real thing, but lacks Angier's skills of presentation and polish. "He's a wonderful magician," says Cutter (Michael Caine), Angier's *"ingénieur,"* the technician who helps him devise his tricks. "He's a dreadful showman. He doesn't know how to dress it up, how to sell the trick." Borden is so committed to the reality of his illusion, it has ceased to be illusion. "It's the only way to escape all *this,*" says Borden, banging a fist against the solid outside wall of the theater where he and Angier see the "Chinaman" Chung Ling Soo perform a water trick that depends on Ling Soo keeping up the pretense, even offstage, of being crippled. "Total devotion to his art, utter self-sacrifice." At first glance, what we have is a contest between showmanship and authenticity, craftsmanship and artistry, Salieri and Mozart, but the great trick of Nolan's film is that no matter how often the deck of the drama tilts, and the audience's sympathies flow from one man to the other, neither ever truly has the upper hand.

At the start, Borden is firmly the villain of the piece. Convicted for Angier's murder, he is taken to Newgate Prison, where he amuses himself by slipping his manacles and clapping them around the ankles of his jailors. "Check the locks, twice," says the warden, locking the door of Borden's cell, dank and gray, immovable. Borden's dedication to authenticity is there in the film's layered production design, use of natural light, and immersive sound design—the clanking chains of Alfred's prison, the groaning spring that locks a dove into a trick apparatus, the creaking winch of the gallows—which do so much to summon the inescapable solidity of the physical world, what Borden calls, gently banging a brick wall with his fist, *"all this."* But against *all this,* the film also pits Angier's delight in illusion with its light-fingered editing, narrative twists, and sleights of hand, all of which lend a metafictional shimmer to even the most seemingly solid events. Time and again, the sound in the picture reaches a crescendo and then falls away abruptly, leaving us staring at a simple image—a top hat, a black cat—as if to wonder what just hit us. Of all the handful of special effects in the film, none is quite as magical as the cut taking us from the

sight of Borden reading Angier's diary in his cell to the shot of a steam train rounding a bend in the Rockies in Colorado, bearing Angier on his search for the secret to Borden's "Transported Man" trick. A low sonic boom on the sound track announces the transition to this earlier part of the story, as if someone just distantly broke the sound barrier.

In this time line, Angier is alive again, traveling to distant Colorado, searching for the reclusive inventor Nikola Tesla (David Bowie) to help him crack the secret of Borden's "Transported Man" trick, and Borden is a free man. An earlier time line still shows him courting his future wife, Sarah (Rebecca Hall), as charming a rogue as Bale has given us since playing the young Jim Ballard in Spielberg's *Empire of the Sun* in 1987. Performing tricks for Sarah's nephew, he could almost be performing tricks for his own thirteen-year-old self. "Never. Show. Anyone," he advises him. "Understand? Nothing. The secret impresses no one—the trick you use it for is everything." Nolan's magicians are as divided within themselves as le Carré's spies, as unable to achieve intimacy for the same reason—a chronic addiction to secrecy. Hollowed out by their enmity for each other, the two men have more in common with each other than they do with the women in their lives. In the battle for our sympathies, however, Borden has a secret weapon: his chemistry with the twenty-four-year-old Hall, here making her American debut with a marvelously supple performance, intrigued by Borden's bravado, but not taken in by it, and secretly a little

Alfred Borden (Christian Bale) and his wife (Rebecca Hall).

amused. She is the first woman in a Nolan film with loves and affections who is not herself an object of desire or dread, her vivacity seeming to offer Borden a way out of his self-imposed maze. Teasing the secret of Borden's bullet-catch trick out of him, her face falls—"Once you know, it's really very obvious," she says—and her disappointment is like the sun going behind a cloud.

"Well, people still get killed . . ." protests Bale, crestfallen, his cockney bravado slipping, the Wizard of Oz with the curtain pulled. Thus weakened, he makes an insincere declaration of his love for Sarah, which she rebuffs. "Not today," she says, scanning his eyes. "Some days, it's not true. Today you don't mean it. Maybe today you're more in love with magic than with me. It's all right. I like being able to tell the difference—it makes the days it *is* true mean something." Bale's set of reactions as he listens to this—smile faltering, then incredulous, then relieved—is superb: He's just received his first lesson in emotional honesty.

A second diary, this time Borden's, read by Angier in Colorado, unlocks a third time line: the most distant past, relaying the events that first set the men's terrible feud in motion, a botched version of Houdini's water-escape trick, in which Angier's wife is lowered into a glass cabinet filled with water, her hands bound, and a curtain lowered over her while she tries to escape. Tying the hands of Angier's wife is Borden, whom we have heard suggesting that he could use a tighter knot—a Langford double—in the interests of authenticity. A curtain descends, and a soft snare drum taps out a pulse, as if sounding out her heartbeat, a rhythm taken over by the tick of Cutter's stopwatch. When it stops, she is dead.

. . .

By the time Nolan began production on *The Prestige*, his family had grown. His and Emma Thomas's first child, Flora, arrived in 2001; their second, Rory, in 2003; and their third, Oliver, just in time to make a small cameo appearance as Alfred Borden's baby daughter in *The Prestige*, where he must vie for the attention of a father otherwise consumed by his work: an exaggeration of the balancing act between family and work that Nolan was experiencing in his personal life. "*The Prestige* was an important film in terms of work-life balance because we'd just had our third child and Emma, even though she loved the project, was quite keen to step back and not be as involved. She wanted to be able to take more of a backseat.

Emma Thomas and baby son, Oliver, on-set.

And in the end that was not possible. I just had to drag her back into the process, because I needed her. The production was a complicated one, trying to do more for less money, we had to just kind of make it up as we went along. We had three very young kids, and she was able to pull it all together—a very complicated production, on location, on a tight budget. That, to me, was the turning point. That was the point at which she was either going to say, 'Yeah, it's too much,' or she was going to find a way to balance everything."

Among the changes Nolan made in his final pass through the script, after Jonah had finished, were the portrayals of the women—Olivia, the treacherous assistant and lover of both men, played by Scarlett Johansson, and Borden's wife, Sarah, who was to be played by Hall. "She sent an audition in on tape that our casting director, John Papsidera—whom Emma and I have worked with for many years—was like, 'You've got to take a look at this.' We said, 'Wow, that's something, she's pretty incredible.' Got her in, added her into a scene with Christian, workshopped it, just the three of us, and she was fantastic. I did the last draft of the script myself, and made some fairly significant changes. Jonah had really done all the heavy lifting over the years, but Emma had talked to me a lot about the credibility of the relationships with the women, so I did that thing in my rewrite that I've come to value, which is, you find the knottiest problem you've got and you embrace that feature of it. It was interesting, because,

when the film came out, I remember I went to see Ricky Jay perform and we were walking up to see him after the show. He had other guests and they started talking about how much they liked *The Illusionist*, and how much they didn't like *The Prestige*. They didn't know, obviously, who we were, but one of them said, 'Why did they have to kill the wife?' And I thought about it, because that had been something that I put into the story. When I look at it, it could not be more valid. It was a very patriarchal society. Women didn't have a lot of options. And she's dealing with, effectively, a madman for a husband. How would that relationship actually function with any kind of reality in that story? That's why she kills herself. She'd have to."

After five years of writing and rewriting, production finally began on January 16, 2006, in Los Angeles, on a tight budget of just $40 million, less than that for *Insomnia*, enforcing Nolan's favorite conditions, creatively: improvisation within a set of restrictions. Fresh from the slog, and expense, of creating Gotham in an aircraft hangar outside London for *Batman Begins,* production designer Nathan Crowley repurposed four old theaters in downtown Los Angeles for the interior locations, with only one set built from scratch: the cramped under-the-stage section that houses the steam-powered hydraulics machinery that makes the larger illusions work. Cinematographer Wally Pfister shot as much as he could with handheld cameras with anamorphic lenses, using natural light as much as possible so that he could run in and capture the scene with a naturalistic, documentary feel, always at eye level with the actors. The actors never knew whether the camera was on them or not.

"This is often the case in films, but you're fighting the genre—or you're fighting what people envision it as. What I was saying the other day about *Insomnia* being a kind of wilderness movie or a fish-out-of-water story—we fought that, every step of the way. *The Prestige* was the same. Every time you cut to the exterior of a building or a street scene with wheel noises, like you're used to on the BBC, it's an awful thing. So, I would say to Richard, 'Look, just make the fucking thing sound like spaceships; just find some interesting sound for the wheels, but just don't make it sound like wheel noises.' You can fight it, to a degree, but people think you're a bit mad. The whole thing about a period film, shot in Los Angeles, on location, for Victorian London, was about, again, how could we *not* have this look like Covent Garden, how do we *not* have it look like *Foyle's War*. And doing it in L.A. was fantastic, because it was just invigorating. It was so challenging. That was coming off the back of where we'd shot *Batman*

Begins and we'd done an American city almost entirely in London. So, we were, 'Okay, let's do the opposite.' I think the best bit of design in that film—and I'm very proud of the design in that film; I loved what Nathan did with it—it was one of those weird moments together; we were looking at the back lot of streets at Universal. And then, at some point, we went into one of the structures and behind it was this vast wooden set of stairways. You don't normally shoot there. But that's the thing we made into the backstage area in the film. It's actually backstage on a movie set. So, we had these dressing rooms and they've got staircases going up every which way, they've all got platforms, and because we put lights behind the windows of the facades, it was really cool-looking. That's what you get when you have to find things that exist in the real world, rather than just create them from nothing. The fact that you take a little pride in the trick can actually form the design or quality of the thing, as well. So, our Victorian prison is on Olvera Street in downtown Los Angeles, which is mad, but that's what we did. But it works, I think, beautifully."

<center>• • •</center>

Nolan's most densely structured film to date, *The Prestige* is, like many a Nolan film, more complicated to describe than to watch. With its four different time lines, its pair of stolen diaries, its flashbacks within flashbacks, its doubles and doubles of doubles, the film is so crammed with feints and twists, you can almost feel the larger movies coming down the pike, but the emotional through line is easily understood: obsession. "What knot did you tie?" Angier demands of Borden at his wife's funeral, and he cannot believe his ears when Borden replies that he does not know. At this point, the pendulum seems to have swung Angier's way: Cut down by grief, the slick showman has acquired unforeseen depth. "Go home. Forget this thing. I can recognize an obsession; no good will come of it," Angier is told by Nikola Tesla, the film's one historical personage, the Slav inventor of the alternating current, whose reputation would eventually be dashed by his rivalry with Thomas Edison. In Bowie's drily amused performance, Tesla is an avant-gardist toiling away on the outer limits of science, issuing a stark, Faustian warning about the machine he is developing. "I add only one suggestion on using the machine: Destroy it. Drop it to the bottom of the deepest ocean. Such a thing will bring you only misery." Nolan had managed to cast Bowie, whom he had idolized since he was a teenager, only after a last-minute rewrite of the script.

"When I tried to cast him, he said no at first, and I knew his agent, so I called him up and said, 'Look, I never do this, but I want to ask him again. I want to go and try and convince him. Is there any way to do that?' He agreed to meet me, and I flew to New York and I met him, and, thankfully, managed to convince him. It's the only time I've ever gone back at somebody who said no, because generally they've got their reasons and you don't really want to convince somebody and then have conflict

Nolan observes Johansson and Jackman on the set of *The Prestige*; Nolan traces the position of Christian Bale's hand before swapping him with his double.

on-set, but there was just no one who could play the part in the way that he would with the same resonances. I think there's a lot in common with Bowie's reputation and the mythology around him. Tesla, in a way, is the man who fell to Earth. There have been a lot of Tesla projects in development over the years at different studios; he is a fascinating figure but a little hard to take on as a subject, but *The Prestige* offered this very tangential way of looking at the character, viewed through the prism of magic and deception, a great genius ahead of his time, but also right out of his time, which is why Bowie seemed exactly the guy to play him. I've worked with a lot of very big stars and they've all become regular people in my mind, because you get to know them when you work with them. Bowie's the one exception, the only one who was just as elusive at the end of working with him as he was at the start. The whole crew, everyone, was fascinated by the guy. He was being perfectly friendly, I mean a very lovely guy, but he just carries this weight of everything he has achieved. It's one of the things I'm proudest of is to be able to say I worked with him."

Throughout the production, Bale and Jackman conducted a long-running series of debates over whose character was the lead in the film. "To me, it was very clear that my character had the sincerity, the substance, was really talking the truth here," said Bale. "And then Hugh would kind of look at me and go, 'What the hell are you talking about? That ain't the case at all.' And then he gave me very good arguments about why his character was absolutely fantastic, a really nicely reasoned and very almost altruistic argument, and why mine wasn't." By the time the production ended, on April 9, neither man had been able to convince the other.

"One of the difficulties of the film is that it was so truly balanced between them," says Nolan. "It's fallen out of favor as a story model, but *Chariots of Fire* has that. In truth, it's a false choice. You have to be both men, or you have to find a way to be both, or try to, because they're not opposites; they're different facets of the same thing. So Borden is the artist, I suppose you'd say. Angier is more the craftsman or the showman. Borden is an artist doing things for his own sake; he's contemptuous of people. You meet people like that in every field, but particularly in artistic fields, people who are so contemptuous of the fact that the world doesn't get it, or doesn't understand. There's massive integrity to that character, and there's a deeper appreciation of magic that Angier doesn't appear to have. But Angier understands something vital to the whole thing, which Borden never got. Right at the end, and this is something that Jonah very

much put into the script before I took it over, there's this moment that he absolutely nailed—that I absolutely love. 'The audience knows the truth: the world is simple. It's miserable, solid all the way through. But if you can fool them, even for a second, then you can make them wonder, then you get to see something really special . . . it was the looks on their faces.' When I first read that in the script, I was like, 'That's great.' He's talking about the nature of magic and how you can make people believe there's more to it. I think that's exactly what a great film will reveal, which is always, the world is way fucking worse than you think it is and you missed it. It should be depressing. The reason it's not is, we want the world to be more complicated than it is. It's pleasurable, because what it's really saying is there's more to this place than meets the eye. You don't want to know the limits of your world. You don't want to feel this is all there is. I make films that are huge endorsements of the idea that there's more to our world than meets the eye."

. . .

In the spring of 1999, as Nolan was wrestling with the final shooting draft of *Memento,* the British painter David Hockney was studying Ingres's *Portrait of Madame Louis-François Godinot* at the National Gallery in Washington, D.C. Hockney knew how difficult it would have been to create a likeness in the few hours Ingres had to make the sketch—visiting Rome between 1806 and 1820, the Frenchman sketched fellow travelers as they paused for lunch—but the sketch didn't look sketched at all; it looked completed. He found himself mesmerized by what seemed like the complete absence of hesitation or trial and error. Was it simply Ingres's uncanny skills of draftsmanship, or had he, like the Dutch painter Vermeer, used an early version of a camera lucida—basically a prism that projected an image onto a flat surface that could then be traced with a brush—to achieve the portrait's uncanny photographic realism? It would certainly explain the lack of hesitation in the Ingres sketch as well as the size of Madame Godinot's head. He might have used a camera lucida to briefly sketch the features of the face, thought Hockney, and then completed the facial image through direct observation.

Increasingly convinced of his thesis, Hockney returned to his studio in L.A. and created a "Great Wall" of pictures, ranging from the Byzantine period to the Post-Impressionists, poring over the creases in the

clothes, the glint of armor, the softness of angel wings, and finding other optical lacunae: images that were too large, or somehow "out of focus," or lit with the strong light sources necessary to make lens projection work. In Caravaggio's *Supper at Emmaus,* Christ's right hand is the same size as Peter's, although it is supposed to be nearer to us; and Peter's right hand seems larger than his left, which is also nearer, while in the same painter's two paintings of Bacchus, the demigod switches the hand with which he holds his wineglass. Caravaggio's favorite models, Mario Minniti and Fillide Levasti, at a certain point in the artist's career, also switched from being right- to left-handed. Hockney found a similar rash of left-handed drinkers in the works of Giotto and others. Mirrors flip left and right, so maybe they, too, were using optics. QED.

"One of the things Hockney does is he takes certain paintings and he flips them and asks, 'Don't they look better that way?'" says Nolan, who was introduced to the painter by his friend Tacita Dean, the artist and photographer. "The wonderful thing about Hockney, when you meet him, there's no bitterness or anger about the art establishment's rejection of his discoveries. He's not a revolutionary. He's not judging or diminishing the achievements of the past. He's interested in understanding what actually went into it, what the techniques were. We've grown up in an era where the dominant imaging format is photography, which is single-point perspective. In film, it's not. In film, the camera's moving from shot to shot. There are all kinds of ways in which the cubist approach to imagery is built into the grammar of filmmaking. He's realized there's this very specific moment

Ingres's *Portrait of Madame Louis-François Godinot*, which British artist David Hockney suspected was completed using a camera lucida. "Perspective is really about us, not the object depicted," he wrote in *The History of Pictures.* The art establishment was outraged.

Fig. 6.—THE CAMERA LUCIDA.

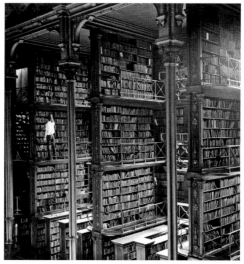

where everything changes, essentially from a pre–photographic eye to a photographic eye. We're still very imprisoned by this notion that this is how we see. I think we're doing that right now with the computer. We have built these machines that are modeled on the brain, essentially, or so they tell us. The truth is, we don't have the least understanding of how the brain relates to the mind—how it exactly works."

Nolan's agnosticism with regard to new technologies is far-reaching. An absolute believer in the difference between photographic and computer-generated imagery, he prefers the grain and texture of celluloid to the flatness of digital, location shooting to sets, and physical sets to computer-generated backdrops. The appeal of his films in some ways rests on the same principle behind the popularity of boutique hotels, lo-fi recording methods, "glitch" music, and Etsy: that in the information age, more value, not less, will accrue to precisely those elements that cannot be cut and pasted—secrets, original ideas, plot twists, the integrity of the photographic image. "I've researched a couple of stories online, *Dunkirk* being the most obvious example, and you start to recognize the language that's been cut and pasted from one source to another," he says. "You just hit this wall. Google are not as powerful as people think

Jorge Luis Borges, whose story "The Library of Babel" featured an "infinite and cyclic" library. "The certitude that everything has been written negates us or turns us into phantoms," he wrote; How many times did Kennedy go golfing as president? Kennedy, press secretary Pierre Salinger, and K. Lemoyne Billings golfing at Hyannisport.

in terms of information collation. They're more powerful than people realize in all kinds of areas, such as collecting data on your movements. They're very good at that. But in a data search, the outcome is always limited. An interesting experiment would be to walk into a library, and go to a book, open the book at a random page, find a fact or piece of information, write it down. Do that ten times, and then go online and see how many of those ten you can find. Our feeling is that 90 percent of the information is online. I have a suspicion the real answer is 0.9 percent."

Another challenge I find hard to resist. A few weeks later, I head off to the Brooklyn Public Library on Grand Army Plaza, thinking very much of the Borges story "The Library of Babel," about an infinite library containing "all that it is given to express, in all languages," which partly inspired the tesseract in Nolan's *Interstellar* (2015). A boundless number of hexagonal galleries, with vast air shafts between, surrounded by very low railings, are home to thousands of scholars, but thousands abandon their native hexagons and rush up the stairways to dispute one another in the narrow corridors; some strangle one another, or are cast down the stairways; others return extremely tired, speaking of a broken stairway that almost killed them. "Others went mad," writes Borges. In other words: a new Inquisition. These days, it reads like an allegory of the coming of the Internet.

The Brooklyn Public Library has numbered, open book stacks. Using a random number generator, I choose first the book stack, then the book, then the page of the book, and opening to that page, I choose the first fact my eye falls upon. In some cases, I hit a dead end in the form of an illustration or a recipe or something that can't be quantified as a fact, but eventually I have my ten facts, and the next time I meet with Nolan, I slip them across the table.

1. A fish in the mouth of an Eskimo mask represents the wish for abundant game or good luck with hunting.
2. When using a soldering iron on Perspex to make a print, fumes necessitate the wearing of a gas mask.
3. Jack Kennedy played golf only three times while in office, a result of both his busy schedule and back pain, all three times in the summer of 1963.
4. Oriental rugs are meant to be walked on with bare feet.
5. When physicist Niels Bohr took colleague Paul Dirac to an Impressionist exhibition and asked him which of two paintings

he preferred, the Englishman replied, "I like that, because the degree of inaccuracy is the same all over."

6. In the fourteenth century, the British House of Lords did not accomplish much in terms of legislation. The only pursuit that truly engaged them was the persecution of some royal favorite, usually homosexual. This normally ended in violence.

7. Painter John La Farge's response to rising industrialism was to promote artistic cooperatives along English lines.

8. In the summer of 1924, Nebraska governor Charles Bryan suspected that urban bosses, particularly Tammany bosses, were planning to extend their "evil immigrant rule" throughout the country.

9. The Thai-Chinese conglomerate Charoen Pokphand started when its founder, Chia Eksaw, came to Bangkok in 1921 with little more than a signboard, a ledger, and some vegetable seeds.

10. A million and a half Muslims lost their homes during the Serbian blitz.

"The one about Jack Kennedy golfing only three times while in office, I couldn't find online, but I did find reason to doubt it. Apparently, he gave out lots of fake stories about how often he golfed. And the factoid about only doing it three times was from a fairly facile picture book about Jackie Kennedy's memorabilia. So I wasn't sure how much it could be trusted," I tell Nolan.

"Ah, but this is not about facts, but information," says Nolan. "The information you learned was that Jackie Kennedy wanted to get across the idea that her husband had only golfed three times. Which is itself useful information, even if it's wrong. It could well be propaganda. But propaganda is information, too, regardless of whether it's a fact or not."

"Well, in that case, the only piece of information I could find online was Rachel Maddow's 'a million and a half Muslims lost their homes during the Serbian blitz.' That was in *The Washington Post*."

"That's pretty interesting. Well done. It's about what I always imagined it would be. It would be interesting to see what averaged out if you did a larger sample, without spending your whole life doing it. I don't think ten times probably is enough. Of course, the other aspect of that is you can look at that book, look at the bar code, see who published it, when they published it. Get some sense of their agenda. When you find facts online, it can be harder to figure out the attribution. . . ."

I am beginning to get flashbacks to the Borges story, and a vision of the rest of my life spent in the stacks of the world's libraries, poring over the bar codes of books in order to prove Nolan's thesis.

"I think ten is enough," I say.

He shrugs.

"Maybe I'm the only one who cares about this, but we're being controlled. Not in the archetypal paranoid way; it's not deliberate control. It's just the way the business model evolved; we are being fed. I'll give you another assignment. This is one that won't take you very long. Google something. See how many results come up, then see how many of those results you can actually access. If you google some person, some famous person, and you get four million results, how many of those results could you access?"

"Now?"

"It won't take long, I promise you. Google some famous person and say you get four million results; it tells you, 'Okay, we found four million results.' Then see how many of those results you could access."

I open my laptop and google "Christopher Nolan's next film," and in just 0.71 seconds 2,480,000 results come up, including, "What is Christopher Nolan's next film after Dunkirk?" (Quora); "Christopher Nolan's Next Movie: What Do We Want It to Be?" (Observer); and "Suspense over Christopher Nolan's Next Project" (Blouin Artinfo).

"Okay, now just go down to the bottom. Go down to the highest page number; do that as many times as you can and see what comes up."

I scroll down to the bottom. There are nineteen pages. I keep doing it until I get to the nineteenth page. There is no page twenty. I feel like Truman bumping up against the edges of his world at the end of *The Truman Show*.

"So what number have you got there? Nineteen? How many to a page? Twenty?"

"More like ten."

"So 190 results. Out of how many did it originally say?"

"It said 2,480,000."

"So a fraction of the advertised amount. I remember asking my dad about this when I was younger. We were on the tube. I said, 'Do things keep developing in the future?' He pointed out—this would have been in the mid-eighties probably—that you get these mature technologies. He said aviation's one. If you look at commercial aviation, it hasn't really changed much since the 747. Concorde came along, but even then really

wasn't taking hold. If you fly on the 787, it's fundamentally not very different. The differences are things like lighter planes, longer range; it's incremental. The radical era of shifting commercial aviation was in the sixties. Think of the end of *Thunderball,* where you see Bond driving his hydrofoil. I went on a hydrofoil to Macau from Hong Kong many years ago—it was a wonderfully exotic thing. They were getting pretty old at that point. Now when you go out there, it's just various high-speed catamarans; racing yachts now lift out of the water. The hydrofoil was from the fifties, I think. It is actually an older technology. It's come around again. It relates to my process because we live and work in an analogue world. *The Prestige* was the first film where we were expected by the studio to digitize the negative and edit electronically. We had a lot of arguments with the post-production team at Disney, but we carried on doing our test screenings on celluloid. From *The Prestige* on, to this day, we've never converted to the other workflow used by most of the industry. We've continued to shoot on film, edit electronically, then take the frame numbers and cut the film by hand and that's what goes out. *The Prestige* was very much the point at which we separated from the rest of the industry—or rather they separated from us."

Nolan gives direction to Hugh Jackman on location for *The Prestige.*

By 2006, when Nolan released *The Prestige*, George Lucas had just finished the third of his prequels to the original *Star Wars* saga, completed with the help of six hundred digital artists, using computers whose amassed power was a little less than that used by NASA but more than that used by the Pentagon. Even their titles suggested the cut-and-paste powers of multiplication enabled by the computer: *The Phantom Menace, Attack of the Clones*. As David Denby wrote in his review of *X-Men* in *The New Yorker*, "Gravity has given up its remorseless pull; one person's flesh can turn into another's, or melt, or become waxy, claylike, or metallic; the ground is not so much terra firma as a launching pad for the true cinematic space, the air, where bodies zoom like projectiles and actual projectiles (bullets, say) sometimes move slowly enough to be inspected by the naked eye. Roll over, Newton, computer imagery has altered the integrity of time and space." The ground was ready for a counterrevolution. Upon its release in 2006, *The Prestige* puzzled some of Nolan's newer fans, fresh from *Batman Begins* and expecting another summer blockbuster with all the trimmings. What they got instead was a grave steampunk thriller issuing Faustian warnings about the pursuit of new technology, a film that was itself something of a fogyish hymn to the cinema's artisanal powers of illusion—light, sound, editing—right down to the photochemical printing of the negative. Even its genre was elusive. What was it, exactly, a period thriller? A murder mystery? A whodunit? Science fiction with a strain of gothic? Nolan's properly sui generis film, *The Prestige,* is the first of his films that cannot really be explained without reference to its director—a Christopher Nolan film.

Like many Nolan films, it ends with a couple of plot twists going off like grenades, the revelation of the first distracting you for just long enough to allow the second, greater impact. In the second, we learn of the secret of Angier's "Transported Man" trick, which leans heavily into the technological future and brought some complaints that Nolan had changed the rules of his movie, but it is the first twist, in which we learn of Borden's secret, and the sacrifice he has made in the interests of authenticity, that bears Nolan's distinctive shimmer—a classic piece of misdirection, with the answer hidden in plain view all along. Nolan underlines the point with a montage that rethreads key portions of the movie we have just watched past us again, like a magician passing his hand through a metal hoop to

show that it is indeed solid. "What's funny about *The Prestige* is we had taken great pains to try and indicate in the first act that there is real magic afoot in the film," he says. "We tried to be very up front with that, but a certain segment of the audience absolutely refused to accept that play and saw it as cheating. It is just the nature of the beast. When Angier says 'real magic,' that's a true paradox. There *is* no real magic. There is reality and there's magic. Magic is illusion. Magic is not supernatural. As soon as something is understood by science, it's not supernatural anymore; in becoming reality, it is no longer magic. My editor on *Memento*, Dody Dorn, had a very interesting take on it. M. Night Shyamalan's movie *The Sixth Sense* came out while we were editing that film, and she said a thing to me that I have never really forgotten; she said, 'The twist makes what you've seen before better.' I filed that away—that's a gem. That's exactly right. Because most of the time the twist invalidates what you've seen. So if you look at Adrian Lyne's *Jacob's Ladder,* for example—fantastic movie, but audiences did not embrace it—it was the same twist as Shyamalan's movie, effectively, but it invalidated what you'd just seen. In *The Sixth Sense,* you've seen him arguing with his wife; you've seen the wife rejecting him all throughout it. Then you suddenly realize she's not been rejecting him; she's been mourning him. So the story you've seen, not only is it better, it's more emotional. That's why it's a remarkable twist. It's not just that it's a twist. It's what it does for the story you've seen. So for it to bring fascination, joy, and entertainment to an audience, there's got to be more

Tim Robbins in Adrian Lyne's *Jacob's Ladder* (1990).

to it. It's got to be something about it that enhances everything that's come before."

"What about the ending of *Psycho*?" I ask. "Does that pass the Dody Dorn test?"

"Oh absolutely. The ending of *Psycho* magnifies everything you've seen because you think back to the shower scene, the whole conversation in his little back office with the little sandwiches—the twist makes what you've seen before much richer: Rather than the murder being committed by a character you never actually meet, it's been committed by somebody you spent a lot of time with. It's more horrifying. You've seen more than you realized you had. You've seen the murderer; you've seen him spying through the peephole."

"What about *Vertigo*? It's kind of the same twist in a way: Two people are, in fact, one."

"I'm a big *Vertigo* fan. I think there's a lot of *Vertigo* in *Inception*, actually. The way in which the twist is revealed in *Vertigo*, for example, breaks all the rules. Hitchcock just tells the audience that it's the same woman,

right after Jimmy Stewart's mourned her death. You don't find it out with Stewart. You have that section of the film where you're completely separated from his point of view, which is a very dangerous road to go down, but Hitchcock makes it work. What he does is to make us look at what Stewart's doing and what he's going through in a very different way. I don't think you judge Stewart quite as harshly as you would if you believed that it was a different girl and he was forcing this change of hairstyle, change of clothes, and so on. The way he behaves toward her is extremely questionable. But I think the fact that you know that she has duped him makes that okay, and you're actually wanting him to get closer to the truth. He's not trying to manipulate or turn her into somebody she's not. He's trying to turn her into somebody that she *was*. So that makes it play differently.

But this is the thing Hitchcock did time and time again. He breaks all the rules, of mystery, and suspense, and yet it works magnificently, so there's very little you can learn from it. Which is probably one of the reasons *Vertigo* has never been bettered. I just don't think anything's come close."

· · ·

In 1964, the cognitive scientist Roger Shepard, working at Bell Labs, the same New Jersey laboratory that gave us the transistor and the laser, made an intriguing observation having to do with our apprehension of musical pitch: Even though Shepard knew, intellectually, that the intervals in a diatonic scale—do, re, me, fa, sol, la, ti, do—are not equivalent to one another, some separated from one another by a full tone, others by a semi-tone, he tended to hear the successive steps as equal, as in a staircase. Even when he used a computer to generate a series of eight tones that divided the octave into exactly equal intervals, the results sounded all wrong and still nonequivalent. The illusion of stepped notes was impossible to over-ride. His next thought was a form of notation that represented this, not in traditional rectilinear fashion, along a one-dimensional line, as with a stave of music, but by means of a cylinder or helix, with notes separated by an octave—two C's, for example, one oscillating at twice the frequency of the other—directly above and below one another on the cylinder (see diagram). Using a software program, Shepard synthesized a bank of tones, each of which could be varied by means of its pitch and "height," and

OPPOSITE Kim Novak as both Judy Barton and ABOVE Madeleine Elster falling from the bell tower in Alfred Hitch-cock's *Vertigo* (1958). In Nolan's estimation, Hitch-cock's film has never been bettered.

asked it to play a series of ascending scales, or glissandi, each starting at staggered intervals, and he heard something remarkable: an impression of infinite ascent, rather like M. C. Escher's never-ending staircase, in which the notes seemed to be continually rising, even though logically no keyboard could accommodate such a feat. "A special set of computer-generated complex tones is shown to lead to a complete breakdown of transitivity in judgments of relative pitch," he wrote in an article entitled "Circularity in Judgments of Relative Pitch," published in *The Journal of the Acoustical Society of America*. In other words, the ear has lost all sense of which way is up.

The resulting auditory illusion—or Shepard tone, as it came to be called—has since been found in the work of many musicians and composers: Bach's Canon a 2 per tonos from the *Musical Offering* and Fantasia and Fugue in G Minor, for organ, BWV 542, both of which feature a similar effect; Pink Floyd's "Echoes," a twenty-three-minute song, which concludes with a rising Shepard tone; Queen's 1976 album, *A Day at the Races*, which begins and ends with one; Robert Wyatt's fading piano outro to "A Last Straw," from his 1974 opus *Rock Bottom;* and Beck's song "Lonesome Tears," on his 2002 album, *Sea Change,* which ends with an orchestral Shepard scale. It was the Beck song that Nolan heard on his car radio one day while in preproduction on *The Prestige,* prompting him to call the film's composer, David Julyan, in London, to ask him what it was. "I called him and I played it for him over the phone. I was like, 'This is the kind of thing we need to do. How do you do that?' And David recognized it immediately; he said, 'Oh, it's a Shepard tone and this is how it works.' So we applied that to the score of that film. I then applied it to various things, including the sound of the Batpod in *The Dark Knight* and ultimately on *Dunkirk,* where I wrote the screenplay in order to literally find the cinematic or narrative equivalent of what the Shephard tone did musically. But it's there in *The Prestige.* David and Richard did a fine job on that."

With the addition of sound editor Richard King, Nolan and Thomas finally had the filmmaking team around them—including Zimmer, cinematographer Wally Pfister, production designer Nathan Crowley, editor

Nolan first heard a Shepard tone, an auditory illusion giving the impression of ceaseless ascent, on Beck's 2002 song "Lonesome Tears" and applied it to the score of *The Prestige.*

Lee Smith—that would help in their coming assault on the Eiger of big-budget Hollywood filmmaking, starting with the much-anticipated sequel to *Batman Begins, The Dark Knight.* As postproduction on *The Prestige* wound down, Nolan turned his attention to his plans for *The Dark Knight,* setting up production with Nathan Crowley in his garage to work on the film's design and David Goyer working on the treatment with him in the office. Their working environment had enlarged considerably since the first film. Where once there had been only a cramped space with an old partners' desk in a small writing den, linked by a single door to an even smaller model-building area, now there was a fully equipped screening room, a real office, and a separate building that housed the art and model-making department located at the bottom end of the garden, almost the mirror image of Nolan's house, the two residences sitting back-to-back. To anyone familiar with the themes of his films, the effect was instantly recognizable: Nolan's home now had a doppelgänger.

"I didn't know the *Dark Knight* films were going to be a trilogy when I started," he says. "I never wanted to go sequel to sequel to sequel. But I think it was clear to me, even before I finished the first film, that they would give me a certain amount of time if I wanted to do another film. I didn't know whether I wanted to or not. It was really about timing and figuring out, Okay, if I'm going to do something of my own, or maybe not on my own—but *The Dark Knight* was very much mine, or it felt very much mine to me, something original, original material—I knew they wouldn't give me more than three or four years to make it."

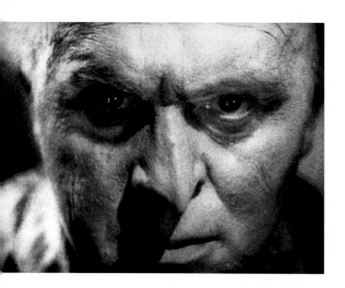

SEVEN

CHAOS

IN APRIL 1933, Fritz Lang was summoned to the offices of Hitler's head of the ministry of propaganda, Joseph Goebbels, on Wilhelmsplatz, across from the Chancellery and the Hotel Kaiserhof. He dressed up for the occasion, putting on striped trousers and a cutaway jacket with a stiff collar, but as he was walking down the long, wide corridors, the walls black—no pictures, no inscriptions, the windows so high that you couldn't look out of them—he found himself starting to sweat. Rounding a corner, he saw two members of the Gestapo carrying guns. He came to a series of desks, and finally to a little room, where he was told, "You wait here."

The door opened onto a long, long office, with four or five big windows spaced along one wall, and there, at the very end of the office, far, far away, was Goebbels, sitting at his desk in his Nazi Party uniform. "Come in, Mr. Lang," said the *Reichspropagandaminister*, who turned out to be, said Lang, "the most charming man that you can imagine."

The two men exchanged formalities and sat down for a long conversation, in the course of which Goebbels apologized profusely for what he was about to do, which was ban Lang's recently completed film *Das Testament des Dr. Mabuse*, a sequel to his famous 1922 two-part silent film, *Dr. Mabuse, der Spieler (Dr. Mabuse, the Gambler)*, about a master criminal with "psychic eyes," the power of hypnotism. Edited while the Reichstag burned, it has been long admired by critics for its spooky powers of pre-

cognition, with its portrayal of a society under the hypnotic sway of a violent madman. ("All of these things I collected from newspaper clippings," Lang later said.) Lang's film starts with Mabuse locked in a padded cell, seemingly unconscious, where he fills up notepads with rambling hieroglyphics, spelling out new crimes for his gang of confederates outside the asylum to perform—burning and bombing attacks on railways, chemical factories, banks. There was nothing wrong with the plot development, said Goebbels, but at the end, the villain should not have gone insane. "It was just the ending we didn't like," said the minister. He ought to have been "killed by the fury of the outraged mob." Better still, the Führer himself should have defeated Dr. Mabuse and saved the world order.

As they talked, Lang watched the hands of a huge clock outside one of the windows moving very slowly as the afternoon went by. Goebbels went on to reassure him that the Führer had "loved" *Metropolis*, and *Die Nibelungen,* which made him weep. " 'Here is a man who will give us great Nazi films!' " Goebbels quoted Hitler as saying, and suggested Lang head up a new agency supervising motion picture production in the Third Reich. Lang later said that it was at this point that he realized the depth of the trouble he was in.

"Mr. Minister, I don't know if you know that my mother, who was born Catholic, had Jewish parents," he protested.

"We know about the flaw you have," Goebbels replied coolly, "but your qualities as a film director are so exceptional that we intend to make you the president of the Reichsfilmkammer."

Glancing at the clock, Lang saw that it was already too late for him to be able to make it to the bank and withdraw the money he would need for what he was about to do next. He made his excuses, told Goebbels he would think it over, went home, packed a gold cigarette case, a gold chain, cuff links, and all the money he had in the house, and departed for Paris the next day.

It is one thing to make a film interpreted by critics as a prophetic critique of fascism. It takes another level of genius to make an antifascist film that is also interpreted by fascists as the work of a pro-fascist filmmaker. Such is the well of ambivalence from which *The Dark Knight* was also drawn. A studio-farmed superhero sequel that is also an expression of a deeply personal vision, a defense of law and order that is also in thrall to the dogs of anarchy, a portrait of a society in which authoritarian and antiauthoritarian impulses are set at each other's throats for a two-hour-

and-thirty-minute death match, a film celebrated by both the Right and Left for what they perceived as its endorsements of their ideas, the film is Nolan's masterpiece of double-jointedness, sleek and pantherish. "*Mabuse, The Gambler* was a huge, huge influence on *The Dark Knight*," says Nolan. "A marvelous film. That to me was the direct feed because that gave us the original master criminal. I had Jonah watch *Dr. Mabuse* and said to him, 'This is what we're going to make the Joker and he's going to be the engine of the story.' He totally got it. My brother's early drafts had a lot of impracticalities and a lot of amazing ideas, but the thing that he absolutely nailed was the character of the Joker. He just had that down. When Jonah came back with his draft, it was like, 'Yeah, there's still work to do,' but the Joker was absolutely there and his effect on the story. I had completely forgotten I made Jonah watch *Mabuse*, in fact, because it's quite long—four hours or something—but I had a funny experience when I showed the kids. I hadn't seen it in years. We got through the whole thing, four or five hours, or whatever it is, and I said, 'Why doesn't somebody make films like that now?' And then I realized I had. Oh, okay, *you* did that. That's what I spent ten years of my life doing."

"I feel like a state within a state with which I have always been at war!" declares the antihero of Fritz Lang's *Dr. Mabuse, The Gambler* (1922) and *The Testament of Dr. Mabuse* (1933), both influential on *The Dark Knight* (2008).

The Joker arrives in Gotham in the very first scene of *The Dark Knight*, like a dark thought or a genie summoned by the hard, clean lines of the Gotham street in which he appears. He is first seen standing with his back to us on Franklin Drive, in the heart of the Chicago Loop, his figure placed in the middle of the frame and standing out against the clean, symmetrical lines of the architecture around him, while the camera dollies in for a shot of the clown's mask he is holding in his left hand. His immobility is eerie: What is he waiting for? A van pulls up in front of him. He gets in. The movie starts.

Originally created by Jerry Robinson, Bill Finger, and Bob Kane in *Batman* number 1 in the spring of 1940, where he was described as "a grim jester," the Joker drew inspiration from Paul Leni's silent expressionist classic *The Man Who Laughs* (1928), about a freak show attraction (Conrad Veidt) whose face has been disfigured by his father's enemies, leaving it in a permanent grin. The character's circus-show origins are what stuck with Hollywood, in iteration after iteration: his brightly colored suits, his clown makeup, and the story of how he got it. Nolan saw instead an anarchist, moving through the story like the shark in *Jaws* or a serial killer, a force of nature driving the film from beginning to end without letup or explanation, motivated solely by the desire to sow chaos. Rather than go bigger than *Batman Begins,* geographically, they would go smaller, tighter, more confined. "You have to look at scale in a different way," Nolan says. "*Batman Begins* had been as big as we could make it. I knew we couldn't stuff any more in, geographically. So you have to look at the scale in a different way. What I wound up doing is looking at it differently in terms of storytelling and cinematography. One of the biggest epic films I have ever seen is Michael Mann's *Heat*. That is a true Los Angeles story, just wall-to-wall within the city. Okay, we'll make it a city story. We're going to shoot in a real city, with real streets and real buildings, because the scale of that can be massive. We are going to use IMAX cameras so we can shoot the full height of the buildings and we're going to give you an antagonist who's interfering with the very fabric of the city. Just from the way we shoot it, the Joker walking down the street will be a huge image. *Heat* was very much an influence, because Mann is a fanatic for architecture, too; he understands the grandeur of a city and how it can become a kind of epic playground. I don't think we realized what an icon that image of the

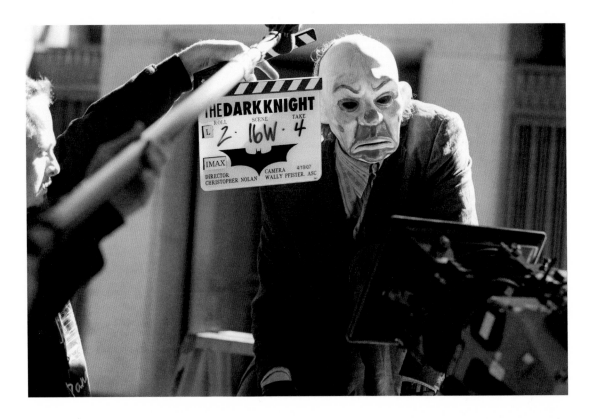

Heath Ledger as the Joker shooting the first scene of *The Dark Knight*.

Joker on that street would be. That's the thing about iconography: You try and build it consciously in all films, and sometimes it's something you know, but sometimes you don't. We put a lot of thinking in it, it wasn't unplanned, but it wasn't until we saw the IMAX footage that we really knew it."

The IMAX superhigh resolution 15/70 format Nolan decided to use is traditionally reserved for nature documentaries about climbing Everest, traveling through the Grand Canyon, or exploring outer space. Giving an immersive density of detail but an extremely shallow depth of focus, the cameras were incredibly heavy—over one hundred pounds—unwieldy, even on a Steadicam rig—and used enormous film stock that could shoot a maximum of two-and-a-half minutes of footage—a normal 35mm film reel can shoot for around ten minutes—that took four days to process. The first five days of shooting in Chicago, at the Old Post Office, for the pro- logue, in which the Joker and his gang pull off a bank heist wearing clown masks, like Sterling Hayden's thief in Stanley Kubrick's *The Killing* (1956), amounted to "IMAX School" for the filmmakers as they all learned how

to deal with the weight and operation of the cameras. Playing one of the bank managers was William Fichtner, one of many borrowings from Michael Mann's *Heat*. "The thing that always fascinated me in *Heat* was the moment where they slice open the vacuum-sealed money, and then they zip up the bag and smash it against the floor so the money breaks up and they can then carry it. I don't know where he finds this stuff, but Michael [Mann] is a research fanatic. It's a fascinating detail in that movie, where you think, Yeah, that's what you would need."

After the first week, production moved to England, where interiors like Gotham City's police station were shot on location near Smithfield in London for the interrogation scene in which Batman attempts to beat the whereabouts of his kidnapped colleagues out of the Joker. From London, production moved for two months back to Chicago, with Nolan and his crew pulling as many visual possibilities out of the streets and buildings as they could. "My assessment of archi-

"If you take a chance, be sure the reward's worth the risk," says Johnny Clay (Sterling Hayden) in Stanley Kubrick's *The Killing* (1956); Robert De Niro in Michael Mann's *Heat* (1996), whose use of urban architecture to frame an epic battle was influential on *The Dark Knight*.

tecture has shifted as I've gotten older," says Nolan. "I think a lot of that is about confidence, because it takes more confidence to strip things away than it does to have visual camouflage. Probably because he's a little bit older than me, but Nathan has a slightly more cynical idea about design clichés. He is very much attuned to modernism and modernist architecture and throughout the *Dark Knight* films was always trying to explain modernism to me, the purpose of modern architecture, taking me around these buildings, talking about materials, talking about how form follows function and so on. He wanted to do a modernist design for *Batman Begins* and I wouldn't let him. I was like, 'No, I see where you're coming from, but it's too bleak. We need more layering.' By the time we got to *The Dark Knight*, we had the confidence to go there. So we're shooting with real buildings; we're building sets that are very stripped down. It was a full-on modernist aesthetic, but I had to be ready to do that. I don't think the world would have been ready for it, actually. We had to build to it."

Francis Bacon's *Study After Velázquez's Portrait of Pope Innocent X* (1953), which Hans Zimmer used as inspiration while scoring *The Dark Knight*.

As he had for *Batman Begins*, he used two composers to score the film, James Newton Howard and Hans Zimmer, with Howard writing a more classical, heroic musical suite for Harvey Dent, and Zimmer embracing the more punk aesthetic of the Joker. Some of the ideas were very much born before Nolan started to shoot. As soon as he finished the script, and six months before Howard started work, Nolan sat down with Zimmer in London and had a conversation about the Joker—his motivation, or lack of it, the way he represented no principle other than pure chaos. How do you describe anarchy musically? Returning to his studio in Santa Monica, Zimmer tacked a photocopy of one of Francis Bacon's Pope paintings to his computer screen and dug into his roots in synthesized music and punk, drawing inspiration from Kraftwerk and *The Damned*. One of the things he got from the character was a fearlessness, and consistency— "You know the thing about chaos, Harvey?" the Joker says to Dent. "It's fair"—and that suggested to Zimmer a single note of some sort, something urgent, dire, simple. For months, he chiseled away at the idea, plugging away at old synthesiz-

ers, making crazy noises and recording musicians experimentally—razor blades on piano wire, pencils scratching tables and floors—long past the point when he should have started writing usable musical cues for the film. The result was four hundred tracks and nine thousand bars of music, which Zimmer put on an iPod that he gave to Nolan to listen to on a flight over to Hong Kong for the final round of location shooting. It was "a pretty unpleasant experience," Nolan told Zimmer upon touching down. "I have no idea where exactly the sound of the Joker is in that nine thousand bars, but you feel that it is there."

What they decided on in the end were variations on a single cello note, played by Martin Tillman, augmented with some very fuzzy guitar work— actually two notes, one distant, airy, and sustained, the other joining it and slowly sliding upward in a glissando, like a string that is being tightened and tightened without ever quite breaking. It was more tonal experiment than theme, a sound of ever-greater dissonance, fusing metallic buzzing and scratching. Tillman had to abandon all his musical training to do it. "The Joker's theme is very unusual because he wormed his way incessantly into the film," says Nolan. "I wanted to start early, wanting to know what it was going to be, because we knew we wanted to make a prologue of the film to release in theaters before it came out. *The Dark Knight* was the first time we did it. We took the first six or seven minutes of the film and made a short film of it and put that in IMAX cinemas. We knew we were going to have to do that and introduce the Joker. So there was enormous pressure to know what the music for the Joker was going to be. Hans had hours

The Joker launches his bazooka ambush of Harvey Dent's police convoy.

and hours of stuff, but we knew it was in there, there was something there. When we started to put it together in the prologue, I remember him being quite surprised that we used the very, very beginning of one of his longest things; it was just the smallest version of the creepiest, eeriest sound. But as soon as he saw the picture, it just made this immediate connection. And then it goes bigger and bigger and bigger at a different point in the film, this tiny little thing that happens that you just associate with the Joker."

Just as radical was Nolan's decision, while editing the Joker's bazooka-led ambush of Dent's paddy wagon, to dispense with musical cues altogether, orchestrating the sound effects of the scene—gunfire, screaming metal—into its own kind of percussion. "We had music written," he says. "What I said to Richard King, the sound designer, because there's so much music in the film, I said, 'I want you to try and cut in sound effects that take the place of music, so that the engines become the drumbeats and high-end sounds become the high hats.' He kind of gulped and went away, but it was a really cool opportunity for him, because you don't usually get five to ten minutes of a film where you go, 'Okay, this is yours now. You can take this and see what you can do.' There's so much music in the films I make. We always start with nothing, and then by the end, it's wall-to-wall. I felt there was a point in the film where you become a little numb to it. So carving out that spot was important, because music can give you a safer feeling around the action, even as it's pumping the excitement. When he pulls out the bazooka, it was like, 'Well, what are you going to do? How do you score that?' Then when the music comes back in, the effect magnifies. People have asked if I would ever make a musical, and I'm like, 'They're *all* musicals.'"

· · ·

The scene in question occurs at just past the seventy-four-minute mark. To satisfy the Joker's demands, Gotham's new district attorney, Harvey Dent (Aaron Eckhart), has decided to identify himself as the Batman. Taken into protective custody by an armored SWAT vehicle, he is driven across the city, accompanied by half a dozen police cars and helicopters in a convoy. It is dusk, almost nightfall, the city streets bathed in cool blue shadow. From an aerial tracking shot looking down, we see the convoy making its way along the bottom of a canyon of skyscrapers, in single file, like wagons in a Western, a shot so classically elegant that we almost don't

notice what looks to be a wall of fire about a block ahead of the convoy, at the top of the frame. It's around now that you notice the sound, or lack of it. As the convoy crosses the bridge and swings a left, spotlit by the helicopters, the sound of their blades drops away and we hear the single sustained cello note, played *son filé*, that we have come to associate with the Joker's chaos.

"What the hell is that?" asks one of the cops as they get closer to that wall of fire blocking the street, now revealed as a burning fire truck—unattended on an empty street, the sight is surreal—and the convoy is diverted to the underpass. "Lower Fifth?" complains the cop. "We'll be like turkeys on Thanksgiving down there."

Sure enough, as the convoy takes an exit ramp underground, losing its helicopter cover, one of the police cars is suddenly knocked out of the way by a garbage truck swinging in from nowhere. One of the police vans is sent hurtling into the river that runs along one side of the underpass as an eighteen-wheeler pulls up alongside the SWAT van. Dent is now boxed in on two sides. The door of the eighteen-wheeler—which bears an advertisement for Hyams Amusement Park, reading "Laughter is the best medicine," except an S has been added, so that it reads "Slaughter is the best medicine"—slides open to reveal the Joker and his men, all in clown masks, hanging by straps from the roof. Casually, as if indifferent to the exact start of festivities, the Joker raises a small pistol and starts firing. Then someone hands him a sawed-off shotgun, which leaves great dents in the side of the SWAT van. Finally, someone hands him a bazooka, and he picks off the police cars, flipping them like dominoes, one by one. The score has disappeared entirely. What we have instead is a percussive drumbeat of squealing tires, torqued metal, and gunshots reverberating cavernously throughout Lower Wacker Drive, one of Nolan's most distinctive spaces, appearing in both *Batman Begins* and *The Dark Knight*: an underground cavern with overhead lighting and heavy concrete pillars that turn it into an Escher-like recursive grid, confining yet deeply recessed, with parallel lines stretching to the vanishing point, its overhead lights conveying a visceral sense of speed as the combatants race beneath it. The effect of removing the music is both eerie and exciting, resulting in a peeled-eyeball intensity, the action scraped clean, all our senses in a state of high alert.

Finally, Batman shows up. At first, he attempts to match the Joker's exponentially escalating attack. Driving the Tumbler, the armor-plated Lamborghini-Hummer hybrid of the first film, he aims straight for the

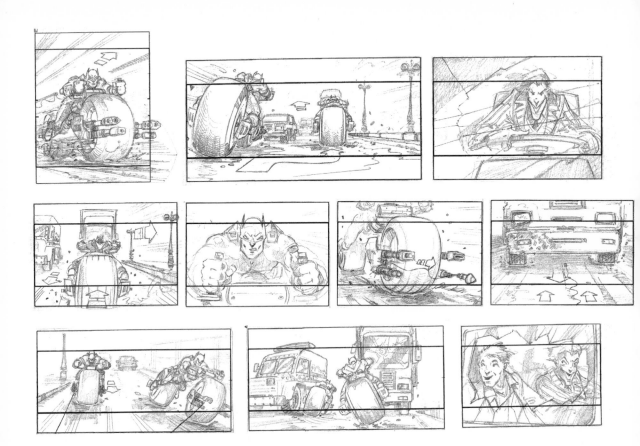

convoy, plows straight into the garbage truck, or, more accurately, *under* it, the Tumbler acting like a wedge that drives the truck up into the concrete roof of the freeway, sending sparks flying and crumpling the cabin like a tin can. The Tumbler stops, spins around, and resumes its pursuit in time to intercept a direct bazooka shot at Dent's SWAT van, sending it flying through the air like a bodyguard taking a hit for his client, before crashing end over end through the concrete barrier. A gang of workers gathers around the crashed vehicle. Inside the smoking, mangled remains, something is stirring. Suddenly, the cockpit descends, panels of the car burst out, like a beetle readying itself to fly, and the front wheel detaches and pulls forward, pulling a second wheel in behind it to form a motorbike made up of the crudest elements of fat wheels, chassis, seat. It looks like a praying mantis built by Harley-Davidson. Sleek, fast, low to the ground, not without danger, the Batpod is by far the coolest of Batman's toys because it echoes his strengths rather than covers for his weaknesses. The bike's engines sound like a cross between a massive turbine and a jet plane readying for takeoff. Straddling it, Batman lies so low as to be almost

Storyboards for the flipping truck sequence in *The Dark Knight* (2008), which Nolan scored with sound effects, not music.

horizontal, one wheel at his hands, one wheel at his feet, his cape pluming beautifully out the back as he roars down Lower Wacker Drive, clipping the wing mirrors of the cars as he goes—*clink, clink, clink*—clearing the way for himself with a blast of the bike's cannons. *Boom. Boom. Boom.*

The image of his chrysalislike emergence from the smoking chassis of the Tumbler could almost be an image of Nolan freeing himself from the wasteful bulk of the first film, whose action sequences mimicked the quickly edited demolition derby of many a summer blockbuster: When a car smashes into another car, you barely flinched. When a truck rams a cop car here, such is our sense of their size and physical mass, you could almost be watching spaceships collide. Such is the quantum leap between *Batman Begins* and *The Dark Knight*—in terms of cinematography, editing, sound, score—that the mismatch of the titles feels like the start of a new series entirely. The IMAX photography brings a sense of scale, while simultaneously slowing Nolan's editing rhythms right down, lending a

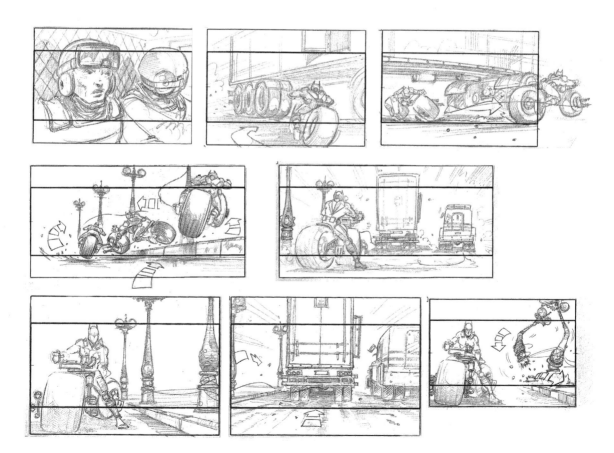

formal elegance to the shot making. After the disorientation of the Joker's attack, the editing rhythms are unhurried, stately, the shots fluid, elegant. Freed from the task of cloaking Gotham in darkness, Nolan is able to concentrate on composition, shooting the glass and steel canyons of the Chicago Loop the same way John Ford used to shoot Monument Valley, using the architecture to concretize space, and turning depth perception into an almost physical pleasure. When Batman finally catches up with the Joker on LaSalle Street, Nolan frames the face-off the way Ford filmed the gunfight at the O.K. Corral in *My Darling Clementine* (1946), the camera slung at their knees, looking up at these mythic figures. When Batman flips the Joker's eighteen-wheeler by entangling its wheels in a long steel towrope that jerks driving cabin and truck through 180 degrees to land on its back with a resounding groan, like Agamemnon felled, it seems more than just a physical stunt, and the closest to an artistic manifesto Nolan has yet come. "I just did what I do best—I took your plan, and I turned it on itself," says the Joker, a line written by Jonah that could as easily sum up Nolan's entire ethos as a filmmaker. He takes the rules of genre and he flips them. He ticks the boxes of the studio while smuggling personal material past them.

Everything is flipped in *The Dark Knight,* from trucks to morality to witnesses to the camera that slowly cranes upside down to take a look at the inverted figure of the Joker, dangling from the Prewitt Building, at the movie's climax. It's not just an eighteen-wheeler that has been flipped, but the big-bigger-best giganticism of big-budget filmmaking itself. We are firmly in Nolan's universe now, a place where traditional measures of strength, weight, and mass count for little and can even be turned against you. Bruce Wayne's first decision, indeed, is to trim down. "I'm carrying too much weight," he tells Alfred. Attempting to bring order to Gotham, Batman has instead provoked the opposite—a string of copycat thugs and two-bit vigilantes, all imitating and styling themselves after the Batman. Blamed by the public for the ensuing violence, he spends much of the movie brooding over reports of his demise, and is only stopped from retiring by the appearance of the Joker, a Lord of Misrule in cracked white makeup, with no motivation except sowing chaos. "I'm a dog chasing cars," he says, wearing a nurse's uniform, in which he has sneaked into Dent's hospital room. "I wouldn't know what to do with one if I caught it." Where Batman is a Swiss Army knife of technological gizmos, driven by a Freudian backstory so long that it took an entire movie to unpack,

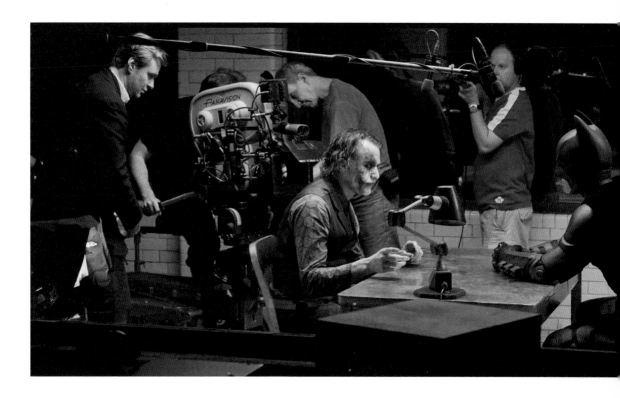

the Joker is a coldly psychotic knife man, driven by nothing other than the desire to create chaos. Every time he tells his backstory, it's different. Effeminate and sly, where Batman is chiseled and armor-plated, like a cross between Alice Cooper and a drag queen who has been left out in the rain, he's an affront to the very principles that keep the Batman pinned in place. These two shouldn't even really be in the same room together, you feel, lest the laws of physics force one or the other of them to *fzzt* out of existence.

Hence the electricity of their first big meeting in the police interrogation room: a long, tiled room that has the feeling of an abattoir. The scene starts in a very controlled way, in darkness, but upon the lights' being turned on, we see Batman standing behind the Joker.

"Why do you want to kill me?" he asks.

"I don't want to kill you," says the Joker, laughing, bopping back and forth in his seat, in and out of the focal frame. "What would I do without you? Go back to ripping off mob dealers? No. You. Complete. Me."

Licking his lips like a lizard, eyes wandering around the room as if half-expecting someone else to show—he has the body language of an abused dog—the Joker proceeds to bond with Batman, asserting grotesque inti-

Nolan sets up a shot for the interrogation scene—the pivot on which the movie turns.

macy with him, two freaks unbound by the codes that keep everyone else in their place. "The only sensible way to live in this world is without rules," he says, smirking. "Tonight, you're going to break your one rule . . ." As the Joker's trolling reaches an unbearable point, Batman erupts, reaching across the desk, grabbing him by the throat, and throwing him against the wall to get Dent's whereabouts out of him. "He's in control," says Gordon, watching through the glass, when one of Gordon's men gets up to intervene, but by this point, you will have noticed the return of that single sawing cello note that announces an onset of the Joker's chaos. Something is wrong.

Giggling excitably, like a schoolboy, the Joker unveils his infernal Sophie's choice: Batman must choose between saving Dent and saving Rachel Dawes (Maggie Gyllenhaal). Either way will leave a stain on his conscience. The Joker isn't trying to defeat the forces of good; he's trying to reveal the very *idea* of goodness as a fraud, to test the very idea of civic connection. Nolan switches to handheld cameras to catch the beating that follows. Slumped against the tiled wall, the Joker puts up not the slightest bit of fight throughout the whole scene, as limp as a rag doll, his head spinning almost through 180 degrees with each blow, but coming back smiling every time, as if each blow were a small victory over his enemy, another chip in his precious principles. He is bent only on one thing: provocation. "You have nothing," he taunts, spitting out a tooth. "Nothing to threaten me with. Nothing to do with all your strength."

Still, he continues to laugh, like Ian Bannen at the end of Lumet's *The Offence*. Batman is just pounding on a rag doll. Originally, the scene was to have ended with him dropping the Joker after he has revealed his information, and then, almost as an afterthought, kicking him in the head as he walked out of the room. On the day, they dropped it in favor of a tight shot on Bale as he realizes the utter futility of what he's done. *The Dark Knight Rises* would turn into a slugfest; *The Dark Knight* feels sprightly with the Joker's anarchy, by comparison with which Batman appears merely brutish. How do you fight someone who thrives on chaos?

• • •

Sometime in the early eighties, Jean Ward went to clean British painter Francis Bacon's house at 7 Reece Mews, the garret in South Kensington where Bacon lived and worked. She knew little of his reputation as a painter as she ascended the steep flight of stairs and found a cramped

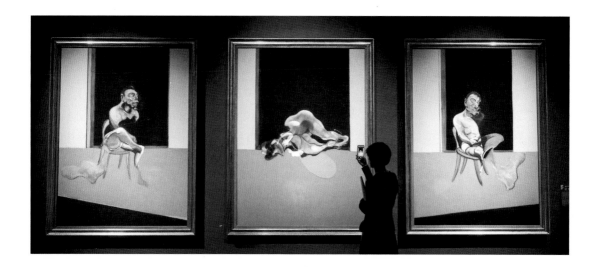

studio, and two other rooms—a kitchen, which also held the bath, and a small bedroom that doubled as a living room, both modest, simply decorated. Bacon had no vacuum cleaner, no cleaning equipment apart from the odd can of Ajax, a domestic bleach he sometimes used to powder his face. Arriving in the morning, Ward frequently found him asleep on the floor and had to step over his drunken form. The painter's legendarily messy studio with its layer upon layer of dust, paint, discarded imagery, champagne bottles, and other detritus, she was forbidden to enter, let alone clean. Clambering over the clutter, Ward would sometimes "expect it to start moving with cockroaches."

Bacon liked the mess, sharing Leonardo da Vinci's conviction that small rooms concentrate the mind. Sometimes he rubbed his fingers in the dust, then along the wet paint of his canvases to introduce another element of controlled chaos into them. "I feel at home here in this chaos because chaos suggests images to me," he told art critic David Sylvester. "And in any case I just love living in chaos. If I did have to leave and I went into a new room, in a week's time the thing would be in chaos." That contrast between chaos and control was one reproduced over and over again in his art, with its mixture of wild, bloody abattoirlike imagery contained within the clean lines of a cage, grid, or hermetically sealed room. The room in question is always sparsely decorated, with curtains, mirrors, and tubular constructions isolating his torqued and tormented figures. "To me, it's this idea of barely contained horror, this idea of the primal barely held in by the structures of society," says Nolan. "Whatever happened in that room of paintings echoes the way in which they were made—very instinctive,

Francis Bacon's *Triptych August 1972* followed the suicide of Bacon's lover, George Dyer. The figure of Dyer on the far left was the image of Bacon's that first hooked Nolan as a teenager. An earlier portrait, *Study for Head of George Dyer* (1967), also appears in the first dream of *Inception,* whose turbulent central romance also ends with a hotel suicide. "Not an hour goes by, of course, when I don't think about George," Bacon said in the summer of 1972. "If I hadn't gone out that morning, if I'd simply stayed in and made sure he was all right, he might have been alive now. It's a fact."

very primal was his process, but he exercised absolute control, destroying canvases that he didn't like and so on, very, very careful with how he presented his work. There's often this geometric mirror; it's a thing that's in a lot of his paintings, this little circle. It's ordered chaos. I think there are a lot of very savage and primal things in Bacon's work, and in the nature of the Joker, that aren't actually chaotic. They're actually quite controlled. In other words, the Joker is not disordered. He talks about chaos and thriving on chaos, but it's the creation of chaos. The way he creates is actually quite precise, and quite controlled."

Nolan first came across Bacon's work when he was sixteen. On a school trip to London to see a Rothko exhibition at the Tate, he saw a poster from one of the gallery's previous exhibitions, a retrospective of Bacon's work, in the gift shop. "I remember looking at the poster and going, 'That looks amazing,'" he says. He bought the poster and stuck it up on his bedroom wall; then a few years later, he saw Adrian Lyne's *Jacob's Ladder* (1990), about a Vietnam vet (Tim Robbins) experiencing hellish flashbacks, which appear to him in the form of Bacon's imagery of blurred, thrashing heads, and tried to re-create the effect in his own Super 8 movies. Later, Lyne told him he'd borrowed the trick from Don Levy's *Herostratus*, the first film to be shown at London's newly opened ICA Cinema in 1967. One of the great "secret films," it's a fierce, dark head trip about an angry, troubled poet (Michael Gothard), whose internal chaos finds release in tortured reenactments of Bacon's *Head IV*, shot with a form of extreme motion capture, with a high frame rate on the camera, which turns his head into a frenzied blur, accompanied by shrieking bursts of chaos on the sound track. Levy's career was sadly truncated: After moving to Los Angeles to work at the California Institute of the Arts, where he taught and conducted research in film, video, and multimedia, he committed suicide in 1987.

"It's very much an art film but a pretty interesting movie, and the imagery is quite remarkable," says Nolan. "A few years after *Jacob's Ladder,* that head shake was in every horror film, in music videos, every trailer you'd see. It takes a while for these things to filter through. I had done my own version of that with Super 8, trying to come up with a character who had a blurred face, or you'd have the face in the frame very quickly. At one point, Lyne has this sort of torso in a cage, not quite the box of the paintings, but pretty close. If you look at *Following,* too, and you look at Jeremy's character—he's wearing a suit and tie and he's got this very distorted eye, which harks back to Bacon."

During the making of *The Dark Knight*, Nolan brought a book of Bacon's paintings to show makeup artist John Caglione and Heath Ledger in the twenty-eight-year-old actor's trailer. The Joker's makeup—broken down and smeared, as if he had worn it for several days and nights, and was falling apart internally—was partly inspired by Francis Bacon's *Study After Velázquez's Portrait of Pope Innocent X* (1953), more familiarly known as "The Screaming Pope." "They got it completely," he says. "They had the white and the red, but they started putting black in there as well and took the skin off and smeared it in this particular way. Heath's skin is visible in places, just as Bacon's canvas is visible in areas of his paintings." The scar prosthetics extended into Ledger's mouth and would loosen as he performed, so he licked his lips repeatedly in an effort to avoid another twenty minutes in the makeup chair. It became one of the character's creepiest tics. "The other thing that Heath did was at some point he said to me, 'I'm going to apply it myself because I want to see what that would look like.' So he applied it himself and he said, 'Maybe we'll learn something.' And what we learned was he wasn't as good a makeup artist as John Caglione, and, of course, we also learned that he had makeup on his fingers, so he said, 'Oh, of course, I'd have makeup on my fingers from applying it myself. . . .' So we left little bits on his hands. That's the thing. It was just wonderful working with somebody that creative and that tuned in—really cool."

Locking himself away in a hotel room for weeks, Ledger experimented with voices and mannerisms until he got something he was happy with, keeping a diary full of lines from the script recopied in his own handwriting, along with various pieces of clip art, including images of the Sex Pistols' Johnny Rotten, Sid Vicious, and Alex (Malcolm McDowell) from *A Clockwork Orange*. When Nolan was directing Ledger in the scene where he comes in and he winds up grabbing Senator Patrick Leahy, he remembers really pushing him. "It was one of the earlier scenes we shot and I was like, 'You have to be this force of nature. This is a fancy party. You walk in and you just piss in the soup.' And when we finished shooting it, he was like, 'Thanks for pushing me on that.' He really owned that character. Heath was a very lovely guy. I don't think it was in any way natural to him to walk in and be that cruel, because there's immense cruelty to the Joker; there's an enjoyment of the uncomfortable place in which he puts everybody that was the opposite of who Heath was. The same with me, it's the opposite of who I am. He was like, 'You gave me an excuse to be horrible.' He really didn't like making people feel uncomfortable."

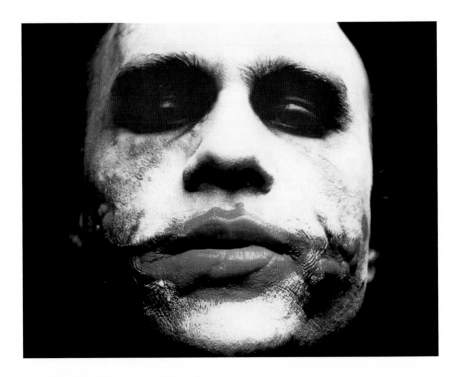

Heath Ledger with makeup artist Conor O'Sullivan; and in full Joker makeup. Ledger applied some of it himself. The scar prosthetics would loosen as he performed, so he licked his lips in an effort to avoid another twenty minutes in the makeup chair.

"Heath and I talked a lot about the character of Alex in *A Clockwork Orange.* I think Alex was the closest to the Joker that had come before. He's a teenager essentially. He's just 'I'm just going to tear it down because fuck it.' He doesn't even care about *why* he's doing it. He's that out there. It's a very real force of human nature, and it's not one that I have. I'm afraid of that in myself. I'm afraid of that side of human nature. The Joker is what I'm afraid of more than anything, more than any of the villains, these days particularly, when you feel civilization is very thinly lined. I think the Joker represents the id in all of this. All three films, we did with a real truthfulness of our intentions. What do we worry about? What am I actually afraid of? What's the worst thing the villain could be doing? I don't have that anarchic impulse, I really don't. I'm much more controlled. I'm afraid of that in myself. I feel like I carefully used it as the engine of the movie, but I was afraid of it the whole time I was making the film."

• • •

I pressed Nolan on the point, because it seemed unlikely to me that he didn't on some level get a thrill from the Joker's chaos—the audience cer-

tainly does—but he remained firm: He found it *frightening*. What makes *The Dark Knight* the movie it is is its director's willingness to fly *against* his own natural inclinations, to arm his own demons. "It's funny, because while it's difficult for me to analyze people's responses—*The Dark Knight* is always people's favorite—I frequently find myself defending the other two. There's a romanticism to *Batman Begins* that we totally threw out for *The Dark Knight*. When I screened both films down at IMAX headquarters before we got into the design process of *The Dark Knight Rises,* we hadn't seen either film in a few years. It was a very interesting experience, because *Batman Begins* played much better than we remembered it. There was a sort of nostalgia, a classicism to it. It was like, 'Wow, we did so much in that film.' Then we screened *The Dark Knight,* and the word we both used is, 'It's a machine.' It just grabs you and runs you through, but there's something almost inhuman about it. Compared to *Batman Begins,* *The Dark Knight* is a cruel, cold film. People talk about my films as being cold, and that's really the only one where I see that, because the Joker is such an engine driving that film in such awful ways. That's all the film is, a relentless series of horrible situations contrived by the Joker, and that was

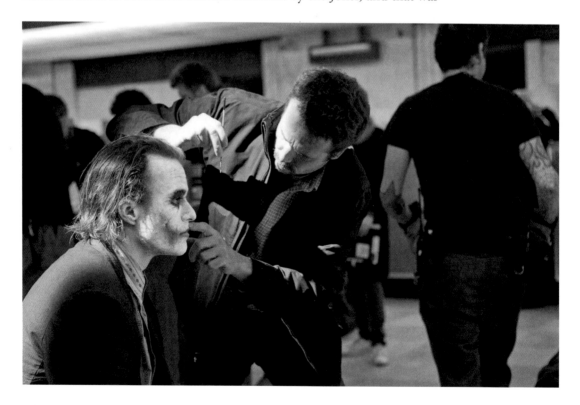

always the intent. There was nothing accidental about that. I pitched it in the studio as 'It's a white-knuckle ride—it's just this descent.'"

One of the things that is most daring about the film is how much its hero is eclipsed in the course of it. After he is left by Rachel Dawes for Gotham's new knight in white armor, Harvey Dent, Bruce Wayne spends much of the film contemplating his retirement, in many ways the film's supporting player. The moral arc of the story is Dent's. Smarting from his humiliation in the interrogation room, Batman is provoked into overreaction—transforming every smartphone in the city into a sonar eavesdropping device, transmitting back information on its owner. "*The city is an open book—people working, eating, sleeping*" read the script directions. "You've turned every phone in the city into a microphone," says Lucius Fox (Morgan Freeman). "This is wrong. Spying on thirty million people wasn't in my job description." Critics would frequently call the *Dark Knight* trilogy "Orwellian," although the label doesn't exactly fit: When Batman first uses his surveillance technology to track the Joker in the Prewitt Building, the effect is noticeably beautiful—it's one of the few genuinely gratuitous special effects in a Christopher Nolan movie—civil liberties be damned! In truth the *Dark Knight* films are more like the kind of film Winston Smith would make if, at the end of *Nineteen Eighty-Four*, he had been put to work making propaganda films for the state whose subtexts nevertheless blurted out all his old refusenik leanings. They are

Nolan directs Aaron Eckhart and Christian Bale in the confrontation between Batman and Harvey Dent over the Joker's henchmen.

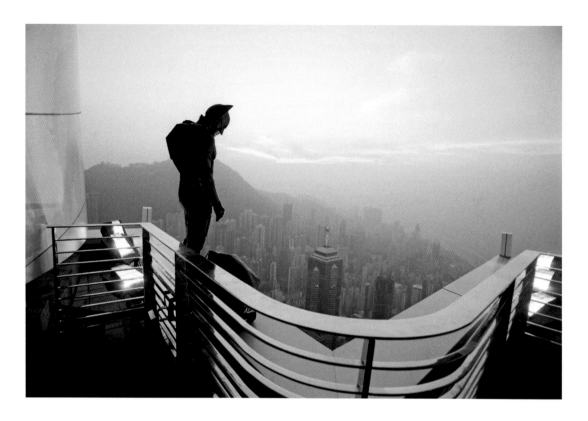

films coauthored by Winston Smith *and* Big Brother, in which authoritarian and antiauthoritarian instincts duke it out for supremacy.

Nolan finds counterpoint to the Joker's chaos in the hard, clean lines of the Chicago Loop. There is a thrilling impersonality to the underground lab with *béton brut* walls in which Lucius Fox cooks up his toys; the Wayne Enterprises boardroom, a crisp, minimalist room in the IBM Building, designed by architect Mies van der Rohe, with floor-to-ceiling panoramic views of Chicago, which Pfister and Crowley enhanced by adding rows of reflective bulbs overhead and a reflective eighty-foot glass table; or Lower Wacker Drive itself. "Infinite space is the ideal that the Western soul has always striven to find, and to see immediately actualized," wrote Oswald Spengler of the grand tract of the Champs-Elysées, where the straight-lined perspectives and street alignments reflect "an unrestrained, strong-willed far-ranging soul, and its chosen badge is pure, imperceptible, unlimited space." Spengler would surely have gotten a kick from Bruce Wayne, another strong-willed, far-ranging soul who finds his home in low-ceilinged geometric caverns of infinite depth. Recursion, the bane

Christian Bale as Batman atop the IFC tower in Hong Kong, a scene Bale insisted on shooting himself.

of Leonard Shelby's existence, is here reslanted as a symbol of power and wealth: Bruce Wayne's billion-dollar man cave.

The ending of the film is one of Nolan's best—a perfect slipknot that ties up all the elements of the plot but loosens the film's meaning so that it plumes in the audience's mind afterward, like ink in water. "David [Goyer] and I came up with the story idea of Batman facing this choice between saving one person and saving the other in the middle of the film. My brother then went and made a grander extrapolation of that for the climax. I immediately called him and said, 'You can't. That's not going to work. Forget it. We do that *Sophie's Choice* thing earlier; you can't just keep doing it.' And he was like, 'You amplify and you follow the Joker's theme until the audience comes to expect it.'" Nolan's bigger objection was kinetic: He couldn't end the movie with something *not* blowing up. "Jonah's always been very much in favor of doing something different, not doing the expected thing. That's a huge impulse of his when he's writing. And my thing is, 'Yes, that's very valuable, but you have to think of it as a piece of music. So if you just don't do a crescendo, it may not work. It may not feel right.' I needed a crescendo. He tried and tried, and finally I took over writing the script, but I couldn't ever get rid of it, so what we wound up doing was taking the action to the Prewitt Building and then crosscutting between that and the ferries. I mean, it shouldn't really have worked, but it did. The movie literally stops. Then it goes, Oh, and another thing."

The "other thing" is a montage, showing us the image Nolan had come up with first when he sat down to write his draft of *The Dark Knight* while scouting locations in Hong Kong: Batman being chased by his police pursuers, the hunter hunted. His victory against the Joker was Pyrrhic: The Joker has wholly corrupted Dent. And so in order to keep Dent's reputation clean, Batman is forced to take the rap for his crimes. "You either die a hero or live long enough to see yourself become the villain," he tells Gordon, repeating Dent's line, and as we see him escaping over the rooftops, pursued by police and dogs, Zimmer builds the alternating D-F melody with cellos and lower brass, while the strings weave a series of ostinatos that swell in volume, accompanied by timpani rolls, like waves. "I'm whatever Gotham needs me to be. A hero, not the hero we deserve—the hero we need. . . . Because sometimes the truth isn't good enough. Sometimes people deserve more." Nolan is notable for his endings, but the ending of *The Dark Knight*, with its Chandleresque evocation of a fallen universe in which the truth can never win out, and the best the good guys can hope for

is a graceful exit from a rotten system, is one of his best—a perfect slipknot tying up the threads of the plot while setting loose all its ambivalences and ambiguities. The feeling it leaves the viewer with is of being caught up in some much larger, majestic cyclical movement—a coda to one story that is also the prelude to another.

<p style="text-align:center">•　　•　　•</p>

America had its own reasons for heeding the ambivalence of the film's message. Coming into public consciousness during both an election year and a crucial period of the Internet's evolution, *The Dark Knight* would find itself buoyed by both. In the fifteen months leading up to *The Dark Knight*'s release, Jonah and associate producer Jordan Goldberg launched what the *Los Angeles Times* called "one of the most interactive movie campaigns ever hatched by Hollywood," using presidential campaign–quality political polling to target over eleven million people in over seventy countries to help publicize the movie. At Comic Con in San Diego, "Jokerized" dollars were found with clues that led you to a vantage point to watch a plane skywrite a phone number, which, when called, issued an invitation to join the Joker's army. Cards at comic-book stores led to a "Harvey Dent for District Attorney" website. Erasing pixels on the site, the final result was the "Joker reveal," the first public image of Heath Ledger as the Joker. A fake news site, modeled on the Drudge Report, was created to peddle fake news about the election. Some fans got as far as coming out on the street in support of Harvey Dent—a fictional candidate running for a fictional position in a fake election in a city that didn't exist. When election time came, voter-registration cards went out in the mail, creating a direct-action group dedicated to supporting Batman through pizza deliveries. When people received their pizza, they found inside the box a Batman mask, propaganda, and directions to an "underground" forum on the Internet, "Citizens for Batman," organizing them to gather in Chicago and New York, where they could watch the Bat Signal light up the city skyline.

The film's politics were endlessly decoded. Many of the film's memorable lines—"You either die a hero, or live long enough to see yourself become the villain"; "Some men just want to watch the world burn"; and "Why so serious?"—saw second life on the newly established platforms of Twitter, Tumblr, and Reddit, the Internet's "front page." If *Memento* had been embryonically viral, *The Dark Knight* was a meme petri dish. An early

viral ad featuring Heath Ledger's Joker scrawled with the line "Why so serious?" was endlessly remixed, with cats, babies, Miley Cyrus, Al Gore, and then presidential candidate Obama all given the "Joker treatment." Left-wing bloggers cried foul; right-wing bloggers claimed credit. In *The Wall Street Journal,* novelist Andrew Klavan penned an op-ed, arguing that the film was "a paean of praise to the fortitude and moral courage that has been shown by George W. Bush in this time of terror." Others on the Left embraced what they saw as the film's stance *against* Bush and Cheney's warrantless surveillance and torture tactics, and the decision of companies like Verizon, AT&T, and Google to turn over more than 1.3 million law-enforcement requests each year to the National Security Agency's two-billion-dollar surveillance center.

"The film's politics seem to suggest that Americans want to maintain the myth of national innocence but secretly acknowledge that the extralegal excesses of the Bush administration may be necessary to fight evil," wrote Ron Briley of the History News Network. "George Bush becomes the Dark Knight who is repudiated by the public but whose actions have saved us, and at some future date, his decisions, like those of Harry Truman in the Cold War, will be celebrated by historians and the public." Running into Bale and Nolan after a screening, the German director Werner Herzog

The final shot of *The Dark Knight* was spotted by Nolan while viewing dailies, a practice he insists on.

said, "Congratulations, this is the most significant film of the whole year." Nolan thought he must be joking. "No, no, no!" replied the German. "This is a film of real substance. It doesn't matter if it's mainstream or not." Having grown up in the rubble of a bombed-out Berlin, later making films mesmerized by the specter of charismatic lunatics, Herzog was better placed than most to appreciate the film's undercurrents.

"The thing we never did, and I say this with hand on heart, is we never reached for relevance," says Nolan. "Because we know how long it takes to make a film. The world moves on incredibly fast. So to us starting on *Batman Begins,* it was always about what we were afraid of, and obviously what we were afraid of post-9/11 was terrorism. We talked about it a bit, about 'the American Taliban,' John Walker Lindh. Bruce goes to a mysterious foreign country and gets radicalized. We didn't do it that consciously, but at the end of the day, we were sitting there writing that film three years after 9/11. There's no way not to have that be a huge part of things. The whole discussion of 'the hero becomes the villain,' at the end of *The Dark Knight,* and 'we get the hero we need, not the hero we deserve'—all this came about because the concept of heroism became very devalued post-9/11. It was heroes this, heroes that. It's understandable why it happened; it's the way language shifts. Watching *Lawrence of Arabia* with the kids at the weekend, and it absolutely presents Lawrence as this vain, false icon, but what people take away is the iconography. That scene where he goes back for the guy in the desert, it's an amazingly rousing moment. Afterward, they give him the robes and he becomes this icon—that moment feels sincere—but afterward you see him admiring his reflection in the blade of his dagger. It's never again the same; it always feels like he's playing a role or he's living up to people's expectations. A lot of great films are like this. The *Dark Knight* films absolutely believe in heroism, but what they say is, true heroism is invisible. That's the kind of heroism that people aspire to but almost never live up to, in my experience. I feel very good about what we did in the *Dark Knight* trilogy, because it has been equally claimed by the Right and by the Left in terms of conversation, and that feels like we win."

Released on July 18, 2008, *The Dark Knight* took in $238 million in its first week, $112 million in its second, $64 million in its third, before receiving boosts from overseas as it opened in England, Australia, and the Far East, so that by October, it was closing in on $1 billion. Then it leveled out, but slowly, playing in theaters right through until March of the following

year, when it received the further boost of eight Oscar nominations, winning only two of them, for Heath Ledger and sound editor Richard King, but the outcry over its omission from the Best Picture category forced the Academy to change their rules to allow a total number of ten nominees. Its theatrical run was thus *nine months*, an astounding figure in the era of the front-loaded opening weekend, where most films grab what profit they can in the first few weeks and then slide from screens, even more impressive in its way than the film's eventual box-office take of $1.005 billion. "I can't get my head around it," Nolan told the *Los Angeles Times* in a series of interviews, running almost a month, in which they crowned Hollywood's new box-office king. Nolan's ascent up to this point had been gradual, even something of a zigzag, following a pattern of advance and regroup, advance and regroup, always pressing ahead but always against resistance. Suddenly, his position at Warner Bros. went from solid to unassailable, while with the public he was almost as famous as his movies.

"It wasn't a massive, life-changing thing at the time. In retrospect, it was, but my career had built to it in ways that were quite controlled, but before *The Dark Knight* I didn't have people recognize me on the street or anything. A few years later, I was scouting *The Dark Knight Rises* with Nathan [Crowley] in Lower Manhattan—he hadn't been able to do *Inception* with me, so we hadn't worked together for a few years—and when we popped into Starbucks for ten minutes to get a cup of tea, somebody came up and asked if I was Christopher Nolan, and when I said yes, they didn't believe me, which was very peculiar. They were like, 'No, you're not—' and I was like, 'Okay, fine. If you don't want to believe me—' Nathan was like, 'Everyone knows who you are,' and he was quite surprised. So that was all different.

"It changed a lot of things, but the immediate thing that it did that was extraordinary was it allowed me to do whatever I wanted as the next film. While nobody ever said that, you just knew it in your bones; I could have shot the phone book at this point, as people like to say. Much more than anything else, it created a massive sense of responsibility, because I was very aware, in that moment, that there were no hurdles, other than the practical hurdles of actually making my next film and hoping for success. Creatively speaking, they were going to let me do whatever I wanted to do, and so then the responsibility is all on you. Everything up to that moment had been a fight or a struggle one way or another; you were justifying every stick of furniture. You would do films where it'd literally go, 'Why are you

using that chair?' and stuff like that. That's what I had grown up doing, and then suddenly realizing, Okay, I'm going to get the last word. It was very liberating in a lot of ways, but it was also scary, because you know that every filmmaker would give their eye teeth for that. So finally you've got it. What are you going to do with it? For the first time, I was able to step back and go, Okay, what do I want to do now? And I'd always wanted to do *Inception*."

EIGHT

DREAMS

THE IDEA FOR *Inception* had gone through many evolutions since Nolan first elaborated a horror story about dream theft in his dormitory at Haileybury, sometime in the mid-eighties. In place from the beginning was the use of music to manipulate or cue the dreamer's responses, a straightforward elaboration of the conditions under which the idea was first conceived: lying in his bed after lights-out, listening to sound tracks on his Walkman. Also in place was the idea of shared dreaming and the idea of a dream within a dream, an idea with a long pedigree from Edgar Allan Poe to Borges, but for Nolan the immediate inspiration was closer to hand. "There was a show they used to do called *Freddy's Nightmares*, which was the Freddy Krueger spin-off, a TV version of the *Nightmare on Elm Street* films, and there were a lot of situations in that where you wake up from a dream into another dream, and then you wake up from that into another dream," says Nolan. "I found that pretty terrifying."

A few years later, while an undergrad at UCL, finally in command of his own hours of sleep, he used to stay up late drinking with his friends, setting the world to rights into the early hours. "I didn't want to miss breakfast, which was at 9:00 a.m., and already paid for at the beginning of term, so I would set an alarm, wake up, go downstairs, eat, and then go back to bed," he says. Frequently sleeping till 1:00 or 2:00 p.m., he

found himself in such a pleasantly drowsy, half-asleep, half-awake state that he was capable of lucid dreaming, which is where you become aware of the fact that you're dreaming, and you attempt to change or control the outcome of the dream. "I remember lucid dreams where I would see there was a book on the table and I would go and look at the book and I'd be able to read the words, and it might even make sense. So you say, Okay, I'm writing this book as I'm reading it at the same time. I found that to be an amazing thing, this notion that you construct a dream that you experience. The other thing that fascinated me was the distortion of time, the idea that a dream, you know, might only take a few seconds but might feel much longer. That felt like a fascinating building block for exploring. I've had that over the years with different films, where small aspects, not whole swaths of the movie, but small things, will pop up or get solved in a dream. Sometimes, it's gibberish. Other times, I've had dreams that have informed narrative choices. I first dreamed the end of the *Dark Knight* trilogy—the idea of somebody taking over Batman and being in the Batcave. Film has a relationship to our own dreams that's difficult to articulate, but there's an extrapolation of your experience working things out through your dreams. You're hoping to make connections and find things that are hidden from you while you're living your life or being in the world. I think that's what films do for us. They're very dreamlike experiences."

It was around this time that he first read Borges's story "The Circular Ruins," one of two stories that would influence *Inception*. The first was "The Secret Miracle," the one about the Czech playwright who finds an executioner's bullet halted for long enough to finish his unfinished tragedy, *The Enemies*—a crucial input on the final act of the film, all of which plays out in the time it takes a van, filmed in extreme slow motion, to fall from a bridge. "The Circular Ruins" opens with a foreigner washing up on the shore in the south of Persia. An old gray man, he crawls up the bank to an uninhabited ruined circular temple in the middle of the jungle, where he falls asleep. "The purpose which guided him was not impossible, though supernatural," writes Borges. "He wanted to dream a man; he wanted to dream him in minute entirety and impose him on reality." He dreams that he is in another such circular amphitheater, only its seats are filled with eager students waiting to hear him give a lecture on anatomy, cosmology, and magic. Finally, after many false starts, he dreams of a "warm secret, about the size of a clenched fist." For fourteen lucid nights, he dreams of it "with meticulous love," and on the fourteenth night, he finds the

pulmonary artery pulsing. Within a year, he has dreamed the skeleton, eyelids, and hair. Praying to God to animate this dreamed phantom, he is told first to educate him, so he increases the number of dreaming hours to do so, all the while nagged by the thought that he has somehow done this before. The old man finds clouds gathering. Fire consumes his temple, "for what had happened many centuries before was repeating itself," writes Borges. "With relief, with humiliation, with terror, he understood that he also was an illusion, that someone else was dreaming him." Nolan would take the image of a stranger washing up on a foreign shore, the lecture hall, although the idea of a dream within a dream had already occurred to him.

"'The Circular Ruins' was definitely influential on *Inception,*" says Nolan. "I think with anything that you wind up loving and come back to over the years is partly because it has a more sophisticated version of some of the things you were already thinking about or interested in, and partly because it opens up a new idea for you. It's both. So the dream within a dream thing, I certainly had before I read the Borges, but 'The Circular Ruins' is a very resonant story for that reason, and I come back to it a lot. With those Borges short stories, you have to have something rattling inside you already that then connects with that, but if you're not already predisposed to that, if it just comes to you as a story, it doesn't necessarily spark anything."

From the very beginning, the challenge was simple: how to make the dream world matter to the viewer as much as the real world, and avoid the groans that greet any explanation along the lines of "Oh, it was just a dream." "That was the overwhelming difficulty, how do you address the idea of dream life, and raise those stakes, without invalidating the experience of the audience watching the film? That was the main challenge. The treatment of dreams in films is inherently problematic. There's a lovely line in *Living in Oblivion,* where they have a dwarf character who's there for the dream sequence and he turns around to Steve Buscemi and he's like, *'I* don't even dream about dwarves.' It's like, What are you *doing*? I think *The Matrix,* for me, was very much inspiration for the idea that you could give a virtual experience stakes in the real world, that it may all have an equivalent value. That was the challenge: How do you do this? How do you get to a point where you can say that what you consider reality or the stuff in the world around you may be no more or less valid than the next layer of a dream?"

The solution? Bring the audience in on the act of deception, so that

it acquires an element of suspense: Will the dreamer realize he is being manipulated and wake up? It would be a little like how in a heist movie the utmost care must be taken not to disrupt the illusion of just another Monday morning at the bank. By the time Nolan pitched his idea to Warner Bros. in 2002, after the release of *Insomnia*, the heist-plot framework was in place, partly for the sheer amounts of exposition the film was going to have to have. In a heist movie, the exposition pretty much *is* the plot, the planning of the gang acting as the blueprint for all the ways the actual heist will deviate from the plan, creating suspense, necessitating acts of improvisation, and so on. The risks and rewards, the esprit de corps, the fatalistic mockery of the "best-laid schemes o' mice 'n men" have always made the genre of appeal to filmmakers sensing a ready-made allegory about the energies that go into the making of movies, hence its appeal to so many debutant filmmakers, Stanley Kubrick, Woody Allen, Quentin Tarantino, Bryan Singer, and Wes Anderson all kicking off their careers with heist movies.

"They're about putting teams together to do things that individuals cannot do," says Nolan. "In a heist movie, you have your main character at the center of it, which is pretty analogous to the director or the producer. With *Inception,* when I was thinking about analogies—what's the technology, what's the process behind this science-fiction idea—I gravitated toward the experience I had of making films. That's the language I know. Okay, you put a team of people together, you go location scouting, you cast . . . The difference with *Inception* is we got to take it several steps further in that

Cobb (Leonardo DiCaprio) and Eames (Tom Hardy) on board the flight of Fischer (Cillian Murphy) from Sydney to Los Angeles, at the time the longest flight in the world.

Nolan and his baby daughter, Flora, playing with a pinwheel in 2003, photographed by Tim Lewellyn; an image echoed in one of the prop photographs showing Maurice and Robert Fischer for *Inception* (in actuality, Cillian Murphy and prop master Scott Maginnis's son).

regard, because you're dealing with world creation, narrative creation, and production design in a really specific way. In *Ocean's Eleven,* they build a version of reality using closed-circuit TV, but we were able to really do the whole thing. Okay, here's this thing being pulled off at the beginning that introduces them, here's the big job, here's the gathering of the team . . . I'd been thinking more in horror-movie terms, and then suddenly it became more of an action film or a spy film, just to give it some grounding, right the way to the end. There's even the shot of him walking through the airport. You see the team, and they nod at each other, just like they do at the end of *Ocean's Eleven.* We never let that go, because that was always the spine of 'How do you get people to come along for that ride?'"

He always knew that to raise the emotional stakes, the journey into the dream world also had to be a journey into Cobb's past. In early drafts of the script, it was more of a straightforward noir, full of double-crosses and betrayal; the guilt driving him turned out to be guilt over his part in the death of his business partner, in the vein of Sam Spade's betrayal of his business partner, Miles Archer, in *The Maltese Falcon* (1941). "I didn't have kids when I first wrote it. Or tried to write it, because I couldn't finish it," says Nolan. "I managed to get about eighty pages in. I got into the beginning of the third act and then got stuck. And I stayed stuck for years and years. At the end of the day, it just didn't lead anywhere that paid off." While making *The Dark Knight,* however—a long shoot of 123 days, during which Emma Thomas became pregnant with their fourth child—Nolan became acutely aware, as never before, of the time spent away from his family. "The family were around for an enormous amount of the film, but Emma was pregnant with Magnus at the time. The last two months, I think, I was in England, finishing the film, and they had to be back here. I was able to be present for Magnus's birth; I flew over, but I had to go right back to England and

carry on the film. I spent about two months there. To this day, I think that's the longest I've been away from them for. Back then, it felt like more of a choice, and I remember thinking, I know it's more fun when we're all together and we can do the thing together. That's why we keep it as a family business. We were learning how to balance those things. I think that's the experience that crystallized that aspect of *Inception*—the call that Cobb has to his kids, trying to talk to them on the phone, the sand castles on the beach."

Since shooting *Memento* in the summer of 1998, it had been an almost uninterrupted decade of filmmaking. While *The Dark Knight* tore it up at the box office, Emma and he took the family to the barrier island of Anna Maria, on the west coast of Florida, for a monthlong vacation. The beaches on Anna Maria are known for their powdery white, quartzlike sand, and while watching his youngest sons, Rory and Oliver, making sand castles, the image stuck in his head, and upon their return from Florida, he dug around in his desk drawer and retrieved his script for the film, which he had abandoned in 2002. Reading it again, he thought, *I think it will work.* "That version of the draft, the Mal character was a totally different character. It was more in the noir tradition of a former business partner, like in *The Maltese Falcon*. I don't remember what changed exactly, but at some point, I remember telling Emma about it and I realized that no, *it was his wife.* It was like, Oh, of course, and then I finished the script very quickly after that. The script finally worked, because suddenly you understood the emotional stakes. I hadn't known how to finish the script emotionally. I think I had to grow into it."

. . .

Inception was thus the work of half a lifetime, as close to a creative autobiography as the filmmaker had yet made, bearing within itself a ghostly afterimage of each stage of its creation, like the rings of the redwood tree in which Kim Novak sees her previous life spans in *Vertigo*. An idea first conceived by Nolan when he was sixteen, nursed at university, elaborated upon when he came to Hollywood, and finally executed in the wake of *The Dark Knight*'s success, *Inception* took input from its maker at every major point of his life—the schoolboy, the university student, the Hollywood neophyte, the success story, the father—a little in the same way that Ezra Pound's *Cantos* grew old alongside the poet, or David Peoples' script for

Unforgiven stayed in Clint Eastwood's desk drawer, maturing like a whiskey until the filmmaker was ready to make it.

For over a decade, he had written his scripts in collaboration with another writer—with Hillary Seitz on *Insomnia,* his brother on *The Prestige,* his brother and David Goyer on the *Dark Knight* films—but *Inception* marked his first script written solo since *Memento.* The threat of solipsism loomed over *Inception,* as it did the earlier film: If the whole thing collapsed, there would be no one to pin it on but himself. The closest he had to a writing collaborator was his star, Leonardo DiCaprio, who met with the director in between location scouting to go over the script and make changes. DiCaprio was particularly involved as the script related to Cobb's dead wife, Mal, to be played in the film by Marion Cotillard, fresh from her Oscar victory for playing Edith Piaf in *La vie en rose* (2007). "The emotional story was what Leo very much responded to and wanted to expand on, so a lot of the rewriting I did with him," says Nolan. "I was working on a more superficial version of the project—*superficial* may be overstating it, because all the story elements were in there, but I was still trying to approach it from a genre perspective. Leo encouraged me and

ABOVE Cobb (DiCaprio) and Mal (Marion Cotillard) in Limbo; OPPOSITE DiCaprio during a break in shooting the scene where he loses Cotillard.

demanded of me to push it in a more character-based direction, more about the relationship. He didn't write, but he would go over the script and come up with ideas. I remember talking to my assistant director, Nilo Otero, about this, and asking, '*Are* there emotional heist movies?' Because a heist movie, inherently, is not an emotional genre. He suggested I take a look at Kubrick's *The Killing*, because it's a heist movie, very much a film noir, as well, but also a little bit more emotional than most heist films, which tend to be fun. That slightly encouraged me, but also you sort of go, 'Well, okay, we're going to do something maybe that hasn't been done before, but hopefully it can work.'"

From DiCaprio, Nolan got the idea—conveyed in no more than half a dozen shots—that Cobb and Mal get the time he promised her, living out their days until reaching old age together. "That was very much Leo," says Nolan. "It made a huge difference. It was a fraught, difficult process; the rewriting went on for months and months because he's very demanding, but it was very productive. I think he made it a more resonant film."

Of all the film's design elements, Limbo proved the toughest nut to crack. Unable to work with longtime production designer Nathan Crowley, who was wrapped up in trying to solve *John Carter* for Disney, Nolan instead turned to Guy Dyas, the British production designer of Shekhar Kapur's *Elizabeth*. Meeting with Dyas in Nolan's garage for four weeks to hammer out the film's design philosophy, they created a sixty-foot scroll depicting the evolution of twentieth-century architecture, from Frank

Lloyd Wright and the Bauhaus to the neo-Brutalism of Gropius and Le Corbusier's grand, unrealized vision of the modern city, Ville Radieuse, a symmetrical series of identical prefabricated high-density skyscrapers spread across a vast green area and arranged in a Cartesian grid, allowing the city to function as a "living machine." At first a handy research resource, the scroll ended up inspiring one of the film's more astonishing designs: the dream city built by Cobb and his wife in Limbo, which stretches back seemingly forever, the buildings getting taller, and older, as they go—a fitting image of the film's own evolution over time.

Nolan wanted it to represent the decaying state of Cobb's subconscious; at its outermost edges, the buildings, once beautiful and pristine, are crumbling back into the sea, like a glacier, with giant architectural icebergs splitting off and drifting away in the water. It was brilliant on the page—a city crumbling into the sea like a glacier—but what did that actually look like? While driving from the airport to the historic medina quarter of Tangier, which was to double as Mombasa for an alleyway chase, they came across an avenue of seemingly abandoned apartment complexes in the middle of nowhere. That gave them their photographic starting point. "Chris wanted

Nolan and Thomas check the monitor while Leonardo DiCaprio and Dileep Rao play a scene.

something that was recognizable," said VFX supervisor Paul Franklin. "So we had the idea—take a glacier and fill it up with buildings." After three months' work, constantly cranking out different versions, they eventually arrive at a weird, mutant city, which from a distance looked like a set of cliffs, chipped with gullies and ravines, until you get closer and see that they are buildings, scored with roads and intersections. Viewing it on laptop, Nolan said simply, "Well, *that* looks like something we've never seen before." By the end, they had worked on Limbo for nine months.

• • •

Twenty-three years after first conceiving of the idea, Nolan commenced principal photography on June 19, 2009, in Japan, with Tokyo's bullet train providing the location of the framing story once the dreamers awake. The production was his geographically largest to date, taking six months of principal photography in five different cities—Tokyo, Paris, Tangier, Los Angeles, and Calgary, Canada—at an estimated cost of $160 million. The production schedule—six months—was as big as that for *The Dark*

Nolan lining up the mirror door shot on Pont de Bir-Hakeim in Paris.

Knight. Something about the idea kept growing. "The scale of that film largely came from traveling different places and shooting real locations," says Nolan, who had many points where he thought to himself, This is a very strange film. "What gave me the confidence was *Memento*, because *Memento* is very much within the noir genre, and that's what grounds you and orients the audience in this disorienting experience. I remember reading M. Night Shyamalan quoted as saying he felt like his brain had been rewired watching it, which I thought was a wonderful, lovely quote. So I'd had this experience of doing something that broke a lot of rules and did something in a very different way that really excited people about movies and about the movie. I felt strongly that there was a big-scale version of that. I felt strongly I could make that work in a bigger way on a bigger budget in a bigger world."

From Tokyo, production moved to Nolan's favorite airship hangar in Cardington, Bedfordshire, where special effects supervisor Chris Corbould built the tilting hotel bar set and the rotating hallway; and from there to Nolan's alma mater, UCL, to shoot the "Ecole d'Architecture," where DiCaprio first comes across his father-in-law, played by Michael Caine, in the Gustave Tuck Lecture Theatre, in which Nolan sat as an undergrad; then moving to Paris for the scenes on the rue César-Franck, where Ellen Page's Ariadne first finds the fabric of a dream starting to unravel, the café and street where they are sitting disintegrating and flying apart in all directions. A lot of this was done in-camera, using air mortars to blast lightweight debris into the rue César-Franck, safe enough that DiCaprio and Page were able to actually sit in the middle of the blasts as the cameras rolled, Wally Pfister using a combination of high-speed film and digital cameras to capture the blasts at a thousand frames per second, which when slowed down had the effect of making the debris look like it was suspended in zero gravity. The destruction was then augmented digitally by the animation team at Double Negative, who were usually on set, along with sound recordists picking up ambient location sound. "He wanted to take it back to the 1970s," said Franklin. "In the days before computers changed the way we did business."

Nolan knew he would need the original score right from the very beginning of the editing process, such was the complexity of the project, in order to guide the viewer, to orient them "emotionally, geographically, temporally" through the film. While writing the screenplay, he had written in Edith Piaf's "Non, je ne regrette rien" as a musical cue for the dreamers to administer the "kick" that wakes them up from their dreams, but

he almost took it out when he cast Cotillard. It was Hans Zimmer who convinced Nolan to keep it in the film, retrieving the original master of the song in the French National Archives, and slowing down the intro so that the single two-step beat—*da-da, da-da*—formed the ominous blares from a brass section that play over credits and throughout the film, like foghorns over a city. All the music in the film is comprised of subdivisions and multiplications of the tempo of the Piaf track, so he could slip into half time or triple time at any moment.

"I didn't know what it needed musically, but I knew it would be such a unifying factor, I wanted to start thinking about it early. Years before, when I first started thinking about it, I fixed on this song and using this song, but as it became a reality—'Okay, there will be a composer on the film and I'm going to use it'—we had to secure the rights, so I needed to have that conversation before we even shot the film. Because I didn't want to shoot it using a different piece of music, I needed to know what it was. Right when we were talking about this, we were under the usual budget crunch and I was thinking about not shooting in Paris and moving some-where else, maybe London, somewhere we were already shooting, and it was actually Hans who stopped me, and he was like, 'No, that meant something in the script and itself connects with the song somehow.' Not

Nolan waits with cast and crew while shooting the hotel sequence.

Nolan prepping a scene in the Gustave Tuck Lecture Theatre in front of a sketch of Brunelleschi's dome of the Florence cathedral.

in a literal sense, but I suppose you could say in a musical sense, and so I thought, Okay. It's those kind of things that you rely on a close creative collaborator for, because you know that he's just made a connection on its importance and he doesn't even have to articulate why."

As was becoming their custom, he asked Zimmer to score the film "blind," without having seen a frame of film. He showed him the script, over a year before filming began, invited him to the set, showed him the designs, actors doing their stunts, but once it actually came time to edit the movie, he wouldn't show it to Zimmer anymore. "I think, of any of the scores we worked on, it was the one that was most about ideas rather than specifics, and so I never really told him it should be this or should be that. It was much more about ideas of time, ideas of dreams. It's a very popular sound track of the films I've made, but it's a very eclectic sound track. There are a lot of different things going on, a lot of different moods, whereas *Interstellar* and *Dunkirk* are very unified. All of our conversations were really about mood rather than about film music. Which isn't always the case; quite often you're being very specific about genre, about what each guy is going to do, all of those 'How are we going to do something different? How can we react to something?' questions. Or be influenced by something. You know, there's certainly a bit in *Batman Begins* where there's a very John Barry feel, and that's something I asked James Newton

Howard for specifically. I was like, 'That's what we're tapping into now.' *Inception* was a big machine of many parts, and a lot of people worked on that sound track. Hans had a terrific team that he put together—he called it a 'band'—some of whom, like Lorne Balfe, were composers in their own right. I didn't have a brief for Hans so much as we had ten pieces of temp music that we made, just the form of a sound track, what it might become, and then it was a question of 'Okay, let's be specific. What is this really? What's the idea?' And then he cracked it."

The Dark Knight had already been pretty heavy with electronics, but with *Inception,* Zimmer turned to David Bowie's avant-garde 1977 album, *Low,* and Robert Fripp and Eno's musical collaborations—*Here Come the Warm Jets* (1974), *Another Green World* (1975), and *Exposure* (1979)—and to the early experimental synthesizer scores he had written for Nicolas Roeg's *Insignificance* and Malick's *The Thin Red Line.* Using an old 1964 Moog synthesizer like the one used by John Barry on the score of *You Only Live Twice*—"a beast," Zimmer said—Zimmer added Bondish guitar work by the Smiths' Johnny Marr, together with one of the largest brass sections that had ever been assembled for a film score, comprising six bass trombones, six tenor trombones, six French horns, four tubas. By way of comparison, *The Last Samurai* used just two tubas. Calling Zimmer to see what he had, Nolan dialed him direct at his sound bunker in Santa Monica. Zimmer played the piece "Time," which plays over the film's ending, breaking the mood slightly as he swore at fumbling "the best bit," then picked up the phone and asked, "Was that too abstract for you to get?"

Nolan asked Zimmer to play it again, this time "on long string samples," so he had the chance to actually grasp the melody. This time, the director heard it. Zimmer came back on the line. "That's all I got," he said. "But I can't figure out where it goes from here." Not long after he hung up the phone, Nolan turned to his editor, Lee Smith, and said, "That's one of the most beautiful things I've ever heard."

• • •

In Douglas R. Hofstadter's 1979 book, *Gödel, Escher, Bach,* which Zimmer reread while writing the score for *Inception,* Hofstadter recounts a conversation between Baron Gottfried van Swieten and Frederick the Great that took place at the king's palace in Berlin in 1774. "He spoke to me, among other things, of music, and of a great organist named Bach who has been

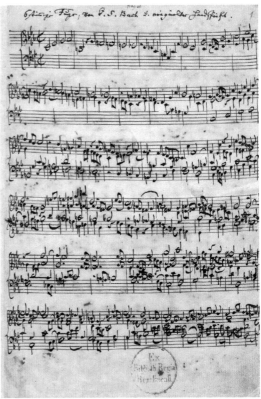

Dutch artist M. C. Escher's lithograph *Cubic Space Division* (1952); the first page of the manuscript of the "Ricercar a 6" from *Musical Offering* by Johann Sebastian Bach; Saito (Ken Watanabe) takes Nash (Lucas Haas) hostage in a dream.

THIS PAGE AND NEXT Nolan's diagram of the nested story lines of *Inception* (2010). When the director first hears or has an idea, his first instinct is to flip it, turning it almost into a three-dimensional object that he can hold in his hands or walk around. Storytelling thus becomes a three-dimensional exercise, like sculpture.

for a while in Berlin," said the baron. "To prove it to me, he sang aloud a chromatic fugue subject which he had given this old Bach, who on the spot had made of it a fugue in four parts. Then in five parts, and finally in eight parts." A fugue is a musical composition, like a canon, based on one theme played in different voices and different keys, and occasionally

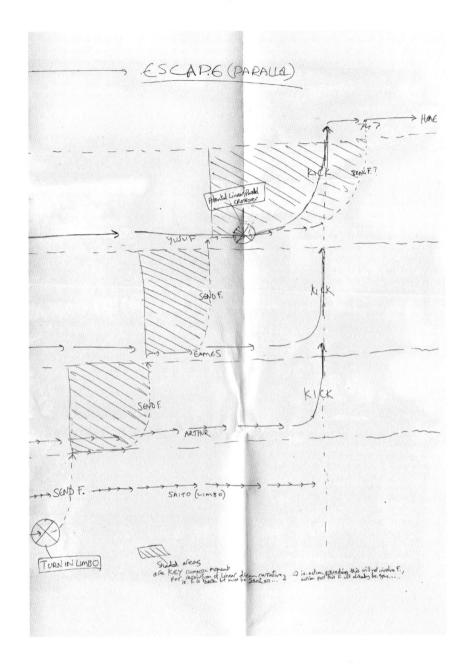

at different speeds or upside down or backward. Each of the voices enters in turn, singing this same theme, sometimes to the accompaniment of the countersubject, and when they have all arrived, all the rules fall away. Hofstadter, a professor of cognitive science at Stanford, draws a comparison between the endless rising loop of Bach's *Musical Offering*, the mathema-

tician Kurt Friedrich Gödel's incompleteness theorems, and the infinite stairwells of M. C. Escher, finding in each "an intellectual construction which reminds me, in ways I cannot express, of the beautiful many-voiced fugue of the human mind."

These days, one would simply refer His Royal Highness to *Inception*, possibly Nolan's greatest feat of structural engineering, juggling not two time lines (*Memento*), nor three (*Following*), nor four (*The Prestige*), but five, all at different speeds, like the musical figures in Bach's fugue, all synchronized to give an impression of ceaseless movement. The outermost ring is a Bond movie, complete with warring Japanese chemical companies and helicopters taking off from the roofs of the skyscrapers, as they do in *You Only Live Twice* (1967). It is the not-too-distant future, and technology first developed by the military is now in the hands of industrial espionage experts who use it to invade the dreams of unsuspecting CEOs and steal commercially sensitive information. Cobb (Leonardo DiCaprio) and his crew are hired by the head of a Japanese energy company, Saito (Ken Watanabe), to infiltrate the dreams of a young Australian businessman, Robert Fischer (Cillian Murphy), and convince him to break up the corporate empire of his dying father (Pete Postlethwaite). To unravel this Oedipal knot, they will have to go deep, inserting themselves not just into Fischer's dreams but deeper still into dreams within dreams, each running at a slightly more dilated rate.

Ten hours buys them a week down in the first level, where they emerge into a rain-soaked car chase in downtown Los Angeles: Fischer's subconscious has armed itself, forcing Cobb's team into a firefight, which eventually will send their van off a bridge. Down again. This time, they find themselves in a luxurious hotel, where they have six months to win Fischer's trust and rouse his Oedipal ire against his father. But up above, that van is still slowly tumbling, so the gravity inside the hotel goes haywire, the hotel corridors rotating like a hamster wheel while the characters attempt to finish a fistfight. Nothing in the film is as consistently delightful as the Brobdingnagian reverberations from one level of the dream to the next: Going to sleep without a visit to the toilet results in a rainstorm, while down on the third level, where Cobb and his team find themselves in a replay of the snowy chase scenes from *On Her Majesty's Secret Service*, snow bikes give chase as they lay siege to a mountaintop fortress pounded by the avalanches loosed by that still-spinning truck. Imagine *North by Northwest*, *Rear Window*, *To Catch a Thief*, and *Vertigo* all playing simultaneously in

four different theaters, with Hitchcock ushering us from one screen to the next, keeping our interest in each plot ticking along, and cutting to the next at just the right moment, and you are close to the feat of engineering Nolan pulls off.

One of the common complaints from critics when the film came out was that it wasn't very dreamlike. "Nolan's idea of the mind is too literal, too logical, too rule-bound to allow the full measure of madness—the risk of real confusion, of delirium, of ineffable ambiguity—that this subject requires," wrote A. O. Scott in *The New York Times*. "Cobb's intercranial adventures aren't like dreams at all—they're like different kinds of action movies jammed together," complained *The New Yorker*'s David Denby. Certainly, the film's status as a filmmaking allegory is there for all to see, as Cobb and his team of oneironauts plan their dreams down to every last detail of costume and setting. You cannot kill anyone down in a dream—the sensation of dying wakes them up—but they can realize they are dreaming, in which case the web of illusion you have cast will slowly come apart, like a movie whose plausibility unravels in front of your very eyes. "We have to translate the idea into an emotional concept," says Cobb, who is the team leader, or director. "How do you translate a business strategy into an emotion?" asks Arthur (Joseph Gordon-Levitt), his trusted associate, the producer. There's the architect Ariadne, who designs the mazelike structures of the dream rather like a production designer. There's a debonair shape-shifter, Eames (Tom Hardy), who dons various disguises, like an actor. There's their corporate employer Saito, who could be the executive in charge of the project. There is Fischer, their intended audience of one. And finally we have a brilliant Asian chemist, Yusuf (Dileep Rao), who is in charge of liquid refreshments, shall we say.

Nolan opens the storytelling of the movie into a game played out between filmmaker and audience. This Bond movie is sentient. "You never remember the beginning of your dreams, do you?" says Cobb, sitting outside the café on the rue César-Franck, to Ariadne. "You just turn up in the middle of what's going on. . . . So how did we end up at this restaurant?" His question is asked equally of the audience, making mischief with the shuffle of mysterious locations that has been par for the course in action adventures since Hitchcock spun the globe beneath Cary Grant's feet in *North by Northwest*. (Do *you* remember why Grant ends up in a cornfield near Bakersfield?) "I guess I thought the dream space would be all about the visual, but it's more about the feel of the place," says Ariadne after the street blows out like confetti—cups, glass, fruit, papers—all hanging there

as if underwater. Flexing her newfound powers of creative license, she folds the entire rue César-Franck back on itself, each street with its own gravitational well, cars and people moving perpendicularly to one another, like Escher's 1953 print *Relativity*. As visually audacious as the effect is, what really sells the effect is the sound it makes as it does so: a distant, weighty clanking, like a massive clock mechanism being wound, actually the sound of an anchor winch devised by King for a twenty-four-gun British three-masted man-of-war in Peter Weir's *Master and Commander: Far Side of the World*, set in 1805.

With its bullet trains and neo-Brutalist architecture, *Inception* looks sleekly modern, but its creative pedigree feels more ancient. The dreams have none of the shimmer or haziness of the Freudian/Surrealist era, and instead the hard clarity of Escher or Thomas De Quincey's opium dreams. Upon being told of Piranesi's engravings of "dreams" by the poet Coleridge, De Quincey noted the similarity between Piranesi's engravings and the architectural splendor of the dreams he experienced while under the influence of the drug.

Creeping his way upwards, was Piranesi himself: follow the stairs a little further, and you perceive it come to a sudden abrupt termination, without any balustrade, and allowing no step onwards to him who had reached the extremity, except into the depths below. . . . Again elevate your eye, and a still more aerial flight of stairs is beheld: and again is poor Piranesi busy on his aspiring labours: and so on,

The rue César-Franck folds back on itself during one of Ariadne's dreams.

until the unfinished stairs and Piranesi both are lost in the upper gloom of the hall. With the same power of endless growth and self-reproduction did my architecture proceed in dreams.

Nolan and Emma Thomas on holiday in California, photographed by Roko Belic. The photograph inspired a key scene in *Inception* years later.

But as many observers have pointed out, De Quincey was mistaken: The series he thought depicted "dreams" instead depicted prisons and contained no such miniature versions of Piranesi, trapped within each flight. "This is not so much a mistake as Piranesi's ecstasy caught precisely," noted Sergei Eisenstein, whose own film *Ivan the Terrible* (1944–1958), bisected its characters' shadows with explosive, Piranesian diagonals and arcs. "The fact that the flight of staircase reproduced the inner flight of the author himself is evident." In other words, Piranesi's prisons *seem* dreamlike. And De Quincey's dreams *felt* like prisons. His "mistake" was no such thing.

Nolan's entire oeuvre might be said to aspire to the same mistake, particu-

larly *Inception,* in which dreams become a very real prison for Cobb's wife, Mal, a ravishingly shot, tear-stained Eurydice whose death is the reason Cobb has been living in exile all these years. "You've created a prison of memories," says Ariadne, horrified. "You really think that's going to contain her?" No mere love interest or romantic subplot, the character of Mal is the pivot on which *Inception*'s feat of narrative engineering rests, her backstory entwining with the central mystery of what inception is, exactly, and why it is so dangerous. "We can still be together, right here, in the world we built together," says Mal, like an addict coaxing her partner into relapse. "Choose," she says, imploringly. "Choose to be here." Who wouldn't be tempted? The woodwork around her looks solid enough, the sunlight dappling it warm, while up in the worlds above, that truck is still falling, the hotel slowly tumbling, and gunfire still raking the snow. The movie's textural precision is the point. A haze of unreality would kill the dilemma. For a second, even Cobb is torn, clenching his fists in front of his face as if to regain his weakening resolve. For all the ingenuity and structural splendor of *Inception,* there is a sadness sweeping through its architecture, palpable in Cotillard's aching performance, but just for a few seconds DiCaprio has caught it, too: It is the sadness of the dreamer who knows that he must one day awake.

. . .

It isn't a sentiment you find much expressed in modern Hollywood, but there is one place you find it in abundance. Enduring the tedium of Cowan Bridge, the Clergy Daughters' School in Lancashire so harsh that her elder sisters Elizabeth and Maria died of tuberculosis after attending it, young Emily Brontë lost herself in the imaginary world of Glass Town, where "lofty mills and warehouses piled up storey above storey to the very clouds, surmounted by high tower-like chimneys vomiting forth the huge columns of thick black smoke, while from their walls the clanking, mighty din of machinery sounded and resounded till all that quarter of the city rang again with the tumult." Written when Charlotte, Emily, and Anne Brontë were teenagers, the literature exploring the fictional Glass Town federation, long dismissed as juvenilia by scholars, is in many ways the precursor to Tolkien's Middle-earth. "Life in Gondal is dominated by a pervading sense of confinement, sometimes physical and sometimes spiritual, where the speaker is chained by powerful emotions, memories, and the consequences of action," notes Brontë scholar Christine Alexander.

"In such a world, death becomes a liberating alternative." The fantasies entertained by Emily were so intense, it caused her physical pain to return to reality.

> Oh, dreadful is the check—intense the agony—
> When the ear begins to hear, and the eye begins to see;
> When the pulse begins to throb, the brain to think again;
> The soul to feel the flesh, and the flesh to feel the chain.

What did the Victorians think dreams were? Before Freud, the dominant theory about dreams was associationism, popularized by David Hartley in his *Observations on Man* (1749), which maintained that during the dream the imagination becomes monstrous by overpowering the dreamer's ability to reason. The dream is not the fulfillment of a secret wish but a kind of runaway fiction. "The illusion of dreams is much more complete than that of the most exquisite plays," wrote Glaswegian physician Robert Macnish in *The Philosophy of Sleep* (1834). "We pass, in a second of time, from one country to another; and persons who lived in the most different ages of the world are brought together in strange and incongruous confusion . . . Nothing, in short, however monstrous, incredible, or impossible, seems absurd." Often the dream's contents were prompted by the incursion of physical sensation, so lying in a smoky room, one might dream of the sack of Rome; there is also "an apparent expansion of time in dreams" noted Macnish, much as a dramatist stretches time in the interests of good drama. All of these aspects of the dream—the connection to physical sensations, the link with the imagination, the dilation of time—would fall out of fashion with the publication of Freud's *The Interpretation of Dreams* in 1899, but they would all play a part in *Inception.*

What dreams were to the Victorians, they are to Nolan: an escape. The heroes of *Memento* and *Inception* lose themselves in fantasy not because their reality is unpleasant but because their reality is intolerable; and when it is suggested at the end of the film that they still might be self-deceived, the audience is strangely jubilant—yay for the mechanisms of denial!—so effectively has Nolan schooled us in the workings of his looking-glass universe. The critics were right about one thing. The Austrian father of psychoanalysis, who saw dreams as the "fulfillment of a wish" and repressed desires the "royal road to the unconscious," would not have recognized any of his teachings in the teeming, architecturally precise underworld of

Inception. The film isn't a Freudian, or even post-Freudian film. It is *pre-*Freudian. If the Brontë sisters had been gamers, *Inception* is exactly the kind of multiplayer game they might have devised.

"When we got to the scene where you're going up and down the elevator to different levels of his mind, I don't think it's possible to dismiss the Freudian nature of that," says Nolan. "It's an interesting idea, Freud, creatively and artistically. If you think of *Spellbound*, with Hitchcock getting Dalí to do the dream sequences and everything—it doesn't play today. There is an echo in *Marnie,* as well. As far as Freud's influence on how we view stories, it's massive, and a little hard to break out of, truthfully. I've employed it; I've also dodged away from it a lot in my writing. So when I wrote about Howard Hughes, I strongly resisted that impulse. And it was a point of contention with the producers, because they wanted the Freudian backstory. I looked at Freud in college in terms of literature and there were some interesting things that we studied to do with the correspondences between the golden age and era of the detective story, and psychiatry, how that really comes about the same time that Freud is gaining popularity. In literary terms, they're very similar. If you read Wilkie Collins's *The Moonstone,* it's not exactly a dream interpretation, but there's a relationship in his work between psychology and experience and memory and the detective story. I actually read it relatively recently, so it wasn't an influence on *Inception,* but I named the boat after it in *Dunkirk.* It was fascinating to

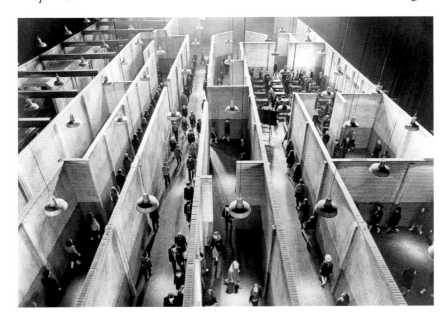

Alan Parker's *Pink Floyd: The Wall* (1982), which Nolan screened for the cast and crew.

Author Wilkie Collins, whose 1868 novel, *The Moonstone*, praised by Henry James as "the most mysterious of mysteries," contains a clue to the dreams of *Inception*.

me that, if you consider it the first detective story, it's also one that deconstructs the modern detective story. For anyone who works in crime fiction in whatever medium, it's humbling, because right from the beginning he turned the whole thing on its head, twisting the rules and playing with them. It's a brilliant book. I mean brilliant."

Running for thirty-two episodes, over eight months, in his friend Dickens's periodical *All the Year Round* in 1868, *The Moonstone* concerns the theft of a precious jewel from a country house. There is an eccentric detective, Sergeant Cuff, who is one of the first fictional characters to employ a magnifying glass. Each member of a country-house party is considered a suspect in turn; the blame shifts from person to person in an apparently endless game of pass the baton. More unusually, it is narrated by most of those suspects in turn, with eleven narrators all told, each taking a turn to give his or her version of events: "From all I can see, one interpretation is just as likely to be right as the other," says one of the characters. But the most salient fact of the mystery is its resolution: The theft was committed by one of the narrators while under the influence of opium. The crime is unconscious, the perpetrator not even aware of his own guilt. "I had penetrated the secret which the quicksand had kept from every other living creature. And, on the unanswerable evidence of the paint-stain I had discovered myself as the thief." Collins gazumps the law of the least likely suspect at first attempt: The narrator did it, a twist it would take over half a century for Agatha Christie to rediscover in *The Murder of Roger Ackroyd* (1926), while Collins's dream thief prefigures Cobb in *Inception* by over a century.

Nolan didn't read *The Moonstone,* however, until after he finished *Interstellar,* so what is it doing in any discussion of *Inception*? It's not too hard to see why so much of *Inception*'s creative gene pool stretches back to the Victorians. It was more or less conceived in the nineteenth century, in the "Victorian hangover" Haileybury, with its neoclassical quads, Latin grace, and cold baths. It draws on a set of influences soaked up while at the school—the TV show *Freddy's Nightmares, Pink Floyd: The Wall,* and the lithographs of M. C. Escher, whose infinite stairwells were for a long

time thought to have as much con-
nection to reality as a trigonometry
equation—"My work has nothing
to do with reality, nor with psy-
chology either," Escher once told
a journalist—but a 2015 exhibition
of Escher's work in The Hague
revealed a considerable degree of
correspondence between his cel-
ebrated postwar labyrinths—*Day
and Night* (1938), *House of Stairs*
(1951), *Relativity* (1953), *Print Gal-
lery* (1956)—and the Romanesque stairwells and passageways of the school
Escher attended in Arnhem, in the east of Holland, at age thirteen. Bored
in class, twice having to repeat a grade, failing to obtain a diploma upon
leaving, he later recounted his school years a "living hell," one whose stair-
wells and corridors he would reproduce in the monstrously extending cor-
ridors and stairwells of his famous postwar prints. *Inception* does something

Nolan in the basement
of the pharmacy where
Yusef supplies his
sleeping drafts, uncon-
sciously influenced by
Nolan's dormitory at
Haileybury.

similar with the neoclassical architecture of Haileybury—particularly the pharmacy, where Yusef administers his Lethean drafts, beneath which is to be found a low-ceilinged concrete basement hung with bare lightbulbs, where twelve sleepers lie in row after row of metal-frame beds, explicitly echoing the repetitive, recursive architecture of Nolan's dorm at Melvill House: a long, spartan barracks with wooden floors, a low ceiling, and two parallel rows of identical metal-frame beds, the youngest boys at one end, the eldest at the other, leaving no one in any doubt as to where they were in the grand scheme of things, where Nolan lay awake after lights-out listening to movie scores. Waking up from a nightmare, Cobb retreats to the bathroom next door, splashing his face with water from a row of sinks identical to those in the Haileybury bathhouse, with tiled walls, deep tubs, and tall-tapped basins.

"They're pretty similar," says Nolan. "You're not wrong. We had years of metal-frame beds and that would definitely be something that I would've had in my head. They were pretty common institutional beds, those standard metal frames, which fit with the postcolonial idea of that part of the world in the film. It wasn't something I was conscious of when I made it. It's just what felt right to me aesthetically. The repetition of the forms, as you describe what a dormitory is and how a dormitory works, that's a valid connection, and the escapism of the music, but it's definitely unconscious. That's the thing about movies. One of the things I found at college, being around students who were good at analyzing literature, talking to the professors, is that a lot of what a filmmaker does is subliminal. While I was making shorts, I would gravitate toward certain images or symbols—clocks, a deck of cards, that sort of thing—because they had a certain resonance. What I've accepted over the years is that the job of director, or position of director, is one in which a lot of what you do is instinctive and unconscious. The tesseract in *Interstellar* is probably the fullest idea of that idea of recursion, visually, because each bedroom is a unit that's slightly different, slightly advanced in time from the others. You're talking about the repetition of units, pattern, and multiplicity—that idea is in all my films. It's there in the tunnel of bedrooms in *Interstellar*, it's there in embryonic form in *Inception,* in the different houses they live in, an evolution of houses over time. It's also there in the tunnel of recursive mirrors in the elevator. I've tried to work it into my movies in different ways."

Nolan is unable to say why his dormitory's form should have so lingered in his imagination, but it was at boarding school that he first felt the

constrictions of time and space beginning to bite and at Haileybury that his imagination acquired its distinctively Victorian sinew—the sense of escape not just as a luxury but a necessity—and in his dormitory the key elements of repetition and recursion, so central to his sense of composition and space, converged for the first time. If ever you were going to nurse a grudge against the laws of perspective, the Melvill dorm would be the place to do it. In its earliest iteration, *Inception* bears some relationship to other examples of what might be called boarding-school gothic, like Edgar Allan Poe's story "William Wilson," about a boy who spies his double in a boardinghouse so labyrinthine "that our most exact ideas in regard to the whole mansion were not very far different from those with which we pondered upon infinity," or Rudyard Kipling's "The Brushwood Boy," where Georgie dreams of "streets of infinite length" until he is arrested by a policeman named Day and returned to his boarding school, then "sat miserably upon gigantic doorsteps trying to sing the multiplication-table up to four times six." What is dream theft but an exaggeration of the sundered self-sovereignty of the boarder? "Do you know how it got hold of me? In my sleep," Winston Smith's neighbor Parsons says of "thoughtcrime" in *Nineteen Eighty-Four,* a nightmarish vision of Orwell's time at the prep school he attended, whose dormitories were patrolled by the matron at night, trying to catch out boys talking and send them to the headmaster for punishment. "Whether he knew it or not, what he did in *Nineteen Eighty-Four* was to send everybody in England to an enormous Crossgates to be as miserable as he had been," pointed out Anthony West in *Principles and Persuasion*s.

It is too simplistic to say, similarly, that Haileybury is the nightmare from which *Inception* is trying to awake. Nolan had a much happier time there than Orwell did at Crossgates. His dorm spelled confinement, but it is also where his storytelling career began, and it is this sense of imaginative double-jointedness, of structure both confining and liberating, that we find endlessly replayed in the kaleidoscopic, prismatic perspectives of *Inception*. The film revisits some of the themes of *Memento*—time, memory, exile— but this time with the esprit de corps of the team that Nolan had gathered around him in Hollywood, the emotional core of a four-time father, and the bullishness of a filmmaker who has just scored a billion dollars at the box office. "You've got to dream a little bigger, darling," says Tom Hardy's Eames, trumping Joseph Gordon-Levitt's handgun with a bazooka, and catching exactly the director's mood—frisky, flirtatious, playful.

Joseph Gordon-Levitt being put through his paces in the rotating hotel hallway. The crew built a 100-foot-long hallway with eight enormous rings encircling the outside, suspended from and powered by two giant electric motors that rotated it through 360 degrees.

Editor Lee Smith and assistant editor John Lee edited as Nolan shot, setting up a mobile editing room at Cardington for a few months while Nolan moved between the soundstages, five or six big sets at a time. Gordon-Levitt spent six weeks being spun like a hamster to re-create the effects of zero gravity while grappling with a security agent, all in-camera, the only digital work the removal of a camera rig from the background of the final shot in the sequence. "When I saw the footage from that scene, it really was stunning," said Smith, who elected to play it in a single continuous shot "simply because our immediate response when we first saw the footage was, 'It just doesn't look possible.'" After that, they went to Paris for a week, Lee working on a few scenes during the day on a laptop in his hotel room. What they could do on a laptop was very limited—no more than half a dozen shots, in case his laptop was stolen. The whole film fitted on a terabyte drive or two. At night, before attending dailies, he would lock the drive in a safe. Every night, Nolan would screen dailies in 35mm and as

they got further into postproduction, Nolan started screening the film for select friends—something he hadn't done since *The Prestige,* which had a similarly complicated plot—to see how it was working. It wasn't until reel three that he had his first real scare.

"Somewhere a few weeks into the cut, where normally you'd be gaining a little bit of confidence that it's coming together, we had a screening, and we just hit this wall of exposition," he says. "There were two massive chunks. The first was the scene with Michael Caine, which was a massive hurdle to get over. We got stuck on that for a long time, and then there was the later reel, where there was just a *lot* of exposition. We were just white as sheets afterward. I couldn't get to sleep for a couple of days. It was just awful. I was like, 'Oh my God, we've just taken $200 million and burned it in a bonfire.' You know what I mean? Actually, we hadn't spent $200 million, but everyone thought we had. And you go, 'Okay, well we might as well have spent $200 million.' When you tell people about your difficulties in the edit suite, I think people who haven't made a film sometimes think things are being overstated. As you make a film, as you find a film—Lee and I cut and we screened it for ourselves—most things tend to work along the sliding scale of like, 'Yeah, that's going to get better. We need to tweak that.' You just adjust it all. It's like tightening with lug nuts on a tire. You do this one, and this one, and this one, so it keeps the rotation. But every now and again, you get something where it just doesn't. And you're like, 'This will never work; this we will never get past. So what do we do?' I haven't had too many of them in my career, but that was one."

The solution was a ruthless cut, chopping the first scene more or less in half in a way that would forever leave a small question mark in some audience members' minds over the exact relationship of Caine's character to DiCaprio's: Is he a teacher, his father, his father-in-law? "The original scene clarified every point of everything that anyone could ever ask about the logic or the history of the story, and we basically cut the scene in half. We went out to lunch and we talked about it, and I said, 'What if we don't worry about explaining? What if you allow people to misunderstand certain things?' Because a lot of people see the film and they think Professor Miles is his father, not his father-in-law. We just said, 'You know what? Just let that happen.' I don't ever remember doing a film where I let go of actual narrative points like that—that is to say, I'm not going to explain this guy's relationship; it doesn't matter that much to the audience, or they'll figure it out if they want to—those types of cuts are very unusual

for me. But once we'd done that, it became a little less of a stopping point. And then the later scene, I don't remember the specific breakthroughs, but it was all really to do with montage. It really speaks to Lee's skill, and the two of us sitting there and going, 'Okay, how can we reorder things so there's a flow and a movement?' And then starting to get music in and use that, and keep a sense of entertainment going. But it was very scary. For a while, it just didn't work."

For the final two reels, six and seven, they edited backward from the point of the convergence, where all four story lines come together, allowing that to dictate the rhythm and pace of each section. "The way we cut that scene was, Lee was trying to follow the structure of the script I'd written. And he'd try to assemble it according to the script, and parts worked, parts didn't work. But eventually, what I said to him was, 'You've got to edit it backward. Just start with the moment of confluence, where everything comes together, and then we'll just layer in the scenes you cut back from there.' Once he got that, he was like, 'Great,' and he was off and running."

Finally, they had reached the place Nolan had spent the better part of two decades figuring out how to get to—what Dante called *il punto a cui tutti li tempi son presenti*—the point where all times are present. As all four time lines converge, there is a magnificent sense of a grand design revealing itself, with music and image so enmeshed that the moviemaking becomes its own kind of music. The Lydian chord progressions of Zimmer's score echo those of John Barry's score for *On Her Majesty's Secret Service*, stepping through four different keys—from G minor to G-flat major to E-flat

Cobb and Mal in Limbo—the line "We had our time together" was DiCaprio's idea.

major to B major—in as many bars of music, the feeling of hearing a major chord where you expect a minor one similar to that of extending your foot into thin air, only to find a step rising to meet it. The musical architecture thus matches the stepped narrative architecture of the movie. In the first time line, that van finally hits the water in a pointillistic slow motion. In the second, Joseph Gordon-Levitt circumnavigates the elevator shaft of the hotel in zero-g and cues up Edith Piaf's "Non, je ne regrette rien" to awaken the dreamers a level down, Piaf's signature note of defiance echoing over the snowy mountain slopes like a Klaxon:

Non! Rien de rien
Non! Je ne regrette rien
Ni le bien qu'on m'a fait
Ni le mal, tout ça m'est bien égal

(No! Absolutely nothing
No! I regret nothing
Not the good things that have happened
Nor the bad, it's all the same to me)

The good and the bad are all the same to *Inception,* too. In the third time line, Fischer reconciles with his father and Hardy rigs the snow fortress with explosives. And in the fourth, Cobb cradles the dying Mal while remembering their lifetime together. "You said that we'd grow old together," pleads Mal, her eyes spilling tears, and then we get the coup de grâce, suggested by DiCaprio during the rewrite process. "We did," says Cobb, as a sequence shows us the two of them as gray-haired octogenarians, holding hands, walking through the buildings of Limbo, two architects rounding out their lifetimes. "We had our time together." A man loses his wife. The same man lives to a ripe old age with her. A son loses his father but is also reconciled with him. If *The Dark Knight* had been the expression of Nolan's ambivalence at its most fulminous, *Inception* provides the counterpoint: a vision of human affairs in which everything evokes its opposite, dreams become prisons, Bond movies become dreamscapes, gravity's spell is broken, and for two hours and twenty-eight minutes the idea of escape at the movies is blessed with a sense of Narnian transcendence.

In the final scene of the film, Cobb returns to his home in Los Angeles, starts his top spinning on his dining room table, but before he can find out

whether it stops or not—in other words, whether he is still dreaming—he is distracted by the sight of his kids outside in the garden. Nolan stays on the top for what seems an agonizing amount of time—the top wobbles, then seems to self-correct, at which point the screen goes dark.

"It cuts in a very specific place," says Nolan. "Everybody takes it differently and we chose the frame, Lee Smith and myself; we went back and forth and then frame by frame. It took a very long time to get exactly the right frame, and it's chosen very specifically because of the dynamics of the wobble. I remember reading online there were some physicists trying to track the movement and all this, but it actually cuts at the moment of recovery of the wobble. It's just spinning, spinning, and then it starts to destabilize, but the thing about spinning tops is that they do destabilize and then restabilize. We had a longer cut of that shot, which was on a later wobble. And maybe the reason why all my films end this way is that you try not to weigh heavy as a presence on your film, but there's a moment when you have to go, 'We're done.'"

NINE

REVOLUTION

"YOU'VE GOT TO THINK OF *A Tale of Two Cities,* which, of course, you've read," said Jonah Nolan upon handing in his first draft of *The Dark Knight Rises* to his brother. Nolan replied, "Absolutely," but reading the screenplay, he realized he had never read Dickens's novel, and he quickly ordered a Penguin edition. *A Tale of Two Cities* opens in 1775, with the release from prison of Dr. Manette, a French physician unjustly held in solitary confinement for eighteen years. "I am frightfully confused regarding time and place," he says. "My mind is a blank, from some time—I cannot even say what time—when I employed myself, in my captivity, in making shoes, to the time when I found myself living in London with my dear daughter here." Leonard Shelby would recognize his condition instantly: Dr. Manette is suffering from traumatic anterograde amnesia.

Nolan was initially reluctant to make a third movie: "There are no good third sequels, basically—*Rocky III* maybe. But they are very difficult. So my instinct was to change genres. The first one is an origin story. The second one is a crime drama very much like *Heat*, and the third one, we needed to blow up bigger, because you can't scale down. The audience doesn't give you any choice, but nor can you go back and do what you did before. So you've got to shift genres. We went for the historical epic, the disaster film—*The Towering Inferno* meets *Doctor Zhivago*. The way Jonah put it to me is like, 'Look, we've just got to go there with the third act of

the film.' We'd made two films and everybody's made all these films about 'This awful thing's going to happen.' We needed to go there. 'All of these films have threatened to turn Gotham inside out and to collapse it on itself. Let's just go there and have the horrible thing happen.' I don't have a favorite of any of my films, but I think *The Dark Knight Rises* is an under-rated movie. There are things in there that we did that are pretty subversive and pretty shocking. It's as close as I'll get to adapting *A Tale of Two Cities*."

Much of what the Nolans borrowed from *A Tale of Two Cities* was cosmetic—the famous final lines about self-sacrifice in the postcredit crawl ("I see a beautiful city and a brilliant people rising from this abyss . . ."); the name of Dickens's bombastic social-climbing lawyer, Stryver, for Daggett's assistant, played by Burn Gorman, and that of John Barsad, the British spy, for Bane's right-hand man, played by Josh Stewart. Other elements were more substantial, primarily the theme of revolutionary justice, as meted out by the self-appointed people's tribunals, where Bane sits like Madame Defarge knitting "with the steadfastness of Fate" in *A Tale of Two Cities*. A frequent visitor of prisons since his father was hauled into debt-ors' prison in his youth, Dickens was fascinated by the irony that a revolu-tion in the name of freedom resulted in so much false imprisonment. It climaxes with the Revolution in Paris, the storming of the hated Bastille, which Dickens presents in a series of bold strokes—cannon, muskets, fire and smoke, falling wounded, flashing weapons, blazing torches, "shrieks, volleys, execrations"—repeatedly comparing the people to a "living sea," a rising tide, an all-consuming fire.

Nolan had his theme and his title.

One of Phiz's illustrations for Charles Dickens's *A Tale of Two Cities*, entitled *The Sea Rises*. "Shrieks, volleys, execra-tions, bravery without stint, boom, smash and rattle, and the furious sounding of the living sea…" wrote Dickens.

. . .

Even as the script was still being written, Nolan set up a model-making department and art room with tools, workbenches, and drawing tables in the production facility that now abutted his house, and set them to work designing the film. Meeting in his office with writer David Goyer in 2008 to see if they had a third film in them, they kicked around the irresolution of *The Dark Knight*'s ending—the fact that Gotham's order was based on a lie—writing plot points and character notes on index cards. Eight years after the events of *The Dark Knight*, the pact between Gordon and Batman that ended the film—which had Batman taking the fall for the late Harvey Dent's crimes—has had its intended effect. Under the "Dent Act," Gotham has cleaned up its act. Thousands of violent criminals rot behind bars, while the 1 percent live high on the hog. In discussion with Goyer, the theme of a third film—"The truth will out"—began to emerge and, with it, the image of something long suppressed rising up. It was Jonah who suggested their villain emerge from the city's sewer system.

"It was Jonah who came up with this idea of this underground prison, open to the sky, too, which is just a phenomenal idea," says Nolan. "I had told him that Bruce needs to be broken down and taken to this place and it's got to be somewhere exotic. What's interesting is, it never would have worked as anything other than an underground prison. It doesn't work if

Nolan on the set of Bane's prison, modeled on the Chand Baori stepwell in Rajasthan, an inverted ziggurat, with multistoried steps built down to water level.

you imagine it in a building but as a hole in the ground, as a pit, then it has resonance, like being trapped at the bottom of a well." Like *A Tale of Two Cities, The Dark Knight Rises* would be an epic of confinement, with Bane banishing Batman at the midway point to the same underground prison in the Middle East from which he first emerged and where Batman must watch as the citizens of Gotham clamber over one another in their efforts to survive. "There can be no true despair without hope," says Bane, like the early Christian doctrinists who held that the damned souls in Hell can see Paradise but can never get there. Like many a Nolan villain, the chief torment he wishes to inflict is psychological.

"The same way we looked at genre, we did the same thing with villains. You have to go, Okay, what different types of villains are there? Ra's al Ghul is very much this Bond villain, an intellectual who's got a philosophy he's trying to put on the world. The Joker is mad. He's a serial killer. Bane needed to be the monster. It's Jack Palance in *Shane;* it's Darth Vader; it's Kurtz. He's a soldier. The first time Tom did the voice for us, it was scary. It gets into your head. I had him do at least one scene dead straight, with a more Richard Burton voice—just like a deep, nasty, villain sort of voice, and it just wasn't the character. Everybody working on the film would do the voice constantly. We'd be on the dub stage and one of us would just be like, 'Behind you.' There's almost a colonial aspect to it, too. It's like someone's speaking English who learned it and mispronounces words every now and again, but not obviously, there's no foreign accent, but there's a precision to the language that's off. It's hard to compete with what Heath did—they're apples and oranges—but it's a pretty amazing character. It really is an incredible performance. And I'm very proud of some of the writing we did for that character, as well. Some of it's Jonah's, some of it's mine, but there's a couple of bits that really stick with me, where he talks about the darkness—'You think the darkness is your ally; you merely adopted the dark'—that turned out so well."

In the comic books, Bane is a brute in a brightly colored wrestling mask; in Nolan's interpretation, he is a gas-masked revolutionary with the build of a bison and a Vaderish breathing muzzle that turns his oddly cultivated accent into a hideous rasp as he delivers long speeches urging the downtrodden citizens of Gotham to take back control of their city from their rich oppressors. "There's a storm coming, Mr. Wayne," warns a cat burglar called Selina Kyle (Anne Hathaway). Nolan and Goyer were at first unconvinced by Jonah's enthusiasm for reintroducing Catwoman into

the series, thinking of the campy Eartha Kitt portrayal, but they came on board once they started thinking of her instead as an off-the-grid grifter, who spends much of *The Dark Knight Rises* in pursuit of the "clean slate" technology that will allow her to erase her criminal past. "There's no fresh start in today's world," she complains, echoing the Orwellian overtones of *The Dark Knight*. "Any twelve-year-old with a cell phone could find out what you did. Everything we do is collated and quantified. Everything sticks." When Bane places a GPS tracker in the jacket of one of his own men, shoots him, and shoves him into the sewer to track Jim Gordon's escape route, his actions perfectly express the film's brutal, neo-Orwellian black wit.

"What's interesting, looking back at those aspects of the *Dark Knight* films—which came from my brother, actually, who's always been fascinated by the use of that technology—and when he was first pitching to me the idea of using cell phones as microphones in *The Dark Knight,* it seemed very improbable," says Nolan. "Now it's almost blah. I suppose the visual-imaging promise of a sonar-signal phone is still another step forward, but frankly the idea of controlling the microphone, switching it on, monitoring the frequencies, certainly doesn't now fall under science fiction. If you had that in a Jason Bourne movie today or something like that, it would pass muster, absolutely. When I think about how exotic and improbable it seemed at the time, that's a pretty amazing shift. In the third film, the MacGuffin was the clean-slate software that Catwoman is after. The idea that you could have software that can essentially erase your identity now seems like a pipe dream—we're long past that point. And that's a pretty terrifying turn of events, when you think about it. Now it just seems unrealistic. *That's* terrifying."

· · ·

Nolan may be the DeMille of disorientation, but he is no modernist in pursuit of disorientation as an aesthetic end in itself, like the Dadaists and Surrealists whose "deambulations" were designed to explore "the boundaries between the waking life and dream life," or the Situationists whose "urban drifting" was supposed to read the city according to the principles of "psychogeography." Nolan seeks orientation, above all, and prides himself on his sense of direction. In the fall of 2017, while visiting Joshua Levine, his historical consultant on *Dunkirk,* at Levine's home in Chalk

Farm, Nolan alighted at the Chalk Farm tube station, found a Boris bike, and endeavored to check the route to Levine's home on the map provided in the tube station. He looked at it for several minutes, unable to make head nor tail of it, then realized that north wasn't upward on the map anymore. "The map now orients to where you are facing on the street, like SATNAV on your phone. So, you're fucked. Because it's pretty much impossible for you to construct a mental map or a bird's-eye view from GPS. It's not really a map at all. It's just a set of directions and instructions. It's beyond anything in *Nineteen Eighty-Four*. You become a robot, essentially. I would be curious to know when they changed it and did anybody complain. Or am I the only person who cares?"

A second-century map for al-Sharif al-Idrisi putting south at the top in the direction of Mecca; a still from the film of George Orwell's *Nineteen Eighty-Four*, which details, among other things, the first off-the-grid romance.

Actually, maps *are* Orwellian, redrawing them one of the ways Big Brother keeps control of the prole population in *Nineteen Eighty-Four*—a version of the outsize map of the western front Orwell had seen pinned up in a blackboard in the library at Eton. "Everything had been different then. Even the names of countries, and their shapes on the map,

had been different. Airstrip One, for instance, had not been so called in those days: it had been called England or Britain, though London, he felt fairly certain, had always been called London," Orwell wrote. It is only by walking in the "labyrinth of London" without a map ("losing himself along unknown streets and hardly bothering in which direction he was going") that Winston Smith first finds the junk shop where he buys the diary in which he writes down his seditious thoughts and runs into the dark-haired girl from the Fiction Department, Julia, with whom he enjoys his off-the-grid romance. "With a sort of military precision that astonished him, she outlined the route that he was to follow. . . . It was as though she had a map inside her head. 'Can you remember all that?' she murmured finally. And in her practical way she scraped together a small square of dust, and with a twig from a pigeon's nest began drawing a map on the floor."

To test Nolan's thesis, I went on a twelve-mile walk through London's parkland, chosen because it's one of the few places in the city where people can't orient themselves using any nearby landmarks. I started at the Royal Geographical Society in Kensington, where I met my friend Marcel Theroux, who had recently returned from a reporting job in Crimea, where he had relied exclusively on his phone to find his way around. "There *is* that feeling that you're shutting your brain off," he said. "You don't bother to learn the routes. You just sit back and you're not aware of where you're going." We turned our phones off, feeling strangely liberated, and started asking for directions from people—which way was north?—without looking at their phones. The day was overcast, suiting our purposes perfectly. Denied their phones and the sun, tube stops and the maps in bus stops turned out to be the favorite means of orientation, and, pointed out one picnicker, moss, which grows on the northwest side of trees, away from the sun. Marcel told me that his nephew Finley had recently gone to a music festival in West London and was meant to catch this bus home but lost power on his phone. "He basically became like an infant. I said, 'Well, couldn't you take a night bus?' But he was like, 'I had to get into a taxi and fork out fifty quid to get back to South London.'"

By the end of the afternoon, we had heard a few horror stories like that. Cornwall—the Bermuda triangle of SATNAV—figured in a lot of stories. As the sun set, we headed for the Serpentine Gallery in Hyde Park, where we completed our last interviews inside a pavilion designed by Mexican artist Frida Escobedo—an enclosed courtyard with a mirrored ceiling,

walls built from a lattice of cement tiles, and a triangular pool, one of whose axes aligns with the Greenwich meridian. There, we found a pair of architects whose experience with the Wayfinder maps used by Boris Bikes echoed Nolan's own. "The Orwellian part is that they can aggregate all your routes and all they need is one bit of connecting information—from WhatsApp or Facebook—and they can figure out who and where you are." An Austrian actress told us she was driving to Milan one night with her husband, only to have SATNAV route them through the Dolomite Mountains. "Six hours in the Dolomites," she said. "I got hysterical, and I never get hysterical."

By the end of the day, we had interviewed over fifty people, ranging in age from twelve to eighty-three. I graded the responses, awarding six points to anyone who guessed true north, five to anyone guessing NNW or NNE, four to NW or NE, and so on, then calculated the average age of each score. The average age of those scoring six was forty-four, that of those scoring five was twenty-seven, that of those scoring four was twenty-two, and that of those scoring two or less was nineteen. It looked pretty good for Nolan's thesis. Phones *have* eroded our sense of direction. He's not the only person who cares. Whether it was all an Orwellian plot remained open to question.

"It was interesting," Nolan said when I presented him with the results. "The story that interests me the most is Finley's, because he became literally an infant. The reason I started banging on about it, I've always had this thing in my films that I've been interested in, which is the tension between our subjective use of the world that we're imprisoned in and our unfailing, unshakable belief that there's an objective reality. I'm interested in things that explore that tension. I hadn't realized just how liberating the idea of a map with north, south, east, and west and the city, or whatever it was, until it starts to be taken away from you and you're not sure how to get there.

"I should point out that Finley objects to his uncle's characterization of him as an infant, but the bigger objection is how objective is north, exactly? I got into an interesting conversation with the map librarian at the Royal Geographical Society about why north is always up on the map. He said Ptolemy was the one who first mapped the world in that familiar half-eaten-doughnut-shaped projection that reflects the curvature of the Earth, but because the only fixed point available to him was the North Pole, he used that. I said to the librarian, 'If Ptolemy had been in Asia or Africa, would he have oriented them south?' He said, 'Well, yes.'

"I'm just trying to think if there's a physical reason for your compass pointing north. But I guess it's pointing south as well, isn't it?"

"So maps really *are* Orwellian."

"I'd forgotten about the maps in *Nineteen Eighty-Four*. I haven't read it in a while. Of course, in Orwell's case, the maps themselves are manipulated imperceptibly. There is a mechanism behind cartography to do with freedom and control and how much information you're given. The bit where you sort of have to retain your tongue in cheek when we talk about these things is, they're not conspiracy theories. It's just there's a danger when we start to rely on particular technologies, or on corporations that manage our information and track our movements. You don't want to overstate it, but they're encouraging dependency. One of the things I try to teach my kids is when we go to a new city, I like to wander around and get lost and then explain to them how I've managed to find my way without a phone, without a map. I don't worry about getting lost, because if you're a tourist, it doesn't really matter when you turn up at a place—it's about embarrassment. I just embrace that, say, 'Look, we'll get lost, but we'll find our way.' It's something that applies to filmmaking very, very directly because you look at the plan of a set you're building; then you have to be able to visualize the subjective shots on the ground if you're going to build that up. You're always reconciling two-dimensional imagery with three-dimensional space. You're always introducing subjective shots with, 'Okay, where is that in relation to the other things that are going on?' It's about the world of the film. The geography of stories is very important to me, and it's something I'm conscious of as I'm planning a film."

. . .

While still in prep on *The Dark Knight Rises,* Nolan had his team look at *The Battle of Algiers* (1966), Gillo Pontecorvo's quasi-documentary depiction of the Algerian War against French occupation, shot in stark black and white on a shoestring budget with nonactors recruited from the streets of Algiers. Banned in France when it first was released, but winning the Golden Lion at the Venice Film Festival, the film was later studied by the Black Panthers for its lessons in revolutionary cell organization and screened by the Pentagon in the wake of the occupation of Iraq in order to better understand how to wage the "war on terror." The claustrophobic, winding alleyways of the Casbah provide the National Liberation Front with the mazelike hideaway they need to unleash guerrilla warfare on a

citywide scale, slipping through checkpoints to set off bombs in cafés that kill scores of civilians. They also looked again at the relationship between the themes and architecture of Fritz Lang's *Metropolis* (1927), *Doctor Zhivago* (1965), and Sidney Lumet's *Prince of the City* (1981), one of only two films Lumet scripted himself, about Danny Ciello, a narcotics detective, caught, like Serpico, between the corruption of his department and the noose of an internal affairs investigation. "It's this underrated Lumet, really remarkable, and the print was in terrible shape, weird colors, but it was just amazing to watch," says Nolan, who paid particular attention to Lumet's eschewal of mid-range lenses, using only wide-angle or long lenses, which elongate and foreshorten the space, so a city block appeared to be either twice as long or half as long, depending on the lens, and avoiding all shots of the sky. "The sky meant freedom, release, but Danny had no way out," said Lumet.

Principal photography on *The Dark Knight Rises* commenced in May 2011, under the code name "Magnus Rex," in Jaipur, Rajasthan, a rural area of India near the Pakistan border, for the exteriors of the prison, the interior of which they built at Cardington: an inverted ziggurat, with the widest part at the bottom and a tall shaft leading up to the surface, based on the Chand Baori stepwell in Rajasthan. When Nolan met with cinematographer Wally Pfister and visual-effects supervisor Paul Franklin during prep, most conversations began with "Can we do this for real?" Even the

Nolan and Bale during a break while on location in India.

most complicated visual-effects shot also contained a photographic element, captured in-camera, be it a foreground element or a background plate. The football game that Bane disrupts by detonating the field was shot at Heinz Field, in Pittsburgh, using a raised section of field with potholes, live explosions, with members of the Pittsburgh Steelers playing the Gotham Rogues football team and eleven thousand extras kept in their seats in the one-hundred-degree-plus heat of a Pittsburgh summer by a raffle of iPads, and a parade of Tumblers in between setups. In post-production, Paul Franklin's visual-effects artists rotoscoped the foreground elements, collapsing the field, enhancing the pyrotechnics, and increasing the horrified spectators from eleven thousand to eighty thousand. Nine weeks in Los Angeles was then followed by twelve days in New York, with the front door of Trump Tower replacing the Richard J. Daley Center as the new headquarters of Wayne Enterprises. Closing down portions of Wall Street with camera equipment, special-effects rigs, and one thousand extras, Nolan staged the climactic clash between Batman and Bane, not far from the real Occupy Wall Street protestors in Zuccotti Park, though not actually featuring them, as the swirl of rumor had it.

"The Occupy Wall Street movement was right there," says Nolan. "We literally had to schedule around them. It was very clear to us at the time that the sympathies of the film were very in tune with the sympathies of that movement. If you want to talk about class in these films, you need to

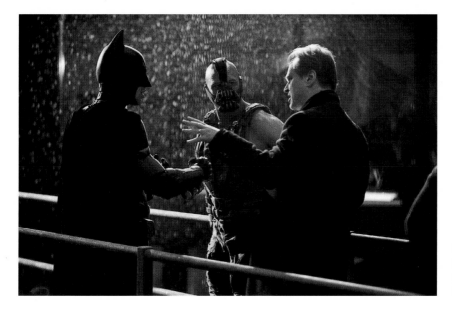

Nolan directing Christian Bale and Tom Hardy during the fight scene in Bane's underground lair.

look at *The Dark Knight Rises*, because Bruce literally has to lose everything and become bankrupt before he can triumph. He's got a lot of self-loathing as well, talking about the way in which the moneyed classes parade their philanthropy. There's a lot of 'This is bullshit.' I actually think the film is quite subversive in the real sense of the word because it ticks the boxes of entertainment, but it pushes very hard on the undercurrents. I never thought we'd get away with it, but we did. I didn't know *how* it would be received. The *Dark Knight* films are not political acts. They're exploring ideas of fears that are important to all of us, whether on the Left or the Right. *The Dark Knight* is about anarchy, and *The Dark Knight Rises* is about demagoguery. It's about the upending of society."

• • •

Written as the 2008 financial collapse began to rumble and shot as the Occupy Wall Street movement gathered strength, *The Dark Knight Rises* shrewdly intuits the press points of the postindustrial economy with its vision of a modern American city torn apart by internecine class warfare stoked by a Robespierre-on-steroids. The first we see of Bane (Tom Hardy), once he has arrived in Gotham, is his back. Sitting crouched on his knees in the darkness of his lair in the city's underground sewer system, his latissimus dorsi and trapezius muscles are thrown into relief by the overhead light, appearing almost sculpted against the surrounding darkness, like

Bane (Tom Hardy) was "born in the dark."

Brando's bald head as he carefully rinses it with a sponge in Francis Ford Coppola's *Apocalypse Now,* stroking his head with the same tenderness he showed a stray ginger cat in *The Godfather* or Eva Marie Saint's glove in *On the Waterfront.* "He touched whatever he touched as if it were part of him," wrote David Foster Wallace in *Infinite Jest.* "The world he only seemed to manhandle was for him sentient, feeling." A keen student of Brando, Hardy offsets and highlights Bane's brutality with similarly feline strokes of delicacy: the little finger twitch before a killing; the proprietorial hand he lays on the shoulder of Daggett (Ben Mendelsohn) before breaking his neck; or his appreciation for the voice of a boy singing "The Star-Spangled Banner" prior to a football game—"What a lovely, lovely voice," he remarks—before launching the citywide explosives attack that brings Gotham to its knees. Thus does Hardy suggest that Bane is a civilized brute or, rather, civilization's brute, the unpaid debt civilization must pay for its heedlessness, risen to manhandle its finery.

The prologue, in which Bane and his men ensnare a turboprop plane with a C-130 Hercules transport plane, is a classic bit of vehicle-on-vehicle abduction straight out of Bond, like the space shuttle that swallows another space shuttle in *You Only Live Twice,* but no Bond villain was ever as detailed when it comes to the fine print of his plan. "Missiles are only the first step to prove our power," says Dr. No (Joseph Wiseman) in *Dr. No* (1962), but what the next steps are *after* he's messed up the launch of the U.S. space shuttle using an atomic radio beam are a blank. "In a matter of hours, when America and Russia have annihilated each other, we shall see a new power rule the world," crows Ernst Stavro Blofeld (Donald Pleasance) in *You Only Live Twice,* but what the system of governance is to be—some capitalist-Communist hybrid, perhaps?—remains unspecified. In *The Dark Knight Rises,* we get blueprints, fine print, a plan for civic takeover detailed down to its last nut, bolt, and rivet. First, Bane leads an attack on the stock exchange, which allows Daggett to launch a hostile takeover of the Wayne Foundation, thus removing Wayne's wealth as a source of his power. The film makes interesting use of the time that has elapsed between *The Dark Knight* and this, four years stretched out to eight, allowing Bruce's body to deteriorate along with the city's wealth gap, and facilitating Christian Bale's best performance in the series: weary, battle-scarred, finally bearing the costs of his Faustian pact with the League of Shadows all those years ago, "holed up with eight-inch fingernails and peeing into Mason jars," as Daggett indelicately puts it, a detail from Nolan's Howard Hughes script.

51 — EXT. GUNMEN SHOOT.

37 52 — GUNMAN ATTACHES GRAPPLE TO THE TURBO PROP

53A — 2ND GRAPPLE ATTACHED.

SHOT CONT'D

53B — THUMBS UP.

54B — P.

SHOT CONT'D

55 — TURBO PROP PILOTS BATTLE CONTROLS.

37 56A — BANE TRAPS CIA WITH HIS HAND CUFFED ARMS AS...

SHOT CONT'D

56B — THE PLANE UP ENDS

38

57 — DOWN & CABIN T

58A — SPECIAL FORCES TUMBLE...

TILT DOWN

SHOT CONT'D

39 58 B — ... OVER THE SEATS.

TILT DOWN

51 — ANGLE TURBO PROP THE NOSE

60

61 — DOWN AN THE SAI LOOKS E AMONG

A doctor tells Wayne that he has no cartilage in his knees, and that his brain tissue is concussed. "I've sewn you up, I've set your bones, but I won't bury you," says Alfred, and when Bruce uses a new plane, the Bat, to escape the police, he chastises him, saying disapprovingly, "You lead a bloated police force on a merry chase with a bunch of fancy new toys from Fox," like Nolan checking himself for signs of franchise mission creep. *The Dark Knight Rises* is the biggest and most brutal film of the three—it features both that new plane, a nuclear explosion, and, disappointingly, the line "Get the president on the line"—but the sight of Gotham's bridges going down in long shot, each bridge leaving a small puff of smoke as the debris hits the water, is a majestic use of computer-generated effects as they should be done. Anyone who was in midtown New York on 9/11 knows that that is exactly how the towers went down: in long shot, and in eerie silence.

Next, pretending to do repair work to the city's infrastructure, Bane's men prime its bridges and tunnels with explosives, using cement mixers to pour an explosive-primed cement into their foundations. "I don't know anything about civil engineering," says the young cop Blake (Joseph Gordon-Levitt), who is onto the plan. "But you know about patterns," says Jim Gordon. The idea of self-detonating buildings is purest Nolan: both constructivist and deconstructivist urges combined. If *Inception* constituted the consummation of the director's love affair with modern architecture, *The Dark Knight Rises* is a thunderous paean to *un*building, detonation, demolition. If the textures of *The Dark Knight* were those of glass and steel, the material most on show here is concrete, from the concrete walls of the sewer system where Bane lurks to the underground bunker where Lucius Fox (Morgan Freeman) shows off his wares. Finally, Bane hijacks that football game, while his men empty out the city's prisons to form a makeshift militia force marching up Fifth Avenue in their orange jumpsuits, waving AK-47s, while the rich cower beneath their lacquered furniture, their furs and silk robes tossed into the street.

"We take Gotham from the corrupt, and we give it to you—the people," Bane coos with curling musicality as the rich are hauled before kangaroo courts presided over by Cillian Murphy's Scarecrow, offering them "death or exile," which amounts to the same thing: "Exile" means being forced to walk the ice that surrounds the city until it cracks. No one ever makes it. Nolan does to Gotham what he did to Leonard Shelby in *Memento:* He puts an entire city in solitary confinement. A *Doctor Zhivago*–like snowfall

OPPOSITE The storyboards for the prologue of *The Dark Knight Rises*.

further isolates the city, marking the beginning of a long winter, which means that Bane's big, climactic brawl with Batman—his blows as fast and furious as Tyson's—comes lightly dusted with snow, of the same kind that Bruce trudged through to get to the League of Shadows' monastery in the first film, which seems to flurry sideways as much as down. Even Nolan's snowflakes don't know which way is up.

<p style="text-align:center">. . .</p>

"It's the longest countdown in the movies," Nolan says. "Like five months or something. Normally, people would say, 'Okay, the city is taken hostage; this is a second-by-second hostage drama.' There were a lot of discussions at the studio about 'How can you say the bomb is going to go off in three months? The bomb's going to go off in three months, but Batman is going to save you in three seconds.' My pitch to the studio, because it was Warner Bros., was Harry Potter, because in all the *Harry Potter* films, there's this moment where now it's snowing, and there's something kind of wonderful about that jump in time." Previewed in three different IMAX theaters, in Los Angeles, New York, and London, the six-minute prologue of the film was met with a barrage of complaints that Bane's voice was all but unintelligible—"Prepare to scratch your head at much of Bane's dialogue," warned *Entertainment Weekly*. "Between the character's labored breathing and quasi-English accent, [Bane] was impossible to understand," said *The Daily Beast*—and before he knew what was happening, Nolan had a full-blown PR crisis on his hands.

"Oh my God," he says. "It was one of the toughest PR things I dealt with on one of my films. The odd thing was, I spent an enormous amount of time discussing it with sound mixers. When we put our prologue out, we had this amazing voice treatment on it, but it was harder to hear, so we wound up simplifying it somewhat—we didn't process his voice as much; we just let Tom's natural voice come through more. The fascinating thing is that when we would show the film to the audience, you would get all these cards saying they couldn't understand a word he said, but we would get zero plot confusion, in the same screening. Now the plot of *The Dark Knight Rises* is expounded by Bane in seven or eight minutes' worth of monologue, throughout the film. So, the speech with Batman, his speech in front of Blackgate Prison, his speech in the stadium. This is a guy with long speeches that tell you what's going on. And everybody knew what

was going on. But when you cover up somebody's mouth, you worry that they can't hear him, and then Tom had this peculiar way of speaking, so for an American audience particularly, it was quite tough to get ahold of. But yeah, it was an interesting process we went through."

Released, like *The Dark Knight*, during an election year in which Obama sought reelection against Mitt Romney, the memes wrote themselves. Conservative radio host Rush Limbaugh claimed the name of Batman's adversary in the film, Bane, was a reference to Romney's former company, Bain Capital. "How long will it take for the Obama campaign to link the two, making Romney the man who will break the back of the economy?" asked conservative commentator Jed Babbin in the *Washington Examiner*. Taking the opposite tack, right-wing writer Christian Toto said it was impossible to read the film except as a paean to the Occupy Wall Street movement. "Bane's henchmen literally attack Wall Street, savagely beat the rich and promise the good people of Gotham that 'tomorrow, you claim what is rightfully yours.'" Somewhere in the middle was *New York Times* columnist Ross Douthat:

> Across the entire trilogy, what separates Bruce Wayne from his mentors in the League of Shadows isn't a belief in Gotham's goodness; it's a belief that a compromised order can still be worth defending, and that darker things than corruption and inequality will follow from putting that order to the torch. This is a conservative message, but not a triumphalist, chest-thumping, rah-rah-capitalism one: It reflects a "quiet toryism" rather than a noisy Americanism, and it owes much more to Edmund Burke than to Sean Hannity.

This is acute, not just because Edmund Burke's *Reflections on the Revolution in France* (1790) heavily influenced Thomas Carlyle, whose *French Revolution: A History* (1837) fed into Dickens's *A Tale of Two Cities*. Condemning the Revolution in Paris as a "digest of anarchy" tearing to pieces "the contexture of the state," the Scottish Whig predicted that it would end up devouring its young and ushering in military dictatorship. Just as Burke predicted the rise of Napoléon Bonaparte, so *The Dark Knight Rises* could take some credit for intuiting the seismic shifts that would lead to the election of Donald Trump, whose black-plate-glass tower on Fifth Avenue provided an exterior for the front of the Wayne Enterprises building. "I'll tell you, it was really terrific," said Trump in a review of the film posted

on YouTube, praising its cinematography and pointing out that "most importantly Trump Tower—my building—plays a role." Never mind that it is a role as a symbol of the ruling class from which Bruce Wayne is forced to divest in his new role as class-war refusenik. When, several years later, upon his inauguration as the country's forty-fifth president, Trump seemed to quote part of Bane's speech in front of Blackgate Prison 2017 ("We are transferring power from Washington, D.C., and giving it back to you, the people"), the borrowing was quickly spotted, as was the use of the film's score and font in a 2020 reelection campaign video. Warner Bros. quickly asked the Trump campaign to remove all references to the film.

"Of all of my films, *The Dark Knight Rises* is the one that's been pushed and pulled in the weirdest number of directions," says Nolan. "I think you have to go out of your way to look at the film and attribute to it right-wing characteristics. If anything, it's specifically left-wing. When people listen to Bane and say, 'He sounds like Donald Trump' or that Donald Trump sounds like him, well, it's about a *demagogue*. He's the bad guy. What was I afraid of when I made *The Dark Knight Rises*? I was afraid of demagoguery. Turns out I was right to be afraid. The film was not supposed to be political. It's not intended to be; it's about primal fears. At the time we were writing, there really was this sense of false calm; everybody thinks everything's okay, we got through the financial crisis, but there are underlying things brewing that could lead to difficult places. By testing the structures, as the films get to do, in a safe, cathartic environment, you're exploring in some ways the dangers of chaos and anarchy, with anarchy in particular, I think, as the prime antagonist of all three films. The idea of a vigilante standing between society and its collapse is a very uncomfortable one for

Batman (Christian Bale) and Bane (Tom Hardy) square off in Gotham, bringing the city to the brink of revolution.

me and for most people, I think, but there's also a certain wish fulfillment to it; you want to believe in heroic figures who can individually tip the balance or inspire people in a particular way. That's the way in which these films were made. I've had conversations with friends of mine and they all ask about why I don't make a film about the things I care about politically, and I always say, 'Well, because it doesn't work.' You can't use narrative to tell people what to think. It never works. People just react against it. You have to be purer about it. You have to be truer to the principles of narrative and telling a story, and that means risking misinterpretation. It doesn't mean you don't care about something, or that it doesn't mean anything to you, but you have to be neutral or objective in your approach. You can't tell people what to think; you can only invite them to feel something. I always think of the great moment in *Gladiator*, where he chops off his head and then turns to the audience and asks them, 'Are you not entertained?' Whatever it is, you've got to entertain."

• • •

One evening in 2007, while scouting locations for *The Dark Knight,* Jonah told his brother about the script he was working on for Steven Spielberg and the producer Lynda Obst, from a treatment by Kip S. Thorne, a physicist at Caltech. Thorne had known Obst since Carl Sagan set them up on a blind date three decades earlier, and they were playing around with an idea for a movie that would involve the mysterious properties of black holes and

Albert Einstein, in 1904, working at the patent office in Bern, Switzerland, where he first intimated the principles of relativity, according to which twin brothers, one on Earth and one returning from deep space, would find themselves to have aged at entirely different rates.

wormholes. "One can imagine an advanced civilization pulling a wormhole out of the quantum foam," wrote Thorne in a 1988 paper, and they included an illustration captioned "Spacetime diagram for conversion of a spherical, traversible wormhole into a time machine." When he first heard the idea, Nolan went very quiet, the same way he had when first hearing the idea for *Memento* while on their cross-country car ride from Chicago to L.A. all those years ago.

"Actually, *Inception* and *Interstellar* are very, very similar films," says Nolan. "When Jonah was writing his first drafts of *Interstellar*, I was writing *Inception*, because by then, he knew what I was doing, and there were definitely a few moments where I was like, 'Okay. Let's be careful not to tread on each other's toes.'" To research the story, and in an attempt to understand relativity, Jonah spent a couple of months studying at Caltech, where, under Thorne's guidance, he delved into what the physicist calls "the warped side of the universe"—curved space-time, holes in the fabric of reality, how gravity bends light—and noticed a common theme to the examples used by Einstein to illustrate the special and general theories

Nolan and his brother Jonah in London during unit photography for *The Dark Knight Rises.*

of relativity. There was always an "inherent sadness" to them, he said: They always involved two people parting, whether one was on a train and another on the platform, or one in a spaceship and the other left back on Earth, waving at each other as the train or spaceship sped off at close to the speed of light. The fact that Einstein used identical twins, siblings, in one of his examples was not lost on Jonah. His draft of the script explicitly evoked his and Chris's early childhood, when the space race was still fresh in everyone's minds and the boys were glued to their TV set, watching Carl Sagan's *Cosmos*, or going to see *Close Encounters* together as a family, before Chris was sent to boarding school and the rest of the family moved back to Chicago.

"We used to look up at the sky and wonder at our place in the stars," reflects Joseph Cooper, a retired NASA pilot and widower who belongs to a lost generation forced out of work by the closure of NASA, whose missions, the textbooks now teach, were a hoax designed to bankrupt the Soviets. "Now we just look down and worry about our place in the dirt." After a minor-league baseball game is interrupted by a bright blue streak in the sky—an old NASA space probe falling to Earth—Coop is directed to a large uninhabited island off Santa Cruz, where he finds an underground industrial facility that is secretly being run by NASA. After helping the scientists unlock the data on the probe, Cooper is asked to head a mission to find habitable planets for mankind to migrate to, an offer he at first turns down, thinking of his son, then accepts, giving them his watch and promising he will return. Thereafter, Jonah's version departs wildly from Nolan's film, but it ends with Cooper finding his way back to Earth, two hundred years after he left, to find his son dead, his farm covered in snow. Struggling to get back to the warmth of his ship, he appears to die in an ice storm but is awakened in a hospital bed on a huge space station, where he meets his great-great-grandson, who has transferred to the station to meet Coop. The old man can't speak, but his grandson reaches into a drawer next to his bed and hands Cooper his watch, the watch he gave his son when he left.

After DreamWorks split from Paramount, and Spielberg moved on to other projects, Nolan contacted Paramount to see if there was any chance of his taking over the project. "When the project became available, I said to Jonah, 'I'd like to get involved on the basis that I want to take your script, combine it with a couple of other ideas, other scripts I've been working on on my own, to do with time,'" says Nolan. "I said, 'Are you

okay with me taking this and making it my own?' What Jonah had written was this phenomenal character, this phenomenal relationship with his son, a great first act really, and an incredible ending. It had all these elements that I really wanted to embrace. He said, 'Okay, take a shot, see what you do.' I think what I wound up doing is pretty damn close to what he was pushing toward."

TEN

EMOTION

BEFORE STARTING WORK ON THE SCRIPT for *Interstellar,* Nolan dusted off his typewriter, the one his father had given him for his twentieth birthday, and typed out a one-page précis summarizing his vision for the film. He does this with all his films. "I'll bang out a page or a paragraph of what I think the film needs, like the bigger picture, what is the thing that I am trying to do, and then I put that away and I come back to it every now and again—for instance, when I finish the first draft, or when I am in preproduction—just to remind myself, because you just get lost in things as you start to figure out the mechanics of how a story can work. How can it achieve what you set out to do? Even more so when you get into preproduction, because you hire people to start designing, building, and scouting locations and everything has to adapt. Because nothing is exactly the way you want it to be. It never is. Budget, location, set, all that. So you start making all those decisions, I won't say compromises, because they're not necessarily; sometimes you are finding something great and going, Oh, I can do this with it and that with it. It's difficult once you're fully engaged in that mechanism. It can be very hard to remember what it is you were trying to do, in a bigger sense."

In this case, the précis had another purpose. He wanted to give it to composer Hans Zimmer and ask him to score a segment of music for the film without even seeing a script. "I called Hans before I even knew

I was going to do this project and I told him, 'I'm going to bring you an envelope with a letter in it, on a piece of paper, that's going to tell you the underlying fable at the heart of the film that we're going to make next. It has a couple of lines from the film. It's the heart of the film. You get one day; just write something and you have to give it to me end of the day, and that'll be the seed from which we can grow the score.' We realized we spent so much time on the other films we'd done, near the end of the process, trying to penetrate the mechanisms we'd created and get back to the heart of the story. This time, I thought, Let's flip the process. Let's start with the score and then build out."

Zimmer was attending a gathering of students at Loyola Marymount University's School of Film and Television when Nolan called him. One day later, an envelope arrived. It was on thick vellum paper, typewritten, which told Zimmer there was no copy, that this was the original. On the paper was a short story, no more than a précis really, about a father and a child, a son, that reminded him of a conversation that Nolan, his wife, Emma, and Zimmer had had in London a few years earlier, at Christmastime. They were dining at the Wolseley restaurant, a big, busy Art Deco restaurant in London's Piccadilly Circus, and it was snowing. Central London had ground to a halt, and the three of them were more or less stranded. They were talking about their children. Zimmer, whose son was then fifteen years old, said, "Once your children are born, you can never look at yourself through your own eyes anymore; you always look at yourself through *their* eyes." Afterward, around 1:00 a.m., they went out into the empty streets at Piccadilly Circus and, after wondering how they were going to get home, had a snowball fight.

Zimmer wrote for a day and at 9:00 p.m. the next day, he finished a four-minute piece of music for piano and strings, inspired by the feelings of what it meant to be a father. He phoned Emma Thomas to let her know that he was done. "Do you want me to send it over?" he asked. "Oh, he's curiously antsy. Do you mind if he comes down?" Thomas replied. So Nolan got in the car and drove to Zimmer's studio in Santa Monica and sat down on his couch, Zimmer later recounted. He made the usual excuses a composer makes when he or she plays something to somebody for the first time, not looking at Nolan, just staring straight ahead, and then when he was finished, he turned around. He could tell Nolan was moved by it. "I suppose I'd better make the movie, now," said Nolan. "Well, yes, but what is the movie?" asked Zimmer. And the filmmaker started describing this

huge, epic tale of space and philosophy and science and humanity. "Chris, hang on, I've just written this highly personal thing, you know?" "Yes, but I now know where the heart of the movie is."

What Zimmer had told him that night in London—"Once your children are born, you can never look at yourself through your own eyes anymore; you always look at yourself through *their* eyes"—had now become "a sort of fable," says Nolan. "You could read it as a ghost story. That notion of the parent as a ghost of the child's future. That was in the fable that I gave him, because I wanted him to write music that was the emotional heart of that story. It's about the parent revisiting the child as a ghost, and struggling to then be free."

Nolan was thinking very much of his daughter, Flora, eleven, and the heartache involved when he goes off to make a film. The working title of *Interstellar* was "Flora's Letter." "I very much related to the dilemma of somebody who is having to go off and do this thing, leave his kids, whom he dearly wants to be with, but really wants to go do this thing," he says. "My job is something that I absolutely love. I consider myself unbelievably lucky to do it, but there is a lot of guilt involved in doing that—a *lot* of guilt. I have a daughter who is the same age as the character. In my brother's draft, it was a son. I turned it into a daughter because Flora was about that age when I was making it. As my kids were growing up, I had this desire to hang on to the past. You become quite melancholy about how fast it's going. All parents talk about it, all parents experience it. So *Interstellar* came from a very personal place."

Cooper (Matthew McConaughey) prepares to leave his daughter, Murph (Mackenzie Foy).

· · ·

It should have come as no surprise that the maker of *Memento* and *Inception*—two masterpieces of watchmaker cinema—should have wound up at the door of Albert Einstein, who deduced the postulates of relativity while processing the patents for clocks in Bern, Switzerland. Every day strolling from his street, the Kramgasse, to the patent office, Einstein had to walk past the myriad electric street clocks, their time coordinated with that of a central telegraph office, thanks to Bern's being at the vanguard of the Swiss effort to synchronize the world's clocks and watches: an ever-widening electrical network bound to an observatory-linked mother clock that multiplied its signals and sent automatic clock resets into hotels, street corners, and steeples across continents beginning on August 1, 1890. Reviewing one patent after another for the new electric clocks in his office, Einstein had a grandstand seat for what the press called a "revolution in clocks." The theory of relativity was, in one sense, a description of his commute. "Einstein was in the thick of it," writes Peter Galison. "Einstein seized on this new, conventional, world-spanning simultaneity machine and installed it at the principled beginning of his new physics."

The greater surprise, at least for those critics for whom *cold* was beaten only by *cruel* as the go-to adjective when describing Nolan's work, was how much emotion the director wrought from Einstein's theories. After a career in which *impersonal,* as jostled only by *cold,* was the go-to pejorative for critics addressing his work, *Interstellar* was a plangent hymn to family connection—a weepie, no less, in which time plays the role usually reserved for distance. In David Lean's *Doctor Zhivago*, Yuri Zhivago (Omar Sharif) is separated from Lara (Julie Christie) by the snowy Ural tundra. In *Interstellar*, time wrenches fathers from daughters and sons from their fathers. Characters break down over video messages sent by their loved ones a lifetime ago. A ghost writes out messages to the living in dust. Underlying the whole story was a simple idea, continuing the conversation between the nineteenth and twenty-first centuries first started by *The Prestige:* that the exploration of space would be no different, in terms of the extremes of human nature it explored and exploited, than had been the exploration of the Earth's oceans and continents during the first age of exploration. "We're explorers, Rom," Cooper tells Romilly (David Gyasi). "This is our boat." Jonah had named the film's twelve-pod circular space station the *Endurance,* after the three-masted barquentine in which Sir

Ernest Shackleton sailed for the Antarctic in 1914, which was immobilized by ice, gripped, and eventually crushed. Two years and a desperate journey later, he and his team stumbled into Stromness whaling station on South Georgia Island. "Tell me, when was the war over?" Shackleton asked the manager of the station. "The war is not over," the manager answered. "Millions are being killed. Europe is mad, the world is mad." All travelers are, to some degree, time travelers.

"*Interstellar* is a classic survival epic really; that was our thinking, and the idea that as you go out into the vast emptiness of space, there is a loneliness, a confronting of the self," says Nolan. "That's what makes the story human, I think. It's the intimacy. When you strip away everything, you send people out to the most desolate spot, ugly truths emerge about who we are." The betrayals the team suffers, first from Dr. Brand (Michael Caine) and Dr. Mann (Matt Damon), draw on the hard survival-of-the-fittest calculus of Darwin and Thomas Malthus, the British economist

Cooper's ship was named after Ernest Shackleton's *Endurance*, seen here marooned in the Antarctic ice in 1916.

whose theories that the exponential growth of human population will eventually outstrip food were first expressed in his *Essay on the Principle of Population* (1798). "My memory of Malthus is even though it's cruel, it's scientifically quite adventurous, in the same way that Darwin was misappropriated by the Nazis—there're all sorts of things you can draw from the idea of survival of the fittest by distorting what that actually meant. Darwin doesn't say that the species will always do what's in its best interest. Darwin's actual theory says those genes that get passed on sustain. It is very immediate, very short-term. There isn't a collective consciousness; there isn't a collective purpose. It's a random round of mutations. How morally, ethically connected are we with the people of the future, say one hundred years from now? What constitutes human connection? Is it people we can see, people we interact with, people we love and live with? Is it the people we know about, from the past, from the future? It is not an easy question. When you look at the cosmos, when you look at cosmic time, cosmic scale, you start to feel that as a species: What's our lifestyle now? How long has it been compared to all who came before? What will happen after?"

Taking over a project that had once been Spielberg's, Nolan was conscious of his responsibilities toward both his studio parents, Warner Bros. and Paramount. The film represented his most conscious effort yet to bridge the gap between the optimism of his early childhood, spent glued to Carl Sagan's *Cosmos* and Spielberg's *Close Encounters of the Third Kind* with Jonah, and the darker, more cerebral speculative fiction of Kubrick and Roeg he had explored in his teens. The other filmmaker he looked at in prep, at the urging of cinematographer Hoyte van Hoytema, was Andrei Tarkovsky, in particular the Russian filmmaker's *The Mirror* (1975). A nonlinear tone poem of autobiographical memories attributed to a dying poet, structured with the logic of a dream, the film interleaves contemporary scenes with childhood memories drawn from the director's own childhood, lyrical reminiscences of his mother and of his father's poetry, partly set in a painstaking reconstruction of the house where Tarkovsky grew up, realized largely through snatches of texture and color—a puddle of spilled milk or a spot of moisture evaporating on a shiny wood table. "That farmhouse," says Nolan. "There is just something about the use of elements in that world—fire, water—that's just really wonderful. I don't see any distinctions of genre or form between the art house and the mainstream. You build on the experimentation of those guys at the cutting edge. Partly it's that a lot of them were working in a time where it was more possible to

go out there and experiment with form. They learned something and they taught you something about what film could do. When I see something, I try not to worry about whether or where it fits into the matrix. If it works for me, it's going to work for the movie."

• • •

Principal photography began on August 6, 2013, in Alberta, Canada, where they had shot the snowfields of *Inception*, but this time they went farther south in the province, where there was a big flat horizon in every direction. Crowley planted five hundred acres of corn to be destroyed in an apocalyptic dust storm created using large fans to blow synthetic dust through the air, as Tarkovsky had planted a field of buckwheat to get the distinctive white flowers that he remembered from his childhood. Working for the first time with Nolan was Dutch cinematographer Hoyte van Hoytema, who had shot Tomas Alfredson's 2011 le Carré adaptation, *Tinker Tailor Soldier Spy*, and who looked for inspiration to Ken Burns's 2012 documentary, *The Dust Bowl*, which gave him such images as the topsoil

Cinematographer Hoyte van Hoytema, Emma Thomas, and Nolan on location in Calgary in 2013.

collecting along the sides of the houses, and the constant struggle to keep the dust out of the house. Burns even gave him some outtakes for the talking heads at the start of *Interstellar*. From Canada, the production team moved to Iceland, returning to the same glacier where they had filmed the League of Shadows exteriors in *Batman Begins*—Svínafellsjökull, at Vatnajökull National Park—and from there to Los Angeles to shoot for forty-five days. Here, on the same stage where he had built the Batcave for *The Dark Knight Rises*, Stage 30, Nathan Crowley built a life-size space capsule, the *Ranger,* its interior so crammed with equipment as to resemble the interior of a submarine. Mounted on hydraulic rams, it pitched the actors this way and that, while outside their window, a passing starfield was projected onto giant wraparound screens, standing eighty feet high by three hundred feet long. Nolan had gotten the idea after screening Philip Kaufman's *The Right Stuff* (1983) for his crew.

"What we wound up doing, particularly when we got to the spaceship interiors, we built spaceships whole so you could shoot them as real places," he says. "We didn't use any green screens. We could shoot the actors going through their reactions to actual things they were seeing. If they were reentering the atmosphere, it would shake the thing, red lights going, smoke and everything. It was like a simulator. Then I would point things out to Hoyte or he would find things and we would just run it, take

Emma Thomas consults with Jonah Nolan during unit photography.

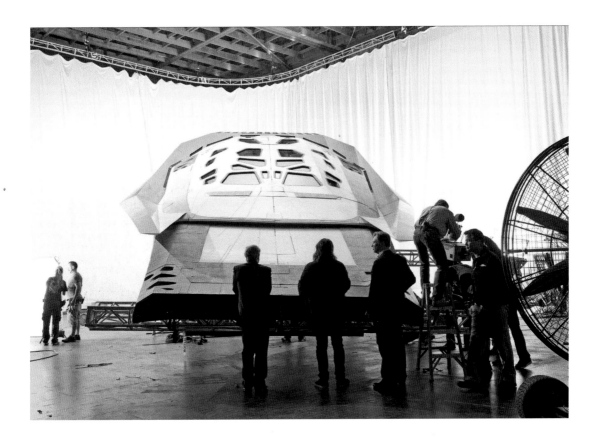

after take after take. Just grab different bits, like a documentary. What I love about great documentary photography is the spontaneity of it, the freedom of it. There's a freshness to the texture of that type of photography. You feel the stuff that's been left on the cutting room floor. You feel that you're just getting the bare glimpses, that there's a reality that runs between the shots, in between the scenes. For me, that makes it feel much more real, like I'm really there. There're a few places where you really see it. The one place I'm struck by it is when they first leave Earth's orbit and there're just these glimpses of them doing a lot of stuff that we might have made a big formal sequence out of—you see them throwing switches and giving a thumbs-up. You feel a whole procedure that you're just getting glimpses of. It just implies complexity and a life to things that I really love."

Here's what we *don't* see in the first forty minutes of *Interstellar*. We don't see any TV reports of the environmental blight that has poisoned the atmosphere and turned twenty-first-century Earth into a coast-to-coast dust bowl. We don't see any panicked reporters stuck in looming dust

Shooting *Interstellar* on a soundstage at Culver City, where the crew mounted a life-size *Ranger* on hydraulic rams and a starfield projected onto giant three-hundred-by-eighty-foot screens.

Nolan consults with
Jessica Chastain
between takes.

storms, explaining how badly the corn crop is going to be hit. We don't see any presidents or high-ranking officials convening urgent conferences to discuss the global environmental apocalypse or ordering NASA to find new habitable planets for the remaining human population. In other words, we don't see any of the usual ways the apocalypse is conveyed in disaster and science-fiction movies. A maximalist movie made in the minimalist mode, *Interstellar* instead gives us a series of talking heads who seem to be participating in a Ken Burns–style documentary about the blight, shots of dusty plates on dinner tables, and a father (Matthew McConaughey) trying to keep his young daughter, Murph, in school. Working from a blue-green palette, cinematographer Hoyte van Hoytema finds a Malickian glimmer in the early-dawn light, shooting the Calgary cornfields with a texture and rawness that is far removed from the sheen of Wally Pfister's images for the *Dark Knight* films, while the first notes of Hans Zimmer's pipe organ turn the horizon line, with its distant mountains, into their own expectant mystery. The film is horizontals, not the verticals you might expect from the title.

The dust motes in Murphy's room, which she believes to be messages from her "ghost," in fact spell out map coordinates for the hidden NASA facility where Cooper will hear of his mission—a plot device lifted from Spielberg's *Close Encounters of the Third Kind*, where intercepted numbers

spell out the map coordinates of Devils Tower, Wyoming, but the imagery of sunlit dust streams in Murph's room is pure Nolan, a poetic rendition of the Poynting-Robertson drag, by which star dust is pulled into circular orbit by the sun. The imagery is so mesmerizing as to render almost intolerable the babble of exposition that follows as Cooper stumbles across NASA's secret bunker, run by wise old Professor Brand (Michael Caine), who explains that some higher intelligence—there's a suspicious lack of curiosity as to who—has placed a handy wormhole next to Saturn for mankind to explore the far-flung corners of space in search of viable planets. They've already lost contact with three crews, but the next ship's ready to go up: All that's needed is an intrepid astronaut to lead the way and decide which of the three leads to follow. "I can't tell you any more unless you agree to pilot this craft," says Brand. "An hour ago, you didn't even know I was still alive. And you were going anyway," replies Cooper, echoing the audience's sense of whiplash. Nolan's plot has crashed into the side of his brother's, and the sensation of watching a second film that has started to play over the first one is hard to shake. A secretly resurrected NASA. Three previous missions. Another ready to go, possibly aided by higher intelligence. And all this just to get Cooper on the launchpad.

Hereafter, the film smooths out. Jonah's version had Cooper landing on a single ice planet, where he finds mine shafts dug by the People's Republic of China, robots, a machine that changes the direction of gravity, fractal alien creatures who absorb sunlight, a space station built outside of space and time, and finally a wormhole that allows Cooper finally to find his way back to Earth. Nolan gives us two planets, a water planet and an ice planet. One allows him to explore the human capacity for love, the other the human capacity for betrayal. The astronauts on the *Endurance* experience time at a different rate from those left back on Earth: When they go down onto a prospective habitable world, a few minutes there might equal weeks or months back on the ship and possibly years back on Earth. Nolan thus splits the loyalties casually attributed by screenwriters to the heroes of summer blockbusters, whose rescue of their nearest and dearest is used, synecdochically, to stand in for a love of humanity in general. Not so fast, says Nolan. Cooper and

Nolan testing the light with Wes Bentley in Iceland.

his crew can save the world, but they may lose their loved ones in the process. "My daughter is ten years old," says Cooper. "I couldn't teach her Einstein's theory of relativity before I left." "Couldn't you have told her you were going to save the world?" says Amelia. "No," he says flatly.

Hence the unbearably tense sequence, scored with a relentless ticktock, in which Coop and his team descend to the watery surface of Miller's planet, where every hour equals seven years back on Earth. "We need to think of time as a resource, just like oxygen and food," says Amelia. "Going down is going to cost us." Setting down on the planet's surface, they find the wreckage of Miller's ship, and as Brand tries to retrieve data from the wreckage, they struggle to free their own ship from the path of an oncoming wave. It floods their engines, forcing them to sit and wait for them to drain. "What's this going to cost us, Brand?" asks Cooper. "A lot." Returning to the *Endurance,* they are greeted by an older Romilly, his beard flecked with gray. Twenty-three years, four months, and eight days have passed. Cooper sits down to all the messages from Earth that have been collecting while he was away.

"Hey, Dad, checking in, saying hi," says his son, Tom, and at first we hear only Timothée Chalamet's voice, the camera staying on McConaughey's face as Zimmer's pipe organ strikes up alternating intervals of five, four, three, and two on the clarinet and flute stops. A passing shard of light through a porthole illuminates McConaughey's face.

"I finished second in school. Miss Kerlick's still giving Cs, so it pulled me down," Tom tells him, and McConaughey breaks into a big prideful grin. As Zimmer's cycle of intervals repeats, this time with more notes layering in the chords around it, the camera slowly dollies in and we see that his eyes are also brimming with tears.

"Grandpa attended the ceremony," continues Tom. "Oh, I met another girl, Dad. I really think this is the one. . . ." With the first appearance of a memory for which he has no reference—a new girlfriend!—McConaughey's face crumples and from here on he is struggling to hold back sobs as Chalamet holds up a picture. "That's Lois, that's her right there," he says.

A shot from behind McConaughey's seat suggests a lapsed interval.

"Murphy stole Gramps's car. . . . She crashed it. . . . She's okay, though," says Tom, who is played now by Casey Affleck, whose sandpapery affect is perfect for what follows, as Tom holds up his firstborn. "His name's Jessie."

Cutting to McConaughey, we see that love for his new grandson has

briefly quelled his grief. He waves to the screen, as a new grandpa might. "Sorry it's been a while," says Tom, clearly struggling to get something out, looking down, hiding behind his clasped hands. "Uh . . . Grandpa died last week; we buried him out in the back next to Mom. . . ." McConaughey is stock-still, absorbing this news like a rock lashed by waves, tears rolling down his face. "Murph was there at the funeral. I don't see her much these days," continues Tom. "Lois says I have to let you go." McConaughey shakes his head just once. "So I guess I'm letting you go. . . ."

The video screen goes dead, the score goes silent, and McConaughey is distraught, grabbing the screen as if to shake it back into life. Finally, a single organ throws out a lifeline and a greenish image on the video screen flickers back to life.

"Hey, Dad," says Murph, now a grown woman, played by Jessica Chastain. "Hey, Murph," he whispers back, stunned by the sight of his grown daughter. "I never made one of these while you were still responding, because I was so mad at you for leaving, and then when you went quiet, it seemed like I should live with that decision," she says, trying to control her anger as Zimmer layers note upon note, slowly increasing in volume. It is her birthday. She is the same age now that Cooper was when he left. "Now would be a really good time for you to come back," she says, and turns the camera off.

This time, however, we see Murph turn the camera off from a point of view just behind the chair in her office. There are NASA ring binders on her shelves. Michael Caine's Dr. Brand sits behind her, observing.

Now we will hear her side of the story.

. . .

"One of the things in Jonah's original script that he just nailed was this moment, and that scene is just key, the spirit of that," says Nolan. "I thought it was a thing I'd never seen before. It really, really spoke to me. I talked to Matthew about it a lot, and the way he wanted to do it was we filmed all of the messages in advance. I didn't want to use visual effects to put them in. But what he wanted to do was not to see them until he shot the scene and started his close-up. What he was doing was right on the edge of being too real because he was experiencing it in a very real way as a father, and I think one of the takes might've actually been beyond it. It's one of the great fascinations I have with acting. I sit there and I watch them

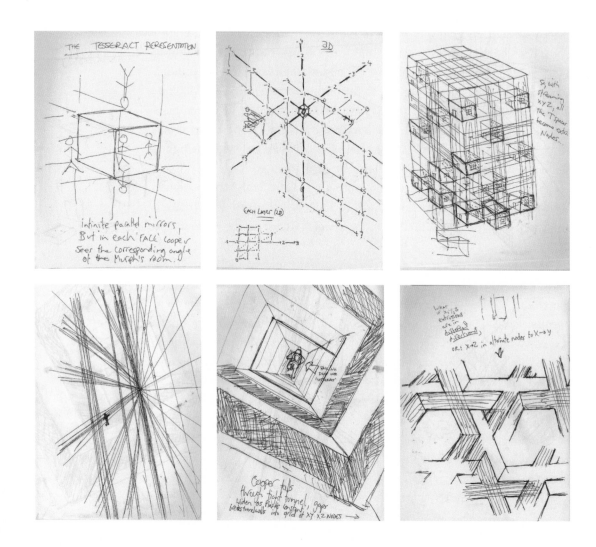

Nolan's hand-drawn sketches for the tesseract.

eye-to-eye, not on the monitor, just glancing at the monitor for framing, because it's my job to try and experience it as an audience member, to try to be open to what they're feeling. And there's often a point where they're so raw and so open that you actually disconnect from them because it's too overwhelming, it's too much, and you feel that you're intruding. It's almost like turning sound up too loud, and it starts to distort. And so, part of what you do as a director is to gauge when you're really in sync with the audience. And a lot of people were. A lot of people still talk to me about that scene, the effect it had on them. And it was intended to. I find it very emotional. It's very much about things that I care about and find emotional."

What he finds emotional in *Interstellar* is the same thing he found emotional in *Memento, Batman Begins, Inception,* and *The Dark Knight Rises*: abandonment. "Pray you never learn just how good it can be to see another face," says Matt Damon's Dr. Mann when they find him on the ice planet, where his betrayal is prefigured by a lovely detail: Descending through a thick bank of cloud, Cooper's craft clips the edge of one, only to see it crumble and break off: It is made of ice. An astronaut driven slowly out of his mind by the isolation and loneliness he has endured, rather like Mr. Todd in Evelyn Waugh's *A Handful of Dust,* Mann has lured them there on false pretenses in order to be rescued. The survival instinct has trumped all else. Cooper's spirit is similarly tested when, descending into the black hole Gargantua, he finds himself trapped in a tesseract, a hypercube of five-dimensional space, allowing him to move forward and backward in time, but pinning him guiltily in one particular place: his daughter's bedroom, at various points in their history. The ghost story comes full circle: *He* is his daughter's ghost.

Matthew McConaughey and Mackenzie Foy on the tesseract set. The ghost story was among Nolan's additions to his brother's screenplay.

There she is brushing her hair; there she is pointing out the dust patterns to him; there he is saying goodbye to her ("If you're leaving, just go")—but Coop is unable to contact or communicate with her except by knocking books off her bookshelf: an encyclopedia, the collected works of Conan Doyle, *Charlotte's Web,* Madeleine L'Engle's *A Wrinkle in Time,* Shakespeare's *The Winter's Tale,* about another girl abandoned. *"Don't go, you idiot!"* he screams at his past self, propelling himself from room to room. *"Don't let me leave, Murph."* The tesseract is an eternal hall of parental regret, forcing him to replay opportunities missed, things not said, paths not taken. Like Leonard Shelby's looped life, it has the timelessness of trauma, endlessly relived, but unlike the limbo into which Shelby finds himself cast, Cooper is not entirely without agency, and finds he can communicate with Murph through the watch he left her, manipulating the second hand like a quadriplegic blinking out his autobiography.

"*Interstellar* comes down very firmly behind the idea of emotional con-

nection between people. That's why I wanted the Dylan Thomas poem. 'Rage, rage against the dying of the light.' That is exactly what I'm talking about. You rage because the lights are dimming. Time certainly is the enemy, quite specifically so in *Interstellar,* an insidious force, one that can play tricks on you. I don't think there was ever any question that I could or would let time win. For me, the film is really about being a father. The sense of your life passing you by and your kids growing up before your eyes. Very much what I felt watching Richard Linklater's *Boyhood,* an extraordinary film, which did the same thing in a completely different way. We all deal with this. There is a positive side to it. I think that's where some of the optimism in the film comes from. The very sadness of saying good-bye to people is a massive expression of the love you feel for them. It is a very important part of the recognition, how strong the bonds are."

Nolan looked at a lot of different sculptors and artists who approached

the idea of distortion of time, including Louis Daguerre's first photograph ever taken of a human being, shot in 1838, when Daguerre used a long exposure to photograph Paris's boulevard du Temple and found the man having his shoes shined, the only one who stood still for the ten minutes it took Daguerre to expose the metal plate. "Gerhard Richter has this book where he has a painting and he splits it in two, and then four, and so on, these slices of the painting that stretch it and make it striped. We literally had the visual-effects guys filming freeways to find out how they move when your eyes fix on them and they start to flicker, those kinds of things. There's an enormous amount that went into it. Usually, I just sort of go with what I like the look of, but it felt for this one that it had to be mathematical. So, as it collapses, it does it according to Necker cube rotation, which is a four-dimensional rotation, a two-dimensional representation of four-dimensional rotation, so it opens in this peculiar way. Mathematicians and scientists would recognize it instantly. When you stood there and you looked at the set, it was really beautiful, but it was accidentally beautiful. I'm definitely a subscriber to the school of thought that when the writer is working, or the filmmaker is working, it's because you're uncovering something, like the sculptor carving something away because it was always there."

· · ·

When Nolan suggested Hans Zimmer score the film with a pipe organ, the composer was horrified. All Zimmer could think of was the organ you always heard in the old Hammer House of Horror films. "The organ thing, I cursed Hans with that," says the director. "I said, 'Look, I really want a pipe organ; have you ever done a score with that?' He'd never worked with the organ on other film scores, so he was a bit daunted, but he threw himself into it." For Nolan, the resonances were more personal—it had been one of the sounds of his childhood. Every morning at Haileybury, from Tuesday to Friday, just after 8:00 a.m., the entire school would squeeze sardinelike into the school chapel for the daily service beneath the massive dome resembling that of Duomo Nuovo at Brescia. The service lasted only ten minutes, just time for a quick pretense of prayer over stomachs rumbling for breakfast and a couple of hymns, belted out with varying degrees of enthusiasm to the accompaniment of a Johannes Klais pipe organ, of a size normally found in cathedrals, with fifty-four stops over three manual keyboards and pedals.

OPPOSITE Nolan's influences for the tesseract included (TOP) Edwin A. Abbott's novella *Flatland: A Romance of Many Dimensions* (1884); (MIDDLE) the first-ever photograph of a human being, taken in 1838 after Louis Daguerre used a long exposure to photograph Paris's boulevard du Temple; and (BOTTOM) *Strip (921-6)* by Gerhard Richter. To create the horizontal strips, Richter photographed one of his favorite pieces, *Abstract Painting, 724-4* (1990) and subjected it to a process of division and stretching so that very thin vertical slices of the painting were stretched out along a horizontal axis.

"I'd heard them before at the Catholic prep school I went to, Barrow Hills. There was an organ there, too. I was very familiar with the instrument, having had a Christian upbringing by virtue of the schools I went to—I was raised somewhat Catholic. My dad was a practicing Catholic; I'm not, and wasn't particularly then, but I did go to a Catholic school. On *Interstellar,* I was very interested in playing with the idea of the organ as one of these tools to inspire religiosity or awe, and so very often, if you listen very carefully to what we're doing in the music, a piece of music will end abruptly, and then you hear the reverberations ring out. We were actually using the confined space of Temple Church. By hearing the echo of the music ringing out, we're using it to create a sense of space, even though it's actually created by confinement. It's a very architectural idea. So if you walk into a cathedral, all of that inspires awe. And *Interstellar* is quite specifically not a religious film, but you're still looking for what you can tap into, what associations you can use to create a feeling of awe. And the organ felt like that. Also, for me, there is Godfrey Reggio's *Koyaanisqatsi,* with that amazing Philip Glass score, which was a huge influence on me. I think it's a wonderful nonnarrative film. That makes tremendous use of the organ."

An experimental documentary of various urban and natural environments—Los Angeles and New York at rush hour, Canyonlands National Park, in Utah, detonated housing projects and nuclear explosions—filmed using time-lapse photography and scored by Philip Glass, to represent the idea that modern life was spinning out of balance, the 1982 film, *Koyaanisqatsi,* was Godfrey Reggio's first film; before making it, he was a monk in the Congregation of Christian Brothers, which made it the first film made by a monk Nolan's cast and crew had ever seen. Set to work composing the score a full two years before the film saw release, Zimmer locked himself away in his London apartment, surrounded by Time-Life books featuring the space pictures of NASA, working on ideas for scenes he hadn't even read in script form but which Nolan described for him over the phone. An instrument whose complexity was unsurpassed by any other machine in the seventeenth century, the pipe organ *looked* a little like a rocket ship. "It's like the giant asleep under the Earth," said Zimmer. "You just hear the air pushing up against the pipes. So it's a magnificent beast that just waits to be unleashed."

Finally locating a recently restored 1926 four-manual Harrison & Harrison organ in Temple Church in London, just off Fleet Street, near the river Thames, Zimmer set up a remote studio in one of the side rooms of

the church, with a large number of microphones placed all throughout the nave. Built for a Scottish estate in 1927, the organ had 3,828 pipes and 382 stops, some of the pipes as short as a pencil, some thirty-two feet in length, emitting notes so low that the windows of the church actually bulged when they sounded. Zimmer placed mikes about twenty feet away, and some were as far as forty feet away from the main pipes of the organ; he also asked the choir to face away from the microphones, for the weird acoustics. "The farther we get away from Earth in the movie, the more the sound is generated by humans—but an alienation of human sounds," said the composer. "Like the video messages in the movie, they're a little more corroded, a little more abstract." A second recording session, at George

Nolan and Hans Zimmer during recordings of the score for *Interstellar* (2014). To stay on schedule, they ran the recording sessions simultaneously.
Photograph by Jordan Goldberg.

Poster for Fritz Lang's *Frau im Mond* (1929), the film that gave NASA its countdown protocol.

Martin's AIR Studios, filled out the one-hundred-piece orchestra with thirty-four strings, twenty-four woodwinds, and four pianos. Realizing that it was going to be impossible to record the amount of music they needed and still stay on schedule, both men ran the sessions simultaneously: If Zimmer was at AIR with the orchestra and pianos, Nolan was in Temple Church with the organ and choir, and vice versa.

"There was an enormous amount to do," recalls Nolan. "And we had been working together for years at that point, working increasingly closely on all those scores in different ways. Hans was very generous and comfortable with me wanting to really get in there and wrestle with things as part of my process, rather than laying the music over the top. I don't think he's ever been someone who wants to come along with music like a coat of paint at the end. He wants it to be deep in the structure of what's going on. And I really took him up on that more and more with each film. The way Hans works is, he would give us a series of very layered cues and sometimes he'd say to me, 'You should come down to the studio and we'll look at the different elements.' There was one layer with the organ where it was just these couple of notes, and I said to him, 'Can you just loop that pattern?' and suggested a couple loop points. He said, 'I'll send it to you tomorrow.' When he sent it to me the next day, he called it 'Organ Doodle,' because it was a throwaway thing for him, part of a much bigger piece, and he just made this lovely little thing from it, sent it over. Lee was editing the countdown, and I started playing with it on a separate system that I could play music on. I said, 'Let me just play it alongside because maybe there's something there.' It was a pretty peculiar piece of music—well, peculiar and complex, just these little organ notes— and we played it over, and Lee and I watched it because it was exactly the right thing, and fit the emotion on it perfectly. It was resounding."

The launch is one of the great *coups de cinéma* in Nolan's filmography, overlaying a shot of McConaughey in tears as he drives away from his daughter with the mechanized countdown of the launch (*"T minus ten—nine—eight—seven"*) to a Mahleresque crescendo on Zimmer's pipe organ. The countdown reaches one, the organ cuts out, and the screen erupts in fire, a *coup de cinéma* bringing full circle a trick first used by Fritz Lang for his 1929 silent film *Frau im Mond* (*Woman in the Moon*),

whose launch countdown, borrowed from the backward countdown used on film reels, inspired the actual blastoff protocol at NASA, after Lang emigrated to the United States, where NASA scientists watched his film. Every NASA countdown is an homage to the grandfather of film noir. Here it spells out Nolan's underlying theme, a twist on Newton's second law: To go somewhere, you must first leave someone behind. The sound mix of the film would, however, be greeted with a chorus of complaints upon its release, with people saying that some of the dialogue was inaudible beneath the music, forcing one cinema in Rochester, New York, to put up signs informing *Interstellar* ticket buyers, "Please note that all of our sound equipment is functioning properly. Christopher Nolan mixed the sound track with an emphasis on the music. This is how it is intended to sound." In other words, Take it up with the director.

"We got a lot of complaints," says Nolan. "I actually got calls from other filmmakers who would say, 'I just saw your film, and the dialogue is inaudible.' Some people thought maybe the music's too loud, but the truth was it was kind of the whole enchilada of how we had chosen to mix it. It was a very, very radical mix. I was a little shocked to realize how conservative people are when it comes to sound. Because you can make a film that looks like anything, you can shoot on your iPhone, no one's going to complain. But if you mix the sound a certain way, or if you use certain subfrequencies, people get up in arms. There's a wonderful feeling of scale that can come from that, a wonderful feeling of physicality to sound that on *Interstellar* we pushed further than I think anyone ever has. We really tapped into the idea of the subchannel, where you just get a lot of vibration. We used that for the rocket launch, and the music. A lot of it was the music where Hans had this organ and he used the absolutely lowest note, which would literally make your chest drop. There're certain low-end frequencies that automatically get filtered out by the software. He took all of those controls off, so there are all those subfrequencies there. And we did the same on the dub stage. It's a pretty fascinating sound mix. If you see it particularly in an IMAX theater, projected, it's really pretty remarkable."

At the other end of the spectrum, he stripped a lot of the usual Foley sounds—hums, whistles, door swooshes—that normally fill out rocket ships in science-fiction movies, in order to be in better accordance with Hoytema's handheld camera work, using instead the sound of everyone moving around the ship, recorded during production. "We played the film once with just that, and then I asked the sound guys what they thought. And they all said, 'Yeah, we should go for it and do it that way,' which was

very, very radical. So Tars, for example, the robot—I mean, I got a recorder in my assistant's office and I got two filing cabinet drawers and just performed it. And that's the only sound that's on there. There's no layering. I think there's something a little bleak or a little unsettling about it because, on the other hand, we have the lavish music, we've got all this stuff going on, but there's this feeling of smallness or simplicity where normally there would be layers and layers of hums and things going on. We just stripped all of that away. There's a feeling of reality in certain moments of the film that people . . . they don't quite understand where it comes from. But there's an unsettling feeling through the whole thing."

It was Zimmer who came up with one of the film's grace notes—the sound of a tropical rainstorm playing against a shot of the ship flying past Saturn. "The idea was to give perspective," says Nolan. "Hans suggested that one of the characters might have taken a recording of a rainstorm, a thunderstorm back on Earth. They might want some kind of connection to the geography they've left behind. So I wound up layering the sound of the storm onto the exterior shot. There's a shot with the very small spaceship going past Saturn—it's so small, it was actually erased on the DVD; we had to go back and put it back in—but there's a very quiet piano; then we go inside to Romilly. He puts his headphones on and the sound takes over when we come back outside of the ship. I really loved the idea of the sound of crickets and rain over this shocking expanse of space, out near Saturn. It's one of my favorite things in the film."

· · ·

As he had with *Inception,* Nolan had a few scares in the editing room. "*Interstellar* was an oddly tricky film to edit, because with every other film I've done, we cut it together long," says Nolan. "We do our first pass. We screen it. It's a bumpy ride at times. We know how to fix it. We trim. We get rid of things that don't work. We find efficiencies and we shrink it, and it gets better and better and better. It gets tighter. Leaner. If you look at *The Dark Knight* in particular, it's so dense. And there are no deleted scenes on the DVDs; there's nothing. We don't leave anything out. We just find a way to jam it all in there. With *Interstellar,* which is a big fat movie, we started to go down that road and just instinctively made things as efficient as possible. And it made the film boring, because on a superficial level it's just people talking, and then you cut quickly to get to more people talking,

which felt like you were missing the whole point of going into space. So we watched it and I was like, 'That's not going to work at all. We have to abandon the approach we've had, myself and Lee, for the last ten years. We can't try to make the film shorter. It's not going to improve it.'"

Nolan had Lee watch *Koyaanisqatsi*. "He had never heard of it, but it's what we needed in the film, because it's just pure imagery. Whatever this film is doing, whatever this feeling is, you're *experiencing* something. We were missing that. We had to make sure that that was in our film. You have to actually give the audience direct experience of the imagery—the awe, the scale. There has to be imagery that takes your breath away and that directly affects you, not just through the characters. We said, 'Okay, we have to work with digital-effects guys. Work with Hans in the music. We have to get that direct experience to give the audience the emotion of the story they're going through.' It's two different types of filmmaking. This movie could only work with both. At times, one was easy to achieve. At other times, the other one was easy to achieve. There were times when we panicked greatly about one side of it. Other times, you panic greatly about the other. I had a good couple of weeks on the film at the end where it was a little scary, definitely kind of 'Okay, we're doing something frightening. We're doing something we've never done before.'"

Godfrey Reggio's experimental documentary *Koyaanisqatsi* (1982), whose imagery and Philip Glass score were influential on *Interstellar*.

• • •

Of all Nolan's films, *Interstellar* had perhaps the roughest ride with critics, if not audiences (if you toggle between the critics' ranking for the film and the audiences' ranking on Rotten Tomatoes, it leaps from ninth position to third, just behind *The Dark Knight* and *Inception*). Online, analysis of the perceived plot holes in the film—from "21 Things in *Interstellar* That Don't Make Sense (*New York* magazine), to "15 Maddening *Interstellar* Plot Holes" (*Entertainment Weekly*), to the slightly less picky "3 'Interstellar' Plot Holes That Make No Sense" (*Business Insider*)—reached the density of a small black hole. Objections ranged from the pedantic to the amusingly pedantic ("Who in the universe would ever know the titles of all their books, from behind, on a bookshelf?") to the genuinely perplexed. Rather than nitpick Nolan with a barrage of complaints, I present him with what seems to me the biggest one: the deus-ex-machina device of the five-dimensional beings who orchestrate the entire plot, placing the tesseract in the black hole so that, rather than perishing there, Cooper can communicate with his daughter and feed her the data that will allow her to save mankind from extinction. It's quite an intervention. Nolan is normally so scrupulous about eliminating any sign of the puppeteer's hand from his own pictures—to the point of fretting over the final shot of *Inception* because the POV seems to be none other than his own—but something about five-dimensional beings seems to bring out his bossier side: The audience must go along with those five-dimensional beings and the hand they lend the plot, no matter that it passes all ordinary understanding.

Cooper (Matthew McConaughey) on the ice planet.

"I think you're missing the narrative point, which is that jumping into black holes is the ultimate act of faith," says Nolan. "He's caught by creatures who you know exist, and you've been wondering who they are for the entire film. Who are they—it's first said in the first act. It's all up front. Who put the wormhole there? And so they're not a deus ex machina; they're specified right from the beginning, whether you like it or not. For people who like the film, they don't read the tesseract as a deus ex machina. They understand where it's coming from."

"I do like the film—"

"Like it more unreservedly."

"—but the thing that saves him is an offstage agency. Aside from that one line—and it's a little weird that Cooper isn't more curious when they are first mentioned—those five-dimensional beings have no dramatic weight. It's you, the dramatist, stepping into your own drama."

"Well, but you wouldn't assign that characteristic to the monolith in *2001*, which, frankly, is the analogy. Kubrick took an intellectual approach to presenting an intelligence he couldn't portray physically. So he presents a machine that it built. I'm really doing exactly the same thing. The difference is, I'm trying to do it in an emotional, not an intellectual, sense. So for me the representation of these beings, what they value and how they interact with us, are about emotional connections."

We chase the issue around the table a few more times, but it seems churlish to pursue it for too long. As Nolan says, "If I'm having to make an argument for why something works, then clearly, for you, something didn't." Emotionally, *Interstellar* works. The tesseract is among the most beautiful things Nolan has filmed, and the ghost story among the more poetic. A whole other film seems to lie therein. That *Interstellar* is also, on the level of narrative logic, a more ungainly film than some of his others— you can feel the welding of his and Jonah's drafts, while its evocation of cosmic loneliness far outpunches the speeches about the power of love— seems in itself significant. Maybe *Interstellar had* to be a messier film for Nolan to break free of the self-imposed strictures that bound his earlier work, which invited the audience into chess-player-like cogitation about the rules of narrative engagement—making the watch face transparent, to use his analogy. Any move in another direction was going to necessitate equally public torque. The watch face had to shatter. Praised for the intelligence of his early work, Nolan found himself in the curious position of asking his *Interstellar* audience to think a little bit less.

"What I've found is the people who let the film wash over them get the most out of it," he says. "They're not approaching it like it's a crossword puzzle, or like they're going to get a test afterward. Certainly online, my films are held to a weirdly high standard, in terms of plot contrivances. I don't really know why that is; in a way, I suppose, it should be a compliment. I think with the structures I've used—when you use a nonlinear plot structure—and with the genres I've worked in, you do invite more scrutiny. Rules are very important to audiences, they really are. People are ruthless. But I am very, very consistent with my rule sets. You make mistakes, of course, but I never admit to those mistakes, and they are almost never picked up on by the nitpickers. What you don't want as a filmmaker is when it feels restrictive. I want to be able to avail myself of the appropriate traditions of conceit and narrative. There's a very good Roger Ebert book about stuff that only happens in movies. No one ever pays for a cab. Or the engine's always running when they get in a car. Any character that has an architectural model in his office is a bad guy, and I've done a couple of movies with architectural models in them. So movies are full of those wonderful rule sets. I don't want to be treated any differently. In other words, I want to be able to make films where nobody pays for a cab. Put it another way, *Inception*'s not real; *Batman*'s not real. There's a leap that you're asking the audience to make; you're providing suspension of disbelief, but at some point, these things just aren't true.

"A studio executive was once talking about *Memento,* and he articulated the idea that you can ask the audience to make a large narrative leap in the first third of the movie, not in the last third. That has stuck with me. When people start talking about what they call plot holes, they're not necessarily taking into account how storytelling works, the rhythm of it. The cut from the bone to the spaceship in *2001* jumping ahead millions of years, followed by a sequence in excruciating detail how this guy gets to the Moon? It's wonderful, it's an amazing sequence, but it's what we would call in script-writing terms 'shoe leather.' It's the most beautiful shoe leather. That's why I say *2001* is the punk rock of movies. It's not that it breaks all the rules. It's a film that doesn't acknowledge that there *are* any rules."

ELEVEN

SURVIVAL

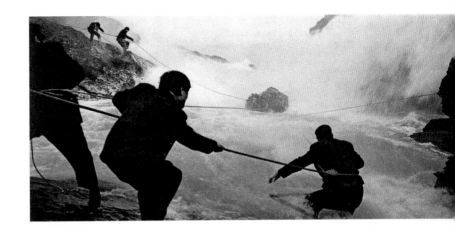

SOMETIME IN THE MID-NINETIES, while he was making *Following*, Nolan and Emma Thomas decided to cross the Channel to Dunkirk in a small sailboat helmed by a friend. "We were kids," says Nolan. "We were in our twenties. We hadn't researched it. It wasn't a crazy thing to do—I mean, Ivan grew up sailing around the world—but it was adventurous. We were just a little early in the year. It was much colder and rougher than we were expecting. The Channel was very rough. The crossing took much longer than it should have. I'd sailed a bit, inland sailing mostly, so it was a bit of a shock to us. We got there in the middle of the night, to Dunkirk, and the word has such resonance, so then you turn up and you see the place; I was so fucking glad to get there. And that's without people dropping bombs on you. You're not going into a war zone. So I came away with a whole different level of respect for the reality of the evacuation. That was the seed of wanting to eventually tell the story. I don't think I was conscious then at the time—I was in the middle of *Following*—but I think the trip itself definitely planted the idea."

The boat trip may have been the seed of the film, but the more immediate impetus to make *Dunkirk* came after a visit by Nolan and his family to the Churchill War Rooms in London, the secret bunker located beneath the Treasury, where you can see the western front planned out by Churchill's generals. Returning home, Emma Thomas slipped a copy of

Nolan consulting with Kenneth Branagh on the mole; the German aerial bombardment of the mole in *Dunkirk* (2017). That was the hook of the story—a literal bridge to nowhere.

Joshua Levine's *Forgotten Voices of Dunkirk* in front of her husband. "For every individual who stood on the beach or on the mole, or retreated clinging to a cow, there was a different reality," wrote Levine of the evacuation, during which some 338,000 men were ultimately saved from the German advance. "Set side by side, these realities often contradict one another. To take one element of the story, the beaches covered a large area; they were populated by many thousands of people in varying mental and physical states over nearly ten intense days of rapidly changing conditions. How could these stories not contradict one another? The whole world was present on those beaches." Out of the welter of detail, one stood out: the description of the "moles," the two long concrete breakwaters on the eastern and western side of the harbor, originally designed to stop it from silting up, which had somehow been left intact after the Luftwaffe's bombing of the harbor itself. The eastern mole stretched almost a mile out to sea, with a fifteen-foot tidal drop to treacherous currents and a wooden walkway on top; while there was no obvious method of docking ships alongside it, soldiers could be brought there relatively easily from the beaches, where the shallow waters made it impossible for British destroyers

to land on the beach. Hundreds of private small-boat owners across the English Channel therefore came to the moles, in constant danger from Luftwaffe bombardments.

"That to me was the hook, because I'd never heard of the mole, and it's such a resonant, primal image. People are literally queuing to know whether they are going to live or die. Then the bombers are coming, and a boat either will come or a boat won't come. I couldn't believe I had never heard of that. It's a symbol of the event itself, a metaphor, even knowing the event pretty well. It's like, My God." Nolan threw himself into reading firsthand accounts of the evacuation, some of them compiled by the Imperial War Museum, and contacted Levine, bringing him on as the film's historical adviser. Levine pointed him in the direction of further reading material and put him in touch with some of the last surviving veterans of Dunkirk.

"Obviously, at this point, the veterans are very old and there are not that many left," says Nolan, "but we were able to talk to them about what it was like to be there, things that in different ways worked that went into the film. The different veterans had a lot of different interpretations about what the 'Dunkirk spirit' means. We had veterans who thought that it applied very much to the little ships arriving to help, other veterans who felt that it obviously applied to the men holding the perimeter, allowing the others to escape. We had people for whom it was simply propaganda. With that many people, 400,000 people on a beach, give or take, you find a lot of very radically different experiences. You find order, but you also find chaos. You find nobility, but you also find cowardice. That was very

The German aerial bombardment of the mole.

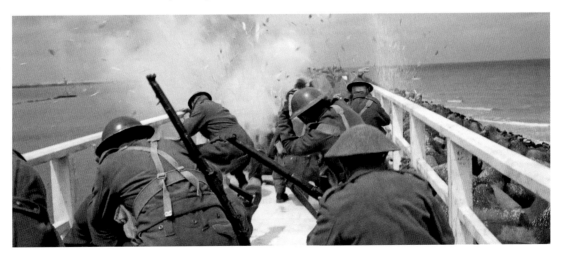

much the approach we took in the film. To try and suggest to the audience that they're seeing certain aspects of the thing, but there are myriad other stories. So that everyone is sitting in the corner praying and having their own story and interpretation."

He found the stark logistical detail—the infernal calculus of torqued metal and souls awaiting deliverance—fascinating. One survivor talked about a chap bringing water from England to Dunkirk, which meant getting off the boat and then not being able to get back on. Where were you going to get food from? Or water? Or go to the toilet? These things suddenly seemed like herculean accomplishments. He decided to have someone trying to go to the toilet at the beginning of the film. Then there was the story of the guy who just walked out into the water, whether to kill himself or swim through the surf to England, no one could say. "I asked the veteran who told me the story, 'Were they going to kill themselves? Swim out to a boat?' but he couldn't answer. He didn't know. He just knew they were going to die. It's a chilling thing to hear. Stories like that just worked their way into the film. That's where I realized that my experience, our experience, Emma's and my experience of going to Dunkirk, the feeling of how difficult that was, was actually relevant, although those things are difficult to convey in movies, because the movies tend to deal with less prosaic difficulties."

When Nolan was living in Chicago in the early eighties, one of the films he saw with his mother at the old Edens Theater in Northbrook was Spielberg's *Raiders of the Lost Ark*. In particular, he recalls the rousing moment when Indy is spotted by his crew alive atop a German U-boat. "It ends with him hoisting himself up onto the tower—he grabs the railing and hoists himself up, and then they cut away—and as a kid I can remember thinking that would be unbelievably hard to do. Just that single action, which in a movie is nothing. For some reason, I always noticed that. . . . One of the hardest things to convey in films is breathlessness. You can have the actor wheezing or whatever, but the truth is, when characters run in movies, the audience doesn't get tired. If a character is underwater and holds his breath, the audience feels that. Sometimes you stop breathing for a bit to see how long you can, too; you kind of get it. But when an actor is running down the street, you don't *feel* that. They could run for an hour and you would never go, 'Why aren't they out of breath?' We just accept this on film. So with *Dunkirk*, it was all about trying to undo that and deal with the physicality, how difficult it is to get on the boat because it's

moving, or you have a stretcher. It's all about how difficult those things are. Nothing is easy."

Dunkirk would be a compilation reel of such last-minute getaways and narrow escapes. The only question he was interested in was, Will they get out of it? Will they be killed by the next bomb while trying to join the mole? Will they be crushed by a boat crossing? Pitching it to Warner Bros., Nolan referenced films like Alfonso Cuarón's *Gravity* and George Miller's *Mad Max: Fury Road,* both white-knuckled survival epics that played like an extended third act of film—pure present tense, pure climax. There would be no shots of generals pushing boats across a map, no Churchill, no politics. From its very first sequence, in which German snipers pick off the men on either side of Tommy as he runs toward the Allied barricades, we are given the film's starkly Euclidean moral calculus: survive or die. While working on *The Prestige*, Nolan had encouraged composer David Julyan to look at something called the Shepard tone, the auditory illusion produced by a superposition of sine waves separated by octaves, so that as one rising tone fades out, a bottom one fades in, tricking the brain into a sense that the pitch is ceaselessly ascending, like a corkscrew. It sounds a bit like an orchestra tuning up. On *Dunkirk,* Nolan structured his entire screenplay that way, interweaving the three time lines in such a way that there's a continual feeling of intensity: the third act of a movie prolonged and stretched to breaking point.

"What I stripped away on *Dunkirk* was the backstory," he says. "Essentially, you have a moment where the character is either introduced or, later on, you have a moment where they're making a case for themselves as characters and for the audience's sympathy. I thought, I'm going to just dump it. I'm just going to try and not have dialogue for a lot of it. Once I'd stepped outside that way of thinking of the writing, I couldn't step back. Once you go down that road, you start to realize how intensely artificial dialogue is in films, even well-written dialogue. The use of dialogue is not unlike the use of music—it's expressive. Once you feel that with regards to a true story you're dealing with, or a real event, I should say, trying to represent that, it suddenly seems a very artificial way of telling the story. So it got stripped away more and more. Emma and I had an ongoing argument about *Dunkirk* after we got into postproduction; she thought it was an art film pretending to be a mainstream film, and I think it's a mainstream film pretending to be art film. The two things are very different. It's pretty interesting, and she pretty passionately believes that, and I'm a little less

convinced of my own view on it, but yeah, it's interesting. It's just about different languages of filmmaking, and I don't have any problem with that. I don't have any problem looking at a movie poster and going, 'Okay, it's this kind of film. That's the ride I want. Now, where are you going to take me?'"

•　　•　　•

While he was still writing the script for *Dunkirk,* Nolan made a short film about the stop-motion animators Stephen and Timothy Quay. Pennsylvania natives who have lived in England for decades, the Quays—pronounced *kwayz,* not *keys*—are identical twins whose work echoes the stop-motion surrealism of Jan Svankmajer, featuring nightmarish imagery of women trapped inside asylums, animated household items, and ghostly doll heads. Premiering on August 19, 2015, at New York's Film Forum, Nolan's eight-minute film portrait, *Quay,* accompanied by three of the brothers' films—*In Absentia, The Comb,* and *Street of Crocodiles*—explored their workshop, cluttered with such lo-fi tools as bits of glass frosted with laundry soap, and interviewed the two brothers about their creative process. "[My assistant] Andy recorded the sound; it was literally just the

Nolan and the Quay brothers during the making of Nolan's eight-minute film portrait, *Quay* (2015), which he shot, edited, and scored himself.

two of us and my childhood friend Roko Belic. I shot it myself, edited it myself, and did the music. For me, it was a thing of having made bigger and bigger films for years; I just wanted to reconnect with the most basic form of filmmaking I started with, and so I made that short film in as small a way as possible and I thoroughly enjoyed it. I had a great experience on *Interstellar,* really great, but it was the biggest form of filmmaking, with very large numbers of people, with many different moving parts. At certain points, I felt very disconnected from the essence of filmmaking and felt the desire to do something very, very intimate, do every job myself, and get back to where I started again."

Critics had been asking a similar question. Interviewed by *The New York Times* after *Interstellar*'s release in 2014, Steven Soderbergh expressed curiosity as to whether Nolan ever had any desire to go back and make a personal film "on the scale of *Memento,*" the implication being that a big film cannot also be personal. "Tasteful and colossal are—in movies at least—basically antipathetic," film critic Pauline Kael wrote in her *New Yorker* review of *Ryan's Daughter,* the film that derailed David Lean's career in the seventies. "The emptiness of *Ryan's Daughter* shows in every frame, and yet the publicity machine has turned it into an artistic event, and the American public is a sucker for the corrupt tastefulness of well-bred English epics." The deprecation of scale goes back to 1915, when D. W. Griffith's *Birth of a Nation* loosed the ogre of giganticism on American film, and in the words of its cameraman, Karl Brown, "Bigger and better became the constantly chanted watchword of the year. Soon the two words became one. Bigger meant better, and a sort of giganticism overwhelmed the world, especially the world of motion pictures." Chiefly through his own attention to budget in his dual role of producer, Nolan's career had been free of such prominent misfires as *Ryan's Daughter,* but Kael's assumption that colossal and tasteful are antithetical rests on a presumption that won't hold true in his case, largely because of the lessons he learned on *Batman Begins* about the paradox of scale at the movies. It is just one more illusion, like any other.

"The frame remains the same size, whether for the smallest close-up or the widest wide shot," says Nolan, whose big war epic turned out to be, in many ways, his smallest movie since *Memento,* traversing a forty-four-mile stretch of the English Channel, and largely confined to a two-mile stretch of beach. "The films that I grew up appreciating were all about clutter and layer and texture. And Nathan's always resisted that and steered me

in more minimalist directions, to the point where we made a war film in which we don't use any of the visually chaotic devices—lots of quick cuts, lots of activity, lots of smoke, lots of fire, bits and bobs flying everywhere—that usually sell the idea of war to an audience. *Dunkirk* is entirely about the absence of those things. It was always going to have to be very, very minimalist and stark, more about abstract imagery."

In particular, they looked at the work of German photographer Andreas Gursky, whose large-format photographic prints show humankind dwarfed by mountains, beaches, racetracks, stockyards, and other landscapes natural and unnatural. The conversation between minimalism and maximalism first started by *Batman Begins,* and continued by *The Dark Knight* and *Inception,* was to find its most abstract, attenuated end-point in *Dunkirk.* The script that Nolan eventually produced was very short, just seventy-six pages, the shortest he had written since *Following,* with three story strands, the first taking place over a week, the second over a day, the third over the course of an hour. Epic in scope, the film narrows as it proceeds, like a noose. The first story, "The Mole," follows young British troops trying

Whitehead and the Highlanders find shelter on the beach in *Dunkirk.* Compositionally, *Dunkirk* is Nolan's most abstract film.

to get off the small half-mile stretch of beach at Dunkirk, where they are hemmed in by German forces, easy prey for the dive-bombing Luftwaffe. "We surround you!" declare falling leaflets. In the second story, "The Sea," a civilian man (Mark Rylance), his son (Tom Glynn-Carney), and the son's friend (Barry Keoghan) take a tiny boat, the *Moonstone,* across the Channel to fetch the stranded soldiers. In the third story, "The Air," British air force pilots Farrier (Tom Hardy) and Collins (Jack Lowden) engage the German Stukas and bombers prowling the skies. The three story lines converge only at the end.

"The idea behind *Dunkirk* that we were trying to get across to the audience is, it's not about individual heroics. It's about a community full of heroism. That's very unique and I think in a lot of ways more relevant to the world and the way the world works. There were two elements of the Dunkirk story whose universal significance we wanted to tap. The first was survival. It's really about the individual instinct for survival. And the second is the desperation to get home. You get into kind of Homeric territory with this stuff, but their odyssey feels enormous. It feels like they'll never get home. It feels big. And that, to me, is very important. I'm not that interested in making a film where the geography of the story is very small. I don't mean the literal geography. I don't mean countries you go to. It can be within a room. Like *Dunkirk.* I'm very happy with the geography of that film, even though by definition it's incredibly simple and claustrophobic. But we found a way to move through that geography in a way that's got much more scale to me. I think *Dunkirk*'s a very intimate film, but it has all this scale. To me the geography, the journey you go on, is everything."

•　　•　　•

Every week, during prep, Nolan screened for his cast and crew a small season of films—in a cinema, on real film stock—to give them some idea of what he was after, including David Lean's *Ryan's Daughter,* which they watched in a special 70mm screening at the Academy of Motion Picture Arts and Sciences, seeing how cinematographer Freddie Young let nature and light and landscape speak for themselves, fitting the cameras with spinning rain deflectors so they could shoot the storms off the coast of County Clare in Ireland. "You sometimes had to drive through a torrent of seawater which swamped you and you had to pull up and think, 'God, what's

FROM LEFT TO RIGHT
Posters for Alfred
Hitchcock's *Foreign
Correspondent* (1940);
Henri-Georges Clouzot's
The Wages of Fear
(1953), and Hugh
Hudson's *Chariots of Fire*
(1981), all of which Nolan
screened for his cast and
crew during the making
of *Dunkirk* (2017).

all that salt water going to do underneath me here?' " said Lean. "But great
fun, you know. Terrific." Nolan also looked at Hitchcock's *Foreign Corre-
spondent* (1940) for its downing of a four-motor, eighty-four-foot plane at
sea, staged in an enormous studio tank in which actors floundered while
hidden blades and an eighty-foot windmill churned the waters. Nolan's
cast and crew admired the relentless action, from beginning to end, in Jan
de Bont's *Speed* (1994), and the mixture of period detail and the anach-
ronistic synthesizer score in Hugh Hudson's *Chariots of Fire* (1981). They
also watched various classics of silent cinema, including D. W. Griffith's
Intolerance (1916), F. W. Murnau's *Sunrise: A Song of Two Humans* (1927),
looking at the crowd scenes in particular, the way the extras moved and
used the space of Murnau's sets, and Erich von Stroheim's notorious, hyp-
notic classic *Greed* (1924), about two men who fall out over a surprise lot-
tery win and end up battling each other against the parched, sun-scorched
backdrop of Death Valley.

"*Greed* had a huge influence on *Interstellar* as well, actually," says Nolan.
"The two astronauts fighting each other in that landscape. *Sunrise* is ele-
mental and fablelike, and *Dunkirk* needed that silence, that simplicity. I
was using the language of suspense, but there's a relationship with silent
cinema—the use of architecture in Murnau is a wonderful expression of
the morality of the people. Murnau built colossal sets, like von Stroheim in
Foolish Wives, and then invited the press in. You'd see the films and they're

relatively intimate stories, and then they walk down the street and you see this colossal set. It's a different type of showmanship, of a different era, but it's pretty amazing and it relates to what Lean was doing in *Ryan's Daughter*. There's a confluence between the crew and the event they are dramatizing; there's the epic scale of what's on-screen and then the epic scale of how it was put there. That's the kind of thing you get from *Sunrise*. That's the kind of thing you get from the silent era, because they were making films in Germany that would play in America, or in America and would play in Germany, that were universal, with no language barrier."

Finally, he screened Henri-Georges Clouzot's *The Wages of Fear* (1953) for the permanent tension endured by the two protagonists, truck drivers transporting a cargo of nitroglycerin across mountain dirt roads, and for its zero-sum estimation of human morality in extreme circumstances. "It actually might have been the last one. Hoyte [van Hoytema] was sitting in front of me; everyone else was behind. I sat and watched it, going, 'This is it; this is our film.' I mean, just look at the scene where the truck has to go back on the platform and the wheels don't respond anymore. Everything

Nolan and Emma Thomas on the beach at Dunkirk.

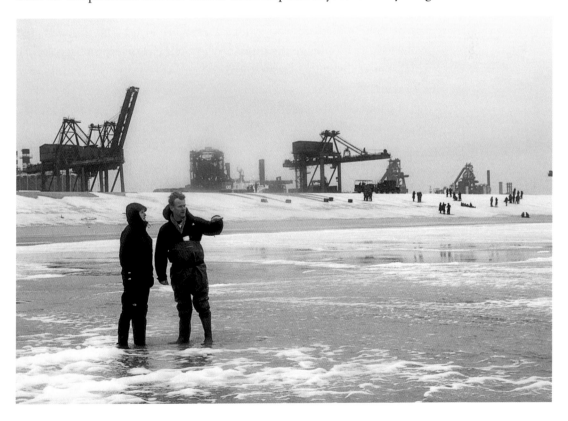

about the design of it, the concentration on the way the tires spin on the wood and you see it creaking; I said, 'This is exactly what we need.' Pure physics, pure suspense. Even the guys fighting in oil at the end. I'm like, 'This is it. This is what I want in the film. . . .'" I turned around at the end of the film, and my crew was horrified. They *hated* it. I've never had this experience before. I think what it was, was the ending is so misanthropic. They just got upset with it. Because then when I would talk about 'Well, hang on; but didn't you like this' or 'didn't you like this?' and they'd get into it and start to explore it a little bit, but they really didn't like it at all. It *is* a cruel ending."

Nolan was keen to speak to each of his actors—Mark Rylance, Cillian Murphy, and Tom Hardy—before they read the script, to prepare them for the film's more experimental aspects. Rylance questioned the script's references to "Germans" and "Nazis" in the crawl at the beginning and later in some of the dialogue. Since Nolan had made the decision never to actually show Germans, even referring to them seemed pointless. They would be an offscreen menace, like the shark in *Jaws*: You see the fin but you don't see the shark. Rylance brought into the conversation the philosophy of Robert Bresson, whose films *Pickpocket* and *A Man Escaped* used real people to illuminate the humanity of their characters through simple action rather than any overtly stated concept of the courage of humanity. "No actors. (No directing of actors)," wrote Bresson. "No parts. (No learning of parts). No staging. But the use of working models, taken from life. BEING (models) instead of SEEMING (actors)."

"I watched Mark really run with the Bresson idea," says Nolan. "It was very important for him to understand the boat and to feel the tiller, because he needed to feel the boat, so what I tried to provide for him was the ability to steer the boat for real, with minimal crew and then a bomber flying above his head for real. We tried to put all that in so that the actors really had that physicality, just get out on the boat with the other actors and an IMAX camera and not improvise it completely, but explore things with the actors. So for weeks we were out on that boat with these great performers and newcomers, Tom Glynn-Carney and Barry Keoghan. Mark, in particular, did a wonderful job of helping the younger actors, bringing them in and teaching them his approach to improvisation. Fleshing out 'Okay what's happening offscreen? What's happening between the scenes? How can we play with that? How can we play with the relationship between the characters?' The younger actors really got excited about that, as did I."

Hoytema, Nolan, and Fionn Whitehead on location for *Dunkirk;* Nolan and his crew on the beach. Nolan wanted little or no separation between cast and crew.

Principal photography commenced on May 23, 2016, in Dunkirk, to coincide with the dates of the real evacuation in order to recapture the weather conditions as closely as possible. "Our first shooting day was in some of the worst weather—the kind of weather where, I think, very few film crews would carry on shooting. We had a good five days at the beginning of the shoot of *Dunkirk* where you couldn't even walk out there. I mean, our set was being ripped to pieces. But it looked marvelous with all this amazing foam washing up the beach. It made this extraordinary transformation on the beach. I'm known in the film business for having good luck with the weather. That's inaccurate. I often have terrible luck with the weather, but my philosophy is to shoot no matter what the weather is, until the safety officer says the winds are too high, or whatever, and we shut down until it passes, but always shooting no matter what weather, just keeping going, keeping going. Letting everybody on the crew and cast know we're really serious about doing that, no matter what the conditions are, so they're not looking out the window first thing and going, 'Oh, we will or won't shoot today.'"

After shooting on the beach at Dunkirk, production moved for four weeks to Urk, in the Netherlands, where Nathan Crowley and marine coordinator Neil Andrea had located nearly sixty ships, like the French Navy destroyer *Maillé-Brézé,* along with a Dutch minesweeper and pilot vessel, all refitted to look like British destroyers from 1940 for the three ship-sinking scenes—the hospital ship, the destroyer, and the minesweeper. The ships were rigged with explosive charges by Paul Corbould, and housings made for the cameras—a combination of 65mm large-format film stock in Panavision and IMAX 65mm—so that Nolan and his cinematographer, Hoyte van Hoytema, both in wet suits, could be in the water along with the actors, the cameras actually floating out on the water. "We were trying to break down the barrier between the crew being out of the water and the cast being in the water," he says. "We wanted to break that down, to be in there with them and get a much more subjective field of vision, and really be a part of the same physical elements they were dealing with. It took a lot of just getting out there and doing it. I'd done a lot of land and aerial work before, but for me the marine stuff was the most challenging, the most unknown. I had never done anything remotely like that. The actors were going to have to be in the water, not for individual shots, but for virtually the whole shoot."

From the Netherlands, production moved to Swanage and Weymouth Harbour in Dorset, whence Rylance sets out in the *Moonstone,* a small

1930s motor yacht, which bore as many as sixty crew members, though designed for just ten. There were over fifty other boats, including twelve used in the crossing, piloted by their owners. For the aerial scenes over the Channel, shot by an aerial unit based at Lee-on-Solent airfield, two Supermarine Spitfire Mk.1a fighters, a Supermarine Spitfire Mk.Vb, and a Hispano Buchón masquerading as a Messerschmitt Bf 109E were used. For the interior shots, Russian Yaks fitted with dual cockpit, with the pilots behind the actors, were fitted with IMAX cameras placed upside down inside the fuselage, because the cockpits were too small, using mirrors to get the shot. Both Smith and Nolan loved how ragged and tense the resulting jolts absorbed by the mirrors made the scenes. "The number of variations we went through on the Stukas, it was insane," said Smith, who was on location for the entirety of the shoot to make sure the raw, unedited footage was in good shape and who assembled a work print that was essentially a silent movie, because even on those rare occasions when they did have sound, it was shot with the IMAX camera, so it was basically useless. All they had to guide them was a sync guide track and the sound of the cameras themselves.

"I wanted to teach the audience how difficult actual dogfights would be," says Nolan. "Put them into the cockpit of a Spitfire and have them dogfight with the Luftwaffe, teach them how you bank chasing a plane and have to get your gun sight ahead of it and anticipate how far it is going to move, what the wind is going to do to the bullets, and so on. I wanted to put the audience on the beach, feeling the sand getting everywhere. Or on a small civilian boat bouncing around the waves, heading into terrifying water. And do this for real as far as possible, just because there are so many heavily manipulated films in terms of computer imagery right now. The strength of real-world situations is that you can present it in a concrete manner, in a way that the audience can really believe in. One of the shots I was most pleased with in *Dunkirk* was the destroyer rolling over, where we attached a camera to the boat itself, so the water action comes in from the side. It's not unlike some of the imagery of *Inception,* except it's real life. I was very pleased with that shot—very, very dramatic."

. . .

Scouting for locations for *Lawrence of Arabia* in Aqaba on the southernmost coast of Jordan, David Lean noticed a curious distorting effect of the mirages created by the desert heat. "The mirage on the flats is very strong

and it is impossible to tell the nature of distant objects," wrote Lean in his diary. "You certainly can't tell a camel from a goat or a horse." From this observation came one of his most famous shots, showing Omar Sharif and his camel in extreme long shot, just a shape on the horizon at first, slowly riding toward Lawrence, sitting in the sand at a well. It was Sharif's first day of shooting. He and his camel were sent a quarter of a mile from the cameras by a roundabout route to avoid tracks being visible to the lens. Using the longest lens he had, cameraman Freddie Young shot at a thousand feet, in one take, as Sharif slowly got bigger and bigger, until his head and shoulders filled the frame. At the end, Lean went up to his production designer, John Box, and said, "You'll never do a better bit of designing in films, ever!" Such shots were what led Gregory Peck to dub the director the "poet of the far horizon."

With *Dunkirk,* Nolan proves himself Lean's gyroscope-spinning heir: the poet of the obscured or lost horizon. Working again with Hoyte van Hoytema, Nolan delivers his emptiest, most abstract film compositionally, framing our first shot of the men on the beach between two white flagpoles. What follows is a very *British* evacuation, with queues upon queues stretching into the distance. Even the disruption of these queues obeys a certain fearful symmetry: When Stukas dive-bomb the beach, the men hit the deck en masse; the effect is strangely pleasing, like a ripple of falling dominoes. We see a series of explosions over the elbows of a crouching Tommy, the explosions moving in a line toward him at precise intervals, the last explosion sending the man lying next to him flying up into the air. His body never comes down—vaporized utterly. "Through much of the film he uses an unusually restricted range of colors, mostly shades of brown and tan, gray, blue-gray, and black," points out film historian David Bordwell. "The action is placed against backdrops that emphasize this same sort of hazy composition where sea, sky, and land come close to blending." In other words, Nolan obfuscates the single most effective means the soldiers have of orienting themselves in any given environment: the horizon line. Joining forces with another young soldier (Aneurin Barnard), the pair almost make a getaway on a Red Cross boat, but it is sunk by the Luftwaffe. They manage to get aboard a destroyer, where Tommy makes his way belowdecks to get tea and jam sandwiches, watching warily as the metal doors are locked. This boat, too, goes down, hit by a U-boat torpedo. As the boat starts to capsize in darkness, the camera tilts forty-five degrees, creating walls of water that surge in horizontally, the men's cries

OPPOSITE TOP Peter O'Toole in David Lean's *Lawrence of Arabia* (1962); BOTTOM Lean shooting *Ryan's Daughter* (1970) on the coast of County Clare in Ireland.

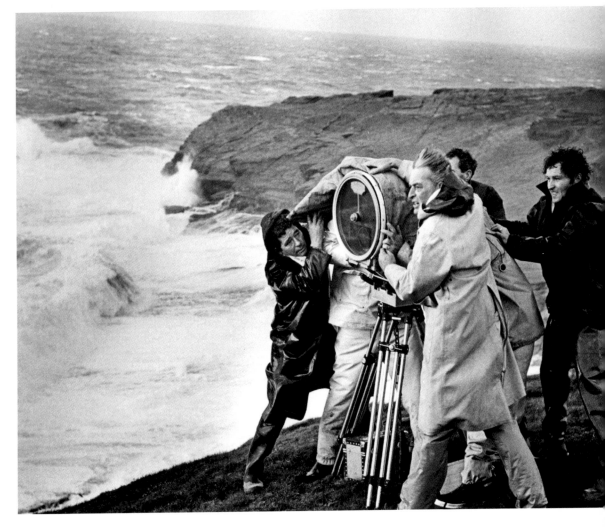

muffled and their bodies pale figures thrashing underwater. One man has not let go of his tin cup.

Again and again, the film returns to Nolan's oldest fear, that of being locked in—specifically, of locking *yourself* in, willingly submitting to structures designed to protect you that turn out, instead, to entrap you. Cockpits become coffins. The boat that saves you will also sink you. Your shelter is shrapnel-in-waiting. All three story lines trend toward enclosure. In the second, set on the civilian boat the *Moonstone,* Mark Rylance and his son Peter (Tom Glynn-Carney) spy a nearly sunken ship; on the way to it, they fish out of the water a shivering sailor (Cillian Murphy), who is numb with shell shock, silent at first. Eventually, he mutters, "U-boat." When George asks him if he'd like to go below, where it is warmer, the sailor refuses, terrified. "Leave him be, George," says Dawson. "He feels safer on deck. You'd be, too, if you had been bombed." Hearing the accounts of survivors who saw all the fires from a distance, Nolan had fixated on that as an omnipresent image: those burning fires on the horizon. The last place you'd want to go. When the sailor grows panicked at the thought of returning to Dunkirk and George locks him in one of the cabins, we feel the click of the lock, the first story still fresh in our minds. In the third story, "The Air," British air force pilots Farrier (Tom Hardy) and Collins (Jack Lowden) engage the German Stukas and bombers prowling the skies. Dipping, rolling, and spinning against a backdrop of sea and air rendered almost indistinguishable by their pewter gray coloring, the battles seem to be taking place in some new element entirely, and when

Collins's downed Spitfire goes up in flames.

one of the planes goes down, a tumult of water quickly fills the cockpit, the canopy refusing to slide open.

The film's spatial audacity in some ways outstrips its temporal ingenuity. By now trained to spot any experiments with time in Nolan's work, critics made much of the film's tripartite time scheme, but Nolan shows little interest in using it for dramatic irony save for the scene when Tommy and his pals try to clamber aboard a lifeboat, only to be forcefully rebuffed by the boat's commander: It is Cillian Murphy's sailor, pre-PTSD. The contrast between his selfish rebuff and shivering fear makes a point about war's impact on men while also casting a cool eye over the human survival instinct. But for that scene, it's possible to watch the film without much consciousness of the differing time frames, seeing it, rather, as a standard piece of crosscut action taking place over the course of twenty-four hours, with Tommy and his men making multiple attempts to get off the beach, Dawson on his way to collect them, and Farrier arriving to save the day. You might have to stretch time a little to get around the limited amounts of fuel available to a Spitfire, and lose one of the film's three boat sinkings, but you could crosscut from land to sea to air and still have had the miraculous convergence of stories at the end.

So why does Nolan do it? What that standard crosscut film does *not* give you, or at least renders more difficult, is the sense of constant, unrelenting tension that the film achieves—a series of races against the clock, narrow escapes, and last-minute rescues straight out of the silent films he studied. Each time frame has been chosen to maximize the number of narrow escapes faced by each individual, and increase Nolan's choices in the editing room. By putting Tommy and his men in almost constant peril, Nolan turns survival itself into its own achievement. When Tommy first sees Gibson on the beach, he is burying a body in the sand, and Tommy instinctively goes to help out, the fact that Gibson is wearing the dead man's boots passing wordlessly between them. Within a single scene, Nolan has habituated us to a moral landscape in which selfishness and altruism jostle each other like soldiers in a mess hall. "All we did was survive," says Alex to the blind man at the film's end. "That's enough," the man replies. It also renders even more starkly the act of heroism on which the film ends, as Tom Hardy's pilot, whom we have seen checking his fuel gauge all movie long, decides to fly past the point of no return and provide one final burst of cover for the men on the beach, his plane gliding, his engine now dead, enjoying a few brief moments of transcendence before

giving himself over to the Germans. Back on the *Moonstone,* asked by Collins how his father knew how to maneuver a boat to evade fire from an airplane, Peter replies, "My brother. He flew Hurricanes. Died third week into the war." Dawson's unwavering commitment to rescuing the survivors is thus explained, tucked away in that briefest of asides, all the more affecting for being so unsung.

<div align="center">• • •</div>

"That scene at the end is a very important moment to me and one that I really wanted to make work," says Nolan, "I think because of the absence of overt heroics elsewhere in the film, it packs an enormous punch. It felt earned." He had grown up with stories about the war told by his father and uncle, both of whom had lost their father, Francis Thomas Nolan, a navigator in a Lancaster bomber. The "old man" in a crew of eighteen-year-olds, he was shot down over France in 1944, a year before the war ended, after surviving forty-five previous missions. "Having grown up on the story of the war, knowing how my grandfather died, I don't think it would have been possible for me to portray a World War II pilot in anything other than heroic terms. World War II was always something that was incredibly important to my father. He used to tell me stories about the air raids. So that was very much a part of my dad's history that he would relate to us, and so, while it wasn't something I was conscious of at the time, when I look back on it, I feel like inevitably at some point I was going to want to tell a World War II story in some way. With the realization that I was going to be showing the air battle over *Dunkirk,* I felt a very strong responsibility to get it right. He was always a harsh critic of historical accuracy in films when it related to airplanes. There's a nod to this in the film when Mrs. Dawson identifies Spitfires just from the engine sound. My dad used to be able to identify the sound of a jet just like that. I don't know how he did it, but a plane would fly overhead and he'd be able to tell from the sound what kind of plane it was."

For *Dunkirk,* the director did something he rarely does—he used a piece of preexisting music, Elgar's "Nimrod" from the *Enigma Variations.* "My dad was a big classical music expert," he says. "He had an incredible ear and was massively knowledgeable about music—all kinds of music, but classical music in particular. After seeing that I liked the music for *Star Wars,* my father introduced me to Holst's *The Planets,* which John Wil-

liams drew on when he wrote the score for that film. When I was starting out, he would suggest classical music to me to use, and it was difficult for me to explain to him why that wouldn't work for me, but it's very, very difficult to use classical music in films. It can be done well—obviously in *2001,* Kubrick uses classical music very well—but it's actually quite hard to do because of all of the other associations it brings." Nevertheless, when Nolan used an orchestra for the first time on the score for *Insomnia,* his father trotted along to the recording studio in central London to hear them record it. "We were recording on Charlotte Street; I can't remember which stage it was—it's no longer a recording stage—but we had a big orchestra there and he came by for that, and he came by for the remix. That was the first time we ever recorded with a full orchestra."

In 2009, as Nolan was prepping *Inception,* his father was diagnosed with stage-four pancreatic cancer, an accidental irony given the deathbed scene of reconciliation Pete Postlethwaite shares with Cillian Murphy in the film, which has left Nolan forever picking out the father references from the film for journalists. "My relationship with my dad is very important—*was* very important," he says. "He didn't live to see *Inception,* because he died while we were making it, or just after we shot it. But the very obvious

Editor Lee Smith, Nolan, and supervising sound editor Richard King at work.

and specific analogy for where the father in that film comes from—no one's ever noticed; it's baffling to me, as I actually thought I would get in trouble for it, and it's nothing to do with my family. Let me put it this way: You're talking about a very powerful Australian businessman faced with passing on his empire. Because I needed the flight from Australia, Sydney to Los Angeles. It was, at the time, the longest flight in the world, or one of the longest. I will say no more. Nobody picked up on that."

With *Inception,* Nolan may have been more interested in expressing his views about corporate monopolies like Rupert Murdoch's than invoking his relationship with his father, but there *is* a musical conversation with his father going on in the score of *Dunkirk.* "Very early on, I sent Hans a recording that I made of a watch that I own with a very insistent ticking and we built the sound track from that sound out. We built the music as we built the picture." Traveling to Dunkirk while they were shooting, Zimmer took a handful of sand, put it in a little glass jar, and brought it back to Los Angeles and kept it on his desk while he composed. The fundamental challenge he faced with Nolan's brief was, how do you write something that consistently gives the audience the sense of constant tension rising? An early demo of Zimmer's had used an air-raid siren, but he also wanted to try an orchestral approach, going to London to record a vast amount of music with a symphony orchestra, over one hundred minutes of music, just to show that the Shepard tone idea could be made to work.

Nolan joins Hans Zimmer during postproduction. *Dunkirk* represented the greatest fusion of sound and image the director had yet attempted.

Upon returning to Los Angeles and putting it up against the rough cut, Zimmer knew he was in trouble. Everything seemed fine until they got into the details of sequences, where they quickly found the problem with a constantly rising sound and an unbroken rhythm was that you couldn't cut into it. If they made a cut in reel four, they had to go all the way back to the beginning of the movie and redo all the music there, too. "It was devastating to go to London to record an orchestral score and put it up against the picture, only to realize that it's not working," said Zimmer. "By then, we were running out of time. The mechanics of time were excruciating. The lack of sleep in particular. *Dunkirk* was one of those movies where I'd be in the studio all day writing, I'd go home, fall asleep, and dream about it. It never left me."

Eventually, Zimmer came around to Nolan's original plan. From survivors' accounts, Nolan's attention had been particularly taken by the vividness with which they remembered the *sounds* of the evacuation—the sound of bombs going off, of ships sinking, of the sirens attached to the wheel struts of the German dive-bombers, which gave out this terrifying screech as they approached—and he determined that the whole score needed to shift and change like a chameleon, incorporating and syncopating with sounds sent over by sound designer Richard King. King would send over the sound of the *Moonstone* boat, and then it would become a musical instrument, the sound effects of boats and motors in the same tempo as the music, the scrape of violins merging with boat horns, sheets of brass instruments melding with the rhythmic surge of a ship's engine, to the point where it is more or less impossible to say where the score ended and the sound design began, fusing mechanical and musical elements into a kind of *musique concrète,* like Edmund Meisel's score for *October.* When Tommy wanders along the beach and sees the multiple queues of men stretching off into the distance and the mole reaching out into choppy seas, we hear a series of diminished scales rising up beneath one another, a musical version of the numbers game propelling each man forward. An ostinato of violins accompanies Tommy and Gibson as they ferry their stretcher to the mole—the violinists seem almost to be *bouncing* their bows off the strings—then seems almost to drift in and out of discord as their plan falters, then regains its footing, the violins speeding up as explosions send up plumes of water on either side of the mole.

"We mixed the film in a completely unique way," says Nolan. "All of the rhythmic structures incorporated sound effects. So, for example, the boat

engines were in same tempo as the music, so they became a kind of musical instrument themselves, to be synchronized with all other elements. I don't think anyone actually noticed, but they felt it. And it was incredibly hard to do and incredibly laborious. It tortured everybody involved. Hans and his guys were cursing me. . . . All of the film was made like that. The music is essentially two cues; there was one cue that was 110 minutes and the Elgar that runs for ten minutes at the end, but all of the rhythmically structured music is just one cue. There's one tiny *Luftpause,* a little pause just before Collins comes out from drowning and the music stops. The music stops for a beat, one breath, and then starts again. I can't imagine there's a longer musical cue in the movies. From the moment it starts over the logos at the beginning, it never skips a beat apart from that one. And then when he falls asleep at the end, the train stops and then the Elgar begins to come in."

At the film's climax—the convergence of all three story lines, with the soldiers, the sailors, and the pilots all meeting in a fiery wash of oil—Zimmer uses not one Shepard scale but three, on three different time signatures all playing at the same time, the bottom part playing the rising scale very slowly, the middle part playing the same scale at double speed, the top part at quadruple speed, all building to a climax at the same point. In other words: a musical version of the film's fugue structure. Finally, as the rescue boats are seen on the horizon, we hear a submerged play on Elgar's "Nimrod," or "Variation IX," from the composer's *Enigma Variations,* slowed down to six beats per minute, with bass notes that don't exist in the original, played by a double bass in its highest register, along with

The brass section tunes up during rehearsals for the *Dunkirk* score.

fourteen cellos, playing in their upper range. Zimmer extended the notes so long that the players' bows weren't long enough to play them, instead letting each player independently come in and come out at different times, giving the music an ever-shimmering texture, like pebbles on a beach or sunlight on water.

"Nimrod was one of my father's favorite pieces of music," says Nolan. "It was played at his funeral while we were carrying his coffin out. It's a piece of music I find very moving—for a lot of people, too—but it weighs very heavily on me, and that's why we wrote it into *Dunkirk*. We stretched it and distorted it, myself and the music editor. We stretched it and manipulated it, and changed it so that you can't quite grab ahold of the melody, and then at times it comes into focus and pays off. I have no idea what my dad would have thought of that, he might have been appalled, he might have loved it, I don't know. But I would say in the case of that film, I am very much having a musical conversation with him."

<center>• • •</center>

The film's box-office take told an unusual story. Released in Nolan's favored July slot, *Dunkirk* took in $74 million in its first week, $41 million in its second, $26 million in its third, rivaling the tally of *Mission: Impossible— Rogue Nation*, *War for the Planet of the Apes,* and *Star Trek Beyond*, only without any of those films' stars, built-in franchise appeal, and made for about half their budgets. Instead, a period war movie about a catastrophic military failure found itself one of the summer's biggest hits, cleaning up throughout August and, by September, crossing the $500 million mark globally. In November, *Dunkirk* matched *The Dark Knight*'s eight Oscar nominations, only this time with both a Best Picture nod and Nolan's first nomination for Best Director. Still, the film faced an eight-month slog to the Oscars. "We don't make movies for awards," Emma Thomas told the *Los Angeles Times* upon *Dunkirk*'s release. "We definitely make movies for audiences." On the night, *Dunkirk* won for Lee Smith's editing, for sound mixer Gregg Landaker, and sound designer Richard King but lost Best Picture and Best Director to Guillermo del Toro's *The Shape of Water*.

"I've given up trying to analyze these things over the years," Nolan told me a few weeks after the awards. "People always talk about the Academy as if it's one mind, and it's not at all. It's a bunch of individuals. I think one thing that Harvey Weinstein did is, he constructed a business model where

the awards were part of the marketing campaign. It used to be *rewarding* a film and now it's helping a film. The awards are part of a patronage system, you might say, and with *Dunkirk*, we were lucky enough not to need it. One very important thing that happened that went unnoticed, though, was that our sound guys won the Oscar for sound editing. But Richard King, who was our sound editor, insisted that Alex Gibson, the music editor, be included in that, so he won the Oscar with them, which has never happened before. May never happen again, but they knew and understood that there had been genuinely no real distinction between music and sound in the mixing of the film. Of all the films I've done, it has the tightest fusion of music, sound, and picture."

<p style="text-align:center">• • •</p>

In 2015, a Texas insurance broker named Bob Padgett, listening to music on his way to work, thought he solved a musical riddle that had stumped scholars for over a century: the "hidden" theme in Edward Elgar's *Enigma Variations*. For decades, musicologists, cryptologists, and music lovers have tried to find the "dark saying" that Elgar suggested was hidden in his work. People have claimed to find everything from Bach's *St. Matthew Passion* to Beethoven's *Pathétique* piano sonata to "God Save the Queen," "Twinkle, Twinkle Little Star," and "Pop Goes the Weasel" in the piece. Part of an orchestra preparing for a concert dedicated to the "mysteries and hidden messages" of the *Enigma Variations* in 2006, Padgett thought it sounded "kind of like a murder mystery or something. Like a whodunit." After being laid off from his insurance job in 2009, he moved to Plano, Texas, and began teaching violin, spending every free moment trying to solve Elgar's Enigma. He gave himself a crash course in cryptography, read Simon Singh's *The Code Book,* even tried translating the melody's rhythm into Morse code. Traveling in his car, he listened to a CD of the *Enigma Variations* over and over, humming famous tunes to see if they'd fit—"Twinkle, Twinkle Little Star," "God Save the King," "Rule Britannia," "Happy Birthday"—until one day, one of his favorite hymns came to mind, Martin Luther's sixteenth-century "A Mighty Fortress Is Our God." After seven years of work, and more than

Edward Elgar in the early 1900s.

one hundred blog posts, Padgett believed he had finally found the counterpoint Elgar intended: the nineteenth-century Mendelssohn version of the hymn, which, when played backward, seemed to fit perfectly.

The theory was met with skepticism by experts. "The backwards 'Ein feste Burg' shows that Mr Padgett is ingenious, if nothing else, in pursuing his obsession," commented Julian Rushton, professor emeritus of music at the University of Leeds, one of the world's foremost Elgar experts. The Enigma, the professor wrote, is "endlessly fascinating—precisely because it's so resistant to a solution." One might say the thing about Nolan's films, which offer a set of variations on themes, much as in a fugue or canon, where a theme is introduced, then a counterpoint to that theme, then a third and a fourth, until all the voices have arrived, at which point the rule book goes out the window and the composer can do what he or she wants. There are several ways a new voice can vary the theme: It can sing it five notes higher or four lower; it can speed it up or slow it down, as Zimmer did with the *Enigma Variations* in his *Dunkirk* score; it can also invert it, jumping *up* by the precise number of semitones the main theme jumps *down,* and vice versa; lastly, it can reverse the theme—play it literally backward—as Bach does at one point in the *Musical Offering,* where one of the players literally turns the music upside down, a trick also known as a crab canon, after the peculiar lateral gait of a crab. Despite its reputation as a backward-running film, *Memento* is no such thing; only the order of the scenes is reversed, not the film itself, except for the credit sequence, in which Leonard stares at a Polaroid of the dead Teddy. The Polaroid starts to fade and finally slides back into the camera, whereupon the man is returned to life, blood unsplatters, and a bullet is sucked back into the barrel. Murder has just been rewound. But a film with whole scenes, sequences, subplots that followed suit would surely be unintelligible. Twenty years after *Memento* was released, Nolan decided to find out.

TWELVE

KNOWLEDGE

O N NOVEMBER 7, 1927, around four in the afternoon, Joseph Stalin dropped by Sergei Eisenstein's editing room. The filmmaker was trying to finish *October,* his full-scale reenactment of the Bolshevik Revolution, shot with sixty thousand extras on the grounds of the Winter Palace, using so much electricity that at one point all of Moscow was forced to do without power. Postproduction on the film was frantic as Eisenstein and his editor worked to finish the film in time for the Revolution's tenth anniversary. Taking endocrine stimulants to survive the punishing schedule, Eisenstein went temporarily blind. Then he received word that the general secretary of the Central Committee of the Communist Party wanted to see the film. Stalin, a former theological student who worked as editor of *Pravda*, always seemed to have a blue pencil on hand to mark up memoranda and speeches of high-ranking Party officials ("Against whom is this thesis directed?") or caricature his inner circle during their endless nocturnal meetings ("Correct!" or "Show all members of the Politburo"). According to Leon Trotsky—his chief antagonist—Stalinism was nothing but a self-serving edit of history, crafted "to justify zigzags after the event, to conceal yesterday's mistakes and consequently to prepare tomorrow's."

Sitting down to watch Eisenstein's film on the last day of editing before the film's premiere at the Bolshoi Theatre, Stalin asked the director, "Is Trotsky in your film?" and ordered more than 3,500 of its 13,000 feet cut, over a quarter of its length, including those scenes that featured Trotsky.

The German composer Edmund Meisel sought to capture the mechanical impetus of the Revolution in cyclopean blocks of sound, with numerous feats of synchronization in the *style mécanique*—chord-cluster woodwinds for factory whistles, bow-slapping basses for marching troops, an upward and downward modulation of semitones for the raising and lowering of bridges. A statue of Tsar Alexander III, seen earlier in the film toppling and breaking into pieces, is seen reassembling itself. "The point is that the film begins with frames which half symbolise the overthrow of the autocracy," Eisenstein later wrote. "[The] 'collapse' of the statue was shot 'in reverse' at the same time. The throne, with its armless and legless torso flew up on to its pedestal. Legs and arms, sceptre and orb flew up to join themselves on. . . . And for that scene Edmund Meisel recorded the music in reverse, the same music that had been played 'normally' at the start. . . . But I do not suppose anyone noticed this musical trick."

The trick he was referring to was a palindrome—an image, word, or figure that reads the same when reversed as it does forward, such as *civic, radar, level, rotor, kayak,* or *tenet.* Nolan's tenth film is a futuristic spy thriller in which bullets, cars, even people start to flow backward in time rather than forward. "We're being attacked by the future," explains Dimple Kapadia, one of several characters tasked with explaining the plot to the film's spy hero (John David Washington). "Inverted munitions" are being manufactured in the future and streamed back to a ruthless arms-dealing Russian oligarch named Andre Sator (Kenneth Branagh), who has bought his way into the British establishment and married a beautiful wife (Elizabeth Debicki), who now despises him. Sator is a cold-eyed sadist, played with Branagh's chilly finesse, and his favorite trick is a "temporal pincer movement," half of his team moving forward through an event, relaying information he then uses to attack from the other end, moving backward through the same event. "Does your head hurt yet?" asks Neil (Robert Pattinson), one of several allies who help Washington stop Sator. The complications of the plot soon melt away from the mesmeric, beautifully alien spectacle of backward-threaded action like flesh from the bone. Bullets heal shattered windows. Exploding jets reassemble. Cars uncrash, rolling back over onto four wheels, undamaged. "I can't get over the birds," someone marvels. Finally, at *Tenet*'s halfway mark, in a twist of stunning audacity, the movie itself hinges through 180 degrees, and Washington's team heads back through the events and scenes that have just played before us, back toward the movie's start.

"I've always been interested in time and the manipulation of time in

Cinematographer Hoyte van Hoytema and Nolan in one of the turnstiles in *Tenet* (2020); John David Washington as the Protagonist.

my films," says Nolan, "but with all these things that I've flirted with, I've never done a time-travel film. This is not really a time-travel film, this has a different take on it, but that notion of inverted time, the jumping-off point, was the imagery of the bullets coming out of the wall, an idea that I'd been sitting on for a very long time, twenty to twenty-five years, something like that." If the movie's action sequences hark back to a nature documentary Nolan once saw running backward in an editing suite in Paris, at age sixteen, its philosophical sub-text was fleshed out while he was scouting for locations some thirty-two years later, in February of 2018, and attended a three-day conference in Mumbai called "Reframing the Future of Film" to discuss, alongside a friend, the artist and photographer Tacita Dean, the cause of protecting film as a medium. "One of the things that Tacita said just stuck with me; she said, 'The camera sees time, and it's the first machine in history to do that.' We are the first generation of human beings who can even conceive of looking at things, who have been able to take that for granted; whereas Cocteau could baffle people with reverse imagery in *Orpheus,* we have to treat it in very much a narrative sense. It gives me

the excuse to reengage with that way of looking at the world. One of the things I was most excited about with *Tenet* was I found something that I wanted to do with this that you can't articulate on a page. You actually have to see it. You have to experience it to properly understand it. It speaks to the essence of cinema."

• • •

Nolan had wanted to write a spy thriller for a long time, having grown up on the Bond films, the work of Ian Fleming, and, later, that of John le Carré, whose *The Night Manager,* in particular, fed into *Tenet,* with its portrait of the corrupt, wealthy inner circle of an arms dealer protected by the British establishment, whose girlfriend was also played, in the recent TV series, by Debicki. In Nolan's version, Branagh's Bond-like villain snarls threats— "How would you like to die?" "Old." "You chose the wrong profession"—on board a yacht off the Amalfi coast. "The situation on the yacht, that's very

Fritz Lang editing *Metropolis* (1927); Lang's *Spies* (1928).

Fleming," acknowledges Nolan. "Specifically, 'Quantum of Solace,' a short story, which is a little more intimate than people think of when they think of James Bond, but I think the villain is more Fritz Lang than Fleming, because he's diabolical, but he's not necessarily a genius. He's thuggish. You feel like he's got tentacles everywhere. Fritz Lang is probably the most important filmmaker to my idea of what this film is—*Spies* in particular. I watched it very early on, but I didn't show it to the crew. It didn't feel direct enough for that, but going back to Mabuse and the way secret societies are integrated into the fabric of it, the use of bureaucratic structures to conceal criminal activity—Lang did that before anyone."

The time-inversion machines in the film, or "turnstiles," are located in "Freeports," giant high-tech vaults to be found at airports all over the world—Oslo, Singapore, Geneva, Zurich—where the rich can stash hundreds of billions of dollars' worth of paintings, fine wine, precious metals, even classic cars, without paying taxes. Looking more like a modernist museum or hotel than a storehouse, with seven-ton doors, hundreds of cameras, and state-of-the-art conservation, temperature, and humidity control, Freeports provide the film with its version of Goldfinger's Fort Knox: what *The Economist* called a "parallel fiscal universe" in the 2013 article that first caught Nolan's eye, a world sustained by behind-closed-doors barter trade that never sees the light of day.

"I thought, What an amazing thing for an action movie, and filed it away. The way we portray it is a little more glamorous, but not much; it's basically a kind of rich person's transit lounge. If Fleming had known about it, he absolutely would have done something with it because it's glamorous, but it's actually kind of grubby. There's a famous painting of the Duke of Wellington in *Dr. No.* Bond walks in and he looks at this painting and does a small double take. It doesn't play anymore because none of us remember that that painting was stolen two years before they made the film. It was in the papers. So there's this fantasy of the secret world of art collecting—you know, Moscow owns the *Mona Lisa,* or whatever. The reality is more along the lines of art gets stolen that can't be sold. So it gets passed from criminal to criminal as collateral. The Freeport thing is the sort of high-end version of that. Because the thing with the Freeport is, you never actually import your work. They actually buy and sell works without leaving the Freeport. So a very valuable piece of art will go through multiple owners without ever surfacing in our world."

Nolan's research also led him to Russia's network of "secret cities"—not to be found on any map, abandoned after nuclear testing rendered

them uninhabitable—which provided his villain, Sator, with his backstory. Growing up in the rubble of one such secret city, Stalsk 12, Sator sets up shop in the ruins of post-Soviet Russia, "the most insecure moment in the history of nuclear weapons," as Priya points out, dealing arms to the highest bidder. From its opening scene, a heist at an opera house in Kiev built in the Brutalist style of Soviet-era architecture, to its climax at Stalsk 12, a ghost city of "gray concrete and abandoned industry along terraced strip mines fused to the earth," *Tenet* is a *béton brut* bonanza, a high-rise tone poem of concrete to put even *The Dark Knight Rises* in the shade. With production designer Nathan Crowley and cinematographer Hoyte van Hoytema, Nolan pored through book after book about Soviet Brutalism—Frédéric Chaubin's *CCCP: Cosmic Communist Constructions Photographed; This Brutal World,* by Peter Chadwick; *Eastern Blocks,* by Zupagrafika—before alighting on an old Soviet-era sports stadium in Estonia, Linnahall (originally the V. I. Lenin Palace of Culture and Sports, built for the 1980 Summer Olympics and then abandoned) to use as a location for his Kiev opera house in the movie's opening scene.

"You remember America boycotted the Olympics that year," says Nolan. "It's the most beauti-

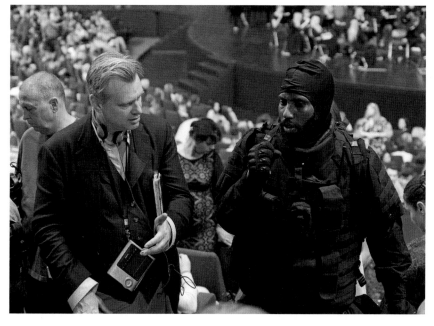

Linnahall stadium in Tallinn, Estonia, built for the 1980 Moscow Summer Olympics by architect Raine Karp and where Nolan shot the film's opening scene with Washington.

ful building, incredible design, the way the walls come down, but it had been derelict for ten years or something. So we had to do it up quite a bit. It's falling to bits because it's beautifully designed but poorly made. You've never seen so much concrete. We went a little crazy." Another big influence on the film for Hoyte and Nolan was the Maersk shipyard in Dunkirk, which they had visited a couple of years earlier. "We got one of their brochures for all the crazy boats they're building around the world. The visual potential of all that crazy infrastructure was fascinating to us. We scouted several in Norway and Estonia, where they have these vast cranes, the efficiency of those things and the incredible engineering that goes into it. We were much more interested in that than in the high-tech world of spy fiction and spy movies, with its fancy monitors and weird graphics and all that stuff. There's been so much of that and it's so much a part of our ordinary lives now, whereas this is more real world. The physics of things, the physicality of that industrial sort of shipping and the wind farms we shot at in Denmark. It was wonderful, very colorful; everything is bright blue and bright yellow. There's an aesthetic to those things that's really extraordinary."

• • •

If the design gestalt of the film was provided by Joseph Stalin, its intellectual godfather was J. Robert Oppenheimer, who provided the film with its MacGuffin, a type of inverse radiation caused by nuclear fission, and its original release date: July 17, one day after the date when Oppenheimer detonated the world's first atomic bomb in the desert of New Mexico in 1945. The test site was code-named "Trinity," after a poem by Oppenheimer's favorite poet, John Donne. The light from the blast, which reached a height of ten thousand feet, was equal to several suns in midday and could be seen more than one hundred miles away and its heat felt at twenty. "A few people laughed, a few people cried, most people were silent," wrote Oppenheimer later. "I remembered the line from the Hindu scripture, the Bhagavad Gita: Vishnu is trying to persuade the prince that he should do his duty and, to impress him, takes on his multi-armed form and says, 'Now I am become Death, the destroyer of worlds.'" Because of its use by Oppenheimer, "Now I am become Death, the destroyer of worlds" has become one of the best-known lines from the Bhagavad Gita, but the Sanskrit word that Oppenheimer translates as "death" is more

usually rendered as "time," so in the Penguin Classics edition, the line is given as "I am all-powerful Time, which destroys all things."

The ultimate Faustian figure—indeed, he once participated in a pastiche of Faust at Niels Bohr's institute in Copenhagen in 1932, together with fellow physicists Wolfgang Pauli, Paul Ehrenfest, and James Chadwick—Oppenheimer is, by the same token, a perfect intellectual foil for Nolan. Tall, thin, highly strung, with an air of the aristocratic bordering on arrogant, he was, in the days following the Hiroshima and Nagasaki blasts, a ner-

vous wreck. "He smoked constantly, constantly, constantly," said Dorothy McKibbin, the office manager at the Los Alamos laboratory of the Manhattan Project. One day, noticing that Oppenheimer seemed particularly distressed, his secretary, Anne Wilson, asked him what was wrong. He replied, "I just keep thinking about all those poor little people." On November 25, two years after the Nagasaki bomb incinerated nearly eighty thousand people, Oppenheimer gave a public lecture entitled "Physics in the Contemporary World" at MIT, in which he said, "In some sort of crude sense which no vulgarity, no humor, no overstatement can quite extinguish, the physicists have known sin, and this is a knowledge which they cannot lose." It is among those included in an anthology of speeches Oppenheimer gave after the war, threading the needle of his ambivalence about nuclear technology, which Robert Pattinson gave to Nolan as a gift at the film's wrap party.

"It's eerie reading, because they're wrangling with this thing they've unleashed. How's that going to be controlled? It's just this most monstrous responsibility. Once that knowledge is out there in the world, what can you do? You can't put the toothpaste back in the tube. It was a savvy, thoughtful wrap gift, actually, because, like you, I've grown up in the postnuclear age. In Graham Swift's *Waterland,* there's a whole section about apocalyptic thinking. We've grown up in the shadow of the ultimate destructive knowledge. There's very little you would miss if that technology disap-

"The physicists have known sin," J. Robert Oppenheimer, father of the atomic bomb, once famously remarked. "We had the pride of thinking we knew what was good for man," he later explained. "This is not the natural business of a scientist."

peared. It's like that Sophocles line they quote in *Angel Heart,* which is the only reason I know it: '. . . how terrible is wisdom when it brings no profit to the man that's wise?' To know something is to have power over it, generally, but what if the reverse is true, if knowing something gives it power over you?"

<p style="text-align:center">• • •</p>

American cinema is a cinema of verbs—to shoot, to kiss, to kill—to which Nolan had added his own particular subset—to forget, to sleep, to dream—but the most dangerous verb in his filmography? To know. "Even if you get revenge, you're not even going to know it happened," says Natalie to Leonard in *Memento.* "Doesn't make any difference whether I know about it," he replies. "Just because there are things I don't remember doesn't make my actions meaningless." The irony being that when he finally does know who killed his wife, he doesn't like the answer, leaving the ending hinging on a different question entirely: Can you unknow something? "Did you mean to shoot Hap?" Ellie asks of Al Pacino's cop in *Insomnia.* "I don't know," cries Dormer. "I just don't know anymore." It could be the cry of all Nolan's protagonists, creatures of Victorian certainty dropped into worlds where certainty is impossible. "Believe it! Sir, I KNOW it," the Victorian art critic John Ruskin once responded when challenged on one of his opinions. Nolan's heroes are Ruskins in Einstein's universe, bedeviled by the limits of what can or should be known. "You say science is about admitting what we don't know," says Murph (Jessica Chastain) in *Interstellar,* a devoted student of the scientific method tormented by the question of what her father knew of the plan to leave Earth permanently—"Did he know? Did my dad know?!"—only to be left staring into a black hole for answers. "Some things aren't meant to be known," says Romilly. Not since Henry James's *What Maisie Knew,* which hinges, in fact, on what Maisie doesn't know, has a creative endeavor swung so pendulously between what James called the "insurmountable urge to know" and the suspicion that "we pay more for some kinds of knowledge than those particular kinds are worth."

The best advice in *Tenet* comes from Clémence Poésy's scientist, who says, "Don't try to understand it. . . . Feel it," one of Nolan's customary invitations for audiences not to overthink the film but to give themselves over to it as it passes through them. Somehow, it seems inevitable that

Nolan's career was going to wind up here: a spy movie, featuring all the more glamorous tropes of the genre—wind turbines, catamarans, Russian oligarchs, and London's members-only clubs—where the clock is ticking for its characters to unknow something. Most spies want to find things out: the microfiche containing the nuclear codes, the map showing the route through the Khyber Pass. The central contest of *Tenet* is so catastrophic that "to know its true nature is to lose," says Dimple Kapadia's character. "We're trying to do with inversion what we couldn't do with the atomic bomb—uninvent it. Divide and contain the knowledge. Ignorance is our ammunition." They must leave nothing on paper, nothing on the record that can be examined in the future and used against them. Nolan's spies want to empty their heads, and ours, the screenplay a further intensification of the minimalist streak he developed writing *Dunkirk*. John David Washington's spy is so secret, he doesn't get a name—he is known in the script only as "the Protagonist"—and while the CIA is mentioned, it is never clear whom he or anybody else works for, although Michael Caine shows up in a members-only club to give him advice and recommend a tailor.

"I was wearing my influences on my sleeve a bit more with this one," says Nolan. "When *Inception* came out, people would ask me about the Bond movies and I would cop to it in a visual sense, but the truth is, *Inception* is more of a heist film than a spy film. On this film, I wanted to use the familiarity of the conventions to help the audience get to this other

Sator Square at Oppede.

place, just like I did with heist-movie conventions in *Inception,* but the weight of spy genre on this film was so heavy, we didn't need to reference anything; we just needed to get on with it and do our version of it. My ambition for the film was to do to spy movies what Sergio Leone had done to the Western—some distillation of essence. I have a hunch that when Leone made *A Fistful of Dollars,* he didn't look at any old Westerns. It's his memory of them; it's the feel of them. So the influence of Bond on this is colossal, but I didn't watch any. In fact, I probably went the longest period of my life not watching a Bond film ever because it's not the real Bond film; it's your memory of it

that's important and what it could be. You want to distill the essence of that secret agent thing. It's trying to take it as far as it can go."

Having completed a draft of the script, he showed it to Kip Thorne, the astrophysicist who acted as consultant on *Interstellar,* and talked at length about the speculative physics underpinning the film. Washington's Protagonist is given the rundown before he enters one of the turnstiles: Wear a respirator, because air won't pass through the membranes of inverted lungs. Friction and wind resistance will be inverted, so expect to feel the wind at your back. Don't worry about falling but rising objects or unprompted instability: A small whiff of smoke thickening around something is a sign a bullet is about to fly backward out of it. After an encounter with fire, ice will form on your suit because heat transfer is reversed. "He was fine with some of them; others he disagreed with. I got far enough with Kip to know that this wasn't *Interstellar.* I wasn't looking for the real science behind it. It's more of an interesting speculation. But, for example, the masks they were wearing, that definitely came about as a result of us talking about osmosis and the passage of things through the lungs. All of the laws of physics that we know of and that exist, they all run the same forward and backward. Except one, which is entropy. So, you know, a cup can reassemble itself. It's just extremely unlikely, because of this and that. But it can happen."

Nolan conducted a lot of simulations with Andrew Jackson, his visual-effects supervisor, recording balls as they passed through water and noting the wave both ahead of and behind the ball as it moved. That gave him some idea as to how, say, backward spinning tires would look during a car chase, with a little disturbance of dust ahead of the tire and then a bigger one behind. He'd long been fascinated by such imagery in film—the rubber gloves flying onto hands in Jean Cocteau's *Orpheus* (1950), the room that explodes and reassembles at the end of Nicolas Roeg's *Insignificance* (1985), the cup that smashes and unsmashes in Errol Morris's film *A Brief History of Time* (1991)—but the only film Nolan screened for his cast and crew was a little-known Nuffield Foundation 16mm documentary by Don Levy, the Australian filmmaker who made *Herostratus,* called *Time Is* (1964), which compiles a series of sequences showing Olympic swimmers diving, commuter crowds swarming, planes and race cars crashing, clouds forming, in a variety of formats—slow-motion, fast-motion, freeze-frame, reversed and in negative—in order to illustrate the concept of time for British schoolchildren. "If therefore there is some part of the universe made of antimatter, its time might seem to us to be flowing backwards," says the narrator,

speculating that when meeting "an antimatter time-reversed person from such a world, not only would communication be difficult but the actual meeting would rid us of everyone concerned"—a speculation on which the plot of *Tenet* turns, as forward-flowing protagonists wrestle with their backward-flowing mirror images.

"It's phenomenally beautiful," says Nolan. "It's a little work of art based on the ways in which the camera allows us to see time differently. I remember when the first real good slow motion came into broadcasting; it was on the 1984 Los Angeles Olympics. When they slowed it right down, I remember the hands of the gymnast going around on the parallel bars—you could see this happening, so you could understand and see things you couldn't see before. You were looking at the world in a new way. And reverse imaging is one version of that, slow motion is another version, fast motion is another, time-lapse photography, reverse photography. You're seeing a real thing, but it's showing you a world you couldn't see any other way. There is no way before photography to see reverse imagery or even imagine that it exists. And that, to me, is what makes *Tenet* the absolute most cinematic film I have ever been able to put together. It can exist only because of the camera."

· · ·

The production saw Nolan shuffling the deck of some of his key collaborators, working for the first time with editor Jennifer Lame, whose work on Noah Baumbach's and Ari Aster's films had caught his eye, and *Black Panther*'s Oscar-winning composer, Ludwig Göransson, whose work he had first admired on Ryan Coogler's Creed films. He had long been a fan of Pattinson's, particularly after seeing him in James Gray's *The Lost City of Z,* and had long enthused about John David Washington's work in HBO's *Ballers,* but visiting Cannes for the first time in 2018 to introduce a new print of Stanley Kubrick's *2001: A Space Odyssey* to mark the film's fiftieth anniversary, he was invited by Spike Lee to the premiere of

Don Levy's 16mm documentary *Time Is* (1964). "We always think of time as going in one direction," says Levy's narrator. "Is this a genuine property of time, or only another of our human limitations?"

Emma Thomas, Nolan, and Washington view the action they have just shot in reverse on one of the custom-built pre-viz monitors; the Protagonist (John David Washington) and Neil (Robert Pattinson) confront one another in the Tallinn Freeport.

BlacKkKlansman. "It was kind of tense, with Spike right behind me. But seeing John David up on the big screen playing a leading man, it felt meant to be. I don't think of actors when I'm writing. You've got to write the character the way you think. But what happens is every now and again, usually just in one scene, they just intrude. The actor puts himself in there. In this case, it was actually the scene that he plays with Michael Caine at the members-only club in London. At some point, John David just stuck himself in that scene, and I couldn't get rid of him."

Branagh had played a Russian villain before in his own film, *Jack Ryan: Shadow Recruit* (2014), where he played a sybaritic oligarch turned terrorist. "Ken had to dig very deep for the characterization because he kept wanting to find the poetry in Sator, and I kept saying, 'He's a brute,'" says Nolan, who credits his wife and producing partner with the casting of Elizabeth Debicki in the role of Sator's estranged wife, Kat, cordial with loathing for her husband and longing for her son, who has been kept from her. "Elizabeth was actually Emma's idea. I had only seen her in *Widows,* where she was very brassy, very dramatic. Kat is, to me, this very English character whom, in the writing of it, I fell in love with. Which I don't always. It's hard to put into words, but I just felt for her dilemma—she's a very privileged person who's in this gilded cage, even though you could look at it the other way and get annoyed by her. That's why the casting was so particular. It had to be somebody that just wins you over."

Before shooting, he went through the script, diagramming the action sequences—a wrestle in the vaults of one of the Freeports, where Washington comes up against his inverted self; a backward/forward car chase on a three-lane highway in Estonia, featuring an eighteen-wheeler, numerous cars, and a fire truck; and the climax at Stalsk 12, featuring the two sets of opposing forces, both "inverse, conventional, forward antagonists, inverted antagonists," as Ives says of Sator's men. "They have it all." Choreographing these scenes required a new level of multiple-dimensional storyboarding. "The massive challenge of the piece was that I thought I would be able to stop thinking forward, as it were, so I'd be thinking in reverse," says Nolan. "I'm quite good at being able to take up a particular way of intuiting things, and one of the things that excited me about the project was the frustration. What I found was that you actually can't do that. None of us could intuit the backward version. We spent a lot of time at the script stage going, 'Well, hang on, does that mean this and does that mean that, and how would you do a car chase that goes in two directions at once?'

THIS SPREAD AND OVERLEAF Nolan's diagrams for the reversed action of *Tenet*. The number-one rule was that they couldn't steal a shot from another part of the movie and simply reverse it. Everything had to be filmed anew. John David Washington had to learn how to fight four different ways—as the Protagonist, both forward and backward, and as his own antagonist, both forward and backward.

Which is kind of fun. And then we were still arguing about the set. The more people burrowed into the script, the less they understood it. It was a really fascinating group discussion for months and months and months."

Cinematographer Hoyte van Hoytema asked a camera-tech company to develop a previsualization monitor that would instantly allow them to see the way a sequence played backward on-set. "The visual-effects guys essentially diagrammed the whole thing. I'd been doing my own two-

dimensional diagrams. They gave me a three-dimensional diagram where you could track any action back and forth in time. The surprising thing was, I had made relatively few mistakes. Things actually fit together well. When you make a mistake in this type of material, it's a massive mistake. We never stopped making them. In the end, I put a pre-viz guy there all the time as a resource. I'd have the same conversation with him every time. I'd say, 'I need to know does this happen before this?' You know, 'Can this

guy have the gun in his hand if he's come through this door?' You know, whatever the question was. And he would start to answer, and I would say, 'No, don't answer; go away to a quiet corner with your computer to analyze it and then come back and tell me the answer in ten minutes.' Because everybody's intuition, including mine, was always questionable. So it was very, very complicated."

• • •

Principal photography began in May 2019 in Los Angeles under the working title "Merry-Go-Round." Nolan started with the simplest sequence first—the fight Washington's character has in the vault with his backward-moving self—before building to the more complicated sequences. "John David had to learn how to fight four different ways," recalls Nolan. "He had to be able to fight as the protagonist. He had to be able to fight as the antagonist. He had to be able to fight as the protagonist backward. He had to be able to fight as the antagonist backward. Very, very complicated. What I didn't want to do was shoot it with John David as a protagonist, then as the antagonist, and just mix and match shots. The number-one rule we realized is, you can't steal a shot from one scene and reverse it. It won't work. Weirdly, almost everything was done in-camera. A great surprise to me. Andrew Jackson was our visual-effects supervisor—the same guy who did *Dunkirk*—and he loves to do stuff in-camera. He was there

on-set as a partner to help me figure it out. And what we started to learn fairly early on is that the stunt guys were very good at acting backward."

Production then moved to Estonia, where the opera house siege was filmed at Linnahall, the old Soviet Olympic stadium, and the backward/forward car chase on the Pärnu highway. From there, they moved to Italy, England, Norway, Denmark, and India, before returning to California, where Nolan and his crew built Stalsk 12—the radioactive ghost city where Sator grew up—around an abandoned mine in the Coachella Valley in Southern California. "We actually got incredible scale. The idea that you would build a city for a film, having already shot in six countries around the world. When you run out of money, what are you really going to be able to build for the end of the film? It needs to feel like miles. In the end, we did a lot of false-perspective building, because with Brutalism, with these balconies and staircases, you can just reduce things to 50 percent scale, you know, and get a very large feel. I was very happy with the way that that came off." The fight amid the ruins of Stalsk 12, with leaning buildings thrusting upward, their upper stories reassembling themselves, like the battle scenes in Mark Twain's *The Mysterious Stranger* (1897–1908), are brought to a climax with a pair of explosions, one going off, one inverted, the ground lifting and flattening, the mushroom cloud pluming inward, the shock wave contracting to a sudden flash of light: Oppenheimer's secret wish granted. "This is how the world ends, not with a bang but a whimper," says someone, quoting from T. S. Eliot's "The Hollow Men." As is often the case with Nolan's endings, it is the resonances that fill the scenes that follow—the echo, not the thunderclap—that prove most intriguing.

"I was very excited about putting that scene together because it's very Leone. It's just a sort of blasted plain with these three guys. If there's a love story in the movie, it's a love story between those guys. That's the emotional heart, and I didn't expect that. I set out to make it between the Protagonist and Kat. That's the logical Fleming course, but neither myself nor John David felt the writing took us there; it just took me the way it took me and I found myself actually emotionally more invested in them. There's a very Western flavor to it, a *Seven Samurai* kind of thing with guys splitting up, and then it becomes this other thing. The crew was very into the scene. They don't normally pay attention. They don't normally express any kind of admiration for what the actors are doing, what's going on. We were on top of a mountain in the blazing sun, with helicopters flying over. Usually when you have those moments with the crew, it's an intimate set-

ting and actors doing something emotional. This was a lot more kind of extroverted. But all the actors, all three of them, were just fabulous in that moment. Everyone was buzzing."

<p style="text-align:center">• • •</p>

Even as he was editing *Tenet* with Jennifer Lame in his editing suite in early November, Nolan started anticipating the reaction to his film. "We tried to make the film palindromically correct," he says. "That is to say if somebody buys a DVD and they watch it backward, it's consistent. These days when you make a film like this, you are in a weird dialogue with the culture as well as the audience sitting in the seats. It's a little unhealthy, because I need to do my job. You have to decide, Okay, am I making this film for the theatrical audience or for somebody who's going to obsessively look at it once they've seen the film three times and then they go online and google this and start to ask, 'Why this and why that?' There are all kinds of questions that they could start to ask, and I have an answer to most of those things, but do you include the answer or not?"

He seemed torn. On the one hand was his commitment to internal logic and to making sure, as he first discovered when he made *Memento,* that the filmmaker is not stuck for an answer, even if that answer is ambiguous. On the other hand was his equally strong determination, forged amid online deconstructions of *Inception* and *Interstellar,* to enjoy the freedoms of imaginative license enjoyed by other filmmakers: his right to make movies in which nobody is shown paying for a cab. Nolan seemed to be in conversation with himself, or at least with audiences' expectations of his films. His career might be considered a kind of conversation with the audience, the two responding to and reacting against each other in real time, like echoes answering each other. If *Memento* had puzzled, *Insomnia* explained. If *The Dark Knight* brutalized, *Inception* and *Interstellar* moved. And if *Dunkirk* surprised many newer fans, *Tenet* seemed confirmation of something that befalls all influential directors sooner or later: Nolan had become his own adjective, like Spielberg and Lynch before him. If *Inception* was his *Vertigo,* then *Tenet,* with its time-bending plot, twists, and betrayals, acres of Brutalist concrete, and Michael Caine cameo, seems destined to be seen as his *North by Northwest,* the film in which Nolan riffs on all things Nolanesque. There was some discomfort in that knowledge, too, as if he were trapped in a recursive loop of his own making.

"Yesterday's battles were being refought, wrong-end first," wrote Mark Twain in *The Mysterious Stranger*. Shooting the film's elaborate climax amid the ruins of Stalsk 12 in Hawthorne (above) and at an abandoned mine in Southern California.

"Can you be sincere and self-conscious? I'm not sure you can. There are things in this project that are all very direct repeats of things I've done in the past—I'm shooting a shell case going back into a gun and I've literally done that before—and the sincerity to me is in not taking them out. When I was writing the film, I went rogue for a long time on my own, without anyone knowing what I was doing, but when I showed the script to my brother, I asked him, 'Is this me repeating myself?' He was like, 'No, it's more the apotheosis of a set of ideas.' I said, 'Great, that's how I feel about it.' You're working out your fascinations in public so people see a development of things, and in some senses that's good. And in another sense, it can be reductive. It can be like, 'Okay, he's repeating himself.' That knowledge is dangerous. Yes, I'm aware of it, but I'm not riffing on my past work. I'm trying to be true to the impulses that have defined me. In other words, I didn't finish the last film and go, 'Okay, I should do another *Inception*.' That wasn't really in my thinking. But emotionally this is the film that was in my heart. You're driving at something; you're driving at your own obsessions cinematically.

"I think the *North by Northwest* analogy makes sense in that *Inception* had a very emotional backstory, but this is much larger than life. The weight is all in the middle. For me, the most interesting directors have always been the ones you recognize, whatever genre they're in. To them, there's simply a right or wrong way of doing things. Although this can evolve over time. And I like to think my films have changed and developed. I think this one is different from what I've done in the past in a lot of ways, but I won't worry about that. That, to me, would be insincere. I'm not going to be different for the sake of being different. The approach, to me, has to be sincere. When I go to see somebody's film and I don't think the filmmaker loved the film, that's when I feel I've wasted my time."

• • •

In 1956, a nuclear physicist named Chien-Shiung Wu conducted an experiment in collaboration with the U.S. National Bureau of Standards to establish once and for all whether there was an operational definition of the difference between left and right. Physicists had long presumed that nature has no preference between the two. Our world should be pretty much identical to its mirror image. But Wu, a Chinese-born American physicist, suspected that parity might not be as universal as everyone assumed, and between Christmas of 1956 and New Year's Eve, instead of accompanying

her husband on the *Queen Elizabeth* to China to see her family, she stayed behind to spin cobalt-60 atoms held at very low temperatures by a vacuum flask. She aligned the magnetic momentum of the cobalt nuclei with a strong magnetic field in order to orient the spinning nuclei so that all the spins were in the same direction, and then counted how many electrons were emitted as the nuclei decayed. If parity was conserved, there should be equal numbers of each.

There were not equal numbers of each. To everyone's astonishment, Nature turned out to be "a semi-ambidextrous southpaw" showing a slight preference for the left. Wu caught the last train back to New York on New Year's Eve—it had been snowing heavily and the airports were closed—to report her findings to her husband. The fall of parity was such an important and exciting result, some physicists didn't believe it at first. Wolfgang Pauli reportedly exclaimed, "That's total nonsense!" when he first heard about it, but after replicating the experiment, he confirmed beyond a doubt that parity didn't hold.

I find all this out in the course of my efforts to come up with a solution to Nolan's version of the "Ozma Problem"—describing the difference between left and right to someone on the phone—a challenge set during

Alfred Hitchcock's *North by Northwest* (1959), which reportedly got its title from Hamlet's disoriented boast, "I am but mad north-north-west."

our first sit-down interview in 2018, but there is one small problem when it comes to relaying Wu's findings to him: I don't understand a word of it. After a few attempts to explain it to friends, it becomes clear to me that I can keep about half of it in my head at any given point, but I don't have a firm-enough grasp of the material to relay it with any real confidence. It's secondhand knowledge, filched from a few books and Wikipedia. I can't in any sense claim the thought process as my own. I fold at the slightest of follow-up questions, let alone the grilling I know I will get from him. "Everything in front of him is always under the microscope," Jonah once told me. "I can always tell when my brother is excited by something you're talking about, because he goes very quiet. When I pitched him *Memento* when we were driving cross-country, he got very quiet. I knew I had him."

Finally, while thinking about something else entirely—picking up my daughter from school—something comes to me. I test it on a few people. It seems good. The next time I see Nolan, I wait until the end of our time together, rather than blurting it out at the beginning like I did the first time, and with as much casualness as I can muster, I say, "When we first started this, our first meeting, in fact, you asked me to describe left and right on the telephone to someone. And I came back to you and said, 'I suggest seeing which way the sun sets,' but that doesn't work, because it doesn't work without knowing ahead of time which hemisphere you are in."

"It wasn't a bad solution," he says, pouring himself some tea.

"I've got a better one."

He makes a sweeping gesture with his free hand that says, "I would ask them to put their hand on their heart."

He stops.

There it is, finally: the silence Jonah told me about.

"I like that, because it's simple," he says finally. "You know, technically the heart's in the middle, but you feel it on the left."

"Ask anyone where their heart is and they'll point to the left," I say quickly.

"No, no, it's a great answer, because the interesting thing about the heart and the asymmetry of the body—and I never made this connection—is it's very unusual for a human to have their organs reversed. The exterior of the body is symmetrical, but the interior is not. One of the reasons I got so fastened on this puzzle over the years is because I am left-handed and I've always wondered why most men part their hair on the left, even if they're

right-handed. Which is strange when you think about it. I've got very straight, fine hair, so I've always had to actually bother to part it; you've got messy hair—well, not messy, but it just does what it does. I've always had to choose. And it's always on the left. What your solution points out is that while the outsides of our bodies are generally symmetrical, some things on the inside are not, like our heart and liver. But the heart is a really great answer, because of the emotional component; it actually makes the puzzle more interesting. And it doesn't cheat. I spend a lot of time trying to come up with these things, and they're not easy."

THIRTEEN

ENDINGS

WHEN NOLAN FIRST SITS DOWN to write a script, he likes to know how things are going to end. Once started, he works in straight-forward fashion until he's reached the end, but he likes to know what that ending is going to be before he gets there. He had the ending of *Inception*—the convergence of all four dreams—ten years before he figured out how to get there, while the image that ends *The Dark Knight*—of Batman being chased across rooftops by his police pursuers—came to him before he had written a word of the script. "I've used that film's ending several times. It's in *Dunkirk*. It's in *Following*. *The Dark Knight* is a fusion of the ending of *Shane, Out of the Past,* and *I Am Legend*. The ending of *I Am Legend*, the novella, is one of the great endings. I'm not sure any of the film adaptations quite did it justice. So he's this lone vampire killer. And you get to the end and he looks out this window at this crowd of vampires, terrified of them, and he realizes that they're terrified of him. He's been slaughtering them every night. And then it ends with the words 'I Am Legend.' I don't think any film can work, it is very rare for a film to work, with an inadequate conclusion. Very rare. And it is very common for a bad film, or a mediocre film, to work very well because it's got a great ending. The first couple of films I did, if you look at *Following* and you look at *Memento*, the conclusion is built into the very fabric of the film. It is not even a habit of mind so much as it is a survival mechanism."

Like *Double Indemnity* (1944), *Detour* (1945), and *D.O.A.* (1950), *Following* and *Memento* begin with either a confession of a crime or the crime itself, and then work backward to the events that led up to it. The circularity is not uncommon to writers of noirs or mysteries. When Edgar Allan Poe met Dickens, in the hopes of finding a British publisher, talk turned to William Godwin's 1794 novel *Caleb Williams.* "Do you know that Godwin wrote it backwards—the last volume first," Dickens told Poe. In Chandler's stories either the client did it or the missing person is guilty or not missing at all. At the end of the story, Marlowe may nominally clear up the mystery he has been assigned to solve, but that mystery is, in turn, part of a larger whole that can never be fully seen or understood. He can never truly win. The little guy gets conned, suckered by the city, while the rich prosper. The truth disappears and a lie becomes legend. As Marlowe says at the end of *The Big Sleep,* "Me, I was part of the nastiness now." The idea of coming full circle is built into many Nolan films—*Insomnia, The Prestige, Batman Begins,* and *Interstellar* all circle back to earlier shots, situations, characters, or lines of dialogue—but the circle is never quite a circle. It's more of a spiral or corkscrew. The ending is nominally at the same point as the beginning, but placed higher or lower on the spiral, affording us a view of where we've come, and also where we are going: Another turn of the screw, still higher up, awaits us. Even today, googling "*Memento*'s Ending" brings up some 4,530,000 results, including articles with titles like "What Does the Ending of *Memento* Really Mean?" (whatculture.com); "*Memento:* Movie Plot Simplified Ending Explained" (thisisbarry.com); and "*Memento:* What's Up with the Ending?" (schmoop.com). *Inception*'s ending brings up 23,900,000 results. In some sense, the journey of a Nolan movie is a never-ending one.

"Why don't you know whether the spinning top falls over? You really don't know, because the picture cuts out. Why does the picture cut out? It's the filmmaker turning the projector off. So there's a deliberate ambiguity. I had a hard time with that, philosophically. I knew I wanted to do it, but I knew that it would violate my own sense of cinematic ethics, because the character doesn't care anymore. Cobb has left to see his kids. There might have been another way of doing it, of withholding that information without it coming from outside the text, if you like. As a filmmaker, it's a cheeky trick, but it worked very well for the audience. They are looking at the top, going, 'This had better tell me that he's not dreaming,' and then it's dark. Why? Because the filmmaker has turned off the projector. The

ending of *Inception,* it forces an ambiguity. I think *Memento,* therefore, in some ways, is the better ending. . . . I think if there's one thing that is significant in terms of the commercial success of films I make, it's that invariably the films have found a way to make ambiguity a positive feeling, and I think that's very rarely the case. *Last Year at Marienbad,* although I didn't view that film as particularly ambiguous when I saw it. *Total Recall* has an ambiguous ending, but it doesn't quite confront the audience with it in the same way."

The confrontation Nolan is talking about often takes the form of a crescendo of image and music rising in pitch and intensity that suddenly cuts itself off, leaving a provocatively dark screen, as if the only way to break the cycle were abruptly. The effect is twofold, one backward-facing and one forward-facing. The audience is left with the memory of what they have just watched at the very point when its resonance is starting to bloom in their heads, but it also suggests something ongoing, another turn of the screw, something further up or further down the narrative spiral. Somewhere, Leonard Shelby is repeating the actions that constituted the action of *Memento,* only this time unseen by us. Somewhere, Dom Cobb is enjoying his time with his children, or waking up to another nightmare. At the end of *Tenet,* John David Washington's Protagonist finds out how long he has known Neil and Ives and on what mission they have been

embarked all this time. The ending also marks a beginning. Nolan's films leave an echo whose reverberations are felt only once it is over.

"*Reverberation* is the word," he says. "It's the echo of it. We used it in *Interstellar* very literally, but it exists in all my films and endings. A crescendo with the reverberations is a great way to go. The end of *Dunkirk*, for example, has a lot of similarities to the end of *Memento*, just technically in the way it's put together. The last image of the script for *Dunkirk* was the burning Spitfire, but in dailies, with Fionn looking up from the newspaper, it just struck me as 'That's actually the grace note that makes the big crescendo work.' It gives you a feeling of abruptness that the Spitfire doesn't. The Spitfire builds in volume, dips down, but it's just the visual of that quiet moment with Fionn where it cuts off. We played around with it. The thing I like about *Dunkirk* that no one ever noticed was, the sound of the newspaper is actually the same sound we used for the leaflets at the beginning. We used the same sound. It just had a nice symmetry to it. Openings are very precious because you have the attention of the audience in a way that is very difficult to get, but endings have to be built to in such a way that you regain that attention, so you have a cumulative effect, a culmination. You have the focus of the audience's attention at the end of the film the same way you were granted it at the beginning."

· · ·

In his 1997 book, *A Personal Journey with Martin Scorsese Through American Movies,* Scorsese elaborated on his idea of the "director as smuggler," epitomized by such directors as Nicholas Ray, Fritz Lang, Douglas Sirk, and Sam Fuller. Dismissed by many critics at the time as mere B-movie makers, genre enthusiasts, these directors, for precisely the reason that they worked at the lower end of the studio pecking order, could conduct their careers relatively undisturbed and "could introduce individual touches, weave unexpected motifs, and sometimes transform routine material into a much more personal expression. In a sense they became smugglers." The argument was an elaboration of an idea first put forward in a 1954 article by François Truffaut entitled "A Certain Tendency of the French Cinema" (*"Une certaine tendance du cinéma français"*), which dismissed the French film industry's fondness for what he called *"cinéma de papa"*—essentially, old fogy cinema—in favor of the more audacious, expressive filmmaking style he and his fellow critics at *Cahiers du cinéma* were excited by in the

work of Orson Welles, Nicholas Ray, Robert Aldrich, and Alfred Hitchcock, visual stylists for whom the script was just a jumping-off point for films that bore their imprint as inescapably as did a poem the personality of the poet or a painting the personality of the painter. "It is less a question of technique than of *écriture*, a personal means of expression," he wrote.

The idea he was advancing had a name: *"la politique des auteurs,"* or "auteur theory," and like a lot of French words that have entered the English language—*cachet, chic, faux pas, savoir faire, crème de la crème, pièce de résistance*—*auteur* caught on in England and America not because we lacked a term in English, but because English cannot summon the prestigious associations of French. "Dare I come out and say what I think it to be is an *élan* of the soul?" wrote Andrew Sarris in "Notes on the Auteur Theory in 1962." Spoiler alert: He did so dare. These days, the term *auteur* has passed into such widespread usage as to have lost all meaning, but for the original critics at *Cahiers du cinéma*, greedily binge-watching all the crime thrillers, Westerns, and mysteries they had been unable to watch during wartime, the term had specific application to the quality of double-jointedness they observed in the Americans working within the studio system while at the same time losing nothing of themselves. "It clearly takes exceptional talent to remain oneself in such a strange enterprise," wrote Claude Chabrol in a 1955 essay that held up Otto Preminger's *Laura*, Orson Welles's *The Lady from Shanghai*, Nicholas Ray's *In a Lonely Place*, John Huston's *The Maltese Falcon*, Jacques Tourneur's *Out of the Past*, and Howard Hawks's *The Big Sleep* as examples of thrillers rendered by a hand profound and even beautiful. "A shortage of themes, says the honest man! As if themes were not what *auteurs* make of them!" he concluded. "The wealth is in the prospectors, no longer in the mine."

Can there be any doubt that if Chabrol were writing today, the filmmaker he would be most excited about—the poster boy for a twenty-first-century *politique des auteurs*—would be Christopher Nolan?

A poster for John Huston's *The Maltese Falcon* (1941).

Working at the very heart of the franchise farm that is modern Hollywood, Nolan is the smuggler par excellence. He has completed eleven features, all box-office hits, all ticking the boxes of studio entertainment, yet indelibly marked with the kind of personal themes and obsessions that are more traditionally the preserve of the art house: the passage of time, the failures of memory, our quirks of denial and deflection, the intimate clockwork of our interior lives, set against landscapes in which the fault lines of late industrialism meet the fissure points and paradoxes of the information age. "Most eras have distinct 'ways of seeing' that end up defining the period in retrospect: the fixed perspective of Renaissance art, the scattered collages of Cubism, the rapid-fire cuts introduced by MTV and the channel-surfing of the 80's," Steven Johnson has argued. "Our own defining view is what you might call the long zoom: the satellites tracking in on license-plate numbers in the spy movies; the Google maps in which a few clicks take you from a view of an entire region to the roof of your house . . . the fractal geometry of chaos theory in which each new scale reveals endless complexity."

To which we might add: the opening credits of *Insomnia* swapping out glaciers for bandages, the way Hans Zimmer's chords echo the stacked worlds within worlds of *Inception*, the sight of Manhattan's bridges exploding in long shot in *The Dark Knight Rises*, the sound of rainfall over Saturn in *Interstellar,* the chunks of concrete beginning to vibrate in *Tenet* like corks waiting to be popped. I began this book by comparing Nolan's work to that of Hitchcock; in the writing of it, I have come to the conclusion that if he resembles anyone, it is Hitchcock's German predecessor Fritz Lang—particularly when it comes to the *Dark Knight* trilogy—but the comparison with Hitchcock is sound in one respect. "Timing was all," said the actress Teresa Wright of her role playing the niece who suspects her uncle of being a killer in Hitchcock's *Shadow of a Doubt*. "If an actor was strumming his fingers it wasn't just an idle strumming, it had a beat, a musical pattern to it—it was like a sound refrain. . . . He really scored the sound effects the way a musician writes for instruments." Hitchcock's most recent biographer, Peter Ackroyd, writes of *North by Northwest* that its plot "may be baffling in cold print but on the screen it is pure flight and pursuit, rapid changes and fleeting moments. One 'switch' follows another with such speed that the audience registers only panic and excitement." The desire to induce panic and excitement is just what it always was, but as Nolan has gotten older, he has, like Hitchcock, grown more intrigued by the abstract potential of composition and the use of music to pattern and structure his films.

"*Batman Begins* is the first film where we start putting a montage together to show Bruce Wayne's seven years with the League of Shadows, so that the musical structure helps define the cinematic arc rather than the cuts. My joke with Hans is that on every film I would learn one more musical term. On *Batman Begins,* it was *ostinato,* which I'm happy to use without having to define it. With *Dunkirk,* it was the German *Luftpause.* Directing is a job where you have to know a bit of everything, jack-of-all-trades and master of none. I know that I never had the dedication or the talent to be a musician, but I'm musically inclined and I know how to use that in my work. Similarly, I could write a screenplay, but I don't think I could write a novel. I can draw a picture, but not well enough to be a storyboard artist. I'm a passionate fan of other filmmakers, and a great believer in the job of directing. I think it's a great job, but it's like being a conductor, not a soloist."

ABOVE AND OPPOSITE Nolan "unrestoring" Stanley Kubrick's *2001: A Space Odyssey* to celebrate the film's fiftieth anniversary in 2019, with the help of cinematographer Hoyte van Hoytema.

Our last interview takes place in Nolan's library, a Frank Lloyd Wright–inspired duplex that sits to one side of his garden. Its bookcases are filled with art books, the work of Agatha Christie and Sir Arthur Conan Doyle, as well as Nolan's collection of vinyl, from Steve Reich's *Music for 18 Musicians* to Kraftwerk's *Man-Machine.* Next to the stack of records, propped

against one of the windows, are two cellos, and two accompanying music stands. "Emma used to play the cello when she was a kid, so I got her a cello and music lessons for her birthday some years ago," says Nolan. "After a while she realized that I was kind of interested in it and wanted to pick it up myself. I would never have thought about cello lessons, but she got me into it. I can just about play 'Twinkle, Twinkle Little Star.'"

As if hearing herself mentioned, Thomas pops her head into the library, looking for papers having to do with their daughter's college application. Flora has just turned eighteen. "She's in the process of applying for colleges," says Thomas, pointing to the Yamaha keyboard that sits on the other side of the room, behind where Nolan is sitting. "She plays the piano and was quite anxious about the fact that when she went to college, then she wouldn't have the piano. So this was her birthday present."

"And it's got different piano sounds," says Nolan, standing up to demonstrate the keyboard's different settings: an acoustic piano, a jazz piano, a concert piano, a classical piano, a pop piano, an electric piano.

"Does it have an out-of-tune one?" I ask.

"It does. Hang on," says Nolan, flicking a switch and plonking out a few notes on what sounds like a slightly out-of-tune piano.

"Funky," says Thomas. "Anyway, I should get on; it's that time of year—" she adds, then disappears into one of the adjoining rooms.

Their daughter's having reached college age isn't the only thing that's happened since I first sat down to interview him. In the time that we have been talking, China has created the first monkey clones and seen the first cases of the coronavirus in Wuhan. The world's last northern white rhinoceros has died in Kenya. A subglacial lake has been discovered on Mars. Prince Harry has married Meghan Markle and left the royal family. Paul Manafort has been jailed. The Event Horizon Telescope has provided the first known image of a black hole. The Australian bush has gone up in flames. Britain has left the EU. Nolan has grown a beard, shaved it off; accompanied a new print of Stanley Kubrick's *2001: A Space Odyssey*

to Cannes; written a feature film, cast, shot, edited it; and accepted an invitation to Buckingham Palace to be made a Commander of the British Empire. He has turned forty-nine and has a few more gray hairs. He finds himself fascinated by the way his movies are aging alongside him, their secrets he once so zealously guarded now debated endlessly on websites and blogs; their innovations worn smooth and turned into clichés by copyists; their themes, once so personal to him, revealed as representative of larger historical trends that he couldn't see at the time.

"There are some filmmakers who never watch their films, but I'm fascinated by how they change over time, how they become more historical artifacts, for good or bad. Films that may have seemed a little broad or old-fashioned when they came out, they can come into their own with the passage of time, because all the other films around them at the time reveal their own artifices. We can only rarely see the historical patterns that are shaping us. I haven't seen *Memento* in years. I watched *The Dark Knight* with my kids recently. The problem with a film like *Dark Knight* is that its genre is very much of its moment. To get anybody to look at a superhero movie again or reaccess them is difficult. There will be a new version of Batman, you know what I mean? Science fiction's different. I always knew in making *Interstellar* that it was all about the long game. What are people going to think of it in twenty years' time? Hopefully, they will revisit it."

Even Kubrick's *2001: A Space Odyssey,* a film he had first watched when he was seven, and has checked in with at every major anniversary since, has changed over the years. "The interesting thing even with a science-fiction masterpiece like *2001* is that it ebbs and flows in its relationship with the future. When I went to a screening about ten years ago for the fortieth anniversary, it was around about the time I had first shown it to my children, and one of their first questions was, 'Why does the computer talk?' At the time, this is pre-Siri, the idea of a talking computer seemed utterly pointless to them. Because to them, a computer was a tool like a screwdriver, just an interface with the world. When I watched it again last year for its fiftieth anniversary, it's more impactful and more resonant than it has ever been, including when the film was released in 1968. The astronauts all sit down to have breakfast, and they each have a tablet that they're watching a program on. And then the iPad comes along and suddenly it's absolutely in sync again. Samsung, when it was in its lawsuit with Apple, tried to submit *2001* as proof that Apple could not own the concept of the iPhone. It wasn't allowed by the judge. But that they even tried to argue that. So there has been an ebb and flow.

"An interesting story about HAL is that Kubrick enlisted all these companies to produce renderings of what a supercomputer would look like in the future. One of which had the astronauts floating around *inside*. There's a letter from Kubrick just being like, 'This is a fucking waste of time and you've got to stop this. This is not at all what I want.' But then it's what's in the film. What's more, it's one of the brilliant things in the film. The idea they'd be inside the computer, not outside. That's what directing is. It's casting about for people and collaborators, then making these insignificant or seemingly insignificant decisions, all day every day for years, and seeing what they add up to."

"Do you ever have things like that—accidental discoveries of things that turned out to be crucial?"

"Certainly, visually. In *The Prestige*, the fog scene where the lightbulbs come on. That fog is not at all what we were expecting or what we wanted up there. It's in several of the scenes where Hugh comes to the laboratory. It defines them. And the final shot of *The Dark Knight* was an accident. I didn't know how, visually, to end the film. The shot we ended up using, I only discovered in dailies. Our setup was, we had the stunt guy on a motorbike and we would chase him with a vehicle, filming. He goes up a ramp and there's a movie light shining down the ramp; he just flew into it, and it flares slightly around the edges of the cape. I saw that in dailies; it's the tail end of the shot. 'There's the light; cut.' But at some point, I was like, '*That's* the end of the film.' You just click these things. You have a couple things like that on a film. Once that machine is rolling, you are surprised by things every day. You look for that. Otherwise, it's painting by numbers. That's what keeps it exciting."

The cinemas Nolan frequented as a boy have almost all disappeared. The Odeon West End, where he first saw Kubrick's *2001: A Space Odyssey* with his father in 1977, has now been replaced by a ten-story complex with hotel and spa for the Edwardian group; the last film to show there was Nolan's own *Interstellar* in 70mm, the poster for which was up on the marquee for months after the theater went dark. The movie theater in Northbrook, Illinois, where he saw *Raiders of the Lost Ark* with his mother, the futuristic-looking Edens Theater, on Skokie Boulevard, was razed in 1994, after showing its last films, *Milk Money*, a romantic comedy with Ed Harris and Melanie Griffith, and *Time Cop*, starring Jean-Claude Van Damme. It was replaced by a shopping center with a Nordstrom, Starbucks, and a Kinko's. The old Scala cinema in King's Cross, the palatial 350-seater from the 1920s, where he saw *Blue Velvet* and *Full Metal Jacket*

and *Manhunter,* was almost bankrupt and closed in 1993, but it reopened in 1999 as a nightclub and music venue.

"People are all interested in 'Will movies die?' It's a thing right now. There is this huge drive to separate the presentation from the content. You really can't, because part of what movies are about is this unique, subjective point of view that you then share with other people. That's why 3-D doesn't work very well—it skews that relationship, because when you're wearing stereoscopic glasses, your brain intuits that they cannot be seeing the same image as you. You're not all looking at a big painting. Or a big billboard, which is what a movie is. That's why they don't like stadium seating for comedies, because you're not as aware of the audience; you don't see the heads in front of you. 'Well, do you have a problem with people seeing *Dunkirk* on my phone or whatever?' No, I don't, but the reason I don't is because it's put into these big theaters as its primary form, or its initial distribution. And that experience trickles down, to the extent where, if you have an iPad and you're watching a movie, you carry with you the knowledge and your understanding of what that cinematic experience would be and you extrapolate that. So when you watch a TV show on your iPad, your brain is in a completely different mind-set. M. Night Shyamalan wrote a piece in one of the trade papers a few years ago when they started to collapse the distribution windows, maybe ten years ago, and he articulated it very well. 'Yes, we make all our money on ancillary sales, but that initial release is what gives it the push.' You know, that's what movies are. We live and work in an analogue world. We need bums on seats. We need people to come to the cinema, engage with the film. What is working in movies right now? What audiences are prepared to come out of their homes to see is a cinema of experience. It's larger-than-life experiences that we can't get on the television, in the home, or on your phone. You're just in the moment and going through the intense experience in something like real time—that intensively subjective experience that I refer to as 'virtual reality without the goggles.' That's what audiences are prepared to come and see."

Nolan's commitment to photochemical film has not only helped revive the fortunes of Kodak but continued to push the technology forward, notably with his groundbreaking use of IMAX. "One of the things that my public conversations with Tacita Dean has brought out is all these issues from the art world, like 'medium specificity' and 'medium resistance,'" he says. "If you take a block of clay and make a piece of sculpture, the way the

clay pushes back on your hand affects the way you make your art. It affects what it is going to become. That is absolutely applicable to the craft of cinema. If you're shooting silently, or in black and white, or with color, or with sound, the resistance of the medium affects your choices. It affects how you approach the actors, how you block a scene, how you break it up, how you move the camera, whether you want to move the camera. The medium pushes back on me. It has resistance. There are difficulties to be overcome. These affect the rhythm of your day. You have to reload the camera, for example, you can only shoot ten minutes at a time. With IMAX, I've actually had to shoot for two and a half minutes at a time, which takes me back to my first films on my father's Super 8 where I had to change the cartridge every two and a half minutes. I'm right back to where I started."

He still likes few things more than a big family outing to see a film. "I never liked going to films on my own," he says. "I still don't. I like going with the kids or going with the family and talking about it afterward. Emma can. She is very happy to go on her own. I don't like it, never have. I couldn't tell you why." One moviegoing experience that has always stayed with him is *The Silence of the Lambs,* Jonathan Demme's 1991 adaptation of the Thomas Harris thriller. It was Nolan's first year at UCL, and he was back in Chicago for the holidays, and he'd been a fan of the book. "So, I went out to some suburban second-run cinema at the very tail end of the first run, you know, an empty movie theater with one or two other people. I wanted to see it with my brother, and I really liked the film. I thought it was a great adaptation. Didn't find it frightening in the slightest. Just watched it, like no big deal. And then it came out months later in London, and I went back to see it in the West End, this time with Emma in a packed movie theater. I was *terrified.* One of my most frightening movie experiences. I remember being so disturbed. The thing that makes films completely unique is the combination of subjectivity, the visceral experience, with shared experience and empathy with the rest of the audience. It's a borderline mystical experience. You read a novel: totally subjective

"I wanted to go back to the time of invention of early cinema," said Tacita Dean of her 2011 installation *FILM* at the Tate Gallery.

experience. You can't share it with other people. You're in that narrative on your own. The stage has the empathetic experience, but every person views the stage from a different point of view. Movies have this very, very unique mixture of the subjective and immersive, but it's also shared. It doesn't happen with any other medium, which is why it's fabulous. And forever."

· · ·

That seemed as good a place as any to leave things. Nolan is not a big one for hellos and good-byes, which he delivers in a shrugging, offhand kind of way, as if he's only going next door. Conversely, he picks up conversations started many years before as if they had just happened yesterday. Getting up, I thank him for his time.

"Do you remember what we talked about when we first met?" he asks.

"You mean in 1999? In Canter's Deli? Vaguely. We talked about your left-handedness and whether it had any bearing on *Memento*."

"You said, 'I think we may have come up with a working theory that explains the structure of *Memento*.'"

"I'm not sure I think that anymore. I think it goes a little deeper than that. I do remember bringing up Paul McCartney's left-handedness. He and Lennon used to sit opposite one another on their hotel beds in Hamburg and just copy the chords the other one was playing. It was like looking in a mirror."

"By the way," he says. "I had a question for you—or actually, just a word. *Dextrocardia*."

It takes me a while to figure out what he is talking about, but when I do, something in me freezes.

"One in every twelve thousand people have their heart on the right side," he says innocently. "Does that invalidate your solution? It's an interesting philosophical question. One in twelve thousand is pretty unusual, I know."

For a few seconds, I hate him. I can't believe it. He's found a way to invalidate my "heart" solution to the left-right problem. Is he *trying* to lend credence to the critics' accusation of heartlessness? But the moment passes and I retake my seat.

"Well, I think it comes down to the question of what's commonly understood to be the heart's location," I say. "As you said, the heart's not much to the left anyway; it's kind of in the center, but *traditionally,* people would know to do this."

I place my hand on my heart.

"But I wasn't viewing it in anthropological terms," he continues. "I was viewing it in Euclidean, or mathematical, terms. The heart solution worked for me really beautifully, because there's the human element. Yes, our hearts are on the left. But now knowing that there are people who have it on the right, albeit very few, in a way it invalidates your answer. It opens up a different way of looking at the puzzle, which is, essentially, why or how could genetics define a left or right to the body as it grows?"

"What about this, then? I would ask them to put their hand on their heart and I would add, 'unless you suffer from dextrocardia, in which case you should put your hand on the opposite side.'"

He looks doubtful. "But if there are extra instructions, doesn't that invalidate it?"

"Not at all," I say, collecting myself. "The challenge was, Could I *communicate* to someone, in *English*, on the *phone*, the difference between left and right? You said nothing about the length or complexity of my explanation."

He looks unpersuaded but seems to be sensing my frustration. "I've always looked at it as an abstraction, not how it would be in the real world. I used the analogy of calling someone on the phone just to remove the physical world from the equation. I want to solve it purely with abstractions, purely with language, purely with ideas. I think your solution is great. I think it's very beautiful, but as when I rejected your planetary idea, there's still something that bothers me. So far the solutions that we've come up with, they depend upon external, physical elements in the real world. Like your body or the planets. It's still fascinating to me that in mathematical, abstract terms, you can't distinguish left and right. Does that make sense?"

"Yes, the real world," I say a little huffily. "That's where it works."

"I'll give you another way of looking at it. If you're talking on the telephone with an artificial intelligence, how do you communicate left from right?"

I'm stumped. I also harbor a nagging suspicion that he has changed the rules on me, although the problem he has now given me—define left and

My last conversation with Nolan touched on the first as if it were yesterday.

right for an artificial intelligence—is much closer to the classic "Ozma Problem" as first set out by Martin Gardner involving extraterrestrials. I'm still reluctant to draw on Chien-Shiung Wu's solution involving spinning cobalt-60 atoms held at very low temperatures by a vacuum flask. I don't know how to lay hold of cobalt-60 atoms and would likely clonk myself in the nose with a spinning vacuum flask. I return to New York and continue with the writing of this book, all the while racking my brains for operational ways of describing the difference between left and right. My daughter turns six. She is getting a little tired of seeing me at my computer every day. I think she thinks this is what I do for a living, that writing about Christopher Nolan is a full-time job. Maybe she'll be asked one day what her dad does, and she'll say, "He writes about Christopher Nolan." One day, she is sitting in my lap.

"Christopher Nolan, blah, blah, blah . . ." she says, pretending to write on my keyboard.

I show her how to actually touch-type it so that it appears on the screen.
Christopher Nolan, blah, blah, blah . . .

"And you can also do this," I say, cutting and pasting the "*blah, blah, blah*" so that it repeats ad infinitum, the words pushing from left to right until they form a new line.

Christopher Nolan, blah, blah, blah . . . blah, blah, blah . . . blah, blah, blah . . . blah, blah, blah . . . blah, blah, blah . . . blah, blah, blah . . .

I repeat the action, the block of text seeming almost to be pushing itself across the screen, left to right, left to right, over and over, like "All work and no play makes Jack a dull boy" in *The Shining*.

blah, blah, blah . . . blah, blah, blah . . . blah, blah, blah . . . blah, blah, blah . . . blah, blah, blah . . . blah, blah, blah . . . blah, blah, blah . . . blah, blah, blah . . . blah, blah, blah . . .

Then I stop.

Something comes to me. It comes with an asterisk. It won't work for androids, artificial intelligence, or alien life-forms. It will, however, work 100 percent for the readers of this book. A few weeks later, I have cause to circle back to Nolan on the phone for some follow-up questions, and at the end of the conversation I say, "I have a new solution to the left-right problem . . . but it comes with an asterisk."

"Okay," he says.

I tell him the solution.

"That's a pretty big asterisk," he says when I am finished.

"I told you."

"I think I prefer your heart solution."

I do, too. Nonetheless, here is the solution I gave him, complete with asterisk.

I would ask the person to pick up this book and read the first sentence, "A man wakes up in a room so dark that he cannot see his hand in front of his face," *and I would tell them,* "Your eyes just moved from left to right."*

* Unless you are reading this book in Arabic, Aramaic, Azeri, Maldivian, Hebrew, Kurdish, Persian, or Urdu, in which case your eyes just moved from right to left.

ACKNOWLEDGMENTS

Thanks first and foremost go to Christopher Nolan for his time, generosity, and spirit of collaboration; to Emma Thomas for her feedback; to my editors, Walter Donahue and Vicky Wilson, for their expert eye and ear; my agent, Emma Parry, for her counsel; Andy Thompson for his help with picture research and for nerves of steel; Kate Shone for cohabiting with a Nolan obsessive for the best part of three years; and my daughter, Juliet, to whom this book is dedicated. My thanks also go to Niki Mahmoodi, Jessica Kepler, Lee Smith, Janet Reitman, Nicholas Tanis, Nat DeWolf, Julien Cornell, Glenn Kenny, Roni Polsgrove, and Sophie Berg for their contributions to the "time/*Tootsie*" assignment in chapter three; to Marcel Theroux for his help with the "map" assignment in chapter nine, and Brigit Rathouse and her family for their hospitality while embarked upon it. I am also indebted to Valerie Adams, Shane Burger, Nick Duffell, Virginia Heffernan, Brad Lloyd, Philip Horne, Dom Joly, Quentin Letts, Oliver Morton, Craig Raine, Alex Renton, Matthew Sweet, and Matthew Tempest for their encouragement, comments, and suggestions.

Francis Bacon's studio as
reconstructed at Dublin
City Gallery.

FILMOGRAPHY

Tarantella *(1989) 4 min, short film*
Directors: Christopher Nolan
Writers: Christopher Nolan
Cinematography: Christopher Nolan

Larceny *(1996) short film*
Director: Christopher Nolan
Writer: Christopher Nolan
Stars: Mark Deighton, Dave Savva,
Jeremy Theobald

Doodlebug *(1997) 3 min, short film*
Director: Christopher Nolan
Writer: Christopher Nolan
Star: Jeremy Theobald

Following *(1998) R, 1 hr 9 min*
Director: Christopher Nolan
Writer: Christopher Nolan
Stars: Alex Haw, Jeremy Theobald,
Lucy Russell
Cinematography: Christopher Nolan
Music: David Julyan
Editors: Gareth Heal, Christopher
Nolan
Producers: Emma Thomas,
Christopher Nolan, Jeremy
Theobald
Distributors: Zeitgeist Films,
Momentum Pictures

Memento *(2000) R, 1 hr 53 min*
Director: Christopher Nolan
Writers: Christopher Nolan
(screenplay), Jonathan Nolan
(short story "Memento Mori")
Stars: Guy Pearce, Carrie-Anne Moss,
Joe Pantoliano
Cinematography: Wally Pfister
Music: David Julyan
Editor: Dody Dorn
Producers: Suzanne Todd, Jennifer
Todd
Distributors: Newmarket, Pathé
Distribution

Insomnia *(2002) R, 1 hr 58 min*
Director: Christopher Nolan
Writer: Hillary Seitz
Stars: Al Pacino, Robin Williams,
Hilary Swank, Martin Donovan
Cinematography: Wally Pfister
Music: David Julyan
Editor: Dody Dorn
Producers: Paul Junger Witt, Edward
L. McDonnell, Broderick
Johnson, Andrew A. Kosove
Distributors: Warner Bros., Buena
Vista International

Batman Begins *(2005) PG-13, 2 hr 20 min*
 Director: Christopher Nolan
 Writers: Christopher Nolan,
 David S. Goyer
 Stars: Christian Bale, Michael Caine,
 Morgan Freeman, Rutger Hauer,
 Katie Holmes, Liam Neeson,
 Gary Oldman, Cillian Murphy,
 Tom Wilkinson, Ken Watanabe
 Cinematography: Wally Pfister
 Music: Hans Zimmer, James Newton
 Howard
 Editor: Lee Smith
 Producers: Emma Thomas, Charles
 Roven, Larry Franco
 Distributor: Warner Bros.

The Prestige *(2006) PG-13, 2 hr 10 min*
 Director: Christopher Nolan
 Writers: Jonathan Nolan, Christopher
 Nolan
 Stars: Hugh Jackman, Christian
 Bale, Michael Caine, Scarlett
 Johansson, Rebecca Hall
 Cinematography: Wally Pfister
 Music: David Julyan
 Editor: Lee Smith
 Producers: Emma Thomas, Aaron
 Ryder, Christopher Nolan
 Distributors: Buena Vista Pictures,
 Warner Bros.

The Dark Knight *(2008) PG-13, 2 hr 32 min*
 Director: Christopher Nolan
 Writers: Jonathan Nolan, Christopher
 Nolan, David S. Goyer (story)
 Stars: Christian Bale, Michael Caine,
 Aaron Eckhart, Morgan Freeman,
 Maggie Gyllenhaal, Heath Ledger,
 Gary Oldman
 Cinematography: Wally Pfister
 Music: Hans Zimmer, James Newton
 Howard
 Editor: Lee Smith

 Producers: Emma Thomas,
 Christopher Nolan, Charles
 Roven
 Distributor: Warner Bros.

Inception *(2010) PG-13, 2 hr 28 min*
 Director: Christopher Nolan
 Writer: Christopher Nolan
 Stars: Leonardo DiCaprio, Tom
 Berenger, Michael Caine, Marion
 Cotillard, Tom Hardy, Joseph
 Gordon-Levitt, Ellen Page, Cillian
 Murphy, Ken Watanabe
 Cinematography: Wally Pfister
 Music: Hans Zimmer
 Editor: Lee Smith
 Producers: Emma Thomas,
 Christopher Nolan
 Distributor: Warner Bros.

The Dark Knight Rises *(2012) PG-13, 2 hr 44 min*
 Director: Christopher Nolan
 Writers: Jonathan Nolan, Christopher
 Nolan, David S. Goyer (story)
 Stars: Christian Bale, Michael Caine,
 Marion Cotillard, Joseph Gordon-
 Levitt, Tom Hardy, Morgan
 Freeman, Anne Hathaway, Gary
 Oldman
 Cinematography: Wally Pfister
 Music: Hans Zimmer
 Editor: Lee Smith
 Producers: Emma Thomas,
 Christopher Nolan, Charles
 Roven
 Distributor: Warner Bros.

Interstellar *(2014) PG-13, 2 hr 49 min*
 Director: Christopher Nolan
 Writers: Jonathan Nolan, Christopher
 Nolan
 Stars: Matthew McConaughey, Ellen
 Burstyn, Jessica Chastain, Michael
 Caine, Anne Hathaway

Cinematography: Hoyte van
 Hoytema
Music: Hans Zimmer
Editor: Lee Smith
Producers: Emma Thomas,
 Christopher Nolan, Lynda Obst
Distributors: Paramount, Warner
 Bros.

Quay *(2015) 8 min, short film*
Director: Christopher Nolan
Cinematography: Christopher Nolan
Music: Christopher Nolan
Editor: Christopher Nolan
Producers: Christopher Nolan, Andy
 Thompson
Distributor: Zeitgeist Films

Dunkirk *(2017) PG-13, 1 hr 46 min*
Director: Christopher Nolan
Writer: Christopher Nolan
Stars: Fionn Whitehead, Tom Glynn-
 Carney, Jack Lowden, Harry
 Styles, Aneurin Barnard, James
 Darcy, Barry Keoghan, Kenneth

Branagh, Cillian Murphy, Mark
 Rylance, Tom Hardy
Cinematography: Hoyte van
 Hoytema
Music: Hans Zimmer
Editor: Lee Smith
Producers: Emma Thomas,
 Christopher Nolan
Distributor: Warner Bros.

Tenet *(2020) PG-13*
Director: Christopher Nolan
Writer: Christopher Nolan
Stars: John David Washington,
 Kenneth Branagh, Michael
 Caine, Elizabeth Debicki, Dimple
 Kapadia, Robert Pattinson, Aaron
 Taylor-Johnson
Cinematography: Hoyte van
 Hoytema
Music: Ludwig Göransson
Editor: Jennifer Lame
Producers: Emma Thomas,
 Christopher Nolan
Distributor: Warner Bros.

Linnahall Stadium,
Estonia

BIBLIOGRAPHY

I drew on the following books while writing this one.

Abbott, Edwin. *The Annotated Flatland: A Romance of Many Dimensions.* Perseus, 2002.

Ackroyd, Peter. *Alfred Hitchcock.* Doubleday, 2015.

———. *Wilkie Collins: A Brief Life.* Doubleday, 2012.

———. *London: A Biography.* Random House, 2009.

Allen, Paul. *Alan Ayckbourn: Grinning at the Edge.* Bloomsbury, 2001.

Andersen, Kurt. *Fantasyland: How America Went Haywire: A 500-Year History.* Random House, 2017.

Anderson, Lindsay. *Lindsay Anderson Diaries.* Methuen, 2005.

———. *Never Apologise: The Collected Writings.* Plexus, 2004.

Ashcroft, R. L. *Random Recollections of Haileybury.* Joline Press, 2000.

———. *Haileybury 1908–1961.* Butler & Tanner, 1961.

Ashfield, Andrew, and Peter de Bolla, eds. *The Sublime: A Reader in British Eighteenth-Century Aesthetic Theory.* Cambridge University Press, 1996.

Attali, Jacques. *The Labyrinth in Culture and Society.* North Atlantic, 1998.

Barnouw, Erik. *The Magician and the Cinema.* Oxford University Press, 1981.

Bartlett, Donald, and James B. Steele. *Howard Hughes: His Life and Madness.* W. W. Norton, 2011.

Baxter, John. *George Lucas: A Biography.* HarperCollins, 2012.

Benedikt, Michael. *Cyberspace: First Steps.* MIT Press, 1991.

Benjamin, Walter. *The Work of Art in the Age of Mechanical Reproduction.* Prism Key Press, 2012.

———. *Illuminations: Essays and Reflections.* Houghton Mifflin Harcourt, 1968.

Benson, Michael. *Space Odyssey: Stanley Kubrick, Arthur C. Clarke, and the Making of a Masterpiece.* Simon & Schuster, 2018.

Billington, Michael. *Harold Pinter.* Faber & Faber, 1996.

Birkin, Andrew. *J. M. Barrie and the Lost Boys: The Real Story Behind Peter Pan.* Yale University Press, 2003.

Boorman, John. *Adventures of a Suburban Boy.* Farrar, Straus and Giroux, 2004.

Boorstin, Jon. *The Hollywood Eye.* Cornelia & Michael Bessie Books, 1990.

Bordwell, David. *Narration in the Fiction Film.* University of Wisconsin Press, 1985.

Bordwell, David, and Kristin Thompson. *Christopher Nolan: A Labyrinth of Linkages.* Irvington Way Institute Press, 2013.

Borges, Jorge Luis. *Ficciones.* Grove Press, 2015.

———. *Borges at Eighty: Conversations.* Edited by Willis Barnstone. New Directions, 2013.

———. *Labyrinths.* New Directions, 2007.

———. *Borges: Selected Non-Fictions.* Penguin, 2000.

———. *Selected Poems.* Penguin, 1999.

———. *Collected Fictions.* Penguin, 1998.

Bowlby, John. *Charles Darwin: A New Life.* W. W. Norton, 1990.

Boyd, William. *Bamboo: Essays and Criticism.* Bloomsbury, 2007.

Bradbury, Malcolm, and James McFarlane, eds. *Modernism: 1890–1930.* Penguin, 1976.

Brontë, Charlotte. *Jane Eyre.* W. W. Norton, 2016.

———. *Villette.* Penguin, 2012.

Brontë, Emily. *Wuthering Heights.* Barnes & Noble Classics, 2005.

The Brontës. *Tales of Glass Town, Angria, and Gondal: Selected Early Writings.* Edited by Christine Alexander. Oxford University Press, 2010.

Brooke-Smith, James. *Gilded Youth: Privilege, Rebellion and the British Public School.* Reaktion Books, 2019.

Brown, Karl. *Adventures with D. W. Griffith.* Faber & Faber, 1973.

Brownlow, Kevin. *David Lean: A Biography.* St. Martin's Press, 1996.

Bulgakowa, Oksana. *Sergei Eisenstein: A Biography.* Potemkin Press, 2002.

Burke, Carolyn. *No Regrets: The Life of Edith Piaf.* Knopf, 2011.

Callow, Simon. *Orson Welles: The Road to Xanadu.* Viking, 1995.

Canales, Jimena. *The Physicist and the Philosopher: Einstein, Bergson, and the Debate That Changed Our Understanding of Time.* Princeton University Press, 2016.

Carey, John. *The Violent Effigy: A Study of Dickens' Imagination.* Faber & Faber, 1973.

Carroll, Lewis. *The Complete Works.* Pandora's Box, 2018.

———. *Alice's Adventures in Wonderland and Through the Looking Glass.* Oxford, 1971.

Castigliano, Federico. *Flâneur: The Art of Wandering the Streets of Paris.* Amazon Digital Services, 2017.

Cavallaro, Dani. *The Gothic Vision: Three Centuries of Horror, Terror and Fear.* Continuum, 2002.

Chandler, Raymond. *The World of Raymond Chandler: In His Own Words.* Edited by Barry Day. Vintage Books, 2014.

———. *The Blue Dahlia: A Screenplay.* Amereon, 1976.

Chandler, Raymond, and Owen Hill, Pamela Jackson, and Anthony Rizzuto. *The Annotated Big Sleep.* Vintage Books, 2018.

Choisy, Auguste. *Histoire de l'architecture.* Hachette, 2016.

Cohen, Morton N. *Lewis Carroll: A Biography.* Vintage Books, 1996.

Collins, Paul. *Edgar Allan Poe: The Fever Called Living.* Icons, 2012.

Collins, Wilkie. *The Woman in White.* Penguin, 1999.

———. *The Moonstone.* Penguin, 1998.

Conrad, Joseph. *Heart of Darkness.* Amazon Digital Services, 2012.

Coren, Michael. *The Life of Sir Arthur Conan Doyle.* Endeavour Media, 2015.

Cummings, E. E. *The Enormous Room.* Blackmore Dennett, 2019.

Dahl, Roald. *The BFG*. Puffin, 2007.

———. *Boy: Tales of Childhood*. Puffin, 1984.

Darwin, Charles. *The Expression of the Emotions in Man and Animals*. Penguin, 2009.

DeLillo, Don. *The Body Artist*. Scribner, 2001.

De Quincey, Thomas. *Confessions of an English Opium Eater and Other Writings*. Penguin, 2003.

Diamond, Jason. *Searching for John Hughes: Or Everything I Thought I Needed to Know About Life I Learned from Watching '80s Movies*. William Morrow, 2016.

Dickens, Charles. *A Flight*. CreateSpace Independent Publishing Platform, 2014.

———. *Night Walks*. Penguin, 2010.

———. *A Tale of Two Cities*. Penguin, 2003.

———. *Nicholas Nickleby*. Penguin, 2003.

Di Friedberg, Marcella Schmidt. *Geographies of Disorientation*. Routledge, 2017.

Di Giovanni, Norman Thomas. *Georgie and Elsa: Jorge Luis Borges and His Wife: The Untold Story*. HarperCollins, 2014.

Dodge, Martin, and Rob Kitchin. *Mapping Cyberspace*. Routledge, 2000.

Doyle, Arthur Conan. *The Collected Works of Sir Arthur Conan Doyle*. Pergamon Media, 2015.

Draisey, Mark. *Thirty Years On!: A Private View of Public Schools*. Halsgrove, 2014.

Drosnin, Michael. *Citizen Hughes: The Power, the Money and the Madness of the Man Portrayed in the Movie* The Aviator. Penguin, 2004.

Duffell, Nick. *The Making of Them: The British Attitude to Children and the Boarding School System*. Lone Arrow Press, 2018.

———. *Wounded Leaders: British Elitism and the Entitlement Illusion*. Lone Arrow Press, 2016.

Duffell, Nick, and Thurstine Basset. *Trauma, Abandonment and Privilege: A Guide to Therapeutic Work with Boarding School Survivors*. Routledge, 2016.

Eberl, Jason T., and George A. Dunn. *The Philosophy of Christopher Nolan*. Lexington Books, 2017.

Ebert, Roger. *Ebert's Bigger Little Movie Glossary: A Greatly Expanded and Much Improved Compendium of Movie Clichés, Stereotypes, Obligatory Scenes, Hackneyed Formulas, Conventions, and Outdated Archetypes*. Andrews McMeel, 1999.

Eco, Umberto. *From the Tree to the Labyrinth: Historical Studies on the Sign and Interpretation*. Translated by Anthony Oldcorn. Harvard University Press, 2007.

Edel, Leon. *Henry James: A Life*. Harper & Row, 1953.

Eisenstein, Sergei. *Film Form: Essays in Film Theory*. Mariner Books, 2014.

Eldon, Dan. *Safari as a Way of Life*. Chronicle Books, 2011.

———. *The Journals of Dan Eldon*. Chronicle Books, 1997.

Eliot, T. S. *Collected Poems 1909–1962*. Faber & Faber, 1963.

Empson, William. *Seven Types of Ambiguity*. New Directions, 1966.

Epstein, Dwayne. *Lee Marvin: Point Blank*. Schaffner Press, 2013.

Ernst, Bruno. *The Magic Mirror of M. C. Escher*. Tarquin, 1985.

Fawcett, Percy. *Exploration Fawcett: Journey to the Lost City of Z*. Overlook Press, 2010.

Fleming, Fergus. *The Man with the Golden Typewriter: Ian Fleming's James Bond Letters*. Bloomsbury, 2015.

Fleming, Ian. *On Her Majesty's Secret Service*. Thomas & Mercer, 2012.

———. *Thunderball.* Thomas & Mercer, 2012.

———. *You Only Live Twice.* Thomas & Mercer, 2012.

———. *Casino Royale.* Thomas & Mercer, 2012.

———. *Dr. No.* Thomas & Mercer, 2012.

———. *From Russia with Love.* Thomas & Mercer, 2012.

———. *Gilt-Edged Bonds.* Macmillan, 1953.

Foucault, Michel. *Discipline and Punish: The Birth of the Prison.* Vintage Books, 2012.

Freud, Sigmund. *The Interpretation of Dreams.* Translated by A. A. Brill. Digireads, 2017.

Fry, Stephen. *Moab Is My Washpot.* Soho, 1997.

Galison, Peter. *Einstein's Clocks, Poincaré's Maps: Empires of Time.* W. W. Norton, 2004.

Gardner, Martin. *The Ambidextrous Universe: Symmetry and Asymmetry from Mirror Reflections to Superstrings.* Dover, 2005.

Gay, Peter. *Freud: A Life for Our Time.* J. M. Dent, 1988.

Geppert, Alexander C. T., ed. *Imagining Outer Space: European Astroculture in the Twentieth Century.* Palgrave Macmillan, 2018.

Gettleman, Jeffrey. *Love Africa: A Memoir of Romance, War, and Survival.* HarperCollins, 2017.

Gill, Brendan. *Many Masks: A Life of Frank Lloyd Wright.* Da Capo Press, 1998.

Gleick, James. *Time Travel: A History.* Pantheon, 2016.

Goethe, Johann Wolfgang von. *Faust.* Anchor Books, 1962.

Greene, Graham, ed. *The Old School: Essays by Divers Hands.* Oxford University Press, 1984.

Greenfield, Robert. *A Day in the Life: One Family, the Beautiful People, and the End of the Sixties.* Da Capo Press, 2009.

Hack, Richard. *Hughes: The Private Diaries, Memos and Letters.* Phoenix Books, 2007.

Haggard, H. Rider. *She: A History of Adventure.* Vintage Books, 2013.

Harman, Claire. *Charlotte Brontë: A Fiery Heart.* Vintage Books, 2016.

———. *Robert Louis Stevenson: A Biography.* Harper Perennial, 2010.

Harris, Thomas. *Hannibal.* Random House, 2009.

———. *The Silence of the Lambs.* Mandarin, 1988.

———. *Red Dragon.* Corgi Books, 1982.

Hartley, L. P. *The Go-Between.* New York Review of Books, 2002.

Hayter, Alethea. *Opium and the Romantic Imagination: Addiction and Creativity in De Quincey, Coleridge, Baudelaire and Others.* HarperCollins, 1988.

Heffernan, Virginia. *Magic and Loss: The Internet as Art.* Simon & Schuster, 2016.

Herzog, Werner. *Herzog on Herzog.* Edited by Paul Cronin. Faber & Faber, 2002.

Highsmith, Patricia. *Selected Novels and Short Stories.* W. W. Norton, 2010.

Himmelfarb, Gertrude. *Victorian Minds: A Study of Intellectuals in Crisis and Ideologies in Transition.* Ivan R. Dee, 1995.

Hiney, Tom. *Raymond Chandler: A Biography.* Grove Press, 1999.

Hoberman, J. *The Magic Hour: Film at Fin de Siècle.* Temple University Press, 2007.

Hockney, David. *Secret Knowledge: Rediscovering the Lost Techniques of the Old Masters.* Avery, 2006.

Hockney, David, and Martin Gayford. *A History of Pictures: From the Cave to the Computer Screen.* Abrams, 2016.

Hofstadter, Douglas R. *Gödel, Escher, Bach: An Eternal Golden Braid.* Basic Books, 1999.

Holmes, Richard. *The Age of Wonder: How the Romantic Generation Discovered the Beauty and Terror of Science.* Vintage Books, 2009.

Horne, Alistair. *A Savage War of Peace: Algeria 1954–1962.* New York Review of Books, 2011.

Houghton, Walter E. *The Victorian Frame of Mind, 1830–1870.* Yale University Press, 1963.

Hughes, David. *Tales from Development Hell: The Greatest Movies Never Made?* Titan Books, 2012.

Isaacson, Walter. *Einstein: His Life and Universe.* Simon & Schuster, 2007.

Jacobs, Steven. *The Wrong House: The Architecture of Alfred Hitchcock.* 010 Publishers, 2007.

James, Henry. *The Wings of the Dove.* Penguin, 2007.

James, Richard Rhodes. *The Road from Mandalay: A Journey in the Shadow of the East.* Author-House, 2007.

Jameson, Fredric. *Raymond Chandler: The Detections of Totality.* Verso, 2016.

Johnson, Steven. *Everything Bad Is Good for You: How Today's Popular Culture Is Actually Making Us Smarter.* Riverhead Books, 2006.

Kant, Immanuel. *Observations on the Feeling of the Beautiful and Sublime and Other Writing*s. Cambridge University Press, 2012.

Kermode, Frank. *The Sense of an Ending: Studies in the Theory of Fiction.* Oxford University Press, 2000.

Kern, Stephen. *The Culture of Time and Space 1880–1918.* Harvard University Press, 1983.

Kidd, Colin. *The World of Mr Casaubon: Britain's Wars of Mythology, 1700–1870.* Cambridge University Press, 2016.

Kipling, Rudyard. *The Complete Works of Rudyard Kipling.* Global Classics, 2017.

———. *Kim.* Penguin, 2011.

———. *"An English School" and "Regulus": Two School Stories.* Viewforth, 2010.

———. *Stalky and Co.* Oxford University Press, 2009.

Kittler, Friedrich A. *Discourse Networks, 1800/1900.* Stanford University Press, 1992.

Lane, Anthony. *Nobody's Perfect: Writings from* The New Yorker. Vintage Books, 2009.

Le Carré, John. *The Night Manager.* Ballantine, 2017.

———. *The Pigeon Tunnel: Stories from My Life.* Penguin, 2016.

———. *A Murder of Quality.* Penguin, 2012.

———. *Smiley's People.* Penguin, 2011.

———. *Our Game.* Hodder & Stoughton, 1995.

———. *A Perfect Spy.* Penguin, 1986.

———. *Tinker Tailor Soldier Spy.* Penguin, 1974.

Levine, Joshua. *Dunkirk: The History Behind the Major Motion Picture.* William Collins, 2017.

Lewis, C. S. *Surprised by Joy: The Shape of My Early Life.* HarperCollins, 2017.

———. *The Silver Chair.* HarperCollins, 2009.

———. *Out of the Silent Planet.* Scribner, 2003.

Lobrutto, Vincent. *Stanley Kubrick: A Biography.* Da Capo Press, 1999.

Luckhurst, Roger. *Corridors: Passages of Modernity.* Reaktion Books, 2019.

Lumet, Sidney. *Making Movies.* Vintage Books, 2010.

Lycett, Andrew. *Ian Fleming: The Man Behind James Bond.* St. Martin's Press, 2013.

———. *Rudyard Kipling.* Weidenfeld & Nicolson, 1999.

Martino, Stierli. *Montage and the Metropolis: Architecture, Modernity, and the Representation of Space.* Yale University Press, 2018.

Mason, Michael. *The Making of Victorian Sexuality.* Oxford University Press, 1995.

Masson, Jeffrey. *The Wild Child: The Unsolved Mystery of Kasper Hauser.* Free Press, 2010.

Matheson, Richard. *I Am Legend.* Rosetta Books, 2011.

Matthews, William Henry. *Mazes and Labyrinths: A General Account of Their History and Development*. Library of Alexandria, 2016.

May, Trevor. *The Victorian Public School*. Shire Library, 2010.

Mayhew, Robert J. *Malthus: The Life and Legacies of an Untimely Prophet*. Harvard University Press, 2014.

McCarthy, John, and Jill Morrell. *Some Other Rainbow*. Bantam Books, 1993.

McGilligan, Patrick. *Fritz Lang: The Nature of the Beast*. University of Minnesota Press, 2013.

——. *Alfred Hitchcock: A Life in Darkness and Light*. HarperCollins, 2003.

McGowan, Todd. *The Fictional Christopher Nolan*. University of Texas Press, 2012.

Milford, Lionel Sumner. *Haileybury College, Past and Present*. T. F. Unwin, 1909.

Miller, Karl. *Doubles*. Faber & Faber, 2009.

Mitchell, William A. *City of Bits*. MIT Press, 1995.

Monaco, James. *The New Wave: Truffaut Godard Chabrol Rohmer Rivette*. Harbor Electronic Publishing, 2004.

Moore, Jerrold Northrop. *Edward Elgar: A Creative Life*. Clarendon Press, 1999.

Morrison, Grant. *Supergods: What Masked Vigilantes, Miraculous Mutants, and a Sun God from Smallville Can Teach Us About Being Human*. Spiegel & Grau, 2011.

Motion, Andrew. *In the Blood*. David R. Godine, 2007.

Mottram, James. *The Making of* Dunkirk. Insight, 2017.

——. *The Making of* Memento. Faber & Faber, 2002.

Munsterberg, Hugo. *The Film: A Psychological Study*. Dover, 1970.

Nabokov, Vladimir. *Look at the Harlequins!* Vintage Books, 1990.

Neffe, Jurgen. *Einstein*. Farrar, Straus and Giroux, 2007.

Nicholson, Geoff. *The Lost Art of Walking: The History, Science, and Literature of Pedestrianism*. Riverhead Books, 2008.

Nietzsche, Friedrich. *The Gay Science*. Penguin, 1974.

Nolan, Christopher. *Dunkirk: The Complete Screenplay*. Faber & Faber, 2017.

——. *Interstellar: The Complete Screenplay*. Faber & Faber, 2014.

——. *The Dark Knight Trilogy: The Complete Screenplays*. Faber & Faber, 2012.

——. *Inception: The Shooting Script*. Faber & Faber, 2010.

——. *Memento & Following*. Faber & Faber, 2001.

Ocker, J. W. *Poe-Land: The Hallowed Haunts of Edgar Allan Poe*. Countryman Press, 2014.

Oppenheimer, J. Robert. *Uncommon Sense*. Birkhäuser, 1984.

Orwell, George. *A Collection of Essays*. Harvest Books, 1970.

——. *1984*. Penguin, 1961.

——. *Such, Such Were the Joys: A Collection of Essays*. Harvest Books, 1961.

Patrick, Sean. *Nikola Tesla: Imagination and the Man That Invented the 20th Century*. Oculus Publishers, 2013.

Pearson, John. *The Life of Ian Fleming*. Bloomsbury, 2011.

Piranesi, Giovanni Battista. *The Prisons / Le Carceri*. Dover, 2013.

Poe, Edgar Allan. *William Wilson*. CreateSpace Independent Publishing Platform, 2014.

——. *The Collected Works of Edgar Allan Poe: A Complete Collection of Poems and Tales*. Edited by Giorgio Mantovani. Mantovani.org, 2011.

Pourroy, Janine, and Jody Duncan. *The Art and Making of the* Dark Knight *Trilogy*. Abrams, 2012.

Powell, Anthony. *A Question of Upbringing.* Arrow, 2005.

Priest, Christopher. *The Prestige.* Valancourt Books, 2015.

Pullman, Philip. *His Dark Materials Omnibus.* Knopf, 2017.

———. *Clockwork.* Doubleday, 1996.

Rebello, Stephen. *Alfred Hitchcock and the Making of* Psycho. Open Road Media, 2010.

Rennie, Nicholas. *Speculating on the Moment: The Poetics of Time and Recurrence in Goethe, Leopardi and Nietzsche.* Wallstein, 2005.

Renton, Alex. *Stiff Upper Lip: Secrets, Crimes and the Schooling of a Ruling Class.* Weidenfeld & Nicolson, 2017.

Ricketts, Harry. *Rudyard Kipling: A Life.* Da Capo Press, 2001.

Roeg, Nicolas. *The World Is Ever Changing.* Faber & Faber, 2013.

Rohmer, Eric, and Claude Chabrol. *Hitchcock: The First Forty-Four Films.* Frederick Ungar, 1979.

Safrinski, Rudiger. *Goethe: Life as a Work of Art.* Liveright, 2017.

Samuel, Arthur. *Piranesi.* Amazon Digital Services, 2015.

Sante, Luc Stanley. *Through a Different Lens: Stanley Kubrick Photographs.* Taschen, 2018.

Sayers, Dorothy L. *Murder Must Advertise.* Open Road Media, 2012.

Schatz, Thomas. *The Genius of the System: Hollywood Filmmaking in the Studio Era.* University of Minnesota Press, 2010.

Schaverien, Joy. *Boarding School Syndrome: The Psychological Trauma of the "Privileged" Child.* Metro Publishing, 2018.

Schickel, Richard. *D. W. Griffith: An American Life.* Limelight, 1996.

Scorsese, Martin. *A Personal Journey Through American Movies.* Miramax Books, 1997.

Seymour, Miranda. *Mary Shelley.* Simon & Schuster, 2000.

Sexton, David. *The Strange World of Thomas Harris.* Short Books, 2001.

Shattuck, Roger. *Forbidden Knowledge: From Prometheus to Pornography.* Mariner Books, 1997.

Shelley, Mary. *Frankenstein, or the Modern Prometheus (Annotated): The Original 1818 Version with New Introduction and Footnote Annotations.* CreateSpace Independent Publishing Platform, 2016.

Shepard, Roger N. *Mental Images and Their Transformations.* MIT Press, 1986.

Sherborne, Michael. *H. G. Wells: Another Kind of Life.* Peter Owen, 2011.

Sims, Michael. *Frankenstein Dreams: A Connoisseur's Collection of Victorian Science Fiction.* Bloomsbury, 2017.

Sisman, Adam. *John le Carré: The Biography.* HarperCollins, 2015.

Skal, David J. *Something in the Blood: The Untold Story of Bram Stoker, the Man Who Wrote Dracula.* Liveright, 2016.

Solomon, Matthew. *Disappearing Tricks: Silent Film, Houdini, and the New Magic of the Twentieth Century.* University of Illinois Press, 2010.

Spengler, Oswald. *Decline of the West: Volumes 1 and 2.* Random Shack, 2014.

Spoto, Donald. *The Dark Side of Genius: The Life of Alfred Hitchcock.* Plexus, 1983.

Spufford, Francis. *I May Be Some Time: Ice and the English Imagination.* Picador, 1997.

Stephen, Martin. *The English Public School: A Personal and Irreverent History.* Metro Publishing, 2018.

Stevenson, Robert Louis. *The Strange Case of Dr. Jekyll and Mr. Hyde.* Wisehouse Classics, 2015.

Stoker, Bram. *Dracula*. Legend Press, 2019.

———. *Complete Works*. Delphi Classics, 2011.

Stolorow, Robert D. *Trauma and Human Existence: Autobiographical, Psychoanalytic, and Philosophical Reflections*. Routledge, 2007.

Strager, Hanne. *A Modest Genius: The Story of Darwin's Life and How His Ideas Changed Everything*. Amazon Digital Services, 2016.

Sweet, Matthew. *Inventing the Victorians: What We Think We Know About Them and Why We're Wrong*. St. Martin's Press, 2014.

Swift, Graham. *Waterland*. Vintage Books, 1983.

Sylvester, David. *Interviews with Francis Bacon*. Thames & Hudson, 1993.

Tarkovsky, Andrey. *Sculpting in Time: Tarkovsky the Great Russian Filmmaker Discusses His Art*. Translated by Kitty Hunter-Blair. University of Texas Press, 1989.

Taylor, D. J. *Orwell: The Life*. Open Road Media, 2015.

Thompson, Dave. *Roger Waters: The Man Behind the Wall*. Backbeat Books, 2013.

Tomalin, Claire. *Charles Dickens: A Life*. Penguin Books, 2011.

Treglown, Jeremy. *Roald Dahl*. Open Road Media, 2016.

Truffaut, François. *Hitchcock: A Definitive Study of Alfred Hitchcock*. Simon & Schuster, 2015.

Turner, David. *The Old Boys: The Decline and Rise of the Public School*. Yale University Press, 2015.

Uglow, Jenny. *Mr. Lear: A Life of Art and Nonsense*. Farrar, Straus and Giroux, 2018.

Van Eeden, Frederik. *The Bride of Dreams*. Translated by Millie von Auw. Amazon Digital Services, 2012.

Vaz, Mark Cotta. Interstellar: *Beyond Time and Space*. Running Press, 2014.

Verne, Jules. *Around the World in Eighty Days*. Enhanced Media Publishing, 2016.

Wallace, David Foster. *Everything and More: A Compact History of Infinity*. W. W. Norton, 2010.

Walpole, Horace. *The Castle of Otranto*. Dover, 2012.

Watkins, Paul. *Stand Before Your God: A Boarding School Memoir*. Random House, 1993.

Waugh, Evelyn. *Decline and Fall*. Little, Brown, 2012.

Weber, Nicholas Fox. *Le Corbusier: A Life*. Knopf, 2008.

Wells, H. G. *The Time Machine*. Penguin, 2011.

West, Anthony. *Principles and Persuasions: The Literary Essays of Anthony West*. Eyre & Spottiswoode, 1958.

White, Allon. *The Uses of Obscurity: The Fiction of Early Modernism*. Routledge, 1981.

Wilde, Oscar. *The Picture of Dorian Gray*. Dover, 1993.

Williams, Tom. *A Mysterious Something in the Light: The Life of Raymond Chandler*. Chicago Review Press, 2012.

Williamson, Edwin. *Borges: A Life*. Viking, 2005.

Wilson, A. N. *C. S. Lewis: A Biography*. HarperCollins, 2005.

———. *The Victorians*. W. W. Norton, 2004.

Wilson, Frances. *Guilty Thing: A Life of Thomas De Quincey*. Farrar, Straus and Giroux, 2016.

Wilson, Stephen. *Book of the Mind: Key Writings on the Mind from Plato and the Buddha Through Shakespeare, Descartes, and Freud to the Latest Discoveries of Neuroscience*. Bloomsbury, 2003.

Wilton-Ely, John. *The Mind and Art of Giovanni Battista Piranesi*. Thames & Hudson, 1988.

Wood, Robin. *Claude Chabrol*. Praeger, 1970.

Woodburn, Roger, and Toby Parker, eds. *Haileybury: A 150th Anniversary Portrait.* ThirdMillennium, 2012.

Woodward, Christopher. *In Ruins: A Journey Through History, Art, and Literature.* Vintage Books, 2010.

Wright, Adrian. *Foreign Country: The Life of L. P. Hartley.* Tauris Parke, 2002.

Wright, Frank Lloyd. *Writings and Buildings.* Edited by Edgar Kaufman and Ben Raeburn. Meridian, 1960.

Yourcenar, Marguerite. *The Dark Brain of Piranesi and Other Essays.* Farrar, Straus and Giroux, 1985.

Images for chapter headings: Canter's Deli in Los Angeles; the old Edens Theater in Northbrook, Illinois; Stanley Kubrick's *The Shining* (1980); *Pink Floyd: The Wall* (1982); Alfred Hitchcock's *Psycho* (1960); Mephistopheles flying from *Faust*; print of Georges Méliès's *The Untamable Whiskers* (1904); Fritz Lang's *The Testament of Dr. Mabuse* (1933); model of the *Plan Voisin* for Paris by Le Corbusier (1925); Gillo Pontecorvo's *The Battle of Algiers* (1966); the stained-glass window of Cologne Cathedral designed by Gerhard Richter; David Lean's *Ryan's Daughter* (1970); the Trinity nuclear test in New Mexico in 1945; Alfred Hitchcock's *Vertigo* (1958).

Chand Baori stepwell,
India.

INDEX

Page numbers in *italics* refer to illustrations.

Abbott, Edwin A., *272, 273*
Ackroyd, Peter, 339
Affleck, Casey, 268
Akira, 35
Aldrich, Robert, 338
Alexander, Christine, 223–24
Alfredson, Tomas, 263
Alien, 27, 28
Allen, Woody, 205
All The President's Men, 57
Aloni, Dan, 108, 109
Ambidextrous Universe, The (Gardner), 72
Anderson, Kurt, 5
Anderson, Lindsay, 34
Anderson, Paul Thomas, 8, 11
Anderson, Wes, 205
Andrea, Neil, 296
Angel Heart, 35, 318
Apocalypse Now, 16, 39, 247
Aronofsky, Darren, 8, 123, 124
Aster, Ari, 321
Attack of the Clones, 168
Attlee, Clement, 31
Avengers, The, 128
Aviator, The, 126

Babbin, Jed, 251
Bach, Johann Sebastian, 172, 215, *216,* 217,
 218–19, 308, 309

Bacon, Francis, 16, 17, 180, *180,* 188–91, *189*
Badalamenti, Angelo, 18
Bale, Christian, 47–48, *130,* 135, 139, *140, 145,*
 148, 153, 154, *154,* 155, *159,* 160, 188, *194,*
 195, 198, 199, *244, 245,* 247, 252
Balfe, Lorne, 215
Ballers, 321
Barnard, Aneurin, 298
Barry, John, 215, 232
Barton, Judy, *170*
Batman: Year One, 123–24, 141
Batman Begins, 10, 34, 49, 53, 127, 128–33,
 130, 134–35, 136, 138, 139, 141, 142–43,
 144–46, *145,* 149, 157, 168, 173, 177, 180,
 183, 185, 193, 199, 214, 264, 271, 289, 290,
 335, 340
Battle of Algiers, The, 243
Battleship Potemkin, 26
Baum, Frank, 72
Baumbach, Noah, 321
Beck, 172
Belic, Adrian, 25
Belic, Roko, 25, 26, 48, 74, 222, 289
Bentley, Wes, *267*
Bergman, Ingmar, 28
Berners-Lee, Tim, 4
Big Sleep, The (Chandler), *59,* 61, 68, 332, 335
Billings, K. Lemoyne, *163*
Birth of a Nation, 289
BlacKkKlansman, 323

Black Rain, 35, 143

Blade Runner, 27, 27–28, 54, 145

Blade series, 128

Blue Velvet, 35, 343

Boarding School Syndrome (Schaverien), 100

Bohr, Niels, 164, 317

Bonaventura, Lorenzo di, 123

Boorstin, Jon, 56–57

Bordwell, David, 8, 298

Borges, Jorge Luis, vii, 7, 16, 17, *55,* 55–56, 59, 71, 86, 87, 91, 101–2, 163, 164, 166, 202, 203–4

Bowie, David, *40,* 41, 154, 158–60, 215

Boyhood, 272

Branagh, Kenneth, 100, *284,* 311, 313, 323

Brando, Marlon, 16, 39, 247

Bresson, Robert, 294

Bridge on the River Kwai, The, 27, 146

Brief History of Time, A, 320

Briley, Ron, 198

Brontë, Anne, 223

Brontë, Charlotte, 223

Brontë, Emily, 223–24

Brown, Karl, 289

Brunelleschi, Filippo, 44, 45, 214

Bryan, Charles, 165

Bugsy Malone, 21

Burke, Edmund, 251

Burns, Ken, 263–64, 266

Burton, Tim, 131

Buscemi, Steve, 204

Bush, George W., 198

Butler, A. G., 45

Caglione, John, 191

Caine, Michael, 10, 43, 106, 131, 148, 153, 212, 231, 261, 267, 269, 319, 323, 328

Caleb Williams (Godwin), 335

Cameron, James, 9, 132

Cantos (Pound), 207

Caravaggio, Michelangelo Merisi da, 162

Carlyle, Thomas, 251

Carrie (King), 69

Cat People, 69

Chabrol, Claude, 338

Chadwick, James, 317

Chadwick, Peter, 315

Chalamet, Timothée, 268

Chandler, Raymond, 7, 17, *59,* 59–61, 112, 335

Chariots of Fire, 22, 32, *33,* 33–34, 160, 292, *292*

Charleson, Ian, *33*

Chastain, Jessica, *266,* 269, 318

Chaubin, Frédéric, 315

Christie, Agatha, 60, 226, 340

Christie, Julie, *38,* 260

Ciello, Danny, 244

"Circular Ruins, The" (Borges), 203–4

Citizen Kane, 67

Clarke, Arthur C., 23

Clockwork Orange, A, 191, 192

Clooney, George, 109

Close Encounters, 255, 262, 266

Clouzot, Henri-Georges, 292, 293

Cocteau, Jean, 312, 320

Collins, Wilkie, 16, 17, 225, *226*

Comb, The, 288

Connery, Sean, *127,* 131, *131, 140,* 141

Coogler, Ryan, 321

Cooper, Gary, 28

Coppola, Francis Ford, 146, 247

Corbould, Chris, 212

Corbould, Paul, 296

Cosmos, 25, 255, 262

Cotillard, Marion, 208, *208,* 213, 223

Cox, Brian, *115,* 116

Crowley, Nathan, 112, 113, 128, *129,* 138, 142, 143, 157, 158, 172, 173, 195, 200, 209, 263, 264, 296, 315

Cuarón, Alfonso, 287

Daguerre, Louis, *272,* 273

d'Alcy, Jehanne, 151

Damon, Matt, 261, 271

Dance to the Music of Time (Powell), 36

Dark Knight, The, 8, 13, 15, 19, 34, 48, 49, 70, 72, 128, 132, 139, 141, 144, 145, *145,* 173, 175–76, 177–78, *178,* 179, 180–88, *181,*

184–85, 187, 191–94, *192–93*, *194*, 196–200, *198*, 206, 207, 211–12, 215, 233, 235, 237, 239, 246, 247, 249, 251, 278, 280, 290, 307, 328, 334, 342, 343

Dark Knight Rises, The, 11, 15, 17, 35, 72, 128, 139, 188, 193, 200, 236–39, *237*, 243, *244*, 244–47, *245*, *246*, 248, 249–52, *252*, 264, 271, 315, 339

Dark Knight trilogy, 9, 17, *48*, 49, 60, 180, 194–95, 199, 203, 208, 246, 266, 339

Darwin, Charles, 137, 150, 261, 262

Dean, Tacita, 162, 312, 344, 345

Dean, Valerie, 149

Debicki, Elizabeth, 311, 313, 323

de Bont, Jan, 292

Demme, Jonathan, 345

Denby, David, 168, 220

De Niro, Robert, 16, *179*

Dent, Chester, 55

De Quincey, Thomas, 221–22

Detour, 335

DiCaprio, Leonardo, 19, 35, 37, 43, *205*, 208, *208*, 209, *209*, 210, *210*, 212, 219, 223, 231, *232*, 233

Dickens, Charles, 17, 226, 235, 236, 251, 335

Dirac, Paul, 164–65

D.O.A., 335

Doctor Faustus (Marlowe), 134

Doctor Zhivago, 146, 235, 244, 260

Donne, John, 316

Donner, Dick, 143

D'Onofrio, Vincent, *47*

Donovan, Martin, 110

Don't Look Now, 9, 41

Doodlebug, 45–46

Dorn, Dody, 88, 116, 169, 170

Double Indemnity, 81, *82*, 83, 114, 335

Douglas, Kirk, 69

Douthat, Ross, 251

Doyle, Arthur Conan, 17, 49, 271, 340

Dr. Mabuse, the Gambler, 174, *176*

Dr. No, 247, 314

Dracula (Stoker), 17

Dungarpur, Shivendra Singh, 96

Dunkirk, 8, 10, 12, 13, 17, 18, 19, 35, 100, 101, 120, 121, 139, 163, 166, 172, 214, 225, 239, 283–87, *284*, *285*, 290, 290–94, *295*, 296–97, 298, *300*, 300–302, *303*, 304–7, 308, 309, 319, 326, 328, 334, 337, 340, 344

Durning, Charles, 94

Dust Bowl, The, 263–64

Dyas, Guy, 209

Dyer, George, 189

Eastwood, Clint, 12, 208

Ebert, Roger, 282

Eckhart, Aaron, 182, *194*

Edison, Thomas, 148, 150, 158

Ehrenfest, Paul, 317

Einstein, Albert, 16, *253*, 254–55, 260

Eisenstein, Sergei, 26, 83, 137, 222, 310, 311

Eksaw, Chia, 165

Eldon, Dan, 132

Elgar, Edward, 17, 18, 19, 302, 306, 308, *308*, 309

Eliot, T. S., 16, 17, 39, 327

Elizabeth, 209

Ellroy, James, 71

Elster, Madeleine, *171*

Empire of the Sun, 154

Empire Strikes Back, The, 25, 96–97

Empson, William, 104, 107

Enigma Variations (Elgar), 17, *18*, 19, 302, 306, 308, 309

Eno, 215

Escher, M. C., 39, 119, 138, 172, *216*, 217, 219, 221, 226–27

Escobedo, Frida, 241

Essay on the Principle of Population (Malthus), 262

E.T. the Extra-Terrestrial, 15, 147

Eureka, 41

Fast & Furious movies, 97

Faust (Goethe), 17, 134

Ferris Bueller's Day Off, 24

Fichtner, William, 179

FILM (Dean), *349*

Film Form (Eisenstein), 25

Fincher, David, 8

Finger, Bill, 177

Fistful of Dollars, A, 319

Flatland (Abbott), *272, 273*

Fleming, Ian, 18, 60, 128, 313, 314, 327

Following, 5, 49, 51, 59, 60, 61–63, *62, 63, 65,*
 66, 67, 68, 69, 70, 74, 76, 80, 81, 83, 84,
 85, 89, 90, 92, 105, 111, 112, 113–14, 120,
 132, 133, 190, 219, 283, 290, 334, 335

Foolish Wives, 292

Ford, Harrison, *27*

Ford, John, 117, 186

Foreign Correspondent, 292, *292*

Forgotten Voices of Dunkirk (Levine), 284

Foucault, Jean-Bernard-Léon, 74

Fox, James, 41, *41,* 56

Foy, Mackenzie, *259, 271*

Frankenstein (Shelley), 150

Franklin, Paul, 211, 212, 244, 245

Frau im Mond (Woman in the Moon), 276,
 276–77

Frears, Stephen, 143

Freddy's Nightmares, 202, 226

Frederick the Great, 215

Frederick William III, 118

Freeman, Morgan, 139, 194, 249

French Revolution (Carlyle), 251

Freud, Sigmund, 224, 225

Fripp, Robert, 215

Fry, Stephen, 29

Fuller, Sam, 337

Full Metal Jacket, 35, 45–46, *46,* 120, 343

"Funes the Memorious" (Borges), 55, 56,
 85–86, 87, 101–2

Galison, Peter, 260

Gardner, Martin, 72, 74, 348

Garr, Teri, 93, 96

Gerlich, Gary, 88

Gettleman, Jeffrey, 74, 132

Gibson, Alex, 308

Gladiator, 253

Glass, Philip, 274, 279

Gleick, James, 5

Glotzer, Liz, 126

Glynn-Carney, Tom, 291, 294, 300

Go-Between, The, 37–38

Gödel, Kurt Friedrich, 219

Godfather, The, 247

Godwin, William, 335

Goebbels, Joseph, 174, 175

Goethe, Johann Wolfgang von, 17, 134

Goldberg, Jordan, 197

Göransson, Ludwig, 321

Gordon-Levitt, Joseph, 220, 229, 230, *230,*
 233, 249

Gore, Al, 5, 198

Gorman, Burn, 236

Goyer, David S., 128, 145, 173, 196, 208,
 237

Grant, Cary, 220

Gravity, 287

Gray, James, 321

Greed, 292

Greer, Jane, *69,* 69–70

Griffith, D. W., 289, 292

Griffith, Melanie, 343

Grove, Andrew, 4

Gursky, Andreas, 290

Gyasi, David, 260

Gyllenhaal, Maggie, 188

Haas, Lucas, *216*

Hack, Richard, 126

Hall, Rebecca, 19, 154, *154,* 156

Handful of Dust, A (Waugh), 271

Hannity, Sean, 251

Hardy, Tom, *205,* 220, 229, 233, *245,* 246,
 246, 247, 251, *252,* 291, 294, 300, 301

Harrelson, Woody, 98

Harris, Ed, 343

Harris, Harriet Sansom, 84

Harris, Thomas, 116, 345

Harry, Prince, 341

Harry Potter films, 250

Hartley, David, 224

Hartley, L. P., 37–38

Hastings, Max, 70

Hathaway, Anne, 238

Hauer, Rutger, 27

Haw, Alex, 54, 61, 62, 65

Hawks, Howard, 338

Hayden, Sterling, 178, *179*

Heal, Gareth, 70, 76

Heat, 9, 16, 70, 108, 110, 177, 179, *179,* 235

Helmholtz, Hermann von, 118, 119, 120

Herostratus, 190, 320

Herschel, William, 4

Herzog, Werner, 97, 198–99

High Noon, 28

Hill, The, 140, 141

Hiney, Tom, 60

His Dark Materials trilogy (Pullman), 36

Hitchcock, Alfred, 9, 14, 57, 59, 76, 111, 112, 170, 171, 219, 220, 225, 292, 331, 338, 339

Hoberman, J., 81

Hockney, David, 161–62

Hoffman, Dustin, 93

Hofstadter, Douglas R., 118–19, 215, 217, 218–19

"Hollow Men, The" (Eliot), 16, 39, 326

Hollywood Eye, The (Boorstin), 56–57

Holmes, Katie, *142*

Hound of the Baskervilles, The (Doyle), 17

Howard, James Newton, 143, 144, 180, 214–15

Hoytema, Hoyte van, 262, 263, *263,* 264, 266, 277, 293, *295,* 296, 298, 312, 315, 316, 324, *341*

Hudson, Hugh, 22, 33, 292

Hughes (Hack), 126

Hughes, Howard Robard, Jr., 16, 125–26, *127,* 127–28, 225

Hughes, John, 24

Huston, John, 131, 135, 338

I Am Legend, 334

If, 34

Image Union, 48

In Absentia, 288

In a Lonely Place, 338

Inception, 8, 11, 12, 13, 15, 19, 35, 37, 42, 43, 45, 46, 47, 50, 53, 55, 60, 64, 71, 92, 97, 118, 119, 122, 123, 127, 136, 150, 170, 189, 200, 201, 202, 203, *205,* 205–7, *206, 208,* 208–14, *210, 211, 213, 214,* 215, *216, 217, 218,* 219–21, *221, 222,* 223–25, 226, 227–34, *230, 232,* 249, 254, 260, 263, 271, 278, 280, 282, 290, 297, 303–4, 319, 328, 330, 334, 335, 336, 339

Infinite Jest (Wallace), 247

Ingres, Jean-Auguste-Dominique, 161, *162*

Insignificance, 143, 215, 320

Insomnia, 5, 59, 60, 72, 108–13, *109, 113, 114,* 114–17, *121,* 121–22, 123, 133, 136, 139, 149, 150, 157, 205, 208, 303, 318, 328, 335, 339

Interpretation of Dreams, The (Freud), 224

Interstellar, 8, 12, 15, 17, 18, 26, 37, 46, 55, 92, 136, 164, 214, 228, 254, 257–59, *259,* 260–62, 263–72, *265, 266, 267, 270, 271,* 273, 274–76, *275,* 277–82, *280,* 289, 292, 318, 320, 328, 335, 337, 339, 342, 343

Intolerance, 292

Ivan the Terrible, 222

I Walked with a Zombie, 69

Jackman, Hugh, 12, 51, 97, 106, 147, 148, *150,* 152, *159,* 160, *167*

Jack Ryan: Shadow Recruit, 323

Jackson, Andrew, 320, 326–27

Jackson, Peter, 9

Jacob's Ladder, 25, 169, *169,* 190

Jagger, Mick, 41, 56

James, Henry, 226, 318

James, William, 72

Jaws, 8, 77, 294

Johansson, Scarlett, 156, *159*

Johnson, Steven, 105, 339

Joly, Dom, 33

Joyce, James, 101

Julyan, David, 54, 88, 89, 102, 172, 287

Kael, Pauline, 289

Kane, Bob, 128, 130, 177

Kant, Immanuel, 4, 5, 72

Kapadia, Dimple, 311, 319

Kapur, Shekhar, 209

Karp, Raine, 315

Kaufman, Philip, 264

Kennedy, Jackie, 165

Kennedy, John F., 163, 164, 165

Keoghan, Barry, 291, 294

Killing, The, 178, *179,* 209

King, Richard, 172, 182, 200, *303,* 305, 307, 308

King, Stephen, 69

Kingpin, 98

Kipling, Rudyard, vii, 131, 135, 229

Klavan, Andrew, 198

Koyaanisqatsi, 274, 279, *279*

Kubrick, Stanley, 16, 23, 35, 46, 57, 120, 141, 178, 179, 205, 208, 262, 281, *303,* 321, 340, 341, 342, 343

La La Land, 97

Lady from Shanghai, The, 338

Lady in the Lake, The, 58, *58*

La Farge, John, 165

Lame, Jennifer, 321, 328

Landaker, Gregg, 307

Lang, Fritz, 9, 142, 174–75, *176,* 244, 276–77, *313,* 314, 337, 339

Lange, Jessica, 93, 94–95, 96

Larceny, 66

LaSalle, Mick, 76

Last Battle, The (Lewis), 37

Last Samurai, The, 215

Last Year at Marienbad, 336, *336*

Laura, 338

Lawrence of Arabia, 16, 138, 146, 199, 297, *299*

Lean, David, 16, 138, 146, 260, 289, 291–92, 293, 297–98, *299*

Le Carré, John, 34, 154, 263, 313

Ledger, Heath, 19, *178,* 191–92, *192–93,* 197, 198, 200

Lee, John, 230, 231

Lee, Spike, 321, 323

L'Engle, Madeleine, 271

Lennon, John, 346

Leone, Sergio, 319

Leopard Man, The, 69

Levine, Joshua, 239–40, 284, 285

Levy, Don, 190, 320–21

Lewis, C. S., 36–37

Lewton, Val, 69

"Library of Babel, The" (Borges), 163, 164

Limbaugh, Rush, 251

Lindh, John Walker, 199

Linklater, Richard, 272

Living in Oblivion, 204

Los Angeles Times, 197, 200, 307

Lost City of Z, The, 321

Lost Highway, 82–83, *83*

Love, Africa (Gettleman), 74

Lowden, Jack, 291, 300

Lucas, George, 9, 22, 168

Lumet, Sidney, 141, 188, 244

Lynch, David, 7, 16, 18, 35, 82–83, 328

Lyne, Adrian, 22, 25, 169, 190

MacMurray, Fred, 81, *82*

Macnish, Robert, 224

Maddow, Rachel, 165

Mad Max, 287

Malick, Terrence, 15, 83, 88, 215

Maltese Falcon, The, 81, 206, 207, 338, *338*

Malthus, Thomas Robert, 17, 261–62

Manafort, Paul, 341

Man Escaped, A, 294

Manhunter, 115, 116, 344, 435

Mann, Michael, 9, 35, 70, 115, 116, 177, 179, 259, 268, 269

Man Who Fell to Earth, The, 9, 40, 41

Man Who Laughs, The, 177

Man Who Would Be King, The, 131, *131*

Markle, Meghan, 341

Marlowe, Christopher, 134

Marr, Johnny, 215

Matrix, The, 81, 104, 204

McCarthy, John, 29

McCartney, Paul, 346

McConaughey, Matthew, 11, 46, *259,* 266, 268, 269, *271,* 276, *280*

McKibbin, Dorothy, 317

Mean Streets, 15

Meisel, Edmund, 305, 311

Méliès, Georges, 151, *152*

Memento, 5, 6–8, *8,* 9–10, 12, 19, 55, 59, 60, 70, 71, 76, 78, *79,* 79–82, 83–85, *86,* 86–91, *87, 91,* 92, 98–100, *99,* 101–4, *102, 103,* 105–6, 107, 108, 109, 111, 116, 120, 122, 139, 149, 150, 161, 169, 197, 207, 208, 212, 219, 224, 227, 229, 249, 254, 260, 271, 282, 289, 309, 318, 328, 332, 334, 335, 336, 337, 342, 346

Mendelsohn, Ben, 247

Mestitz, Kate, *91*

Metropolis, *142,* 175, 244, *313*

Meyer, Stanley, 143

Mies van der Rohe, Ludwig, 48, 195

Milk Money, 343

Miller, Frank, 124, 141

Miller, George, 287

Miller, Luke, 45

Mirror, The, 83, 262

Mission: Impossible—Rogue Nation, 307

Mitchum, Robert, 69, *69,* 70

Montgomery, Robert, *58,* 58–59

Moonstone, The (Collins), 16, 17, 225–26, 289

Moore, Jerrold Northrop, 19

Morris, Errol, 320

Morrison, Grant, 130

Moss, Carrie-Anne, 78, *87,* 88, 90

Murder of Roger Ackroyd, The (Christie), 226

Murdoch, Rupert, 304

Murnau, F. W., 16, 292

Murphy, Cillian, 136, 144, *205, 206,* 219, 249, 294, 300, 301, 303

Musical Offering (Bach), 172, *216,* 218–19, 309

My Beautiful Laundrette, 143

My Darling Clementine, 186

Mysterious Stranger, The (Twain), 327, 329

Naked Gun, The, 93, 96

Napoléon I, 118, 251

Neeson, Liam, 135

New Yorker, The, 13, 76, 168, 287

New York Times, 11, 220, 251, 289

Nielsen, Leslie, 93

Night Manager, The, 313

"Nimrod" (Elgar), 302, 306, 307

Nineteen Eighty-Four (Orwell), 194, 229, 240, 243

Nolan, Brendan, 18, 21, 22, 23, 26, 166, 274, 302, 303, 304, 307, 343

Nolan, Christina, 22, 23, 43, 286, 343

Nolan, Flora, 155, *205,* 259, 341

Nolan, Francis Thomas, 302

Nolan, Jonathan ("Jonah"), 22, 26, 35, 39, 74–75, 77, 78–79, 80, 84, 85, 104, 105, 115, 149, 156, 160–61, 176, 186, 196, 197, 208, 235–36, 237, 238, 253, 254, *254,* 255–56, 259, 260, 262, *264,* 267, 269, 271, 281, 330, 332

Nolan, Magnus, 206

Nolan, Matthew, 22

Nolan, Oliver, 15, 155, *156,* 207

Nolan, Rory, 15, 155, 207

North by Northwest, 219, 220, 328, 330, 331, 339

Novak, Kim, *170,* 207

Obama, Barack, 198, 251

Observations on Man (Hartley), 224

Obst, Lynda, 253

Ocean's Eleven, 123, 206

October, 305, 310

Offence, The, 141, 188

Oldman, Gary, 35, *140,* 141

On Her Majesty's Secret Service, 219, 232

On the Waterfront, 247

Oppenheimer, J. Robert, 316–17, *317,* 327

Orpheus, 312, 320

Orwell, George, 229, 240–41, 243

O'Sullivan, Conor, *193*

Otero, Nilo, 209

Otomo, Katsuhiro, 35

O'Toole, Peter, *299*
Out of Sight, 109
Out of the Past, 69, 69–70, 338

Pacino, Al, 72, *109,* 110, 111, *113,* 114, 115, 116, 117, 133, *140,* 318
Padgett, Bob, 308–9
Page, Ellen, 212
Pantoliano, Joe, 78, *86, 102, 103*
Papsidera, John, 156
Parker, Alan, 21–22, 35, 41, 42, 225
Pattinson, Robert, 311, 317, 321, *322*
Pauli, Wolfgang, 317, 331
Pearce, Guy, 19, 78, *79,* 85, *86, 87,* 88, 89, *91, 99,* 101, 102, *103,* 104, 120
Peck, Gregory, 298
Penrose, Roger, 118, *119*
Peoples, David, 207
Perfect Spy, A (Le Carré), 34
Perfidia (Ellroy), 71
Performance, 9, 41, *41,* 56
Perkins, Anthony, 57
Pfister, Wally, 85, 157, 172, 212, 244, 266
Phantom Menace, The, 168
Philosophy of Sleep, The (Macnish), 224
Piaf, Edith, 208, 212, 213, 233
Pickpocket, 294
Pink Floyd: The Wall, 16, 41–43, *42,* 172, *225,* 226
Pinter, Harold, 37, *38*
Pirandello, Luigi, 98
Piranesi, Giovanni Battista, *137,* 138, 220, 221–22
Planets, The, 302–3
Pleasance, Donald, 247
Podesta, Patti, 85
Poe, Edgar Allan, 7, 49, 112, 202, 229, 335
Poésy, Clémence, 318
Pollack, Sydney, 93, 94
Pontecorvo, Gillo, 243
Portrait of Madame Louis-François Godinot (Ingres), 161, *162*

Postlethwaite, Pete, 219, 303
Pound, Ezra, 207
Powell, Anthony, 36
Preminger, Otto, 338
Presley, Priscilla, 93
Prestige, The, 12, 17, 19, 51, 72, 91, 92, 97, 106–7, 120, 138, 139, 147, *147,* 148–49, 150, *150,* 152, 153–60, *154, 159, 167,* 167–69, 172, 173, 208, 219, 231, 260, 287, 335, 343
Priest, Christopher, 149
Prince of the City, 141, 244
Principles and Persuasions (West), 229
Principles of Psychology, The (James), 72
Psycho, 57, 170
Ptolemy, 242
Pullman, Bill, *83*
Pullman, Philip, 36
Pulp Fiction, 67, 104

Quay, 288–89
Quay, Stephen, 288, *288*
Quay, Timothy, 288, *288*

Raging Bull, 88
Raiders of the Lost Ark, 24, 25, 67, 147, 286, 343
Rao, Dileep, *210,* 220
Ray, Nicholas, 337, 338
Red Dragon, 116
Reflections on the Revolution in France (Burke), 251
Reggio, Godfrey, 274, 279
Relativity (Escher), 221, 227
Reservoir Dogs, 67
Resnais, Alain, 92, 336
Rhodes-James, Richard, 29, 32
Ricci, Massimo, 45
Richter, Gerhard, *272,* 273
Right Stuff, The, 264
Roache, Linus, 133
Robbins, Tim, *169,* 190
Robert-Houdin, Jean-Eugène, 151–52

Robinov, Jeff, 123, 124

Robinson, Jerry, 177

Roeg, Nicolas, 9, *40*, 41, 56, 92, 141, 143, 215, 262, 320

Rogers, Kasey, *112*

Romney, Mitt, 251

Rushton, Julian, 309

Ruskin, John, 318

Russell, Lucy, 54, 68, 76

Ryan's Daughter, 146, 289, 291, 293, *299*

Ryder, Aaron, 84, 90

Rylance, Mark, 19, 291, 294, 296–97, 300

Sacks, Oliver, 99

Sagan, Carl, 25, 253, 255, 262

Saint, Eva Marie, 247

Salinger, Pierre, *163*

Sarris, Andrew, 338

Scarfe, Gerald, 41–42

Schaverien, Joy, 100

Schumacher, Joel, 123, 124

Scorsese, Martin, 15, 28, 126, 127, 337

Scott, A. O., 220

Scott, Ridley, 13, 16, 22, *27*, 27–28, 35, 101, 132, 143

Scott, Tony, 22, 143

"Secret Miracle, The" (Borges), 91, 203

Seitz, Hillary, 109, 110, 114–15, 116, 208

Serpico, 111, *140*, 141–42

Seven Types of Ambiguity (Empson), 104

Shackleton, Ernest, 260–61

Shadow of a Doubt, 339

Shafer, Martin, 126

Shakespeare, William, 271

Shane, 238, 334

Shape of Water, The, 307

Sharif, Omar, 260, 298

Shelley, Mary, 150

Shepard, Roger, 171–72

Shining, The, 78, 103, 345

Shyamalan, M. Night, 169, 212, 344

Silence of the Lambs, The, 345

Silverman, Greg, 124

Singer, Bryan, 205

Sirk, Douglas, 337

Sixth Sense, The, 105, 169

Skjoldbjærg, Erik, 108

Smith, Lee, 135, 173, 215, 230, 231, 232, 234, 276, 279, 297, *303*, 307

Soderbergh, Steven, 6–7, 13, 92, 108, 109, 117, 123, 289

Sophocles, 318

Souriau, Etienne, 152–53

Speed, 292

Spellbound, 225

Spengler, Oswald, 195

Spielberg, Steven, 9, 15, 25, 147, 154, 253, 255, 262, 266, 286, 328

Spies, *313*, 314

Stalin, Joseph, 310, 316

Stanwyck, Barbara, *82*

Star Trek Beyond, 307

Star Wars, 22–23, 32, 67, 97, 302

Stewart, Jimmy, 170

Stewart, Josh, 236

Stewart, Sara, 133

Stoker, Bram, 17

Strangers on a Train, 59, 112, *112*

Street of Crocodiles, 288

Strip (Richter), *272*, 273

Study After Velázquez's Portrait of Pope Innocent X (Bacon), *180*, 191

Sunrise, 16, 292, 293

Supergods (Morrison), 130

Supper at Emmaus (Caravaggio), 162

Svankmajer, Jan, 288

Swank, Hillary, *109*, 110

Swieten, Gottfried van, 215, 217

Swift, Graham, 39–40, 317

Sylvester, David, 189

Tale of Two Cities, A (Dickens), 17, 235, 236, *236*, 238, 251

Tarantella, 48

Tarantino, Quentin, 66, 92, 205
Tarkovsky, Andrei, 83, 92, 262, 263
Tempest, Matthew, 52
Tenet, 15, 96, 311–12, *312*, 313, 314–16, 318–21, *322*, 323–28, *324–26*, *329*, 330, 336–37, 339
Tesla, Nikola, 154, 158, 160
Testament of Dr. Mabuse, The, 174–75, *176*
Theobald, Jeremy, 45, 51, 54, 61, *62*, *63*, 68
Theroux, Marcel, 241
Thin Red Line, The, 88, 215
Thomas, Dylan, 272
Thomas, Emma, 12, 13, 50, 54, 65, 66, 74, 83, 84–85, 90, *91*, 124, 155–56, *156*, 172, 206, 207, *210*, 222, 258, *263*, *264*, 283–84, 286, 287, *293*, 307, *322*, 323, 341, 345
Thorne, Kip S., 253, 254, 320
Thunderball, *127*, 167
Tillman, Martin, 181
Time Cop, 343
Time Is, 320–21, *321*
Time Travel (Gleick), 5
Tinker Tailor Soldier Spy, 263
Tobolowsky, Stephen, 84
Todd, Jennifer, 89–90
Todd, Suzanne, 90
Tootsie, 93–97, *94*
Toro, Guillermo del, 307
Total Recall, 336
Toto, Christian, 251
Totter, Audrey, *58*
Tourneur, Jacques, 9, 69, 338
Townsend, Peter, 29
Treasure of the Sierre Madre, The, 131
Triptych August 1972 (Bacon), *189*
Trotsky, Leon, 310
Truffaut, François, 337
Truman, Harry, 198
Trump, Donald, 251–52

Twain, Mark, 327, 329
2001: A Space Odyssey, 16, 23, *23*, 32, 57, 281, 282, 303, 321, 340, 341, 342–43

Uncle Buck, 24
Unforgiven, 208

Veidt, Conrad, 177
Vertigo, 57, 170, *170*, 171, *171*, 207, 219, 328
von Stroheim, Erich, 292

Wages of Fear, The, 292, 293–94
Walker, Robert, *112*
Wallace, David Foster, 247
Ward, Jean, 188–89
War for the Planet of the Apes, 307
Warner, Frank, 88
Washington, John David, 311, *312*, *315*, 319, 320, 321, *322*, 323, *324*, *326*, 327, 336
Watanabe, Ken, 37, 144, *216*, 219
Waterland (Swift), 39–40, 42, 317
Waugh, Evelyn, 271
Weaver, Sigourney, *27*
Weinstein, Harvey, 13, 307–8
Weir, Peter, 135, 220
Welles, Orson, 92, 146, 338
Wells, H. G., 17
West, Anthony, 229
What Maisie Knew (James), 318
Where Eagles Dare, 27, 33
Whitehead, Fionn, *295*
Wilkins, William, 30
Wilkinson, Tom, 144
Williams, John, 302–3
Williams, Robin, 110–11, 112, 114, *114*, 133
"William Wilson" (Poe), 229
Wilson, Anne, 317
Winter's Tale, The (Shakespeare), 271

Wiseman, Joseph, 247
Wright, Frank Lloyd, 17, 209, 336, 337
Wright, Teresa, 339
Wrinkle in Time, A (L'Engle), 271
Wu, Chien-Shiung, 330–31, 332, 348

X-Men, 168

Young, Freddie, 291, 298
You Only Live Twice, 35, 123, 215, 219, 247
Yourcenar, Marguerite, 138

Zimmer, Hans, 17, 18, 32, 101, 143–44, 172, 180–82, 196, 213–14, 215, 232, 257–59, 266, 268, 269, 273, 274–76, *275,* 278, 279, *304,* 304–5, 306, 307, 309, 339, 340

Back Hand Spring
by Eadward James
Muybridge, 1881.

ILLUSTRATION CREDITS

Frontispiece	Photofest
Copyright page	Nuffield Foundation
Opposite epigraph	© Nicolas Grospierre
Opposite half title	Alamy

Page	
3	Telstar Logistics, Creative Commons
6	Getty Images/Barbara Alper
8	Photofest
11	Alamy
14	Courtesy of Syncopy
18	Sotheby's
21	Public domain
23	Everett Collection
24, 25	Public domain
27	Photofest
28	Luke Miller
30 (top)	Public domain
30 (bottom)	Søren Bjørn-Andersen
33	Photofest
37	WikiCommons
38	Photofest
40 (top)	Everett Collection
40 (bottom)	Photofest
41, 42	Photofest
44, 46	Public domain
47	Photofest
48 (top)	Photofest
48 (bottom)	squeaks2569
51	Photofest
53 (top)	© Mary Hinkley, UCL Digital Media
53 (bottom)	© UCL Digital Media
55	Everett Collection
58 (top)	Everett Collection
58 (bottom)	Photofest
59	Public domain
62, 63, 65	Photofest
69	Everett Collection
71 (top)	Paul Kranzler and Andrew Phelps
71 (bottom)	Public domain
77, 79, 82, 83	Photofest
86 (top)	Neal Peters
86 (bottom)	Photofest
87	Photofest
91	Alamy
94 (left)	Photofest
94 (right)	Kate Babb Shone
99	Everett Collection
102	Photofest
103, 108	Alamy
109	Everett Collection
112	Alamy
113	Warner Brothers
114	Photofest
115	Everett Collection
119	Public domain
121	Warner Brothers
125, 127	Photofest
129	Tim Lewellyn
130, 131	Everett Collection
136	Alamy
137	Public domain
140, 142	Photofest

145	Warner Brothers
147	Photofest
148	Public domain
150	Photofest
152 (top)	Photofest
152 (bottom)	Public domain
154, 156	Photofest
159 (top)	Alamy
159 (bottom)	Photofest
162	Public domain
163 (top)	Public domain
163 (bottom)	Wikimedia Commons/U.S. National Archives
167, 169, 170, 171	Photofest
172	Public domain
174	Alamy
176 (left)	Alamy
176 (right)	Photofest
178	Alamy
179	Photofest
180	Artepics/Alamy
181	Photofest
184, 185	James Cornish
187	Warner Brothers
189	ITAR-TASS News Agency/ Alamy
192	Alamy
193	Everett Collection
194, 195, 198	Warner Brothers
202	Wikimedia Commons
205	Photofest
206 (top)	Tim Lewellyn
206 (bottom)	Courtesy of Christopher Nolan
208	Photofest
209	Alamy
210, 211	Warner Brothers
213, 214	Alamy
216 (top left)	Alamy
216 (top right)	Creative Commons
216 (bottom)	Everett Collection
217, 218	Christopher Nolan
221	Photofest
222 (top)	Roko Belic
222 (bottom)	Warner Brothers
225	Everett Collection
226	Alamy
227 (top)	Warner Brothers
227 (bottom)	Public domain
230, 232	Warner Brothers
235	Photofest
236	Impress/Alamy
237	Warner Brothers
240 (top)	Public domain
240 (bottom)	Photofest
244, 245	Warner Brothers
246	Photofest
248	Gabriel Hardman
252	Photofest
253	Public domain
254	Warner Brothers
257, 259, 261	Alamy
263, 264	Warner Brothers
265, 266	Alamy
267	Warner Brothers
270	Christopher Nolan
271	Warner Brothers
272 (top)	Public domain
272 (middle)	Creative Commons
272 (bottom)	Atelier Gerhard Richter
275	Jordan Goldberg
276, 279, 280	Photofest
283	Alamy
284	Photofest
285	Alamy
288	Roko Belic
290, 292	Photofest
293	Warner Brothers
295 (top)	Everett Collection
295 (bottom)	Alamy
299	Photofest
300	Alamy
303, 304, 306	Andy Thompson
308	Public domain
310	Alamy
312	Warner Brothers
313	Photofest
315 (top)	Tallinna Linnahall/A. Valminud
315 (bottom)	Warner Brothers
317	Alamy
319	Public domain

321 Nuffield Foundation

322 Warner Brothers

324, 325, 326 Christopher Nolan

329 Warner Brothers

331, 334, 336, 338 Photofest

340, 341 Roko Belic

345 Courtesy of the artist, Frith
Street Gallery, London and
Marian Goodman Gallery,
New York and Paris. Photograph
by Marcus Leith and Andrew
Dunkly, Tate, courtesy of the
artist, Frith Street Gallery,
London and Marian Goodman
Gallery, New York and Paris.

347 Roko Belic

352 Wikimedia Commons/
antomoro

356 Jonas Bengtsson

366, 378 Alamy

A NOTE ON THE TYPE

This book was set in Adobe Garamond. Designed for the Adobe Corporation by Robert Slimbach, the fonts are based on types first cut by Claude Garamond (c. 1480–1561). Garamond was a pupil of Geoffroy Tory and is believed to have followed the Venetian models, although he introduced a number of important differences, and it is to him that we owe the letter we now know as "old style." He gave to his letters a certain elegance and feeling of movement that won their creator an immediate reputation and the patronage of Francis I of France.

Composed by North Market Street Graphics, Lancaster, Pennsylvania
Printed and bound by Mohn Media, Gütersloh, Germany
Designed by Maggie Hinders